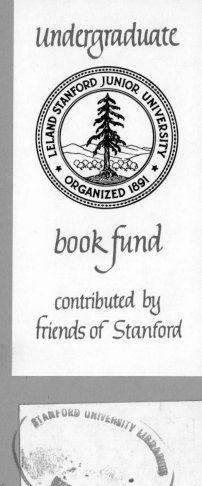

WESTERN SCULPTURE DEFINITIONS OF MAN

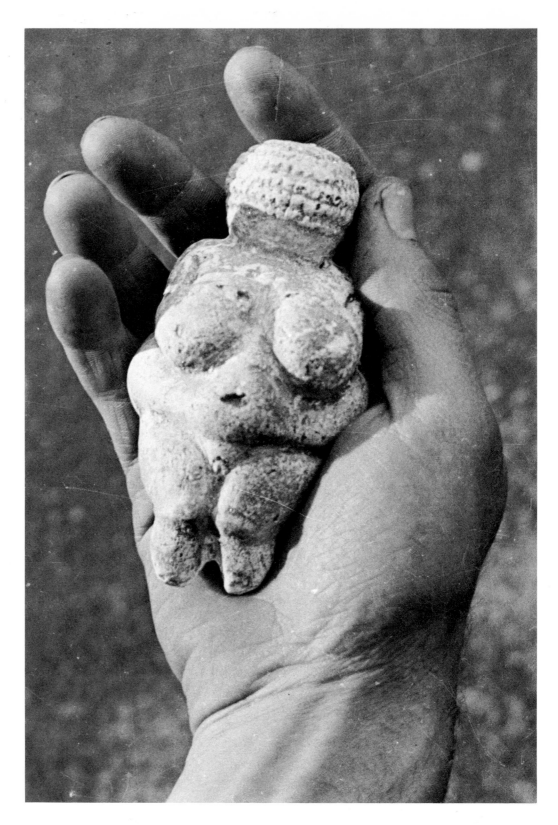

Venus of Willendorf (Fig. 11), held in the hand of sculptor William Tucker.

WESTERN SCULPTURE
DEFINITIONS OF MAN

Ruth Butler

NEW YORK GRAPHIC SOCIETY
BOSTON

1976

Designed by Betsy Beach

Library of Congress Cataloging in Publication Data

Butler, Ruth, 1931–
 Western sculpture.

 Bibliography: p.
 Includes index.
 1. Sculpture—History. I. Title.
NB60.B88 730′.9 74-21497
ISBN 0-8212-0429-7

First printing

New York Graphic Society books are published by Little, Brown and Company.
Published simultaneously in Canada by Little, Brown (Canada) Limited.

Printed in the United States of America

Preface

As I began to think about a general study of sculpture in the late 1960's, I became increasingly conscious of two facts. First, when the literature of art history began to grow in the late nineteenth and early twentieth centuries, the history of sculpture was not a subject that aroused much attention. In Hannah Lee's *Familiar Sketches of Sculpture and Sculptors*, the first general book on sculpture published in the United States, in 1854, the author noted:

> The subject of Sculpture among us Americans has been but little studied except by the initiated. Painting has her thousand votaries, and is illustrated and described by a hundred authors, while sculpture stands off in moonlit solitudes, and, like the Egyptian Isis, veils her features from the crowd.

Familiar Sketches surely raised no swell of enthusiasm. The late nineteenth century is significantly lacking in interesting books on sculpture, either in the United States or Europe. Not until the second quarter of the twentieth century did a number of European historians begin to publish studies on individual problems in the field of sculpture. And in this country books on the subject have appeared in considerable number only since World War II.

The second fact apparent to the contemporary student of sculpture is that in recent years the long-standing indifference towards sculpture has decreased. And this change is related to the work and the ideas of Western artists during the past ten years. The German sculptor Joseph Beuys commented during an interview in 1969:

> Man hasn't thought much until now about sculpture. We ask: "What is sculpture?" And reply: "Sculpture." The fact that sculpture is a very complex creation has been neglected. What interests me is the fact that sculpture supplies a definition of man. (*Artforum,* December 1969)

The present book has been written with the intention of exploring something of the complexity referred to by Beuys. The other interest that he points to—sculpture as a definition of man—has been an underlying theme throughout the book: What are the special ways in which sculptors have struggled with the question of man's essential nature? This leads us to think about the reality specific to the sculptured work—the surfaces and spaces, the difference

between sculpture in the round and in relief, between sculpture as monolith, as fragment, and as assemblage. We have to consider the particular themes best suited to sculpture, as well as the way in which stress on the body in its different aspects has continually altered.

Although this is a survey and by its nature large in scope, I have tried to avoid too many generalizations. Thus, I chose to consider a small number of sculptures in some detail, hoping that the major concerns of Western sculptors would come to the fore, even though this method meant greatly restricting the number of masters and works discussed in the book. My commitment has been to begin with the work of sculpture rather than with an idea about it. At the same time I have stressed the context in which each work exists, so the structure of the book is therefore historical.

Writing a book takes up no small part of a person's life, so at the finish it is important to remember who shared it. First is the late Burton Cumming, Editor-in-Chief of New York Graphic Society until 1971, who asked me to write the book and whom I remember with particular warmth. Betty Childs, Senior Editor of New York Graphic Society, has guided me through the years and made me believe that the actual realization of a book can be an agreeable process and a noble venture. I wrote most of the manuscript at one of those wonderful desks available to scholars at the Library of Congress. My thanks to the L. C. staff for making it a thoroughly pleasant place in which to write. My thanks also to my former colleagues and students at the University of Maryland, particularly Elizabeth Pemberton, Roger Rearick, and Jeanne Janes, each of whom helped on particular sections. Many have aided in the gathering of photographs; I wish to thank especially: H. W. Janson, Debra Pincus, Fred Licht, Gillie Faure, Daniel Rosenfeld, June Hargrove, Ursula Schlegel, and Josephine Withers.

But most important, without particular friends who are generous with their lives, their criticism, their encouragement, and suggestions, I can not imagine how anyone ever completes books. This book has had three such friends: Josephine Withers, Jane Van Nimmen, and H. W. Janson.

R. B.

Charlestown, Massachusetts,
January 1975

Contents

Illustrations

Photographs were lent by the owners unless otherwise noted. Dimensions in captions indicate height first.

Frontispiece:
 Venus of Willendorf (see Fig. 11) held in the hand of sculptor William Tucker. (Photograph by Sean Hudson, first published on the cover of *First*, no. 2, 1961, the journal of the sculptors at St. Martin's School, London.)

92 GIOVANNI BOLOGNA. Side view of Fig. 90.

93 JEAN GOUJON. *Lamentation.* 1544–45. Louvre, Paris. (Marburg–Art Reference Bureau)

94 GERMAIN PILON. *Lamentation.* 1583–85. Louvre, Paris. (Jean Roubier, Paris)

95 ALESSANDRO VITTORIA. *St. Jerome.* 1560's. S. Maria dei Frati, Venice. (Alinari, Florence)

96 GIANLORENZO BERNINI. *St. Jerome.* 1661–63. Chigi Chapel, Duomo, Siena. (Alinari, Florence)

97 GIANLORENZO BERNINI. *Francesco d'Este.* 1650–51. Pinacoteca Estense, Modena. (Alinari–Art Reference Bureau)

98 BENVENUTO CELLINI. *Cosimo I.* 1545–47. Bargello, Florence.

99 EDWARD PIERCE. *Sir Christopher Wren.* 1673. Ashmolean Museum, Oxford.

100 GREGORIO FERNÁNDEZ. *Pietà.* 1616–17. National Museum of Sculpture, Valladolid. (Foto MAS, Barcelona)

101 GREGORIO FERNÁNDEZ. Detail of Fig. 100. (Foto MAS, Barcelona)

102 GIANLORENZO BERNINI. *Ecstasy of St. Theresa.* 1642–52. Detail of the head. Cornaro Chapel, Santa Maria della Vittoria, Rome. (Anderson–Art Reference Bureau)

103 JUAN MARTINEZ MONTAÑÉS. *The Immaculate Conception.* 1628–31. Polychromed wood. Cathedral, Seville. (Foto MAS, Barcelona)

104 FRANÇOIS DUQUESNOY. *St. Susanna.* 1629–33. S. Maria di Loreto, Rome. (Anderson–Fototeca, Rome)

105 GIANLORENZO BERNINI. *St. Longinus. ca.* 1630–38. St. Peter's, Vatican. (Anderson–Fototeca, Rome)

106 FRANÇOIS DUQUESNOY. *St. Andrew.* 1627–39. St. Peter's, Vatican. (Anderson–Fototeca, Rome)

107 View of the gardens. Versailles. (Alain Perceval, Paris)

108 PIERRE PUGET. *Milo of Crotona.* 1672–82. Louvre, Paris. (Alinari–Art Reference Bureau)

109 ANTOINE COYSEVOX. *The Garonne.* 1685–86. Parterre, Versailles. (Archives Photographiques, Paris)

110 ANTOINE COYSEVOX. *The Duchess of Burgundy as Diana.* 1710. Louvre, Paris. (Alinari–Art Reference Bureau)

111 JEAN-BAPTISTE PIGALLE. *L'Amitié* (Madame de Pompadour). 1750–51. Rothschild Collection, Paris. (Service de Documentation Photographique, Paris)

112 ETIENNE-MAURICE FALCONET. *Bather.* 1757. Louvre, Paris. (Service de Documentation Photographique, Paris)

113 FALCONET. Detail of Fig. 112. (Service de Documentation Photographique, Paris)

114 JEAN-BAPTISTE LEMOYNE. *Louix XV.* 1757. The Metropolitan Museum of Art, New York (gift of George Blumenthal).

115 JEAN-ANTOINE HOUDON. *Comte de Mirabeau.* 1791. Louvre, Paris.

116 CAMILLO RUSCONI. *St. Matthew.* 1715–18. S. Giovanni in Laterano, Rome. (Alinari–Art Reference Bureau)

117 BALTHASAR PERMOSER. *St. Augustin.* 1725. Stadtmuseum, Bautzen. (Marburg–Art Reference Bureau)

118 JOSEPH NOLLEKENS. *Venus Chiding Cupid.* 1778. Usher Art Gallery, Lincoln.

119 *Venus de' Medici.* Roman copy after a Greek original of the 4th Century B.C. The Uffizi Gallery, Florence. (Alinari, Florence)

120 JOHAN TOBIAS SERGEL. *Venus.* 1770's. National Museum, Stockholm.

121 ANTONIO CANOVA. *Venus Italica.* 1805–1812. Pitti Gallery, Florence. (Alinari, Florence)

122 CANOVA. Rear view of Fig. 121.

123 FRANCOIS RUDE. *Mercury Attaching His Wings.* 1828–1834. Louvre, Paris. (Service de Documentation Photographique, Paris)

124 FRANCOIS RUDE. *Marshal Ney.* 1852–53. Avenue de l'Observatoire, Paris. (Bulloz, Paris)

125 ANTOINE-LOUIS BARYE. *Bull Attacked by a Tiger. ca.* 1836–38. Louvre, Paris. (Service de Documentation Photographique, Paris)

126 AUGUSTE PREAULT. *Ophelia.* 1843, cast in bronze in 1876. Musée des Beaux–Arts, Marseille. (Giraudon, Paris)

127 JEAN-BAPTISTE CARPEAUX. *Ugolino.* 1860–1862. (Archives Photographiques, Paris)

128 MICHELANGELO. *Lorenzo de' Medici.* 1525–34. Medici Chapel, Florence. (Alinari–Art Reference Bureau)

129 AUGUSTE RODIN. *The Gates of Hell.* 1880–1917. Rodin Museum, Philadelphia.

130 AUGUSTE RODIN. *The Thinker.* 1880. The Metropolitan Museum of Art, New York.

131 AUGUSTE RODIN. *Flying Figure. ca.* 1890–91. Rodin Museum, Paris. (Robert Descharnes, Paris)

132 Sculpture exhibition at the Exposition of 1900, Grand Palais, Paris.

133 ARISTIDE MAILLOL. *Action in Chains.* 1905–6. Bronze, 7'. Museum of Modern Art, Paris. (Agraci, Paris)

134 AUGUSTE RODIN. *Walking Man.* 1905–07. Museum of Modern Art, Paris. (Archives Photographiques, Paris)

135 HENRI MATISSE. *The Serf.* 1900–03. The Hirshhorn Museum and Sculpture Garden, Smithsonian Institution, Washington, D.C.

136 HENRI MATISSE. *La Serpentine.* 1909. The Baltimore Museum of Art.

137 CONSTANTIN BRANCUSI. *Sleeping Muse.* 1910. The Hirshhorn Museum and Sculpture Garden, Smithsonian Institution, Washington, D.C.

138 CONSTANTIN BRANCUSI. *Sleeping Muse.* 1910. Museum of Modern Art, Paris. (Service de Documentation Photographique, Paris)

139 PABLO PICASSO. *Head of a Woman.* 1909. Kunsthaus, Zurich.

140 JACQUES LIPCHITZ. *Seated Man with Guitar.* 1918. Stadt Kunstmuseum, Duisburg.

141 JACQUES LIPCHITZ. *Harpist.* 1928. Collection of Mrs. T. Catesby Jones, New York.

142 ANTOINE PEVSNER. *Dancer.* 1927–29. Yale University Art Gallery, New Haven (Gift of Collection Société Anonyme).

143 JULIO GONZALEZ. *Woman Combing Her Hair.* 1936. The Museum of Modern Art, New York (Mrs. Simon Guggenheim Fund).

144 MARCEL DUCHAMP. *Bottle Rack.* 1914. Collection Man Ray, Paris. (Ph: Courtesy George Rainbird, Ltd.)

145 ALEXANDER CALDER. *A Universe.* 1934 (motorized version of stabile *Universe* of 1931). The Museum of Modern Art, New York (Gift of John D. Rockefeller, Jr.)

146 ALEXANDER CALDER. *Steel Fish.* 1934. Collection of the Artist, Roxbury, Connecticut.

147 DAVID SMITH. *Tank Totem V.* 1955–56. Collection Mr. and Mrs. Howard Lipman, New York (Ph: Archives of American Art, Smithsonian Institution)

148 DAVID SMITH. *Tank Totem VII.* 1960. Storm King Art Center, Mountainview, New York.

149 ROBERT MORRIS. *Untitled.* 1967–68. Installation view at Leo Castelli Gallery, New York.

150 ROBERT MORRIS. *Untitled.* 1968. Installation view at Leo Castelli Gallery, New York.

151 CLAES OLDENBURG. *Giant Blue Shirt with Brown Tie.* 1963. *Mr. and Mrs. Ivan Beck, New York City.*

152 CLAES OLDENBURG. *Lipstick on Caterpillar Tracks* being erected, May 1969, Yale University, New Haven. (Shunk-Kender)

153 CLAES OLDENBURG. *Lipstick on Caterpillar Tracks.* 1969. Yale University, New Haven. (Shunk-Kender)

154 GEORGE SEGAL. *Man in Chair* (Helmut von Erffa). 1969. Collection Giuseppe Panza di Biumo, Milan. (Ph: Geoffrey Clements, courtesy Sidney Janis Gallery, New York).

155 RONALD BLADEN. *Untitled.* 1966–67. The Museum of Modern Art, New York (James Thrall Soby Fund).

156 GEORGES VANTONGERLOO. *Construction in an Inscribed and Circumscribed Square of a Circle.* 1924. Collection Peggy Guggenheim, Venice.

157 GERMAINE RICHIER. *Don Quixote of the Forest.* 1950–51. Walker Art Center, Minneapolis (Eric Sutherland)

158 JEAN ARP. *Human Concretion.* 1935. The Museum of Modern Art, New York.

My intention . . . is to be as clear and as short as I can in writing you which of the two most excellent manual arts, i.e., painting and sculpture, holds the first rank. Stating the arguments first in favor of one and then of the other, I shall compare them so that it will be possible to see which of the two should be preferred. And since I intend to take sides, and indeed believe myself to be on the right side, i.e., on the side of painting, I shall now present its defense, stating, nevertheless, the opposite arguments as faithfully as I can. The subject, however, is really very difficult and would need long and careful consideration; therefore I do not promise to discuss it fully, but, as I said, only as clearly and as briefly as I can.

The painter Bronzino, letter to
Benedetto Varchi, *ca.* 1546

ONE

The Paragone

A Comparison between Sculpture and Painting

Western sculpture is being reappraised during our generation. Critics speak of a "renaissance of sculpture," of its "liberation," its "vast potential," and the "worldwide surge" of sculptural creativity. It has even been suggested that sculpture "threatens to become the art form *par excellence* of the rest of the century." [1]

In the process, sculpture's relationship to painting has changed, for sculpture now rivals, sometimes absorbs, that art which has been the primary vehicle for expressing the Western perception of visual reality. By the late 1950's the critic Clement Greenberg found it "evident that the fate of visual art in general is not equated as implicitly as it used to be with that of painting." [2] Each year the justness of this observation has become clearer. And a new parity has come about for the first time since the Renaissance, when painting and sculpture were the subject of the *Paragone*, that critical dispute on the ranking of the arts.

There was a well-founded tradition in ancient and medieval literature of comparing different intellectual and creative fields. In the Middle Ages especially the idea of higher and lower degrees of knowledge and expression was taken for granted. The worthiest perception of life was that which was closest to Divine Truth; without doubt the senses provided the least certain route to such exalted enlightenment, so the visual arts—classed with the *Artes Mechanicae*, the mechanical arts—could not possibly vie with the Liberal Arts. The terms used for painting and sculpture were interchangeable: the Latin noun *imago*, or *ymage* in English, indicated a likeness in either art, and in twelfth- to sixteenth-century France an *imagier* was an artist who made painted *or* sculpted images; *figura* and its various derivatives had a similar broad meaning. To be sure, medieval man was aware of the differences between painting and sculpture; the Eastern Church, with its intense fear of anything so real as sculpture in the round, knew it best of all. But theoretical discussion of the relative merits of the two arts was irrelevant when both were subject to the Church, which saw them as equal in measure and worth. The paramount requirement for the craftsman—the *imagier*—was to teach the Church's lessons; the choice of painting or sculpture depended upon appropriateness to a particular ritual.

A fundamental change in the Renaissance was the recognition of objectives other than didactic or liturgical. By the fifteenth century in Italy an artist's aspiration was to create an image that looked like a form in nature. Once the goal was clearly stated, it was logical to ask

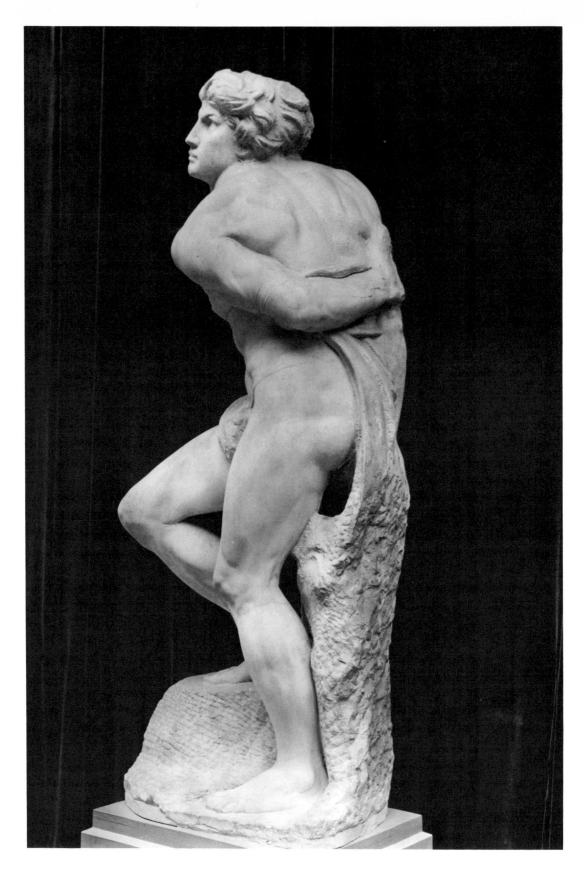

1. MICHELANGELO. *Rebellious Slave.* 1513–16. Marble, 84″. Louvre, Paris.

what art form would best serve to obtain it. This new sense of art having a purpose manifest in the work itself, independent of any teaching or ceremonial context, and a new self-awareness about the intellect's involvement in creating the work had a liberating effect. The result was a flourishing discourse, and we find that by the sixteenth century artists and literati were exchanging letters—like Bronzino's to Varchi (see page xvi)—full of discussion about "which of the two most excellent manual arts, i.e., painting and sculpture, holds the first rank." [3]

The debate has been in progress ever since, with painting usually emerging as victor. Sculpture's position was frequently defensive, and in certain respects this has influenced the history of post-Renaissance sculpture.

The central issues in the developing dialogue can focus attention on the intrinsic characteristics of sculpture. First, and central to the art, is its material existence. A sculptor has to be able to fashion clay, chisel hard stone, and mold bronze; these are all difficult tasks, and sculpture usually has been seen as meritorious by that fact alone. Yet champions of painting sometimes deplored even this technical conquest. Leonardo da Vinci (1452–1519), who took up the Paragone at length with overwhelming bias in favor of "the science of painting," found that "the sculptor pursues his work with greater physical fatigue than the painter, and the painter pursues his work with greater mental fatigue." [4] For Leonardo, it was clearly more possible for painters than for sculptors to share the prestige gained by the figurative arts as they moved into the illumined circle of the Liberal Arts.

But no one denied the great advantage of sculpture's durability. It was most obvious to a society actively accumulating antiquities in bronze and marble, while very little remained of Greek and Roman painting. Leonardo conceded the point grudgingly: "Sculpture is more enduring, but excels in nothing else." [5]

In the Middle Ages an artist learned the techniques of his art according to the guild he entered. It was this system that determined his training and the standards by which every carver and founder worked. During the Renaissance, however, artists were able to consider the nature of a material and how the process they used affected the appearance of the work of art in a new way. They thought of medium more in terms of choice, realizing that a bronze statue based upon a clay model fashioned by manipulating and adding material was fundamentally different from a stone figure subtracted from a solid block. By the sixteenth century the contrast between carved and modeled sculpture became yet another aspect of the Paragone. The argument was most interesting in the case of Michelangelo (1475–1564), who clearly preferred carving, believing that true sculpture could *only* be made by taking away. Moreover, for him the very gesture of removing superfluous material was a moral act; Michelangelo saw his stone as alive and holding within it an inner image that waited to be brought forth. In his poetry he compared carving a statue to the development of a man's inner life:

> As when, O lady mine,
> With chisell'd touch
> The stone unhewn and cold
> Becomes a living mold,
> The more the marble wastes,
> The more the statue grows;
> So, if the working of my soul be such
> That good is but evolved
> By Time's dread blows,
> The vile shell, day by day,
> Falls like superfluous flesh away.[6]

Looking at one of Michelangelo's finished figures, we can always imagine the shape of the block from which it was carved and affirm his poetic statements about the "living mold" (Fig. 1).

Even more important than the material and technique was the inherent characteristic of an art form that permitted an artist to create as God Himself, to make something as marvelous as nature. Leonardo's polemic is the Renaissance's most sweeping testimony to the fabulous ways known to the painter:

> [He] can suggest to you various distances by a change in colour produced by the atmosphere intervening between the object and the eye. He can depict mists through which the shapes of things can only be discerned with difficulty: rain with cloud-capped mountains and valleys showing through; clouds of dust whirling about the combatants who raised them; streams of varying transparency, and fishes at play between the surface of the water and its bottom; and polished pebbles of many colours deposited on the clean sand of the river bed surrounded by green plants seen underneath the water's surface. He will represent the stars at varying heights above us and innumerable other effects whereto sculpture cannot aspire.[7]

Leonardo pointed out that sculpture, possessing neither color, nor chiaroscuro, nor the possibility of rendering distance, nor the ability to treat a wide range of subjects, could not achieve such feats. Further, he stated that even characteristics we do recognize as within the domain of sculpture, such as foreshortening and shadows, are "caused by the nature of the material and not by the artist."[8]

The sculptors' most vigorous response to the painters' offensive came when they spoke of sculpture's three-dimensionality. It was through this that the sculptor became most like God: he was the fashioner of men and women who occupied actual space. Though his range of possibilities was not so broad as that of a painter, his was a uniquely forceful statement. It was summarized by Bronzino in his letter to Varchi:

> They [the sculptors] add this: both arts must imitate and resemble Nature, which is their master, and Nature's works are three-dimensional and can be touched with the hand; painting is only an object of vision and of no other sense, while sculpture exists also in three dimensions in which it resembles Nature, and is an object not only of vision but of touch, too.[9]

This feeling for the third dimension kept sixteenth-century sculptors continually engaged in discussions about the importance of contour, profile, and the multiple views possible to a sculpted figure in contrast to painting's single view, and the reality of a solid figure in space as opposed to the illusion of one on a painted surface. Michelangelo remarked, "There is as much difference between painting and sculpture as between shadow and truth."[10] Benvenuto Cellini (1500–71) called painting a "lie," albeit a beautiful one,[11] while one of the gentlemen in Castiglione's *Courtier* defended sculpture by saying, "Don't tell me that being is not nearer the truth than merely seeming to be."[12]

The Paragone became a fashionable pastime, and in the late sixteenth century we find the president of the Accademia de San Luca calling for an end to these "time-wasting quarrels." As the seventeenth century developed and the unity of the arts became crucial to painting, sculpture, and architecture, the polemics slowly lost their force. Bernini (1598–1680), Michelangelo's successor as master of all three arts, was capable of arguing on either side, but his choice of arguments is of interest. He stated that "sculpture achieves truth—a blind man can judge it, but painting is a deception and a lie. . . ." But his biographer, Filippo Baldinucci, also reported:

[He] declared that painting was superior to sculpture, since sculpture shows that which exists with more dimensions, whereas painting shows that which does not exist, that is it shows relief where there is no relief and gives an effect of distance where there is none. However, there is a certain greater difficulty in executing a likeness in sculpture and, as proof, Bernini pointed to the fact that a man who loses his color no longer looks like himself, whereas sculpture is able to create a likeness in white marble.[13]

The only thing we can be certain of is Bernini's focus on the three-dimensional nature of sculpture. The Baldinucci statement indicates that Bernini anticipated views held in the eighteenth and nineteenth centuries of sculpture as an unimaginative reproduction of nature lacking the creative originality of painting that conjures up something on a flat surface. He then tried to offset his negativism by pointing out the great skill required of a sculptor to create a convincing physical reality without the aid of color.

In the eighteenth century the range of discussions about art grew in breadth within the context of the beginnings of art criticism and of art history. But modern theory was also dependent on the past, especially in France, where the classical traditions of the sixteenth and seventeenth centuries continued without major changes. It was taken for granted that there was a direct relationship between the knowledge required to execute a work and the value of the result as a work of art. This idea became the sculptors' major debating point in the early and mid-eighteenth century when they were called upon to compare the arts. They argued that their art was more difficult than painting because it was more limited in what it could represent, it required greater physical effort, and it was almost impossible to alter once under way. Yet when we think about the atmosphere of the eighteenth century—the gentle sensuality, the playfulness, and the ingenious illusionism—we wonder how much weight such an argument could have carried; it sounds like a last stand. In a sense it was; the word borné (limited) was perhaps the adjective occurring most frequently in French eighteenth-century criticism of sculpture, and it was not complimentary. What had been considered the glory of sculpture—its ability to capture reality through the third dimension—was now often seen as a sort of simple-minded, unimaginative translation; eighteenth-century people were less interested in the straightforward imitation of nature than they were in the interpretation of nature through expressive and subtle means. The encyclopedist Denis Diderot (1713–84), who was also the most important French art critic of the period, felt that the solidity and hardness of a sculptor's materials totally precluded the expression of witty or delicate thoughts, the very kind he and his contemporaries valued most highly. He noted that when a painting failed in one way—in the design, for example—but succeeded in another—such as color—the result could still be a marvelous work of art. But he did not forgive sculpture her faults, nor did others. The point was even reached in the eighteenth century when a sculptor might be asked to execute his statues on the basis of a painter's designs.

Diderot certainly preferred painting to sculpture. In his criticism of the Paris Salons (where many more paintings than sculptures were exhibited), he devoted much more space to the painters than to the sculptors. However, in his reviews of the 1760's he did take note of the modern sculptor's special relationship to antiquity. This became the most significant factor in the history of late eighteenth-century sculpture, and it was instrumental in creating a high moment before the decline of sculpture in the nineteenth century.

In the latter part of the eighteenth century the distinctions between painting and sculpture became more sharply defined than ever. The writers of the Enlightenment saw new

relationships between philosophy and art; the relative status of the arts was no longer a matter to be left to artists and their partisan friends battling among themselves for recognition.

At the same time proponents of Neoclassicism were recommending that artists study antiquity in order to find the simplicity lost in the Rococo style. Since the most readily available original antique monuments were sculptures, the movement had a special significance for contemporary sculptors. Neoclassicists stressed the separation of painting and sculpture; they found the two arts answerable to different criteria and created for different purposes. This was the *last* significant development in the Paragone until the twentieth century. And the result was devastating for nineteenth-century sculpture.

No one in the eighteenth century was more instrumental in bringing about the conversion to Greece than the German archaeologist Johann Joachim Winckelmann (1717–68). The publication of his *Thoughts on the Imitation of Greek Works in Painting and Sculpture* in 1755 was a landmark in cultural history. Winckelmann discussed the superiority of the Greeks, their environment, their way of seeing, and—most of all—their art. His suggestion that the direct imitation of the Greeks would lead to perfect beauty was a departure from the classical academic doctrine that had taught artists to imitate nature and then correct her faults with the aid of ancient works. He believed man was the most fitting subject for art, that the quintessence of beauty was harmonious line, that form took precedence over color, and that of all the colors white was the most perfect. It is clear that for Winckelmann the ideal work of art was a marble statue of the naked human body.

The poet and philosopher Johann Gottfried von Herder (1744–1803) was strongly influenced by Winckelmann; he responded to Greek sculpture with the same wild exaltation. His analysis of the reasons for this response went even deeper, perhaps, than Winckelmann's. Herder was especially aware of one feature of sculpture's three-dimensionality: it could be touched. For him, the essential character of each art was determined by the senses. Developing his aesthetic theory from this, he refined the distinction between the appeal of the two-dimensional surface to sight and the three-dimensional form to touch. Herder noted that the terminology used to discuss art was based solely on the experience of vision, and because of this, touch had been relegated to an inferior position, whereas he believed that touch appealed to a deeper, more elemental part of our being. It was through touch that we might know truth. Painting deals with color, light, and space: it can easily become artificial. This is not possible for sculpture, since each work is uniform, dense, and eternal. From sculpture we learn to understand bodies and forms, so it is imperative to keep them simple so that they can always be comprehended tactually. There should be no malformations or distortions: "The ugly and disgusting statue which I touch in my thought, and continue to feel in its distortion and its *Unnatur* is disagreeable." [14] Herder believed that sculptors ought to consider their works first as objects to be touched before considering their visual aspects.

The relationship of painting to sculpture was thus stated in a new way: the two did not compete since what one could do the other could not, and both had value. Herder saw them as having different spheres of efficacy within modern society: Painting was the "dream," sculpture was the "truth"; painting thus could deal with contemporary drama, whereas sculpture dealt with the human form as an everlasting ideal of living beauty. Painting was an art that could grow and change, while sculpture had already achieved perfection in Greek hands.

The philosopher Georg Wilhelm Hegel (1770–1831) made a similar distinction between painting and sculpture in his aesthetic theories. His argument was based not only on the

intrinsic qualities of the two arts, but also on their roles during three historical stages. He thus clarified the meaning of classical and modern more sharply than Herder had done. Hegel saw art as the interaction of form and idea. The kind of art a civilization creates depends upon whether the form or the idea takes precedence. An early stage of art depends more strongly on form. Hegel called this the Symbolic stage and considered architecture its truest expression. When form and idea come into a balanced relationship art moves toward perfection. This is the Classical stage, best represented by sculpture. Then as ideas take priority the resulting decline is the Romantic stage, and painting becomes the most adequate form of visual expression. Hegel realized, of course, that all three arts were present in each stage. His discussion covered the old points of the Paragone; he noted, for example, that sculpture was difficult in that it required a proper environment, lacked color, had a limited capacity for expressing feelings and representing action. But for Hegel, form in sculpture was important enough to balance out painting's multiple advantages. He had an extremely positive conception of that sense of sculptural form—form embodying the most permanent aspect of human existence—man's own image. When a man looked at a statue he felt something of the latent force of his innermost being. Thus, sculpture was an inquiry into the most elemental nature of man, and this was indeed a sublime function.

Hegel's historical analysis related sculpture to Greek civilization and painting to the post-antique Christian era. Eighteenth-century critics and archaeologists believed that little good painting came out of Greece; this made sense to Hegel, as it supported his idea that only sculpture could respond to such an intensely rational world as the one realized by the Greeks. But Christianity (read: pain, torture, penance, and martyrdom) was pure Romanticism, and painting was much better suited to telling the tale of human woe.

We might think that the far-reaching study and appreciation of the nature of sculpture in the late eighteenth century would have led to a great sculptural renewal. It did not. Winckelmann, Herder, Hegel, and other philosophers and connoisseurs of the time who saw sculpture as the leading art form could only recognize it in Greek terms. Their approach allowed for no progress in sculpture, since its apogee had been reached long ago for all ages. The Neoclassical artist's response often lapsed into pure imitation.

Nevertheless, Neoclassicism did produce an international movement of high-quality work in sculpture. The real difficulties did not arise until the nineteenth century, as Neoclassicism became less and less relevant to the modern age. Classical movements had always lent themselves to academic situations. Neoclassicism, based on a great amount of actual knowledge provided by modern archaeology and having a more articulate theoretical structure than any previous art movement, was eminently teachable. Once installed as the orthodox doctrine in both Europe and America, its inflexibility created the grounds for a split very characteristic of nineteenth-century art: the division between contemporary movements and the official structures which controlled education and the access to public recognition. For painters it sometimes became a healthy tension, but not for sculptors. They had either to accept the restrictive and prejudiced academic system, or—if they were strong enough to stay outside—face the possibility of little recognition and few commissions. There were high-minded statements about the sculptor's great mission to render truth in stone, but the assumed route to this eternal verity—that of static figures and naked simplicity—was more often than not a cul-de-sac. The problem for the sculptor in the first part of the nineteenth century was how to express the passionate and lyrical sensibility of modern man without giving up the symmetry of

form and the simplicity of outline that had come to be considered intrinsic to the nature of sculpture. The problem was so false and the likelihood of solving it so slim that Romantic critics were often indifferent to sculpture. Stendhal, committed as he was to the *sensibilité moderne*, believed sculpture to be the only art alien to Romanticism.

Charles Baudelaire (1821–67) wrote some of the most penetrating criticism of the mid-nineteenth century; his two best-known essays on sculpture appeared in his "Salons." In 1846 he was very young—only twenty-five—and he had no use for sculpture at all. Writing on Delacroix, his favorite modern artist, he criticized everyone who could not appreciate the painter's draftsmanship:

> . . . particularly the sculptors, men more biased and one-eyed than is allowed, and whose judgment is worth at most half that of an architect. . . . Sculpture, to which color is impossible and movement difficult, has nothing to do with an artist preoccupied chiefly with movement, color and atmosphere.[15]

He entitled the sculpture section of his article "Why Sculpture Is Tiresome," and in it developed his view that sculpture was a very primitive art; even peasants could understand it, although they were totally unmoved by painting. For cultures beyond a primitive stage, sculpture could be only a "complementary art," the "humble associate of painting and architecture, and serving their intentions." The association of sculpture with a primitive historical phase was widely accepted in the nineteenth century: painting was such a sophisticated art that it would have been impossible for an uncivilized man to create it, while the same fellow would have had no trouble molding soft clay into shapes.

By 1859 Baudelaire had matured; his criticism took on a new breadth. He began his criticism of the sculpture section of the Salon with a definition of the "divine role of sculpture." The sculptor's mission was to make particular aspects of the human experience eternally palpable in the hard material that was his alone. Baudelaire now recognized how difficult a task this was and how few artists of his own time could even begin to approach it:

> If you think over how many perfections must be combined to obtain this austere magic, you will not be surprised at the fatigue and discouragement which often seizes our minds as we go through the galleries of modern sculpture, where the divine goal is nearly always misunderstood, and the pretty, the meticulous, complacently substituted for the majestic.

Phryne (Fig. 2), by James Pradier (1790–1852), was the kind of sculpture Baudelaire had in mind.[16] But he was fully aware of what sculpture could be, and he even evoked sculptural images in his poetry—*La Beauté* speaks of poets standing before a motionless, monumental figure to be inspired by the "dream of stone" whose great eyes emit an eternal light. But he also knew that contemporary sculpture measured up neither to that of the past, nor to what it could be if it were fulfilling its mission, so most of the time he was "wearied by the monotonous whiteness of all these great dolls." Even at its best, Baudelaire believed, sculpture was simply not on the same level as painting. Sculpture was three-dimensional and opaque like an object in nature, and it stimulated the mind and emotions through the reality of its form. Painting, by the nature of its flat surface, began as an abstraction, and it provided the possibility of a higher form of intellectual and emotional experience. Baudelaire spoke of the art of Delacroix as "the invisible, the impalpable, the nerves, the *soul*. . . ." Such words describe the highest experience possible in terms of Romanticism and could never be applied to sculpture.

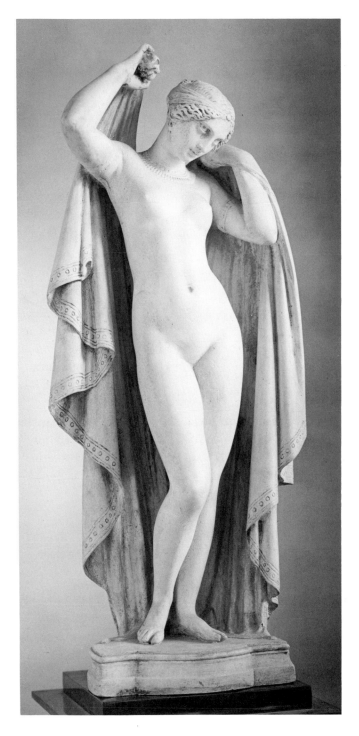

2. JAMES PRADIER, *Phryne.*
1845. Tinted plaster, 16″.
Museum of Art and History,
Geneva.

Baudelaire's belief in the potential greatness of sculpture—despite his dislike of contemporary works—was unusual for the mid-nineteenth century. Most critics fell into one of two categories: the classicists, who never ceased to speak of the sculptor's sacred mission to render truth in marble, and the advocates of modernity, who judged sculpture from the point of view of

3. MEDARDO ROSSO. *The Bookmaker.* 1894. Wax over plaster, 17½".
The Museum of Modern Art, New York (Lillie P. Bliss Bequest).

painting. To the modernists, sculpture lacked ideas and subtlety; it was primitive as a form and unable to deal with modern life. A reviewer of one of the Salons of the 1860's complained that all modern sculpture consisted of one long search for a *"raison d'être."* [17] In the development of an art form, as in the life of an individual, expending energy to justify one's own existence is an indication of serious trouble.

The abysmal state of sculpture in the nineteenth century and the depreciation of the artistic values associated with it—three-dimensionality, clarity of form, and the ability to focus most forcefully on the human body—were surely related to the great movements of the second half of the century. French Impressionism and the related contemporary styles in other countries were the greatest threat yet to orthodox classical values. Tactile considerations were put aside for optical ones, form gave way to atmosphere, reality was measured in light and expressed through color, everything became impalpable, fluid, and fleeting. What was a sculptor to do? How could he be relevant in contemporary terms? In some way he must revise the static concepts that had governed sculpture ever since Neoclassicism. The most important contributions toward this end were made by Auguste Rodin (1840–1917) and Medardo Rosso (1858–1928).

4. Auguste Rodin. *The Prodigal Son.* 1880–82. Bronze, 54¼".
Allen Memorial Art Museum, Oberlin College, Oberlin, Ohio.

Rosso's solution was to create works that were as close to painting in form and intent as possible. He designed pictorially modeled works to be seen from one vantage point only (Fig. 3). He had been deeply impressed by Baudelaire's 1846 Salon article and suggested that Baudelaire was justified in treating sculpture as an inferior art "when he saw sculptors make a being into a material entity in space, while in actuality, every object is part of a totality and this totality is dominated by a tonality which extends into infinity just as light does. . . . What is important to me in art is to make people forget matter."[18] Rosso not only wished to dismiss solidity from the experience of sculpture, but he also resisted sculpture's three-dimensionality:

> One does not walk around a statue any more than one walks around a painting, because one does not walk around a figure to receive an impression from it. Nothing is material in space.

> If it is conceived of in this way, art is indivisible. There is not the realm of painting on the one hand and that of sculpture on the other.[19]

There was much talk in the late nineteenth century, as there is today, about the unity of the arts and of how one medium can partake of values peculiar to another, but it is difficult to see in Rosso's solution a true merging of painting and sculpture. Rather it was a capitulation; nothing could show better the total triumph of the painterly values that we associate with nineteenth-century art.

Rodin's solution was different. In working out his powerful new style he remained thoroughly within sculptural traditions. The painters of the 1860's wanted to find more natural, casual attitudes; Rodin carried on a parallel search for new poses not in the classical studio repertory (Fig. 4). He parted company with the Impressionists, however, in his faithfulness to the nude figure and the seriousness with which he approached subject matter. His method of putting figures together in spontaneous juxtapositions rather than in traditional compositions has a certain correlation with the painter's juxtaposition of color areas, for in both cases the effect is dependent upon the contiguity. There is also a correlation in Rodin's broken, light-capturing

5. RAYMOND DUCHAMP-VILLON. *Baudelaire.* 1911. Bronze, 15¾″. The Museum of Modern Art, New York (Alexander M. Bing Bequest).

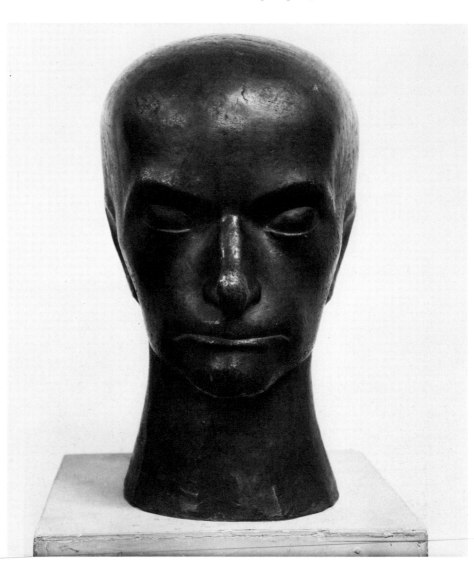

surfaces, which have something of the effect of the bold brushstrokes of a Monet or a Renoir. Yet Rodin, unlike Rosso, never relinquished the sense of sculptural form; instead he revitalized it through movement, stress on its tactile appeal, and the use of light to reveal form. By the 1880's a small number of discerning critics understood that Rodin had effected a radical change; by the twentieth century it was generally recognized: "Something new has come into sculpture," wrote a critic in 1902. "There is a troubling upheaval of some restless inner life in the clay; even sculpture has gone the way of all other arts, and has learned to suggest more than it says, to embody dreams in its flesh, to become at once a living thing and a symbol." [20]

There is no doubt that by 1900 something new had come into sculpture, and there has been a steady outpouring of high-quality work ever since. Rodin's genius was a singularly important factor in restoring sculpture's self-respect. His towering stature brought dignity to the art, and, moreover, he created a style of such strength that younger men could react against it—as early as the first decade of the twentieth century.

Many of the greatest twentieth-century sculptors were already at work in 1910. At that moment, however, it was painting that was undeniably synonymous with progressive art, and

6. UMBERTO BOCCIONI. *Development of a Bottle in Space.* 1912. Bronze, 15″. The Museum of Modern Art, New York (Aristide Maillol Fund).

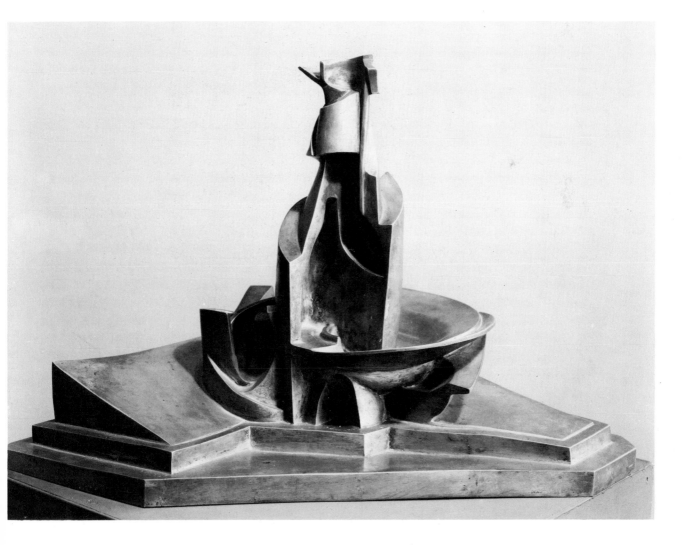

that situation prevailed—with hardly a hint of change—until the 1940's. In 1911, when Cubism was just beginning to become known to the public, Roger Allard wrote, "No interested and impartial observer could doubt that, of all arts, painting now occupies the most advanced point on the ideal curve of evolution." [21] Contemporary statements about sculpture have quite a different tone: Raymond Duchamp-Villon (1876–1918), one of the first Cubist sculptors, wrote, "We are suffering, or rather sculpture suffers, from museum sickness. . . ." [22] And, with a typical Futurist stamp of the foot Umberto Boccioni (1882–1916) cried, "Why should sculpture remain behind, tied to laws that no one has a right to impose on it?" [23] Why, indeed? What was the problem? Anyone could see that Boccioni's or Duchamp-Villon's sculpture (Figs. 5 and 6) was not simply the pale reflection of painting, that it had as much vitality as any contemporary canvas. What is more, among the primary concerns of painters in the first two decades of the twentieth century were plastic values, geometric forms, and the analysis of objects in terms of their weight, density, and volume. Are not these the terms of sculpture? How is it, then, that decade after decade sculptors protested what they perceived as discrimination against their art? How could an art journal editorial of the 1920's begin, "Sculpture runs into total indifference from the public, which gives all its preference to painting. . . ." [24]

Traditions that are centuries old do not change easily. Painters had initiated the probing of visual problems for so long that the situation was not to be altered promptly just because a few late nineteenth-century sculptors had proven that sculpture's style and content could be of the same kind and quality as painting's.

The Cubists were concerned with three-dimensionality and the plastic experience of objects, but their vision depended more on lessons learned from a painter—Cézanne—than from sculpture (although primitive carvings did affect their work). The art public remained faithful to the painters: in 1910 it was more interesting to witness the record of a painter moving around an object, analyzing its structural elements, denoting separate views, than it was to move around a real form composed of solids and voids. The problem of relating objects in a painterly space without using illusionistic perspective seemed infinitely more challenging and subtle than the analysis of a real compact volume.

A practice important in twentieth-century art that is obviously more germane to sculpture than to painting is the use of tangible objects as art materials. But this, too, began in painting, in the form of collage, two years before Picasso (1881–1973) put a silver sugar strainer into his bronze *Glass of Absinthe* in 1914 (Fig. 7).

Contemporary with the *Glass of Absinthe* are Marcel Duchamp's (1887–1969) "ready-mades," objects not shaped by the artist but recognized and selected by him. Within the Dada movement's cult of anti-art, ordinary three-dimensional objects were "chosen" for exhibition. Are they art? Are they sculpture? The Dada answer to these questions is silence. But the objects presented enormous difficulties for the public. The reason for this was not simply an unwillingness to treat seriously new works in three-dimensions. Traditionally sculpture had separated itself from the real world by its material, its placement, and its scale. When not differentiated by such means the object becomes enigmatic, difficult to separate from objects that are not art, and threatening to preconceived ideas about the nature of art in a way that painting never can be.

There is an even greater problem when we consider sculpture's major theme—the human figure. Somehow the painter's conversion of the old subjects into nonrepresentational forms was a less anguished passage than the sculptor's parallel surrender of their historical concern with

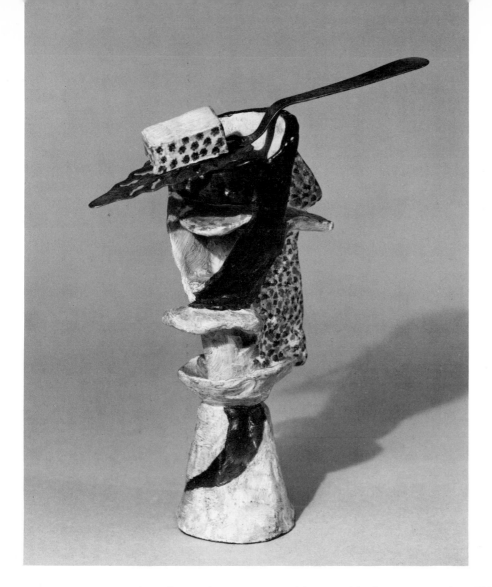

7. PABLO PICASSO, *Glass of Absinthe.* 1914. Painted bronze with silver sugar strainer, $8\frac{1}{2}$ x $6\frac{1}{2}''$. The Museum of Modern Art, New York (Gift of Mrs. Bertram Smith).

man's image. The spectrum of subjects in painting had been very broad, but the human figure was almost the sole subject of sculpture, making any departure from this age-old tradition very awesome indeed.

However important the dethroning of man's image, it is but a part of the twentieth-century revolution in sculpture. But an even more profound change has occurred in sculpture which has had only sporadic counterpart in recent painting, and this has been a change in the nature of the art itself.

Traditionally sculpture has been solid and opaque. It told the truth; it was not *like* something, it *was* something. As Michelangelo saw it, it was honest enough to cast a shadow. Color was not a leading consideration. Its appeal was as much tactile as optical; man could touch it, caress it, take delight in the sensations of its surface. It was difficult to make, but its durability compensated for that. An artist needed a great deal of technical ability; if he made a mistake he could not cover it up easily, as a painter might with an overlay of pigment.

Some twentieth-century sculptors have been faithful to this tradition; freed from the constraints of representation, they have been able to search for sculpture's nature as material

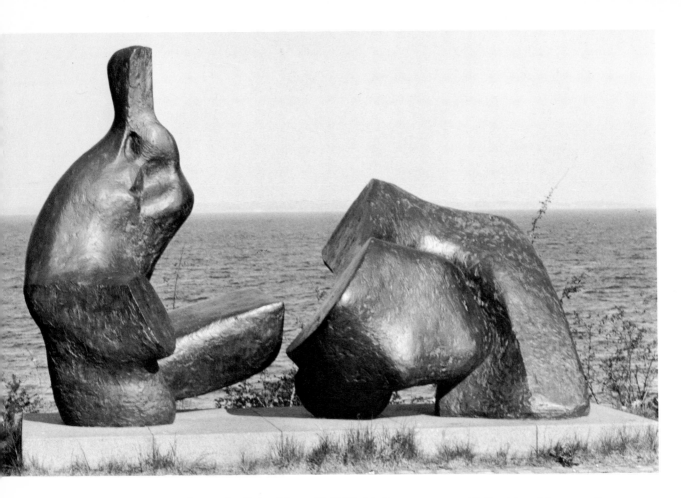

8. HENRY MOORE. *Reclining Figure V.* 1963–64. Bronze, approx. 8'. Louisiana Museum of Modern Art, Humlebaek, Denmark.

object in a more profound and personal manner than ever before. No twentieth-century sculptor has been more articulate about this than Henry Moore (b. 1898) (Fig. 8):

> One is a sculptor because one has a special kind of sensibility for shapes and forms, in their solid physical actuality. I feel that I can best express myself, that I can best give outward form to certain inward feelings or ambitions by the manipulation of solid materials—wood, stone, or metal.[25]

Many sculptors, however, have turned their backs on this kind of orthodoxy, and we have become quite accustomed to using the word "sculpture" for works that are neither solid forms nor stable structures.

In 1912 Alexander Archipenko (1887–1964) pierced a sculptural mass in a new way (Fig. 9), creating figures in which parts—head, thigh, breast, even a whole torso—that were normally solid and convex were treated as spatial cavities. By the 1920's and 1930's figurative and nonfigurative "drawings" in space and thin scaffold constructions had become so common that these extremely dematerialized objects and ethereal constructions were recognized as no less characteristic of sculpture than solid, volumetric forms had been in the past.

The passing of the monolithic concept of sculpture was reinforced by new approaches to materials: rethinking the potentialities of traditional ones (for example, polishing bronze so that cohesive surfaces appear dispersed through mirror-like reflections); adopting new ones

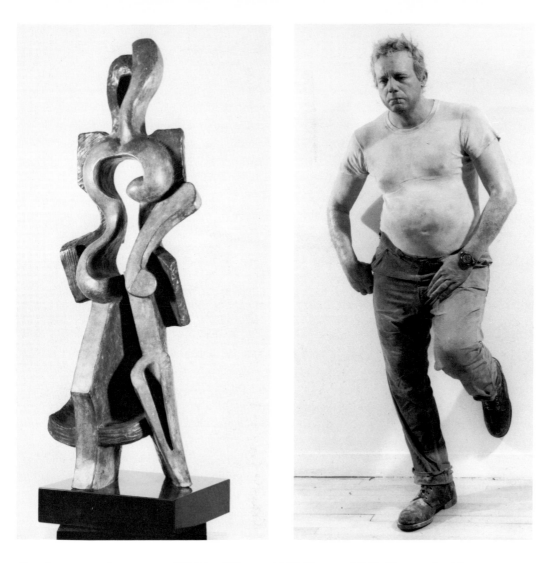

9. ALEXANDER ARCHIPENKO. *Walking Woman*. 1912. Bronze, 26½″. Denver Art Museum.

10. DUANE HANSON. *Man Against Wall*. 1974. Polyester and fibre glass, lifesize. Coll. Mr. and Mrs. B. Reiner, Bethesda, Maryland.

(Plexiglas); and borrowing the techniques of industry (use of the oxyacetylene torch) to provide greater flexibility. Even the huge primary structures of the 1960's are not a return to the monolith; we sense their hollowness.

Color, long considered by academic doctrine to be outside the range of sculpture (Leonardo made much of this in his *Paragone*), has become as natural to sculpture as it is to painting. The inhibitions of the post-Renaissance world with regard to polychromed statues came in part from the effect color has on lifesize, naturalistic figures: they become too thoroughly *present*, too much like us. The religious figures of seventeenth-century Spain (Fig. 100), the outstanding post-Medieval examples of polychromed sculpture, had an incredible naturalness and immediacy which gave them the ability to awaken the most intense feelings of piety. But when man ceased to be the central subject of sculpture, color no longer automatically implied heightened reality. Yet, when used on a realistic lifesize figure as some artists have done in the late 1960's and 1970's, the effect is just as we feared—an eerie presence out of the waxworks—one that vies with us for the space when we enter its "room" (Fig. 10).

The concept of sculpture as solid and durable has been put aside in favor of the new desire to "assemble," rather than to carve or cast. And if the beholder can see how a work is put together, he can imagine how it could come apart. And so Jean Tinguely (b. 1925) gave us his *Homage to New York*, a "self-constructing and self-destroying work of art," which fulfilled its mission by ending up in a heap one night in March 1960 at the Museum of Modern Art in New York.

The thought of Tinguely's sculpture machine brings us to another twentieth-century assault on the traditional nature of sculpture. An age obsessed with movement could hardly accept an art that was defined as static: stability, too, had to be cast aside. The Futurists knew it in 1912:

> We cannot forget that the tick-tock and the moving hands of a clock, the in-and-out of a piston in a cylinder, the opening and closing of two cogwheels with the continual appearance and the disappearance of their square steel cogs, the fury of a flywheel or the turbine of a propeller, are all plastic and pictorial elements of which a Futurist work in sculpture must take account.[26]

So did the Constructivists when they renounced "the thousand-year-old delusion in art that held the static rhythms as the only elements of the plastic and pictorial arts." [27] In 1928, László Moholy-Nagy (1895–1946) published *The New Vision*, in which he discussed the five stages of sculpture; the fifth was "kinetic" sculpture. He visualized rings, rods, and other objects in actual movement, and the space described by the path of movement became a new kind of sculptural volume: "virtual" volume as opposed to the traditional material volume. Through this, our experience moves from "tactile grasp" to "visual grasp." [28]

Twentieth-century sculptors have, indeed, shown that qualities of three-dimensional mass, contained surfaces, stability, and certain types of materials and settings are not essential to sculpture. During the same period painters have continued to color flat surfaces much as they did in the Renaissance. The response of critics and historians to this contrast has been to give considerable thought to the definitions of sculpture. In 1946 the art historian Wilhelm Valentiner noted, "No attempt has been made . . . to find a common formula for old and modern sculpture, a formula that must exist." [29] But the majority of historians continue to cling to traditional definitions. In the 1950's Herbert Read, who has written extensively about sculpture, still extended the view that "the peculiarity of sculpture as an art is that it creates a three-dimensional object *in space*" [30]—even though most sculptors were then speaking about and creating sculpture in terms of "open, airy, discontinuous forms. . . ." [31]

It seems unlikely that the formula Valentiner called for could exist. But there is an area where contemporary historians and sculptors have found common ground, and this is their mutual concern for materials and techniques. Historians have reemphasized the distinctions made by Renaissance artists (almost forgotten in the nineteenth century) between carved and modeled work. Similarly, sculptors have been very conscious of the decisive nature of material and the choice of technique. Reg Butler (b. 1913) participated in the general shift of the late 1940's in England from the direct carving stressed by the advanced sculptors of the 1920's and 1930's to open wrought-iron images; then in the 1950's he began modeling his figures. He wrote of the importance of materials and processes:

> A great deal of sculpture since Brancusi has been a matter of concentrating on the expressive possibilities of the material one uses. . . . I know that the forms of sculpture I made when I worked direct in iron were very different from these forms that I'm making today, and that difference is largely linked with one's response to the materials at hand. In exactly the same sense, when I make a sculpture in wax, the tiny sculptures that I've been engaged in this year,

the forms that come from manipulating wax condition the ultimate form of the object and make it in one sense a very different thing from what it would be if I'd made it in plaster.[32]

For many artists the material is no longer simply the means to create a form. It is the central reality of their statement. Naum Gabo (b. 1890) believed:

> Our attachment to materials is grounded in our organic similarity to them. On this akinness is based our whole connection with Nature. Materials and Mankind are both derivatives of Matter. Without this tight attachment to materials and without this interest in their existence the rise of our whole culture and civilization would have been impossible. We love materials because we love ourselves.[33]

Is sculpture to be the dominant visual art of the latter part of the twentieth century as some now suggest? Predictions are more uncertain than usual these days, but what is clear is that sculpture is no longer second to painting.

The most important factor in sculpture's ascendancy has been the wealth of materials and processes now available to the sculptor. Everything that is matter is his; he can appropriate it as his own, imitate it, or tear it apart without any hierarchy of values attached to his choice. It is no longer sculpture that seems limited as an art form, but painting. The situation today is the reverse of that of the late eighteenth and nineteenth centuries: it is painting that is more easily associated with the art of the past, not sculpture; it is painting as a form that can now be more readily linked with ideas of fiction and illusion, and sculpture that most naturally embraces concepts of realness, of undeniable concrete factual existence. Painting must remain attached to a surface, a frame of reference different from our own; sculpture shares our space, we relate to it physically, and we can thus experience it on a more transactional or existential level, an experience central to the twentieth-century search for meaning. William Tucker (b. 1935), one of the young English sculptors working today with industrially fabricated primary structures, has explained:

> The essence of sculpture is surely its worldliness, its very existence in the world, being made of the stuff the world is made of, yet separate from it, marked off by its completeness, "thingness": this thingness is not just objectness, otherness, in the sense of being separate from human existence, but its sheer lack of use, of necessity, of recognizability, detaches it from the thing-world: it must become subject and central: still, but active, in relation to the human spectator. . . .[34]

An Italian sculptor, Pietro Consagra (b. 1920), considers our *need* for sculpture:

> The necessity of sculpture, as I see it—in terms of our thinking and our culture—is bound up with the origin of man's nature, so much so that we can not imagine a world without sculpture. . . . Man has more resemblance to a telephone pole than to his own photograph—even this is a reason for the need of sculpture.[35]

Discussion of sculpture's nature and its relationship to painting becomes both more plentiful and more searching as we approach the present day. The question has become urgent because sculptors have effected a radical redefinition and have given us alternatives to the older concepts. If the word "sculpture," deriving from the Latin *sculpere*—to carve or hew—has not made much sense recently, we have nevertheless thought about this art deeply enough to reach for a broader understanding of what it is and what it has been.

They go down, and they veil their heads, and ungird their garments, and cast stones, as ordered, behind their footsteps. The stones began to lay aside their hardness and their stiffness, and by degrees to become soft; and when softened, to assume a new form. Presently after, when they were grown larger, a milder nature, too, was conferred on them, so that some shape of man might be seen in them, yet though but imperfect; and as if from the marble commenced to be wrought, not sufficiently distinct, and very like to rough statues. Yet that part of them which was humid with any moisture, and earthy, was turned into portions adapted for the use of the body. That which is solid, and cannot be bent, is changed into bones; that which was just now a vein, still remains under the same name. And in a little time, by the interposition of the Gods above, the stones thrown by the hands of the man, took the shape of a man, and the female race was renewed by the throwing of the woman.

Ovid, *Metamorphoses* I, 399–414

TWO

The Mediterranean World

Figures in the Round/
Figures on a Relief Plane

Ovid speaks of men and women of an ancient race renewing themselves by throwing stones to form images of their own bodies. Other ancient peoples believed that the race of mortals came forth out of the black earth. Everywhere the notion of human procreation involved the deepest emotions, for related to it was the concern for survival. Man survives through the woman, sucking her nourishment, and it is not surprising, then, that the oldest images in stone and clay, the works of prehistory, are mostly of women. All over the European continent, some 30,000 to 20,000 years ago, small female images of various sorts were made, imbued by their makers with their own notions about natural human life. These little statuettes were shaped to suggest the functions and processes of woman's body: copulation, pregnancy, birth, and lactation.

One of the most famous of these statuettes is the *Venus of Willendorf* (Fig. 11). Its maker held a piece of limestone in his hand; as he marked it with a cutting tool, scraped away at the surface, rounded off the edges, and painted it red, he already knew the general type of image that he would make. He developed roundness as it can be realized only in sculpture; the stone became ovoid and agreeable to hold in the hand. He was concerned with the expanse of pendulous breasts, fleshy hips, heavy thighs, and spherical head. He described the curls of the hair, the nipples, navel, and genitals, but neglected the face and the extremities. The body parts not only are unequally stressed but are treated with varying degrees of naturalism. Some details—the quality of fleshiness, the bend of knee, and slope of shoulders—are natural, while others—the deeply incised breasts, the flat, fleshless arms, and the hair, in rhythmic knobs—are stylized. We can not know the statuette's exact use, but we can see in this *Venus*, as in similar figures, the potent symbolism of the life force, represented by the fertile woman, in the world of the primitive hunter.

The stylistic difference between this Paleolithic *Venus* and an idol found on Amorgos, an island in the Cyclades (Fig. 12), goes far deeper than the striking opposition of squat, dumpy forms to tall, slender ones. The Cycladic artist emphasized the same anatomical parts as the earlier carver had: gently bent knees, genital area, softly protruding navel and breasts, arms clasping the body, head at a tilt (to the back; the earlier head came forward), and a face nearly featureless except for one sharp ridge for a nose. The essential difference is the consistency of

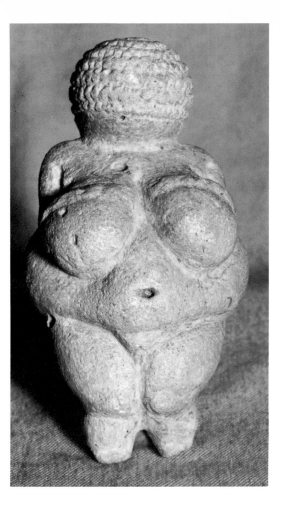

11. *Venus of Willendorf.* 30,000–20,000 B.C. Limestone, 4⅜″. Museum of Natural History, Vienna.

emphasis, the homogeneity of forms, and the constant degree of abstraction in the later figure. It is far more schematized; the artist worked always with angular forms; he kept to his triangles and trapezoids. Surface handling is part of the harmony, for he carved and polished his planes to a smooth, simple continuity.

The elegance and restraint of this figure from the island of Amorgos reflect a very different kind of society from that represented by the robust, fertile female of the primitive past. The Cycladic idol was created in the Aegean world at the end of the third millennium by a man who knew civilized living; his people farmed, traded, and mined the metals that were basic to the Bronze Age revolution in Greece. The greater refinement of the Cycladic piece depends on excellence of materials and craftsmanship. It was carved from marble of the region, either Parian or Naxian, both regarded through the centuries as among the earth's most beautiful stones. The sculptor also made use of the local emery, highly prized for its capacity to incise, smooth, and polish.

We know from the number of similar small idols found in Mediterranean countries that this kind of figure was the outstanding plastic creation of the Aegean world during the Bronze Age. The dominant element in the religious life of the Aegean peoples during the third and second millennia was a female cult; a naked female idol with distinct sexual attributes indicates something of their ideas of fertility and of the Great Mother. Like the Paleolithic *Venus,* the Amorgos idol functioned within the context of belief. What is noticeably different is the restraint in the sexuality of the later image. Since Cycladic idols have been found in burial sites, they were evidently made to accompany the deceased to their graves; they had to benefit the dead as well as the living, and this may explain the attenuated expression of fertility. The

Aegean peoples wanted their idols to serve in some manner as offering or protector, and they chose for this a female image of fundamental dignity conceived in thoroughly abstract form.

In a Greek figure (Fig. 13) we look for the first time at a goddess who *stands.* Like the Paleolithic and Neolithic sculptors, its sculptor depended on frontality and symmetry as the

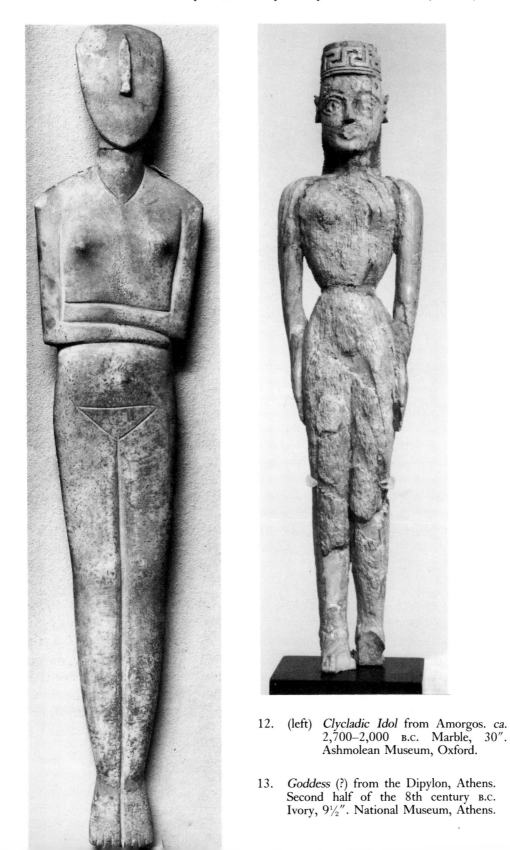

12. (left) *Clycladic Idol* from Amorgos. *ca.* 2,700–2,000 B.C. Marble, 30″. Ashmolean Museum, Oxford.

13. *Goddess* (?) from the Dipylon, Athens. Second half of the 8th century B.C. Ivory, 9½″. National Museum, Athens.

basis of his organization. Like the Cycladic idol, the figure is slender and contained; nevertheless we perceive instantly the greater humanity within it. Facial features are important: the wide eyes, prominent nose and ears, the fully developed mouth. The body contributes equally to the sense of life. The feet, although pressed together like those of the earlier idol, are level, weight-bearing. Hands pushing against thighs give the same concentration of physical force. The stone is no longer a solid block, as it was in the earlier images, and the openings carved between the arms and body, and between the legs, contribute to the definition of physical existence. The gentle swell of breasts, shoulders, belly, buttocks, and thighs reinforces this definition. Beside the *Venus of Willendorf*, the feminine curves of this goddess are very modest, but the tautness with which the Greek sculptor has rendered them gives his statuette far greater life.

This work was made very early in the history of Greek art, but already it possesses a natural vitality we know as peculiarly Greek. It was created in the eighth century B.C., when after centuries of social and political stagnation and poverty following the collapse of the Mycenaean world, Hellenic culture began to come to life. Contact with the Orient grew. The myths of the Greeks became more firmly set, as we see them in the great epic roughly contemporary with this sculpture, the *Iliad*. Personal wealth was increasing, as we know from the richness of graves such as the one that yielded this little ivory goddess. And the Greek's awareness of himself grew significantly during the eighth century, so that he was able to make the cultural distinction between Greek and non-Greek. Athens, where the statuette was probably made, was one of the centers of an emerging artistic spirit. The key to this spirit was a new feeling for the human body that became clear only in the eighth century, when both carvers and pottery painters invested much of their interest in experiments with the figure.

How are we to interpret this small, alert figure carved in ivory and found in a grave outside the Dipylon gate in Athens? Some scholars have questioned the divinity of the subject, wondering if it might not be a servant, concubine, or adorant. But the noble bearing, cylindrical crown *(polos)* decorated with a meander, and the close relationship in both the pose and material to statuettes of Near Eastern goddesses seem to indicate a more elevated status. By the eighth century, as the Greeks began to formulate their mythic traditions more clearly, they were better able to visualize their gods and goddesses; but they did not yet live in plastic form. Sculptors may well have turned to the Orient, with its long tradition of sacred sculpture, to find suitable forms for their deities. But what goddess is this? Athena? Or Hera? The Greeks already worshiped both, but we cannot know exactly and must simply see here an image far more human than those fashioned for the devotees of the old fertility cults.

Tradition has associated the name of Daedalus, a mythical maker of gods' images, with the earliest works of monumental Greek sculpture. A combination of circumstances made it possible for seventh-century artists in the Greek islands and on the mainland to make the first large-scale sculptural works for centuries. Prosperity, the rise of the city-state based on a new class of free non-nobles, an improved military system, and expansion through colonization were elements in a changing socio-political climate. The Greeks came to know their Near Eastern and Egyptian neighbors, peoples with great traditions of monumental sculpture. The seventh-century sculptor selected subjects, poses, and ornamental patterns from forms already existing in the history of sculpture; he also learned about materials and techniques from older cultures, and thus the Greek artist provided himself and his people with an independent, if at first eclectic, sculpture. By the end of the century he had created a monumental figure type in a dense, vigorous, abstract style that was fully Greek.

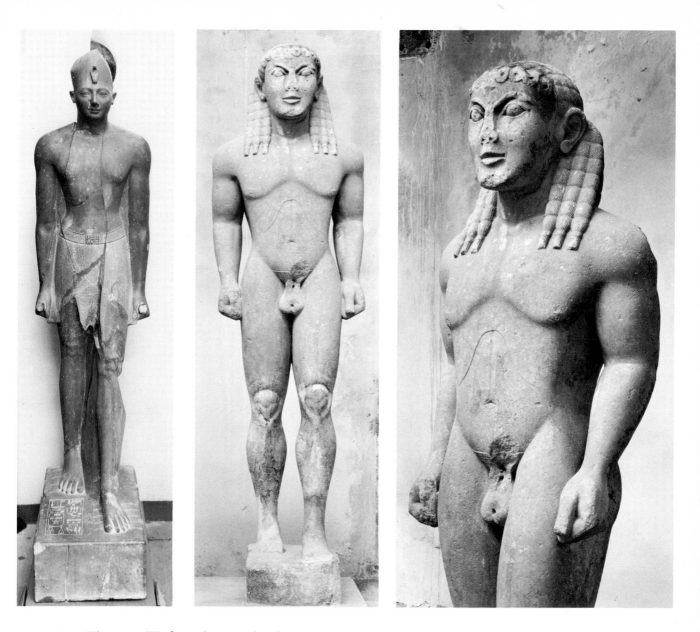

14. *Thutmose III*, from the Temple of Karnak at Thebes. *ca.* 1450 B.C. Basalt, 6'5".
Egyptian Museum, Cairo.

15–16. *Cleobis*. Early 6th century B.C. Ionian-island marble, 7'9" (including base).
Museum, Delphi.

Within the Greek civilization there developed a potential for the growth of a self-conscious, questioning man that had no counterpart in previous cultures. Accordingly, the famous inscription on the wall of the Temple of Apollo at Delphi, "Know thyself," was a command. In the sixth century the descendants of the clannish, myth-bound people who had populated the Greek lands in the previous century began to challenge the old religious views, to investigate democratic ideas even while they lived in oligarchic states, and to speculate about nature in a rational, scientific way. Around 500 the philosopher Heraclitus of Ephesus made the statement, "I have searched from myself." This, he believed, had led him to understand the world in a special way. His words indicate something of the philosophical ferment of the sixth century and its progress toward establishing man, in both his spiritual and physical nature, as the central subject of human inquiry.

Since monumental Greek painting has not survived, we have *had* to see Greek images in sculptural terms. Even if we knew more about Greek painting, however, it seems unlikely that it would displace sculpture as the essential representational art of the Hellenic world. In the *Corpus Hippocraticum,* medical works of the fifth and fourth centuries, one author wrote: "Sculptors make an imitation of the body." If there was ever a society that needed to represent the human figure as a plastic image in order to articulate an evolving concept of the individual, it was that of Greece. Because the Greeks held a new and higher concept of man's dignity, they learned to express themselves in sculpture mainly through the human form, in contrast to other Mediterranean peoples, who developed art forms rich in fantastic beasts and exotic fauna. The philosophers taught that through learning and an ethical life man could perfect himself. Sculptors knew another way: their work was the most public of the arts, and every day the Greek people saw images of an ideal human beauty adorning their buildings and standing freely in sanctuaries and marketplaces.

The most important image of sixth century Greece was the standing nude male, the *kouros.* He was alive, youthfully fearless, and gave full expression to the aristocratic taste of the age. He was the product of a society formed by masculine standards, one that admired the trim body of the athlete.

Cleobis (Figs. 15–17), one of a pair of over-lifesize statues, is the early sixth-century kouros type. The figures were votive offerings made at Delphi by order of the city of Argos for two local heroes, Cleobis and Biton, sons of an Argive priestess of Hera. On the day of the goddess's feast, when the priestess discovered the oxen for her chariot were missing, her sons harnessed themselves to the chariot and drew it to Hera's shrine. Their mother then implored the goddess to give her sons the greatest possible reward. And so, after Cleobis and Biton had prayed and feasted, they lay down in Hera's temple, not to rise again. Solon found the story an illustration of perfect happiness, for the Argives had experienced a glorious death at an age when the pain of life can not yet be known.

Cleobis is in the style we have come to speak of as Archaic. Its beauty is bright, unyielding, and abstract; it accords well with the myth about the uncompromising acceptance of death as a divine reward. The athletic power of the thickset body relates to the strength that saved the honor of a state. The stance is erect, the frontality unwavering, the proportions broad, and the impression of a solid cubic form is clear from front, back, and sides. The statue retains the four-sided character of the block from which it was carved: projection is slight; the forward (left) leg and trunk form a continuous plane, only the foot and the flattened features of the face extending beyond. Since the head is aligned with the forward leg, the back leg and foot give a slight but evident hint of energy and push. Clarity is fundamental to the style. We can measure all the parts; our eyes do not know a moment of confusion. Tresses of hair can be counted, and the chest and stomach area reads as a hexagon further subdivided by a vertical center line and a horizontal line across the rib cage. Details of anatomy—the kneecap, pubes, facial features, ears, and hair—are not described as organic parts of the body mass but as sharply cut, linear patterns on the surface.

We readily see the similarity between a Greek kouros and an Egyptian freestanding male statue, *Thutmose III* (Fig. 14), of the fifteenth century B.C. For more than a century scholars have pointed to this similarity to support the case for Egyptian influence on the initial stages of monumental Greek sculpture. Though it remains only a hypothesis, the link is worth examining. There are obvious specific points of correspondence: In both the left leg advances

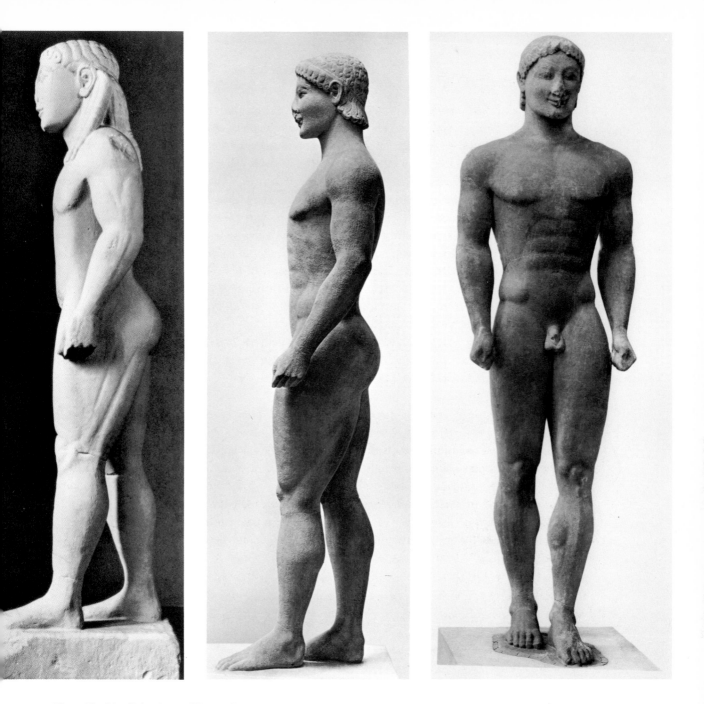

17. *Cleobis.* Side view of Fig. 15.

18–19. *Kouros*, found in Attica. *ca.* 540 B.C. Parian marble, 6'10" (including plinth).
Glyptothek, Munich.

and clenched hands are held against the thighs. Both have lucid, clear forms; we understand
them immediately. They are rigid, vertical, symmetrical. The mass of each is cubic and
blocklike; the sculptor approached the stone from four sides and worked the side and frontal
aspects together according to a specific canon of proportions. Each statue is an ideal image, but
one shows the beauty of youthful vitality, the other the dignified restraint of middle age.

But there are essential contrasts, especially in the freshness and brilliance of the Greek
statue beside the passive stillness of the Egyptian image. The Greek figure is less natural; it

bears more patterned geometry on its surface, but by this means the carver of *Cleobis* imparted an alertness to the face and body. The Egyptian sculptor did not articulate the anatomy of the body very much, and the face, natural as it is, is almost expressionless. The weight of *Thutmose III* bears down on massive, solid legs, whereas the *Cleobis* appears to pull itself up—we sense taut energy in muscled arms and legs. The contour of the Greek work is more lively; it has been completely liberated from the stone, something an Egyptian artist could not do. The Egyptian statue is clothed, as was customary; *Thutmose III* wears the pleated kilt of royalty. The Greek figure is unclothed; the Greek affirmation of the human image is evident in their stress on the ideal of a naked body. Originally *Cleobis* was polychromed; in that state it would have presented a still livelier image, and the contrast would have been even sharper. Although the Egyptians did use polychrome on sculpture, this king is carved in basalt, a material realized to its fullest potential through polishing; the hardness of the stone linked the image materially to the eternity through which both subject and maker intended it to last.

Egypt was an agrarian empire with a social system that changed little from century to century. Its hieratic nature and concern with death and afterlife were manifest in all artistic representation. Statues were specifically designed to secure eternity through magical means for the person represented. Such an image as the one of Thutmose was an efficacious double, and through it this man who ruled by divine right would be spared the transiency of mortal life. For this purpose a style suggesting eternal repose was indispensable. The image would stand undisturbed for all time in tomb chamber or temple; the Greek votive figure, in contrast, was destined for the open sanctuary where the heroic offering to the goddess, the life of Cleobis, could be remembered daily.

An art created to preserve existing forms must perpetuate a thorough-going conservatism. That was the spirit of Egyptian art for millennia, in sharpest contrast to the kind of restless questioning taking place in sixth-century Greece. There men of scientific temper challenged traditional religious views and observed their world the better to reason and speculate on the nature of reality. Greek sculptors consulted nature as well as the works of their predecessors, and decade after decade they rendered more convincing representations of the human figure. It was the beginning of the revolution that eventually carried Greek art to fully developed natural representation, the first in the history of Western art.

Gisela Richter called the kouros the "laboratory in which the Greek sculptor worked out this naturalistic art. . . ." [1] The evolution of Archaic art is so cohesive that we can formulate a chronology based solely upon the closeness of observation of human anatomy—a method rarely possible in the history of art. If we contrast *Cleobis* and a kouros from Attica done around 540 B.C. (Figs. 18, 19), we find the later one no less compact or tense. Yet its fluid smoothness makes the early sixth-century work look stiff. The later forms are rounder, and the energy appears almost organic. The sense of the four-sided block is less apparent, and the placement of the head, directly over the body mass instead of pressed forward, creates a new equilibrium. Contour is more elaborate and interesting: the close-cropped hair reveals the head shape, the plasticity of the muscles provides movement in outline, and the hands no longer press against the body. The facial features are not carved with linear sharpness and do not lie so flat across the surface. In only half a century sculptors had discovered that without changing figure type or proportions they could create—through contour, posture, surface, and features—a richness and expressiveness in this traditional figure simply by their intelligent response to nature.

The sixth-century Greek sculptor developed a monumental concept of man's image that was suited to both gods and heroic mortals. They were interchangeable; without an inscription we

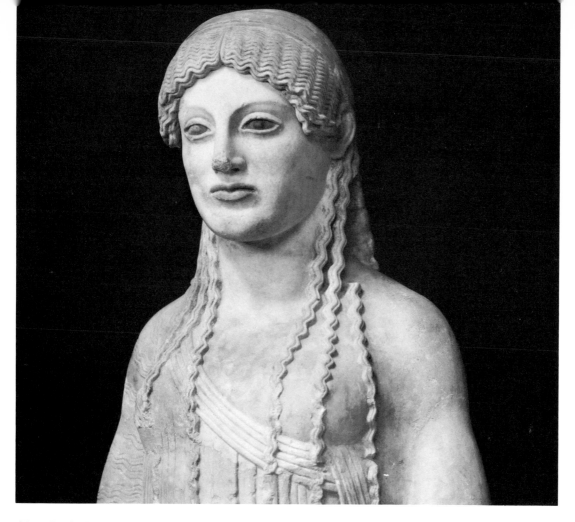

20. *Euthydikos Kore. ca.* 500–480 B.C. Parian marble. Acropolis Museum, Athens.

hardly know the god from the mortal. With cubic forms, a mathematical approach, and an elaborate set of conventions, artists established a style that showed humanity as fresh and filled with the spirit of youth. They described the directness of youth schematically, developing the characteristic Archaic facial expression. We recognize it in the large, compelling eyes of *Cleobis* and the small triangular cuts at the corners of his mouth barely hinting at a smile. The master of the kouros from Attica made the pulse of life still stronger in his figure, reinforcing the features with a more plastic structure and rounding the forms to give the force that volume can provide.

The female equivalent of the kouros was the *kore,* a standing maiden. In the early fifth century a great Attic sculptor made a kore dedicated by a certain Euthydikos on the Athenian Acropolis (Fig. 20). The artist worked with sixth-century conventions, but he realized a statue that was a remarkable transformation of the Archaic style. The radiance of the Archaic gives way to seriousness, and the structure of the head is more cohesive as a three-dimensional solid, while all the simplicity of earlier works is retained. The sculptor developed the sense of relief, cutting deeply into marble to delineate form and pattern. The features of *Cleobis* are flat by comparison, and even those of the kouros from Attica seem added on. The maiden's hair is rendered in an elegant Archaic coiffure, but in its weighty fall over forehead and temples it is substantially denser than the hair of earlier figures. The eyes focus, not just because flakes of polychrome remain, but because anatomy is described—differentiated eyelids, with the upper lid heavy and firm, and eyebrows that arch more naturally, not with the geometrical regularity seen on earlier faces. The contribution of the sculptor of the *"Euthydikos Kore"* was the new aesthetic revealed by the intense facial expression, for here are tentative hints of the inner life

21. *Head of Athena*. Detail of Fig. 22.

behind the facial mask. The swelling plastic life in cheek, chin, and lips give this kore a heavy sullenness that is quite personal and individual. This is a profoundly different reality from that of Archaic animation.

The *Euthydikos Kore* was created before 480 B.C., for the figure was found among the broken statues the Athenians buried after the Persians devastated the Acropolis in that year. The dominant factors in Athenian life at the beginning of the fifth century were the growth of their fledgling democracy and their increasing fear of Persia. The first penetration of Persian forces into mainland Greece was repulsed by the Athenians at Marathon in 490 B.C. Athens stood up to the supposedly invincible Eastern army alone, and her prestige as a state grew immeasurably. It was during these decades that the Athenians were developing an awareness of their status as citizens, of their life-style and its contrast with that of the subjugated peoples living under Oriental rulers. All this is part of the new spirit seen in the grave, resolute expression of the *Euthydikos Kore*.

22. *The Stymphalian Birds.* Metope from the east side of the Temple of Zeus at Olympia. *ca.* 460 B.C. Parian marble, approx. 5′ square. Louvre, Paris.

The search for a deeper awareness of individual worth grew during the period following the war. It was nowhere more evident than in the important new literary form, the tragedy. The plays of Aeschylus revealed the conflicts in men when they struggle within the human community, with the gods, and with their own fate. His work represents a shift of sensibility away from the rich, varied beauty of Archaic lyric poetry that parallels the change taking place in sculpture. The sculptor of the *Euthydikos Kore*, his roots in the sixth century, still loved pattern, but the expression he carved on the maiden's face hinted at the revolution to come.

During the next few decades work began at the sanctuary of Olympia, the greatest sculptural ensemble of the Early Classical period. The sculptors assembled in the workshops of Olympia had broken away from Archaic formalism; they no longer felt the irresistible pull of conventions. A comparison of the head of Athena (Fig. 21) from one of the metopes (Fig. 22) of the Temple of Zeus with the early fifth-century kore permits us to see what had taken place.

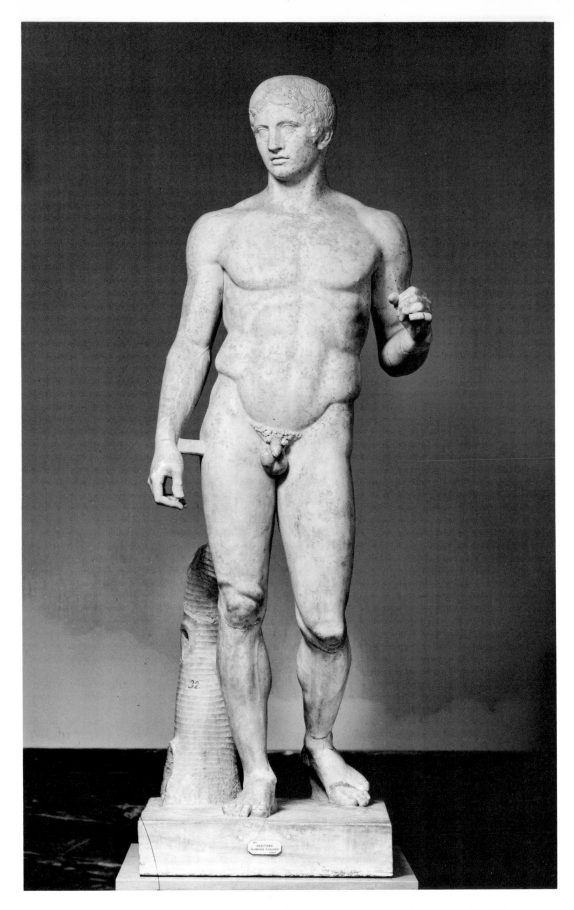

23.　*Doryphorus (Spear Bearer).* Roman copy after an original by Polyclitus. *ca.* 450–440
B.C. Marble, 6′6″. National Museum, Naples.

The sculptor of the *Athena* did not insist on the same degree of symmetry. He subdued rather than emphasized sharp edges and regularity in the features. The mouth opens enough for breath to escape; the set of the eyes and their relationship to the eyebrows show greater organic reality. Hair has weight; it is no longer a matter of linear delight. Here is a fresh view. We can describe the facial expression of the *Euthydikos Kore*, but we can speculate on the *character* of the *Athena*. Traditionally Athena was Greece's wise warrior goddess. Here she is endowed with grace, nobility, and charm—qualities mingled for the moment in a single head. This is no longer the schematized idealization of an impersonal deity; the sculptor has loosened his style sufficiently so that we can identify feelings as well as features.

The sculpture of Olympia, the most important sculptural ensemble done in the Peloponnesus, was a highly significant turning point in the approach to rendering nature. Because the Olympia master and the sculptors who worked with him drew upon numerous sources, there are conflicting hypotheses of his origin. Was he from the islands, where the tradition of carving was highly developed, or from Athens, with its flourishing school of modern art? Or was he, like the architect of the Temple of Zeus, from a Peloponnesian school? In any case, he was acquainted with the newest elements of style and with the liveliest philosophic and cultural ideas of the very intense and inventive post-war generation in Greece.

In the aftermath of the Persian wars the aristocratic society of the Hellenic world dissolved. The Greeks saw their triumph over the Persians as a victory of free men; it allowed them to become more self-confident and to embrace more fully the political and cultural ideas embodied in the *polis*, the city-state. Increased individual awareness was totally bound up with the Greek's relationship to his community. His religion, too, was part of the social climate; his gods were the gods of the *polis*. As the community assumed a more distinct character, the gods became more personal. Sculptors played an essential role in the process, for with the advent of greater naturalism they could more easily give form to the humanized deities of an increasingly anthropomorphic religion. The face of Athena shows this well.

Mid-fifth-century Greek aspirations converged on such concepts as ideal beauty, pure harmony, and physical perfection, with man wholly at the center. According to contemporaries, and judging from the copies known to us, the sculptor who expressed these aspirations most intensely was Polyclitus. His work is known only through copies, but even these reveal the tremendous changes that were taking place and the remarkable way Polyclitus transformed the traditional male nude into a physically perfect man. The copies give us only a hint of the beauty of the originals. Polyclitus worked in bronze (like most Greek bronzes, his were melted down for the raw metal in antiquity), and we know that the standard of bronze sculpture was very high, particularly in the Peloponnesian homeland of Polyclitus. Innovations were frequently worked out in bronze rather than in marble. The bronze cast was developed from a model in clay and an artist could work the soft clay in his hands with far greater freedom than he could carve hard stone. The combination of clay model and bronze cast allowed him even to open up the form, extend gesture, and create movement.

When Polyclitus made his *Doryphorus* (Spear Bearer) (Fig. 23) early in his career, he took up the best-established theme in Greek sculpture—the standing athlete. He summarized in this figure the revolution of the first half of the fifth century. Greek artists had reached a new understanding of harmony, and sculptors expressed it through movement to replace the direct appeal of the static sixth-century shapes. The weight of the *Doryphorus* is wholly on the right leg; the relaxed left leg rests lightly on the toes. The arms move out in gesture and function, the

shoulder dips as the hip is raised, and the head turns so that the focusing eyes have direction. In the Archaic kouros, the parts of the body were organized symmetrically on either side of a central vertical axis; in the Polyclitus, a gentle, flowing s-axis is established instead. What happens on either side indicates a new rhythmic counterpoint of outline and form: the profile of the straight, weight-bearing leg echoes the central axis, while the bend of the relaxed leg creates interest in the vertical profile. The arm and leg of the right side accord in their straightness, just as the bending limbs of the left side agree in form. Other relationships are established across the body in terms of function—the right leg bears weight; the left hand once bore a spear. The great emphasis on anatomical divisions characteristic of Archaic kouroi is continued in the Classical figure—look at the knees, the joining of hips and abdomen, the lower edge of the thorax, and the median line through the center of the torso. But the figure is rendered naturally and plastically, so that the entire system works together in flowing harmony. This harmony takes precedence over the lines, crevices, or bulging muscles that clarify the junctions of the structure.

Polyclitus needed a great deal of anatomical knowledge to arrive at a figure like the *Doryphorus.* His efforts were, in a sense, parallel to developments in medicine, a new field of study in Greece in Polyclitus' time. The human body was becoming the object of practical investigation and treatment. But to understand completely the basis of Polyclitus' achievement, we must look beyond the new approach to natural philosophy and empirical investigation. For he wanted to visualize human perfection in terms of rhythmic relationships. His tool of measurement derived from the division of a line into an "extreme and mean ratio," what we call the "Golden Section." Polyclitus, and his contemporaries, found that by relating the parts of the figure to each other and to the whole through reference to "The Section" an aesthetically ideal set of relationships was created. Polyclitus was the first sculptor to articulate clearly the importance of commensurability of parts, and he formulated his ideas in a treatise. Contemporary artists looked upon the *Doryphorus* as a visual illustration of his treatise, and the sculpture became known as "the Canon." It is difficult to determine what philosophical connotations are implicit in Polyclitus' search for physical perfection through a formal canon. But to some degree we must connect it with the belief in the numerical harmony of a world-soul, current in the philosophical circles of the Pythagoreans throughout the fifth century.

Relief, rather than statuary, was the form of sculpture most often created by the earlier Eastern Mediterranean people. The Greeks altered the emphasis, but relief was part of their heritage from Egypt and the Orient, and just as in these older traditions, the Greeks found it essential for the development of the aesthetic and symbolic qualities of architecture. Sixth-century Greeks experimented widely in building stone temples; they applied sculpture in a variety of ways, concentrating on the area above the columns. The traditional places for sculptural embellishment became the triangular gable at the top of the façade (called the pediment), the continuous frieze, and the rectangular areas of the Doric entablature called metopes. These carvings were brightly painted; through form and color they strengthened the architectural rhythms and contributed enormously to the richness of the whole effect.

Relief has its origin in drawing. Imagine drawing a line around a form by incising it into a hard material and then removing the material outside the line; these are the rudiments of relief. Egyptian relief was so insistently two-dimensional that often only the nature of the material separates it from painting. Even when the Egyptians and other early artists, such as the Assyrians, increased the depth of their relief, the sense of the third dimension was absent, or

24. Reconstruction of the elevation of the Temple of Zeus at Olympia showing the placement of the metopes (after Dörpfeld).

nearly so, because they showed figures according to their most characteristic profile, with a continuous front plane against a flat background plane. Thus these early reliefs lacked the one element indispensable to any definition of Western sculpture from the Greeks to the nineteenth century—the third dimension. This primitive approach to relief is parallel to the creation of statuary in terms of a four-sided mass. A relief, in this sense, is the front of the four-sided block. It is delimited by a left and right edge and closed by a front and back plane. What the Greeks did within this restricted form was very different from what had been done before; they introduced foreshortening, created space, and made their figures plastically real. Even in the highly patterned Archaic reliefs there was abundant experimentation with foreshortening and depth, although the transition from plane to plane on which these properties depended was often angular and awkward.

Greek sculptors approached the relief form in a new way because they had a different conception of its purpose. The Greeks were storytellers, and they needed a narrative art form more than earlier Eastern peoples had.[2] For a Greek, a relief or a painting was a vehicle for the narration of the realities of human experience that were expressed in mythology. The sculptors of the Classical age, who succeeded in developing organic function, movement, and expression, revolutionized the Greek relief and brought it to its full potential for clear narrative presentation.

Soon after 470 B.C., when the Eleans established their supremacy at Olympia, they built the Temple of Zeus. It was for the king of the gods, patron of this cultural center where, in solemnity and splendor, the Greeks paid tribute to the glory of man's body. The building had the majestic, geometric beauty of the Doric order. At each end of the cella were six metopes, each carved with one of the twelve labors of Heracles (Fig. 24). The metopes are nearly square and over five feet tall—the largest Greek metopes we know. The almost lifesize figures are carved in very high relief and tell the tale of Heracles, the son of Zeus and prototype of victors, with magnificent clarity. Perhaps this is the first thing we understand when we look at these reliefs—that they are remarkably readable, through dimension, composition, and style.

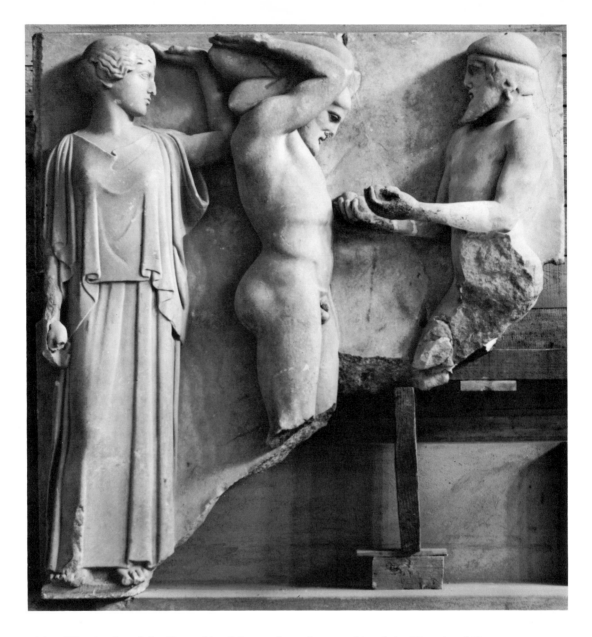

25. *The Apples of the Hesperides.* Metope from the east side of the Temple of Zeus at Olympia. *ca.* 460 B.C. Parian marble, approx. 5′ square. Museum, Olympia.

The best-preserved metope is *The Apples of the Hesperides* (Fig. 25). Heracles prevailed upon the giant Atlas to obtain for him these apples of immortality, and he assumed Atlas' burden of the heavens for the duration of the quest. The moment the Olympian master has chosen from the drama is the exchange of the apples for the heavens. Heracles focuses intently on the fruit in Atlas' hand while his taut body resists the weight of the sky that rests on the flat of his upturned hands, his burden eased only by a folded pillow. The gaze of Atlas is no less intent as he searches the face of Heracles. Only Athena, Heracles' protectress, seems totally impassive as she effortlessly lends a hand to the support of the heavens. We remain unsure if giant and hero are aware that divine intervention is about to resolve their seemingly insoluble plight. The artist's subtle use of contrasting poses makes clear the different relationships. Heracles and Atlas stand firmly facing each other, two three-dimensional male figures

convincingly described in space by the gradual recession of the bodies from the front to the back plane. In contrast, Athena's pose is old-fashioned; she stands powerfully erect in perfect frontality, turning her head sharply to the left so that her face presents a pure profile. Thus she appears less three-dimensional than the male figures, even though the salient planes of her garment and those of the male bodies project to the same outermost relief plane. The artist has in this way divided the space of the relief almost equally among the three figures and yet has differentiated between the roles of the active protagonists and the Olympian interloper.

The sculptural means of the master of Olympia were consistently simple and direct; thus the reliefs fulfilled their decorative function in the architecture at the same time that they elucidated the stories of Heracles' mortal life. Since the temple no longer stands and we now see the metopes in a museum, this point is lost except in our imaginations. Strong stress on verticals and horizontals, as in the *Apples of the Hesperides,* harmoniously echoed the design of the whole building. Balance within each composition was fundamental to this concept. Here Heracles acts as the central axis, and the artist has employed the pillow as a device to increase his height, for beside a goddess and a giant the mortal was short. The pillow also fills and solidifies the triangle formed by the arms of the hero and his protectress, making a solid area to support the heavens. This active, filled area between Heracles and Athena is balanced by the area between Heracles and Atlas, for the bent leg of Atlas narrows the space between the two; their toes would have touched, though this part has been lost. The same kind of balance is achieved by the unfilled space between the heads of the two male figures and that at the lower left between the legs of Athena and Heracles. The artist also used effectively a simple vertical as a foil for an undulating sequence of forms and line—thus, the front line of Heracles' body is a rigid complement to the movement of Atlas, while the line of his back turns gracefully about the rounding forms of shoulder, waist, buttocks, thigh, and calf in the sharpest possible contrast to the straight fall of Athena's peplos. Not only are the compositions of the Olympia metopes balanced and direct, but the individual figures are emphatically solid and volumetric. Space is created as much through the implied weight of the figures and the depth of the relief as through the articulation of planes.

The style of the next great series of Doric reliefs is very different from the strict, clear statement made at Olympia. These are the sculptures of the Parthenon, the works of Phidias and others, begun in 447 B.C. on the Athenian Acropolis.

The development of the Acropolis under Pericles assured Athens a permanent place at the summit of Greek art. There is no doubt that Pericles deliberately set out to establish Athens as a city of unique greatness. Since the state and her divine protectress Athena were inseparable in the contemporary mind, there was no better way to confirm the supremacy of Athens than by making the sanctuary of the goddess into a place of incomparable magnificence. The single richest monument was the Parthenon, which approached the essence of refinement in the Doric order—by its excellent material, its harmonious proportions, the multitude of sensitive and subtle details, and the sheer abundance of sculpture. It was the most ambitious project yet undertaken—two pediments over ninety feet long, ninety-two sculptured metopes, and a 524-foot frieze—and the entire project was completed in less than fifteen years. A great number of sculptors worked on the ensemble; close study reveals many individual styles. There is a question of how much of the Parthenon sculpture is actually the work of Phidias. We know that he did not remain in Athens long enough to see the sculpture to completion, but certainly he was the principal creative force at the Parthenon, and we can still identify his personality with the concept of the frieze.

26. Reconstruction of the Parthenon, showing placement of the frieze.

This continuous frieze around the cella of a Doric temple was one of the innovations of the Parthenon (Fig. 26). Earlier architects had used such a frieze only on the exterior of Ionic buildings, or on rare occasions on a Doric façade (such as the sixth-century Temple of Assos, where the frieze rests on top of the architrave, below the triglyphs and metopes). The earliest continuous friezes were not usually used as narrative fields, but as surfaces that bore rhythmic sequences of ornamental figures. By the late sixth century sculptors did design interrelated groups in compositions that had a beginning and an end, but these were usually neither harmonious nor unified. Nothing really prepares us for the vision of a continuous procession covering over five hundred feet of uninterrupted surface in an integrated, harmonious design. What Phidias gives us is a commemorative picture of the ceremonial pageant in Athena's honor, the procession of worshipers to her sanctuary to offer her a newly woven peplos (Fig. 27).

The frieze is in low relief; the sculpture is part of the wall and does not destroy the surface continuity. We can imagine the original linear sketch drawn on the uncut marble. Phidias did not reject the older tradition of composing ornamental friezes—the sequence and movement in one direction on a shallow band—but he revitalized it. The relief of the Parthenon frieze is shallower than that usually carved in metopes; yet it looks no less spatial than the Olympia metopes (Figs. 22, 25). On the contrary, the implication of space is even greater in the Parthenon frieze. Behind this anomaly lies the advance from the early Classical to the full

Classical style of the second half of the fifth century. Both works have the normal ground plane of a Greek relief—a uniform, neutral, and unadorned surface that does not give any indication of an environment. The concept of space here is not illusionistic. But the measurable, real space is not the significant factor either. The space in the Parthenon frieze is purely sculptural, realized through the apparent volume of the figures and the way they are carved in planes. Figures overlap more frequently than ever before; the three-quarter view has become the usual mode of representation, and frontality a thing of the past. The carving of draperies is rich and diverse; plane after plane is handled as a sequence of folds through which we recognize the perfectly controlled recession into depth. Movement is more natural, figures more relaxed. There is a gentle flow of physical motion that leads our eye back and forth in depth. The sculptural rendering of texture, greatly enriched during the generation between Olympia and the Parthenon, also helps us to grasp the passage from one plane to another. The hands and arms of the Parthenon maidens against the heavy folding garments aid enormously in clarifying this progression of receding planes, while in the Olympia metope the placement of the arms of Heracles and Athena against the folded pillow, undifferentiated in texture, did not create this kind of spatial feeling. As the planes have become more complex and the figures interact in a more physical way, the spaces between the figures have changed in quality. They are neither so clear nor so abstract; instead, they begin to take on an atmospheric, resilient life in which the figures can move.

One of the most appealing characteristics of the style of Phidias and of Classical sculpture in general is the beauty of the draperies. The Parthenon maidens' garments are not outshone by those of the most elegant Archaic kore, but what was once rendered as ornament through line has become weighty raiment irregularly and deeply carved into creases, pleats, gathers, and smooth surfaces. Bodies are not suppressed by this interest in drapery; rather they swell beneath, and a lively pattern of light and shade results from the deeper carving.

The composition of the Parthenon frieze, completely encompassing the temple, required a unified narrative. But the unity of the processional scene was far from Phidias' sole concern. Its visual interest and ritual significance were equally important. The arrangement and relationships of the figures are based on a highly refined sense of rhythm: by continuous repetition of poses, by gestures showing slight but constant variation, and by a sense of measured space, a recognizable beat has been established. At times it accelerates; then it diminishes to a slow, solemn tempo, as we see it in the fragment of the maidens. The rhythm contributes more than visual interest, however, for it is through rhythm that we can interpret the scene and recognize the profound and purposeful movement of a religious procession. In fifth-century Greece the word *rhythmós* was applied to the idea of repeated compositional patterns; the creative artist found it was essential to recognize *rhythmós* in forms as they moved in nature in order to project *rhythmós* into the ideal humanity of Classical Greek art.

We use the word "Classical" in referring to the work of Phidias, Polyclitus, and other artists of their time, and to the artists who followed in the fifth and fourth centuries. For some the image this word conveys may be vague because of the numerous implications it has had since the seventeenth century, when it was first used in connection with the representational arts. The most common uses have been, first, to describe the arts of ancient Greece and Rome, established during the Renaissance as the Western standard of beauty, and second, to refer to art forms of such balance that they have a kind of perfection. Already in antiquity the art of Periclean Athens and that immediately following it was seen as an ideal, possessing a unity and harmony that

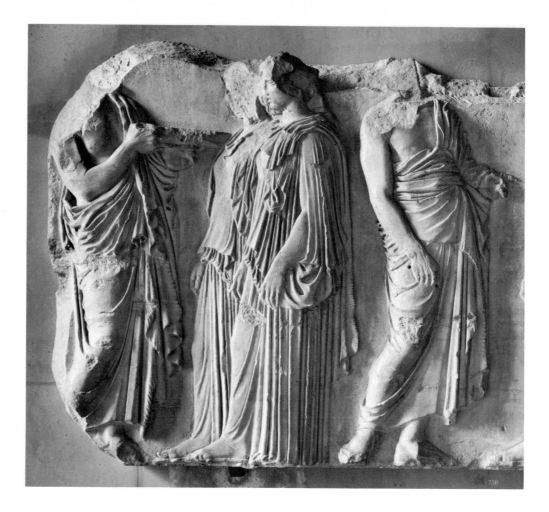

27. *Panathenaic Procession.* Fragment from the east frieze of the Parthenon. *ca.* 448–438 B.C. Pentelic marble, 3′7″. Louvre, Paris.

made possible perfect beauty and expressed the noblest thoughts of man. The Greeks did not use the word "Classical," but the idea was there. Dio Chrysostom (*ca.* A.D. 40–112) spoke of the effect of Phidias' Olympian *Zeus:*

> And among men, whoever might be burdened with pain in his soul, having borne many misfortunes and pains in his life and never being able to attain sweet sleep, even that man, I believe, standing before this image, would forget all the terrible and harsh things which one must suffer in human life. Such is the vision which you have conceived and rendered into art. . . . such is the light and such is the grace which comes from your art.[3]

Twentieth-century art historians have simply taken an old and much-used critical term and applied it specifically to the latter part of the fifth and the fourth centuries when naturalism and idealism were held in balance.

After the Peloponnesian war at the end of the fifth century, the Athenian state and society bore little resemblance to the vigorous, self-confident city of Pericles. The execution of Socrates as an unbeliever and a corrupter of young men in 399 B.C., which can be seen as a rash and defensive act of civic discord, seems to set the stage for the unstable decades to come. As the city lost its ability to deal with dissenting views and the ideal of the *polis* began to disintegrate, individuals sought private wealth and personal fame in a new and uncommunal fashion. The

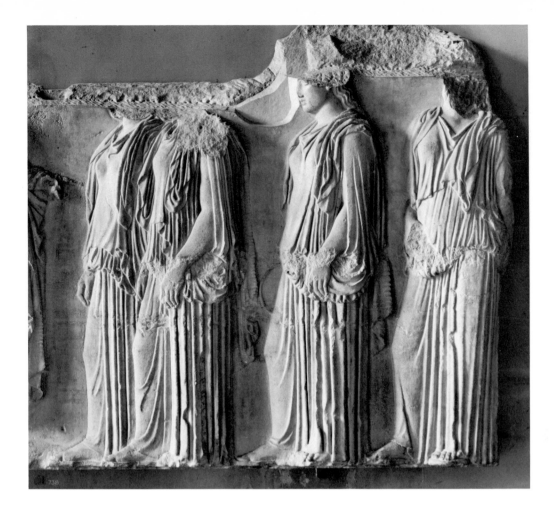

fourth century was a critical period for Greece from a socio-political point of view, with the major cities declining in power and the ideal that had once existed of a common destiny becoming an open fraud. Yet in another way, particularly evident in art and philosophy, it fulfilled what had been begun in the fifth century. Goals were pursued in a different manner, for the search was more personal and individual achievement was stressed. We think first of great masters—Scopas, Praxiteles, Lysippos—not of sites of religious and civic pride like Olympia and the Athenian Acropolis. The quest for naturalism intensified, but at the same time a certain level of idealism was maintained.

The major sculpture is known mostly from Roman copies and sources, but some outstanding fourth-century originals have survived. One, a bronze figure of a youth found in the Aegean Sea near the island of Anticythera, was recovered in pieces in 1900 and meticulously reassembled (Fig. 28). The sculptor—who we assume was from the Peloponnesus and learned his technique in its great schools of bronze-casting—depended upon the Polyclitan tradition that influenced all early fourth-century statues of heroes and athletes. He stressed the same anatomical divisions and used the weight-bearing, relaxed-leg arrangement. But he made fundamental changes in the proportions and the mobility of the figure—it is taller and does not have the stocky, muscular build of the *Doryphorus*. The relaxed leg, held back and out, suggests an agility absent from the balanced standing/walking compromise of the fifth-century solution. Consistent with the novel stance is the thrust of the right arm reaching forward and to the side; there is distinct movement to the right, in contrast to the insistent regularity of a perfectly

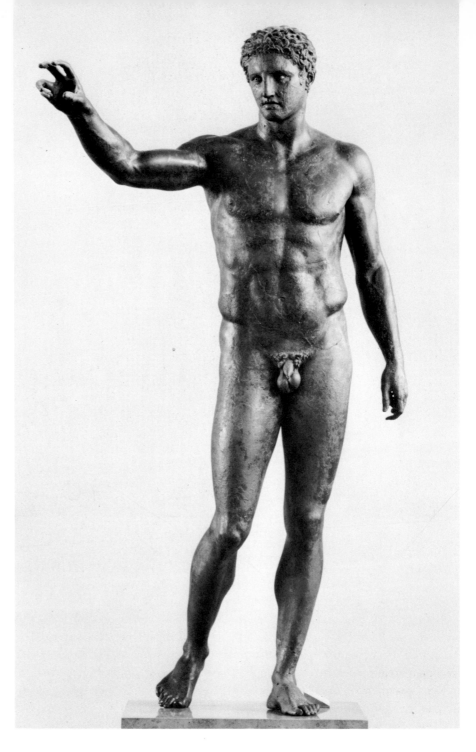

28. *Youth*, found in the Aegean Sea off Anticythera. *ca.* 350 B.C. Bronze, 6′5″.
National Museum, Athens.

balanced sequence of parts on either side of a central axis of the Polyclitan ideal. A tentative
approach to spatial freedom emerges as the idea of a self-contained image recedes. In harmony
with the opening up of the pose is the increased fluidity in the treatment of the anatomy. Lines
are less distinct; structure is no longer described by a hard pattern of lumps and hollows but is
suggested by a subtly shifting skin that rises and falls in accord with the bones and cavities
beneath; and this skin is given even greater life by the nature of the bronze surface, especially
suited to capturing highlights and casting hollows as shadow.

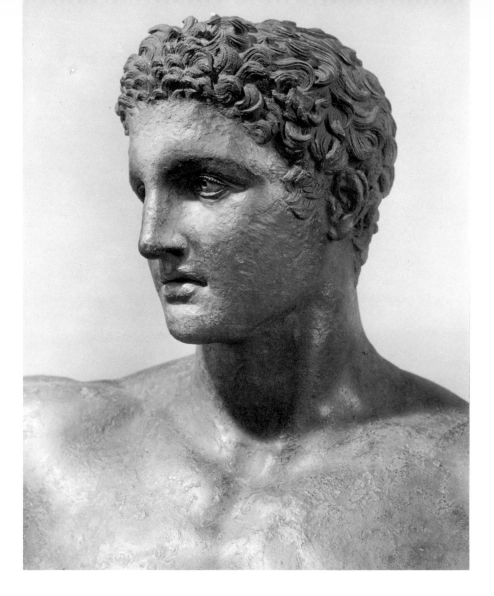

29. *Youth.* Detail of Fig. 28.

The nobility of the youth's features, the restraint of his expression (Fig. 29), are in complete agreement with the Classical ideal (Fig. 23). But the sculptor was more interested than his fifth-century predecessor in developing a sense of character. This is evident in the softening of the features—the rounded nose, the large, fleshy lips that lower in the corners, and the supple eyebrows under which are fixed deep-set eyes of stone, their gaze strongly directed. The most striking difference from the fifth-century work is the treatment of the hair, which is curly and soft and seems to grow from the head rather than to sit as a hard cap of linear coils parallel to the skull. The use of bronze, dependent on an original wax or clay model, permitted the more subtle surfaces and greater spatial freedom that we see here, since these qualities are more easily obtained in the additive modeling technique than in the carver's stone.

As naturalism replaced abstract concepts of beauty, artists learned to search men's faces for what was revealed there. Scopas, one of the most innovative sculptors of the fourth century, had a particular gift for registering emotions through facial features. Even though his figures have not survived—there are only copies, fragments, and reflections left—this ability is well documented in contemporary sources. We can see it in a copy of the *Meleager* (Figs. 30, 31), usually associated with Scopas. The original was probably in bronze and only a little later than

the *Youth* from Anticythera, but the approach to style and expression is quite different. The regular outline and smooth surfaces are gone. Meleager's jaw is square and powerful; his round chin protrudes. There are deep shadowy pockets in the loose hair mass. The forehead is creased above the fleshy brows, and shadows are present over the wide eyes, which do not gaze steadily but apprehend in the instant, just as the partially opened mouth seems to emit a gasp. The whole atmosphere is one of inner agitation and pathos. The pursuit of naturalism and the desire to represent man as seen led artists to record fleeting expressions and momentary actions. The faultless, enduring qualities of Classical art, which depended on a careful correcting of nature, began to give way. Scopas was a central figure among the sculptors who gave direction to the highly emotional work of the third, second, and first centuries—the Hellenistic period.

The individualistic and questioning fourth-century society found not only that naturalism was well suited to its temper, but also that little-known subjects and sentiments were consistent with its existing mood. One subject, rare in Greek sculpture before the fourth century and

30. *Meleager.* Roman copy after an original by Scopas of *ca.* 340–330 B.C. Marble, 3′10″. Fogg Art Museum, Cambridge.

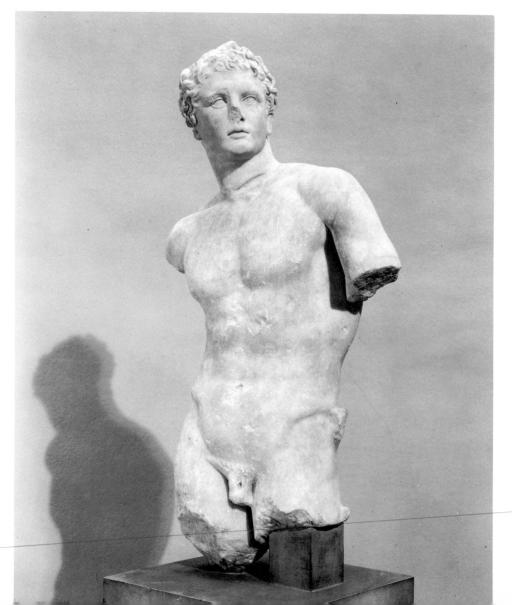

common thereafter—a subject that has a key place in the subsequent development of Western sculpture—was the female nude. In primitive times the fertile woman, the Great Mother, was always naked; the Eastern goddesses of love—Mylitta in Babylonia, Istar in Assyria, and Astarte among the Phoenecians—were also fashioned as nude figures; but Greek people clothed their love goddess. When Praxiteles first made her he also draped her body; but then he sculpted her nude. The ancient world made it clear they preferred the latter:

> Superior to all the works, not only of Praxiteles, but indeed in the whole world, is the Aphrodite which many people have sailed to Knidos in order to see. He made two statues and offered them for sale at the same time; one of them was represented with the body draped, for which reason the people of Kos, whose choice it was (since he had put the same price on both) preferred it, judging that this was the sober and proper thing to do. The people of Knidos bought the rejected one, the fame of which became immensely greater. Later King Nikomedes wished to buy it from the Knidians, promising that he would cancel the city's whole debt, which was enormous. They preferred, however, to bear everything, and not without reason. For with that statue Praxiteles made Knidos famous.[4]

31. *Meleager.* Detail of Fig. 30.

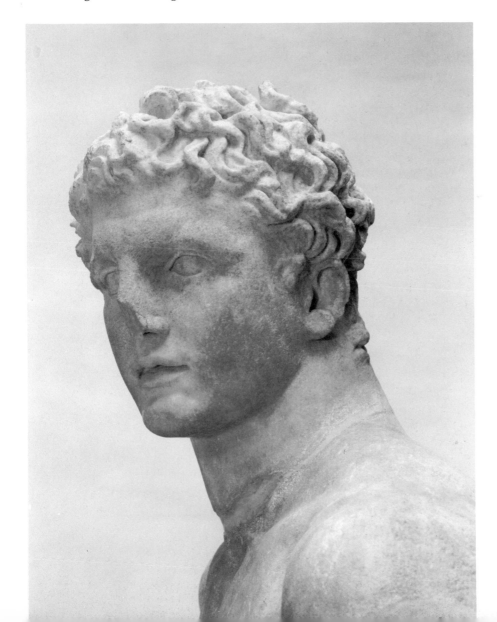

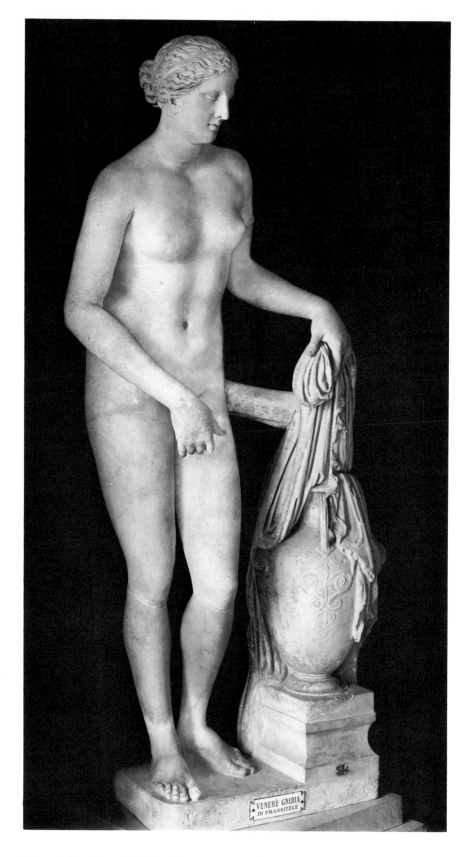

32. *Aphrodite of Cnidus.* Roman copy after an original by Praxiteles of *ca.* 350 B.C. Marble, 6'8". Vatican Museum.

Ancient texts, the number of copies—forty-nine are known—and the many female figures influenced by the *Aphrodite of Cnidus* tell us she was something dazzling and splendid; but as with the *Doryphorus* we have a limited notion of the statue's original beauty. Even the replicas are highly restored (Fig. 32). We can have no sense of the delicate surface, the soft modeling, and the "melting gaze" spoken of by the writers of antiquity. But we do know something about the pose, the composition, and especially about Praxiteles' sensitive approach to feminine beauty and sensuality.

Aphrodite was not created for a large temple—how out of place she would have been there! She was put in an intimate shrine at her Cnidian sanctuary. Praxiteles showed her preparing for the ritual bath, a reminder of her watery birth. She drops her garment on the hydria with her left hand, while the right moves in front of her. The pose is frontal and still essentially that of Polyclitan type, with a weight-bearing and a relaxed leg accounting for the rhythmic movement of the entire body. When this type is translated into the rounded forms of the feminine body and modeled in the fourth-century manner—softly and without sharp divisions—it becomes an idyllic, sensuous creature, far removed from the solemn divinities of the fifth century. Though the pose is not original, Praxiteles worked out a composition that clearly partook of one of the most innovative trends of fourth-century sculpture. The figure is spatially conceived. The body from the knees to the top of the head forms a gentle concave arc, quite different from the Polyclitan/Phidian upright trunk. The mid-point of the arc is defined by the right hand, and some spatial extension is realized through the use of the picturesque accompaniments of drapery and hydria.

The Praxitelean image of the goddess of love was so human and approachable that it remained relevant to Greek culture and later artists for centuries. The Aphrodites of Hellenistic times all somehow looked back to this one. The most famous—that curious figure in the Louvre that people react to so strongly, some with lavish praise and others with sharp criticism—is the *Aphrodite of Melos* (the "Venus de Milo") (Figs. 33, 34).

This Aphrodite was created by a master from Antioch on the Maeander, a small town in Asia Minor, in the late second century. The culture of Hellenism by this time was eroding, and the Mediterranean world had become a civilization in transition. Art centers were so diverse that we cannot generalize about the sculpture in any way; there was neither a dominant style nor a defined evolution. During the Hellenistic period visual experiences were ever wider. Artists saw and recorded more of nature, and they learned more from older art in all its diversity than had any previous group of artists. Their desire to experiment was such that they felt free to fuse elements from several sources into a single work. So it was with the master of this *Aphrodite*. The conflict in the mode of its expression accounts for some of the difficulty people have in coming to terms with the work.

In the years that followed the statue's discovery on Melos in 1820, people recognized in the big, forceful body the kind of broad planes found in the Parthenon pedimental sculpture. And since the Western European had only recently come into a new understanding of fifth-century style—through the Parthenon marbles, which entered the British Museum as the gift of Lord Elgin in 1816—the majestic figure was believed to be a fifth-century masterpiece.

Aphrodite's head is related to the work of Praxiteles, with soft, wavy hair, triangular forehead, and a gentleness about the lips. But the face lacks the sweetness of the Praxitelean face. The body is also disposed in the Praxitelean way, with the weight on the right leg and the resulting shift of the hips—but there the similarity ends. The *Aphrodite of Melos* is a

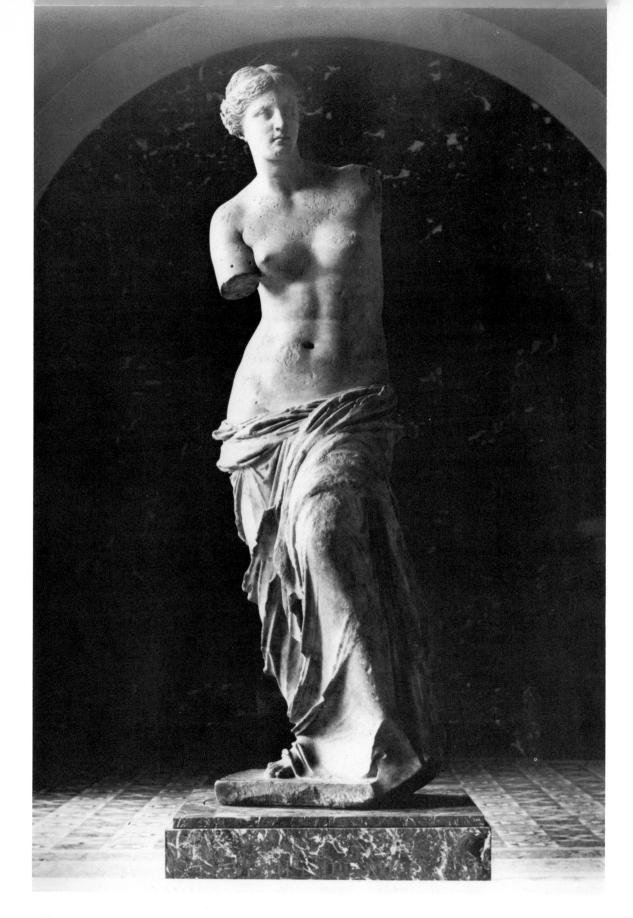

33. *Aphrodite of Melos.* Second half of 2nd century B.C. Parian marble, 6'8". Louvre,
Paris.

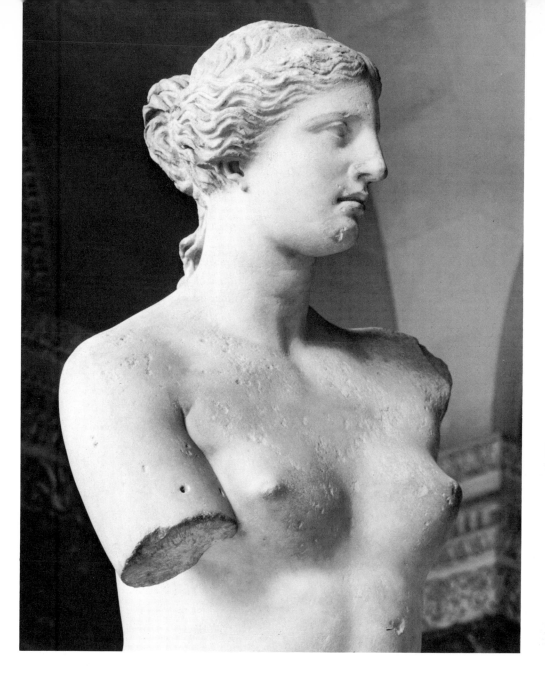

34. *Aphrodite of Melos.* Detail of Fig. 33.

completely different kind of sculptural form, far removed from the fifth- and fourth-century concept of frontality. The proportions are tall and stretched out. The left foot is raised and comes forward strongly, creating distance between it and the weight-bearing right leg. The legs are unified, however, by the wrap of drapery resting precariously on the hips with the ends loosely falling between the legs. The drapery is deeply undercut with sharp, angular ridges, resulting in exaggerated contrasts of light and shadow. The mass formed by the drapery and legs gives the impression of both tension and movement. This impression is reinforced by the movement of the left leg to the right while the torso turns to the left. Even the breasts go in different directions. The head comes slightly forward on the neck, and the eyes gaze into the distance. The whole body appears to rotate around a spiral axis, rather than being distributed on either side of a central axis. This is a fully tridimensional composition with the body extending itself spatially in all directions.

The second-century master of the *Aphrodite of Melos* was concerned with a combination of effects not related to naturalism: the tension of a rotating body; the highly sensual contrast of the nude and the partially draped areas; the instability implying momentary change created by the arrangement of the drapery; the disproportion of the small head on the big body. The ensemble gives the impression of plantlike growth—the twisting form swelling upward to carry the head of a remote and dreamy goddess. It is a very complicated figure, the product of a highly sophisticated understanding of the many possibilities of artistic choice.

In the fourth century, Praxiteles had inspired the world by creating a goddess who did not induce awe but invited man's intimate appraisal of the purely beautiful in human terms. Two centuries later the sculptor from Asia Minor made an image of the same goddess that was at once more divine and more sensual—a combination that expressed the mysterious power of sexuality that had been Aphrodite's since the origin of her cult.

Early in the second century B.C., as Greece fell under Roman sway, the Roman censor Marcus Porcius Cato, a man deeply suspicious of all things Greek and yet sensitive to their power, remarked of the artistic treasures of Greece: "I fear that these things will make prisoners of us rather than we of them." [5] The statement tells us much about the curious and unprecedented exchange of hegemonies that took place between an emerging power with an enormous gift of organization and an older civilization with an extraordinary cultural tradition. Each gave the other an offering of its excellence, but Rome's giving and Rome's taking were aggressive and self-conscious. Cato was a reactionary; he stood for an older tradition of Roman austerity. What he dreaded had already taken place, for second-century Rome was strongly Hellenized; its theater, literature, art, and religion were fast merging with those of Greece.

Rome loved the art of Greece. Roman citizens became increasingly attracted to its beauty as images, statues, and paintings poured into the capital with each new triumph in the late third and second centuries. We know best what happened to sculpture—how the Romans plundered it, copied it (the Naples copy of the *Doryphorus* (Fig. 23) was made for the Palestra in Pompeii), and hired Greek sculptors to create new works for Rome. These developments were central in the formation of Rome's artistic taste. Looking back to older works of art—creating eclectically—had become part of the artistic climate of Greece, as we saw in the *Aphrodite of Melos*. Rome not only accepted this eclecticism, but reinforced it, showing a particular taste for the legacy of the Classical period, the fifth and fourth centuries. Phidias, Polyclitus, and Praxiteles would not stand out in such strong relief in history were it not for the Romans.

Copying, wholesale importing, and the hiring of foreign artists—all this does not sound conducive to the creation of a distinct style. And on occasion historians have seen Roman Republican art as a late phase of Greek art. Yet there is a special element in Roman sculpture; even in its most classicizing moments in the first century B.C. there are qualities that are peculiarly Roman. In two areas a distinct Roman sculptural style became particularly well developed: in portraiture and bas-relief. Both accorded with the Roman's special sense of history and of his own destiny, for they preserved the reality of events and people.

We have seen that by the late fourth century Greek sculptors were moving away from the ideal likeness toward the individualistic portrait. Whereas previously physical beauty was primary, sculptors now emphasized the likeness and the spirit of the individual. The search for likeness continued throughout Hellenistic times; sculptors came to believe that the whole personality could be captured in a plastic representation.

The Romans were profoundly receptive to this kind of artistic concern; effigies had always been important in their tradition of cohesive, patriarchal family life. They bore deep respect for

the authority of ancestors, whose memory and deeds were preserved by their visible presence in masks and busts. The experimental realism of Hellenistic portraiture thus invigorated an existing Roman usage.

A comparison of two highly personal portraits of the first century B.C.—one Greek (Fig. 35) and one Roman (Fig. 36)—reveals clear stylistic differences. The portraits represent the divergent trends in the creative life of these two cultures, the older sinking ever deeper in disillusion, the younger expanding and consolidating. Posidonius, the subject of the Greek portrait, was born in Syria in the second century. He studied in Athens, founded a school of philosophy in Rhodes early in the first century, traveled in Egypt, Spain, and Gaul, and finally went to Rome toward the end of his life. Here was a man who really knew about the changing alignment of the Mediterranean world in the first century. He was the great Stoic philosopher of his time. His eclectic, original, and vast syntheses were far-reaching and profoundly influential on his contemporaries. In Rome his concept of a comprehensive, unifying life force and his moral theories emphasizing action and commitment to the established social order were held in the highest regard.

The quality of the *Posidonius* is extremely fine. It shows strength and at the same time conscious restraint. The close, turning locks of hair and the flat growth of beard have a controlled dryness about them, so that the tension in the facial features seems more forcefully projected. The creased forehead, puckered eyebrows that cast the eyes into shadow, wrinkles pulling out at the eyes, tight temples, and loosening of flesh beneath the eyes, in conjunction with the full, intense lips that imply, but do not show, a breath held in or a sound about to be uttered—all this suggests a gathering storm within this man. In addition, the asymmetry of the shoulders, the pull to the right, and the taut stretching of the neck tendons also carry the sense of psychological stress.

The style and spirit of the portrait of an unknown Roman is very different (Fig. 36). The anonymity itself is significant. The Greeks, for the most part, were interested in portraying famous people; Posidonius was not an ordinary man. The Romans, too, thought honorific portraits important, especially images of elder statesmen they wished to commemorate in public places. But their tradition of family honor, begun in the patrician families and passed on to plebeian houses, was even stronger and brought with it the special quality we see in this bust. Immediately we are made to see this man's physiognomic uniqueness. This kind of portrait, very popular during the Republic, put tremendous stress on accurate likeness: the big nose, small eyes, tightly pressed lips, fleshy jowls, laps of cheek skin, and all the wrinkles of old age have been carved or incised into the marble surface with graphic precision. Whereas the Greek sculptor stressed certain features that would give the "idea" of Posidonius' personality and then organized them within the unity of a plastic whole, his Roman successor interpreted an old man's homeliness and resolute character more matter-of-factly, without particular emphasis on any one part. We are convinced that this Roman looked like this in life. His portrait is a close-up of an actual existence—a proud but nameless Roman citizen—while the Greek portrait is an interpretation of the character of a brilliant philosopher. The two styles lent themselves to exploring two kinds of reality.

When the Roman custom of preserving individual physiognomy was vitalized by Hellenistic sculpture's refinements of style and technique, a tradition of portraiture was begun that continued for centuries. Something of the same thing happened with relief sculpture, for similar reasons. The Greeks had sensed divinity to be inherent in the whole material universe; they invented marvelous stories of gods and imbued them with the sensuousness of the universal

35. *Posidonius.* First quarter of the 1st century B.C. Marble, 17″. National Museum, Naples.

processes of nature. Romans fostered instead a sense of history and saw a divine plan in individual actions; thus Roman artists pictured historical events well before the Greeks did. The earliest continuous story we know in Greek sculpture was carved at Pergamon in the second century B.C.; it portrayed the exploits of Telephos, the city's legendary founder. Romans had rendered military successes on tablets since the third century. Their tradition put high value on the recording of events, but as relief sculpture evolved it came to be much more than simply history in stone. Roman receptivity to Greek influence grew, and with it the use of symbolic representation. This, too, could be used in the service of Roman history.

Architectural monuments built under the Roman Empire still survive in profusion in the Mediterranean world. Often the sculpture that adorned their surfaces had as much political as

36. *Bust of a Man*. Second quarter of the 1st century B.C. Marble, 11″.
National Museum of Antiquity, Chieti.

decorative purpose. It was primarily through the reliefs that the leaders of the Roman state were able to dignify their public statements. The emperors used art to create a favorable image of themselves and a wishful image of political reality under their reigns. It is scarcely an accident that the names of emperors are used meaningfully to designate the art styles of the hundreds of years the Roman Empire endured, while the artists remain, for the most part, anonymous.

Dynastic rule and *pax Romana* were secured by Octavian. His victory over Antony and Cleopatra at Actium in 31 B.C. was officially interpreted as a triumph of the humanistic tradition of Western-Italic peoples over the degenerate mysticism of the East. He became *Princeps*, the person of highest rank in the state; he took the law unto himself, and in 27 B.C. the senate voted him the distinction of "Augustus." Looking back on more than a century of murderous rivalries and Republican wars, Augustus set about creating stability and order, determined that Rome's image as a military power should be superseded by one of flourishing culture. The doors of the Temple of Janus in the Forum, open in time of war, were ceremonially closed. Augustus worked to revive the traditional cults of Italy and to enforce public morality that there might be a spiritual base underpinning the state and enforcing the legitimacy of the Principate as he had founded it. To a great extent he succeeded, and no monument is a better expression of his view

37. *Imperial Procession.* Detail of the frieze of the Ara Pacis. 13–9 B.C. Carrara marble, 63″. Via di Pitetta, Rome. (Illustration taken from plaster in the National Museum, Rome)

of himself and his goal for the state—his desire to keep ancestral and Republican traditions alive even as he wielded sole power—than the Ara Pacis.

The site for this altar of Augustan peace was consecrated in the Field of Mars (Campus Martius) in 13 B.C., after Augustus had returned from visiting the provinces in Gaul and Spain. Its theme depended on an interweaving of the contemporary with symbol and legend. The origin of Rome, of the Roman people, and of the Julio-Claudian dynasty was related in reliefs depicting the legends of Romulus and Remus and of Aeneas, who was considered a prototype of Augustus. A complementary set of reliefs spoke in symbolic terms of the consequences of the *pax Romana*—peace and fruitfulness. The most famous of the reliefs are those that show Augustus' own day—representations of the procession that took place on July 4, 13 B.C., the day the site was consecrated (Fig. 37). On the two long sides are the Princeps, his family, and the great personages of Rome—magistrates, senators, priests, and vestals—who accompanied him out of the city to sacrifice to Pax on the Field of Mars.

It is impossible not to be reminded of that other great procession of people winding their way out of a city's narrow streets and up a hill at its center—the Panathenaic procession on the Parthenon. The theme is an equally strong expression of the state's power and the great past, and the reference is in no way accidental. The artists of the Roman altar were Greeks, and the Parthenon frieze is clearly an ancestor of the Ara Pacis. Nevertheless, the strength of the

historical repetition is startling. Here are two reliefs, both strikingly innovative in their times, both depending upon a particularly balanced classicism, and both revealing in similar fashion the spirit of two cultures at the height of their glory under unparalleled leadership. Because of the similarities, the differences reveal all the more clearly the contrast between the way the Greeks of the Classical period and the Romans of the early Empire lived and saw their own traditions. The Parthenon frieze showed the great numbers of Athenian citizenry—its length was unprecedented—and demonstrated their devotion to their patron goddess. The figures appear in groups according to their function in society; the view is comprehensive, the figures are typical, anything specific is omitted. Indeed, scholars are divided about whether this is a contemporary procession as it took place in the fifth century or a view of the heroic past when the festival originated.

The Ara Pacis, however, is entirely specific. Scholars may disagree about which occasion is portrayed—the consecration of the site in 13 B.C. or the dedication of the altar in 9 B.C. (in which case the artists would have had to visualize a future event)—but that a unique contemporary event is represented is not in question. The artist wrought penetrating portraits; today some of their identities are in dispute, but they were entirely clear to first-century Romans. All the details of dress and the attributes that indicate social place and role in the ceremony were carefully depicted. The image of Augustus is that of an aristocrat among family, friends, and peers, very much in keeping with his desire to de-emphasize his exceptional position. The state's enduring quality and its link to the past are made real through the depiction of individuals in a specific situation, and the result is totally different from the Athenians' recognition of themselves in the timeless beauty of the heroic and symbolic Panathenaic frieze.

The style of the Ara Pacis reliefs is thoroughly classical. This is not so much the result of dependence on Classical Greek prototypes as it is the product of a spirit that moves through the whole, particularly in the procession. The overlapping, the massing of figures, unifies the composition, which is pervaded by the slow rhythm based on the sequence of major and minor vertical figures. There is not the strong repetition, the sense of *rhythmós*, of the Parthenon frieze; rather, the slight variation of gesture, height, and view gives the scene an informality and an immediacy totally absent from the ceremonial representations of figures in the Greek relief. The quietly shifting glances and easy, gentle gestures—a woman rests her hand on a child's head, hands pull on the edges of togas, a youth lays an axe lightly across his shoulder—are much more intimate. The body types and their positions are typically classical, with the Polyclitan weight-shifting stance used repeatedly. In the detail illustrated we see how the use of this type and stance in frontal view gives a particular sense of presence to the man and woman on either side of the child. The dignified bearing of the figures is magnified by volume made visible in the full and graceful wrap of the togas. The deep, fluid folds, depicted with natural ease, show great skill in carving (part of the evidence that the sculptors were Greek) and provide a controlled but lively sequence of light and shade.

A finely developed ability to handle relief space is important for the style of the Ara Pacis, in which the area of the procession is completely filled both laterally and in depth by figures. In the first file they extend slightly in front of the architectural ground line and are given strong coloristic emphasis by the deep-cut shadows and corresponding highlights. The heads of the figures in the rear are lower, for them the carving is shallower. The resulting perspective gives a measured but convincing spatial illusion. It accounts for the apparent ease with which such a large number of individuals have been rendered in what is, after all, a very confined area.

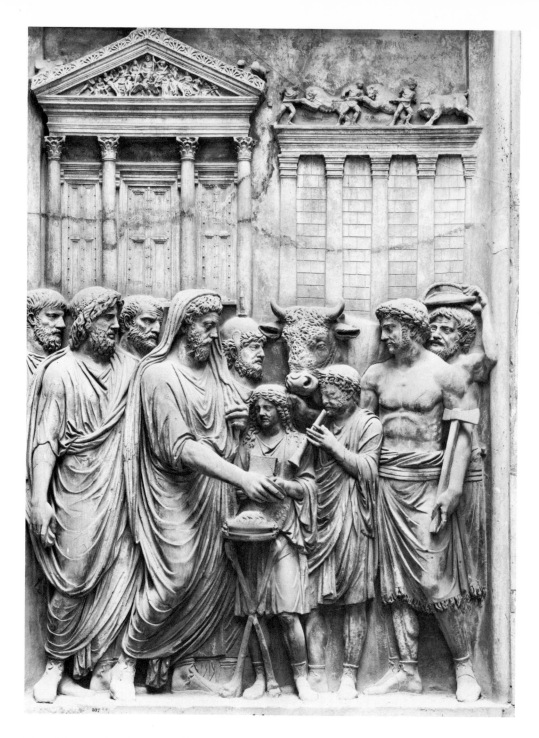

38. *Marcus Aurelius Sacrificing on the Capitol.* After A.D. 176. Marble, 13'7″.
Conservatori Museum, Rome.

As the Parthenon was a high point in Greek art, the Ara Pacis represents a particularly fine moment in the history of Roman sculpture. Theme and style are in profound harmony, brilliantly combining Greek formal concepts with the new spirit of Roman subject matter and ideas. Such accord of classical style and Imperial ideology was not to be repeated, but the influence of the Ara Pacis was fundamental to commemorative reliefs created throughout the Empire.

What Augustus established was of lasting value. For almost two centuries the *pax Romana* brought the Empire political unity, economic prosperity, and commercial dominance. The great peace was not seriously threatened until the reign of Marcus Aurelius (A.D. 161–80). But even then artists continued to work in the grand tradition of classicism that had been the dominant sculptural style during the Principate. One of the last and most beautiful expressions of the style is to be seen in a group of reliefs from a triumphal arch built to commemorate Marcus Aurelius' victories over the Germans and the Sarmatians in A.D. 176. The final panel in the series shows the sacrifice to Jupiter on the Capitol (Fig. 38) in fulfillment of vows taken at the initiation of war. The Emperor is shown pouring a libation onto the tripod altar. A figure personifying the Senate is to his right and behind him are representatives of the military, here shown in a position subordinate to representatives of the civil government.

Stylistically the work is in the tradition of the Ara Pacis—we see it in the easy movement of the figures, in the classical drapery turning gracefully about the figures, and in the composition of the figures in two rows. But the design of the panel is considerably less classical. Instead of the modulated dispositions of volumes that gave the Ara Pacis figures such stability, here the stance of the figures shows sudden shifts of weight. The weight shift and the representation of the figures in three-quarter views facing the middle combine to create a movement toward the center, which is reinforced by draperies sweeping in a circular motion around the bodies. The moderate pace and vertical emphasis in the series of erect bodies of the Ara Pacis is quite absent here. We also find such an odd, unnatural, and unclassical detail as the figure of the flute player, represented as an adult but reduced to three-quarter size to fit into the composition beneath the sacrificial animal.

The intensity in the facial expressions is further evidence of change from the earlier classicism; the furrowed brows and staring eyes of the participants concentrating on the sacrifice are in a different spirit from the restraint of the Augustan celebrants. The feeling is magnified by the wreath of hair and beards surrounding the faces. Beards, occasionally worn in the first century A.D., came into full vogue during the second; men wore luxuriant growths of hair and thereby magnified their presence.

It is also in the heads that we find the greatest technical change: the consistent use of the drill in the beards and hair, which introduces a flickering surface quality. Roman sculptors employed the drill in addition to the chisel to remove marble from the deepest cavities; during the second century this practice became more and more common. With it grew the taste for the kind of decorative patterns that resulted from the practice.

The most noticeable difference, however, from the earlier work is in the spatial treatment: an architectural background is used to create an ambiance and to clarify the composition. The highly decorative, powerfully pedimented temple stands behind the major figures, while the low, flat, horizontal building stands behind the functionaries at the altar, corresponding to their status. Viewed at eye level (as they are in Fig. 38) the heads are at the same level (isocephalic), and we do not have the illusion of space given in the Ara Pacis. However, to a viewer standing on the ground looking up at the reliefs on the arch, the rigidity of the horizontal and vertical divisions would have been far less emphatic and the impression of illusionistic depth much stronger.

Both the Ara Pacis and the relief of Marcus Aurelius show the Emperor taking part in a great ceremony of state religion celebrating the end of a war, but the Augustan peace was pervasive, whereas the peace celebrated by Marcus Aurelius' sacrifice was only a temporary end

to hostilities. The Augustan relief is both more classical and more natural; it fits the spirit of a man who wanted to be in touch with tradition, to control the future direction of Rome, and yet share in Republican sentiment with his people. The Aurelian relief is more emotional, less naturalistic—in spite of added descriptive detail; it is a sterner, more ritualistic scene. It was done in the last years of the reign of a Stoic emperor, a man who had great virtue but little warmth. It was his hard task to imbue his reign with a sense of Roman Imperial valor at a time when a return to arms signaled the end of the Roman Peace.

The portraits of the second century show the same kind of forceful contrast to Republican and Augustan portraits that we find in reliefs. Our vivid knowledge of the types of individuals who lived in the urban centers of Rome comes both from literature and portraiture and is central to our understanding of Roman history. Some of the best portraits are of private citizens, with whom the artist could spend long hours in a way he seldom could with the emperor and his family. Such a work is the bust of Cacius Volcacius Myropnous (Fig. 39), found in Ostia near a tomb which it must have marked. We know the subject's name from the inscription carved in Greek letters on the base; the style suggests that it was made in the third quarter of the second century A.D. The image is of an intense young man. His face is long and angular, with hollow cheeks. He has a wispy mustache and hair growing along his jawline. His fashionable mop of curls is thick and full of movement, marked by repeated accents of deep shadows cut by the running drill. This technical device heightens the pictorial quality; the effect is intensified by the sharp contrast of the hair and the smooth face, where the high polish on the yellowish Greek marble has survived. The eyes are stressed; the irises are incised as rings, and within them a round drill-hole indicates the pupils. The resulting upward gaze, in combination with the thin protruding eyelids, gives the face an expression of remote and wan spirituality. The artist tried to interpret psychological aspects of the individual in a way very different from the straightforward realism of Republican portraiture (Fig. 36) or the controlled classical humanism of the Ara Pacis figures. The result is a thoughtful portrait of the highest quality, a work permeated with sadness and marked by an extremely personal feeling.

The traits seen in the bust of Volcacius are not unusual for a work of the second century. A large number of portraits survive from the Antonine age (A.D. 138–92); they are known for their sensitivity and pictorial handling, and often stress pensiveness, reflection, and spirituality. The second century has long been regarded as the final glow of Imperial greatness. The Antonine period is sometimes spoken of as a Golden Age. A famous passage of the second-century Christian writer Tertullian supports this image:

> A glance at the face of the earth shows us that it is becoming daily better cultivated and more fully peopled than in olden times. There are few places now that are not accessible; few, unknown; few, unopened to commerce. Beautiful farms now cover what once were trackless wastes, the forests have given way before the plough, cattle have driven off the beasts of the jungle, the sands of the desert bear fruit and crops, the rocks have been ploughed under, the marshes have been drained of their water, and, where once there was but a settler's cabin, great cities are now seen.[6]

Edward Gibbon, whose writings (published in 1776) have been highly influential on modern interpretations, shared this view. His *History of the Decline and Fall of the Roman Empire* begins: "In the second century of the Christian era, the empire of Rome comprehended the fairest part of the earth, and the most civilized portion of mankind." And he counted the Antonines in his "happy period." Yet this is not the spirit of the somber Volcacius, nor that of a

39. *Cacius Volcacius Myropnous*. From Tomb 6 at Isola Sacra near Ostia. A.D. 160–170.
Marble, 24″. Museum, Ostia.

considerable number of other intense-looking men and women known to us in second-century
sculpture. And indeed, in recent years historians have recognized that the outward tranquility of
the Antonine age is deceptive—prosperity was not as widespread as it seemed, and numerous
weaknesses and tensions lay beneath the surface. The portraits could have told us this.

There is nothing equivocal about the evidence of the Empire's problems during the third
century. It was convulsed by depressions, invasions, epidemics, and violence. Its portrait
sculpture reveals much about the stressful times, and it does so in the widest variety of styles. A
concentrated look at the third-century portraits in the great public collections of Rome and
Ostia reveals antagonistic styles, sometimes naturalistic, but more often schematized, abstract.

Gallienus (ruled A.D. 253–68) was one of the soldier-emperors who led Rome in its
ultimately losing struggle. During his reign both eastern and western frontiers were constantly

40. *Emperor Gallienus.* A.D. 260–68. Marble. Ny Carlsberg Glyptotek, Copenhagen.

battered by Rome's enemies. In Rome itself many tried to usurp his throne, and his death wounds were made by the knives of his own officers. What was remarkable about Gallienus was his interest in cultural concerns even while surrounded by crises. His taste was clearly touched by Hellenism; he even traveled to Athens to be invested as a magistrate and to Eleusis to be initiated into the mysteries of Demeter.

There are a number of portraits believed to be of Gallienus, and many are marked by a classical feeling. But even Gallienus' sculptors, artists capable of an unusual degree of plastic naturalness for the third century, produced some works that betray a most unclassical style and spirit. One of these is a colossal late portrait (Fig. 40). This massive head is completely surrounded by stylized hair, the beard growing well down on the neck. The head has none of the evasive sensuality and subtle textures of the *Volcacius*; instead it is firm and impenetrable. The features are not modeled gradually into relief, but are cut into rigid horizontals and verticals that divide the face into patterns. The drilled eyes roll up beneath lowered brows in a hard stare; this had already become the conventional "transfigured" look of late antique art. To a certain extent the expression can be understood in relation to the ideas of the Emperor's friend

41. *Emperor Constantine.* A.D. *ca.* 330–40. Bronze, 73″. Conservatori Museum, Rome.

Plotinus, founder of Neoplatonism and the most articulate voice in the pagan world during the late Empire. He taught that men might be fulfilled by turning away from sensuous experience and toward a divine oneness. Plotinus believed this unity could best be expressed abstractly, and the resulting aesthetic differed considerably from that of earlier classical times. According to Plotinus, the beauty of the body did not lie in its proportions and the relationship of the parts to the whole, but in the degree to which it was illuminated by the internal "soul." With such a concept, external beauty ceased to be a prerequisite for art. The sculptor of Gallienus worked in the new abstract style and through it made the Emperor's image regal, distant, and unapproachable. The third century came to be increasingly sensitive to the parallels between an earthly ruler exerting power by divine right and a single god governing the cosmos. It was a blueprint for world order, one regulated by an omnipotent being. The emperor portraits mirror this belief; the individuality diminishes as the image emerges in a transcendental state.

Two ideas had especially strong impact on the image of man in the late third and fourth centuries—the negative attitude toward the body that permeated religions, Christianity among them, and the related view of man's body and soul as antagonistic. When such views are

expressed in plastic form, the result is abstract rather than naturalistic. This is clear in the great bronze head of Constantine (Fig. 41). To some extent such an image was prepared for by the stern spirituality of third-century portraits like the *Gallienus*. But in the *Constantine* everything is magnified, intensified, and transformed. The sense of volume and shape is more articulate, for the outline is firmer, the surface tightened, and illusionistic textures absent. Each feature is emphatic because of the regularity of shapes, the bigness, and the patterned, linear quality. The enormous eyes particularly have power. They are emphasized by the raised eyebrows, which are separated by muscles modeled as deep, vertical furrows. The artist who made this head, his patron, and his society had put aside both ideal beauty as the Greeks knew it and the realism cherished by the earlier Romans. Instead they chose a stark, expressive type of image. The suppression of individual traits was carried so far that although numerous portraits of Constantine the Great are known, we remain unsure if this head portrays him or Constantine II, his son.

A spiritualized portrait like this tells us more about the *idea* of the subject than about his actual appearance. By the time Constantine became sole emperor, in A.D. 324, the concept of absolute monarchy was well established—he fortified it by making it hereditary—and rule by divine right was unquestioned. Society revered the person of the emperor. This Oriental attitude fitted the man who, realizing that he ruled alone and needed neither Rome nor her senate, moved the capital of the Empire to the East—to Byzantium.

Constantine's greatest significance for history was his recognition of the power of the Christian God. With this he seemed to gather within his own person much of the late antique world's longing for unity, for the "One." Almost every thoughtful person inclined toward some form of monotheism in the late fourth century. Christians were more reluctant than others, however, to reconcile their beliefs with the traditional myths. Thus, when the Emperor embraced this exclusive God who had been human yet divine, his omnipotence was greatly magnified.

The superhuman nature of Constantine is expressed through the gigantic size of the image. The huge abstract eyes endow the face with a power not seen since the Archaic kouroi. Here, as in the works of the sixth century B.C., they represent life; but now it is life of a different kind—rather than conveying the brightness and intensity of an animated human being, these eyes are mirrors that reflect the soul, wondrously and potently transforming the Emperor's presence.

Most Romans of the Empire believed in immortality. They expressed their belief in the sumptuous furnishings of cremation or burial; their urns, altars, and sarcophagi all bear witness to a cult of the dead—a desire to please the deceased, to express grief mingled with respect, and to preserve unbroken contact with the dead. By the second century A.D., as the idea of "soul" became more significant, there was more impulse to keep its bodily shell intact, and cremation gave way to burial. The sarcophagus, more familiar in the East than in Italy, thus grew in significance as an art form. These carved coffins have a special importance in the history of Roman art, as they were most often ordered and paid for by private patrons at a time when the Empire was so unstable that few public buildings were erected and even fewer reliefs were carved to tell of Roman glory. The style of third-century Roman relief sculpture, therefore, is best followed in sarcophagi. As with contemporary portraits, stylistic variation is so wide that any kind of regular development is almost impossible to comprehend. Classical work of high quality was produced at the same time as work in an emerging style in a strongly contrasting mode.

The sarcophagus of L. Publius Peregrinus (Fig. 42), a Roman centurion who died at the age of twenty-nine, was carved in the middle of the third century, perhaps during the reign of Gallienus. Publius ordered or selected (there were numerous shops in which sarcophagi were carved before they were purchased) a coffin that would preserve a very particular image of him, and a rather unusual one for a soldier. He is seated in the center of the relief dressed in tunic and pallium and reading from a scroll. Beside him a female figure holds a closed scroll and leans attentively toward him. The cultural ambience of this young man is manifested by the Sages and Muses packed into the length of the sarcophagus panel. The relief testifies to continuing intellectual activity during the chaotic third century, for here a soldier has chosen to be remembered for one thing alone—his interest in the world of philosophy and poetry.

The style is fundamentally classical in the same Hellenic tradition as the two Roman reliefs already examined. Here many figures are lined up. This arrangement, which we have seen used before to show participants in a procession or a sacrifice, became one of the most common methods of organizing figures on sarcophagi. Beyond the most general aspects of composition and dress, pose, and coiffure, the style here is different from that of the earlier reliefs. The heads are at the same height whether the figures are standing or sitting. The figures are not solidly placed, and there is a certain awkwardness of proportions, with broader heads on shorter bodies. Abruptness and angularity characterize the bodies and the movement of drapery. There is none of the fluid ease seen in the earlier monuments, and although there is repetition (in the muses' profiles and in the almost identical postures of the Roman matron and the sage at the right), it is in no way rhythmic. Draperies are modeled as rounded folds in a classical manner, but as we look more closely we see how often the artist formed the shadowy underturning of a highlighted

42. *Sarcophagus of L. Publius Peregrinus.* A.D. *ca.* 260. Marble, 52″. Torlonia Museum, Rome.

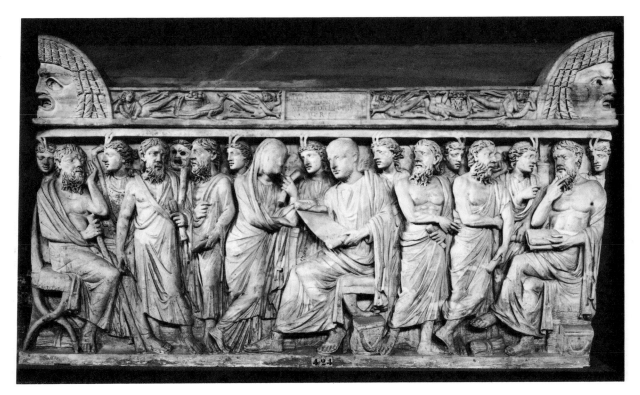

fold not by removing the marble, but instead by cutting a straight, deep gouge that acts as a fold but does not look like one. The strongest divergence from a classical way of seeing is in the inconsistency in the sizes of the figures and the lack of illusionistic space. All the figures tend to project from the relief ground to the same extent, so that those in the background are pressed into the foreground; the effect is crowded and spaceless. Without a sense of depth, a consistent sense of proportions, or flowing movement, the figures do not easily relate to one another.

The absence of the refined classicism of Augustan and Aurelian art must be considered partly in the light of the famous "decline" of late antique art. But in the style of the Publius tomb we find a particular kind of energy and variety that comes from the mass of packed bodies lined up in disparate poses and unclear relationships and from the withdrawn spirituality of their expressions—their rolling, upturned eyes, wrinkled brows, and half-open mouths. It is a work far too classical to be seen as a conscious opposition to the tradition of Roman Hellenism, but it contains within it elements that were to be developed by later artists who would deliberately abandon the naturalism that had been an unquestioned value throughout Greco-Roman antiquity.

The sculpture of the fourth century became more clearly anti-classical. The distance in terms of style between the third-century Publius tomb and a sarcophagus carved in the period of Constantine (Fig. 43) is greater than that between any of the reliefs yet examined. We have here the coffin of one "Sibinus, companion in marriage, who lived 44 years, 10 months and 13 days—of high merit. In peace." We do not know his occupation or his interests, as we do of Publius, but we know his faith, for he was Christian. The sarcophagus, which was surely not carved especially for him, has more to do with his identity as a Christian than with his personal experience. Sibinus is not portrayed but is represented by an orant, a female figure in the

43. *Sarcophagus of Sibinus.* A.D. *ca.* 320. Marble. Lateran Museum, Rome.

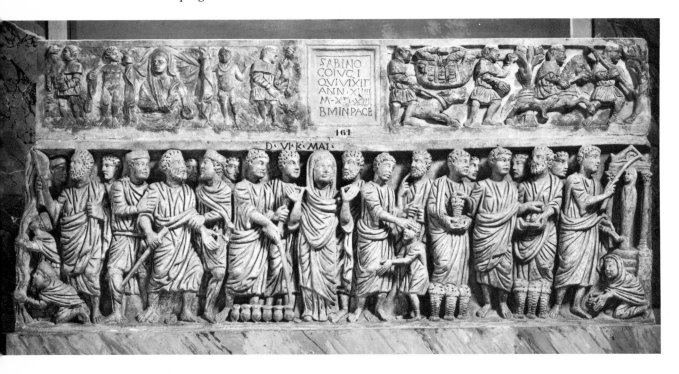

attitude of prayer, a symbolic reference to the deceased as he enters into eternal life. On either side of the orant Peter and Christ perform life-giving miracles of healing and saving which intensify the atmosphere of hope cherished by the pious supplicant.

Like that of Publius, the Sibinus sarcophagus is carved in high relief. The arrangement is similar: figures are placed symmetrically on either side of the central image and the ends are treated in like fashion—seated sages on the first, Christ and Peter paired at the corners of the other. In both sarcophagi the upper edge of the relief determines the position of the heads. Beyond these similarities, dissimilarity predominates, both in the composition as a whole and in the individual figures. The third-century sculptor had shown little interest in the classical idea of developing a coherent sense of depth in relief; here it is completely absent. As a result of the stress on the surface plane and on the rectangular enframement, which together force a new kind of order on the composition, there is no real sense of the relationship of figures to one another in depth. The figures, arranged on the surface, are frontal, and there is strong emphasis on the horizontal, not only in the heads but in the line of the shoulders, the tunic-ends, and the feet. The surface is emphasized further by the treatment of draperies as an elaborate system of incised lines and by the consistent use of the drill in forming the beards, hair, nostrils, mouth corners, eyes, and joinings of toes and fingers. The scattered spots and lines made by the drill produce a linear quality quite different from the plastic effect of the earlier relief. What was texture has become pattern; where the beards and locks were rich and flowing, they are now divided and ordered according to a rigid plan.

The figures are significantly different from those of earlier Roman styles, particularly in proportions and movement. They are squat, with big, round heads; their hands are oversized (look at the hands of Jesus and the open palm of Peter to the left), but the relationship of the extremities and the head to the body is by no means consistent. There is no movement, no sense of the distribution of the body's weight—a fundamental element in the sculptural representation of man since the fifth century B.C., and consequently our grasp of the corporeal nature of these bodies is uncertain. The faces do not help; they all have similar expressions, characterized chiefly by the enormous, intense, unfocusing eyes of a type familiar from the colossal head of Constantine.

This is a rustic piece; we could find more elegant carving on fourth-century sarcophagi, but the Sibinus sarcophagus is a typical example showing the penetration of new elements into Roman workshops. It is difficult to ascertain their specific source, but they are provincial in character and parallel to types of carving that were being done in the East and in Africa.

A pagan sarcophagus would have served as well as the Sibinus tomb to show fourth-century style. What is specifically Christian about the work is the subject and its symbolism, not the forms or the way they are carved. It was made in an intensely religious age; the dominant spirit of current beliefs, whether pagan or Christian, was other-worldly, and a traditional classical style was incapable of rendering this spirit in satisfactory visual form. With the choice of Constantine and the Peace of the Church, Christianity became the religion of the future. Therefore, a Christian work is most appropriate to show the initial stage of a style fashioned to express the beliefs of a society that held God and man's soul, rather than his corporeal existence or his political beliefs, as the prime elements of a man's life. As Christians sought to embrace more fully transcendent realities, they became increasingly distrustful of the body. The problem for the future, for European sculptors of the Middle Ages, was to develop art into a means of helping man experience the invisible.

Whether the Image of God is in Man?

Objection 1. It seems that the image of God is not in man. For it is written (Isa. xl. 18): To whom have you likened God? or what image will you make for Him?

Objection 2. Further, to be the image of God is the property of the First-Begotten, of Whom the Apostle says (Col. i. 15): Who is the image of the invisible God, the First-Born of every creature. *Therefore the image of God is not to be found in man.*

Objection 3. Further, Hilary says (De Synod.) *that an image is of the same species as that which it represents; and he also says that an image is the undivided and united likeness of one thing adequately representing another. But there is no species common to both God and man. Therefore there can be no image of God in man.*

On the contrary, *It is written (Gen. i. 26):* Let Us make man to Our own image and likeness.

I answer that, *As Augustine says (Qq. 83):* Where an image exists there forthwith there is likeness; but where there is likeness there is not necessarily an image. *Hence it is clear that likeness is essential to an image; and that an image adds something to likeness—namely, that it is copied from something else. . . .*

But equality does not belong to the essence of an image; for, as Augustine says: Where there is an image there is not necessarily equality, *as we see in a person's image reflected in a glass. . . . Now it is manifest that in man there is some likeness to God, copied from God as from an exemplar; yet this likeness is not one of equality, for such an exemplar infinitely excels its copy. Therefore there is in man a likeness to God; not, indeed, a perfect likeness, but imperfect.*

St. Thomas Aquinas, *Summa Theologica* (Question XCIII), after 1265

THREE
The Christian West

Holy Images and
Biblical Narrative

When we think of art in Europe in the twelfth century we have an image of sculpture, of robust and massive carvings in perfect accord with the buildings that formed the framework of their existence. How this came to be is not simple. Between the period of colossal Constantinian figures and Christian sarcophagi and that of the images of Romanesque churches, sculpture was the art form that declined the most precipitously and plastic values were the ones that retained the least currency. By the fifth century sculptors were imitating painters, and sculpture in the round was nearly nonexistent in the Latin West. Concurrent with this was a gradual loss of interest in the human figure, which had been the main concern of sculptors throughout antiquity.

Man's image in three-dimensional form was far less in evidence in the late Roman Empire of the fourth and fifth centuries than previously. This was the time when German peoples were on the move, when the economy was declining, and when the Latin West was reduced to the status of province of the Byzantine East. All this marked an end to any kind of political unity in the Mediterranean. The Christian Church remained the sole stable institution that extended throughout what had been the jurisdiction of Rome.

In this period of conflict and uncertainty, antagonisms between the East and West and the North and South were fundamental in forming the vision of artists. In 476 a barbarian general deposed Rome's last emperor. Now there would be but one emperor, and he would be in Constantinople. The date itself is not important—many events led to it—but the change has a strong symbolic significance in regard to the differences between East and West. The East never completely submitted to the barbarian invaders, whereas the West was thoroughly penetrated by them, and they eventually became the ruling class. While the East suffered no shock strong enough to interrupt the traditions of antiquity, the new artistic language of the West was a radical departure from the old forms. The development of this powerfully anti-classical vision owed a special debt to the Northern peoples whose art forms were in opposition to those of the classical Mediterranean; Northern art was primarily ornamental and its forms almost totally abstract.

The clash of cultures was sharpest on the Italian peninsula, the old core of the Roman Empire. A tiny reliquary lid now in Grado, created in northern Italy in the sixth century,

67

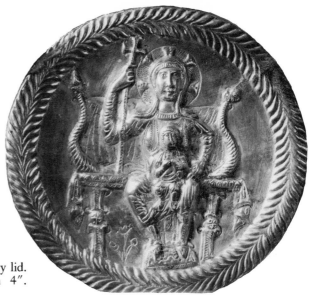

44. *Virgin and Child Enthroned.* Reliquary lid. Mid-6th century A.D. Silver, width 4″. Cathedral Treasury, Grado.

demonstrates in miniature what happened to sculptural forms in this society riddled by racial, political, and religious strife. The size of a large coin, the lid shows the Virgin enthroned with the Christ Child on her lap (Fig. 44). The artist who fashioned this reliquary lived in Aquileia, an old Roman town northeast of Venice, at a moment when his city was renewing itself after being destroyed by the Huns. When the Byzantine Emperor Justinian retook Italy from the barbarians, Aquileia had become the ecclesiastical center of the region. It was closely connected to the Eastern Empire, and the style of the reliquary relief is expressive of that relationship.

The artist liked a rich surface; he hammered the low relief in a repoussé technique, putting the thin silver sheet over a wooden form and molding its volumes. At the time he worked, sculpture in bronze had almost ceased to exist; in its place were small works like this one in precious metals. They were not the products of simple craftsmen but the works of the major artists of the time. The sculptor fixed the Virgin in a rigid and frontal pose. He aligned the Christ Child with the center of her body. By flattening her angular arms, the tall cross, and the heavy, upright throne legs, he gave the composition an insistent verticality, complemented by the forceful horizontals of the back and seat of the throne. In a classical work this combination would result in an extremely stable composition. Here, however, the image seems to float on an immaterial plane of indefinite depth. There is no ground line and the third dimension is disregarded. The Virgin is superimposed on the throne rather than seated on it. The figure is not a classical type; it is neither organic nor harmonious. The seated posture is depicted unconvincingly, and the right arm is twice the length of the left. Nevertheless, there are elements that do relate to the heritage of antiquity: the breasts, knees, hands, and cheeks are rounded even in this low relief, and there is an interplay between the two sides of the body. The impression of the whole, however, is far from the classical grasp of the human body. Two elements further contribute to this: first, a crudeness, especially in the awkward asymmetry of the faces and in the placement of the Virgin in relation to the throne. Second, the artist has laid a dappled surface pattern by punching points into the Virgin's robe, her large nimbus, and the cloth stretched behind her. The entire surface is stippled, and the figure has become more ornamental than organic. The effect is that of a potent, non-material, solemn image. We see here a sculpture which has successfully departed from the tradition of classical art in order to suggest a transcendental reality.

Justinian was the last Latin-speaking emperor; his great desire had been to lead the Empire back to its former glory and return Italy to the Imperial domain. In 568, only three years after his death, the Lombards, a Northern people stronger than any previous invader, moved over the Alps and captured the peninsula. Ten years later they had a large portion of Italy under their control, and by the end of the century the kingdom of the Lombards was well established in Italy. They had come as conquerors and they resisted Romanization as no one had before. It took centuries for any real blending of race and culture to take place, and only in the eighth century do we find much evidence of Roman manners and language in the daily lives of the Lombards.

Thirty miles northeast of Aquileia is Cividale del Friúli. Under the Lombards it superseded Aquileia as the region's center. When the Lombard dukes took up residence, even the patriarchs of Aquileia moved to Cividale, and it was here that some of the best Lombard reliefs were carved. Altars and ciboria were done in an intaglio technique, adapting the designs which the Lombards traditionally used on fibulae, tomb ornaments, jewelry, and the various portable objects of a nomadic people.

By the eighth century, when the Lombards had become more firmly rooted in Italian soil, their art had developed to include both stone carving and the depiction of the human figure. One of the best examples is an altar apparently ordered by Ratchis, who became king in 744. It is unusual for a Lombard work because of the complexity with which the Christian narrations have been treated: the *Ascension, Visitation,* and *Adoration of the Magi* are each portrayed on a separate side. The way the scenes are depicted has its background in Byzantine art, but a comparison of a detail of the Madonna and Child (Fig. 45) in the Magi scene with the Madonna of the Grado reliquary lid (Fig. 44) shows how much farther we are from the classical tradition. The artist had no interest in showing bodies as organic or in portraying them by any system of proportions. He compressed the figures and the throne and floated them on the background, barely joining them to the patterned surface below. The cutting was shallow, but he incised his steady, even lines with great care in parallel sequences. The resulting rhythm—angular and awkward as it is—has real life. Further, compare the Madonna and Child with a Byzantine piece, a personified figure of Constantinople on a fourth-century coin (Fig. 46), which was the kind of image that served as a source for the scenes on the altar. The comparison emphasizes how intent the Lombard artist was upon describing shapes, separating the forms from each other, and working on the surface. The figures of the Ratchis Altar are more vivid and expressive than those of either the fourth-century coin or the Grado reliquary lid; the unusual faces held in bony pear-shaped heads, with enormous eyes set in thick lids, great triangular noses, and strange, slit-like, downturned mouths contribute strongly to this expressiveness.

In both the Grado lid and the Ratchis Altar the images of Mary and Jesus are intense and potent, but the Lombard work has a suggestion of a quasi-magical power. How did this kind of representation become so important in the religious art of a faith that had once feared graven images? The early Church shunned objects that might become idolatrous, yet by the late fourth century St. Augustine was speaking of his concern about Christians and their images (see p. 66). There are fifth-century tales of representations with magic power and sixth-century descriptions of the Faithful praying to pictures. The cult of relics also was established by the end of the fourth century; Christians believed that miracle-working forces resided in the bones and other physical remains of saints. They grew increasingly desirous to experience divine presence, and the image became for them a vehicle that could effect a meeting between the worshiper and the

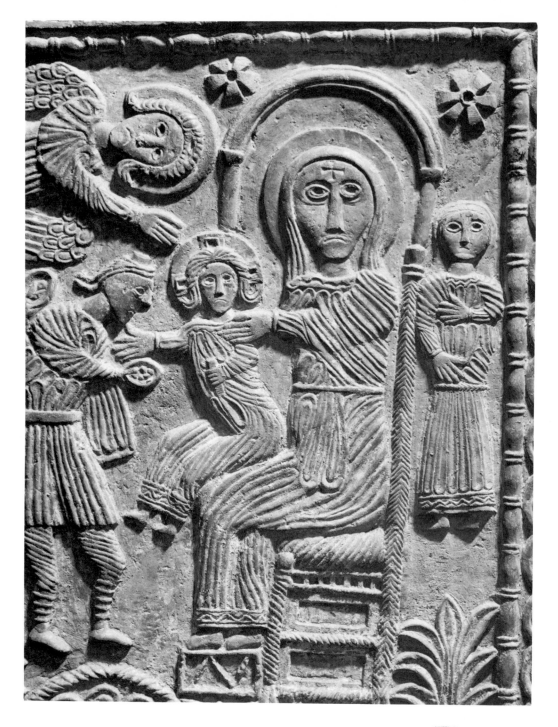

45. *Madonna and Child.* Detail from the *Adoration of the Magi* on the side panel of the Altar of Ratchis. A.D. 740's. Limestone. Duomo, Cividale del Friuli.

46. *Coin from Constantinople.* Reverse. Struck by Constantine to commemorate the dedication of the city on May 11, A.D. 330. Silver. Castello Sforzesco, Milan.

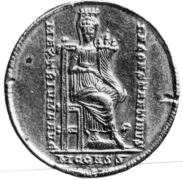

unseeable God. Such an image was usually a painting. A figure in the round was still too close to the pagan idol and not appropriate to the anti-corporeal, transcendent Christian quest. In time the traditions of carving and casting were all but lost, partly for this reason.

Strangely enough, it was a movement against images that provided the impetus for a theological formulation with a positive interpretation of the nature of images in Christian life. In the eighth and early ninth centuries the Eastern rulers of the Empire forbade the use of the figure in religious art. The seriousness of their attack on images inspired an equally serious defense of them. Those who formulated the response to the iconoclasts took their cue from the New Testament; they asked, "If Christ can not be represented, could he have really been human?" They showed that iconoclasm was in fact an attack on the whole doctrine of the Incarnation—Christ made human—the very basis of Christianity. Ultimately the defenders won, and images re-emerged with an even profounder significance for Christians. An image of Christ could be considered more than simply a reminder of the Incarnation; it had a special relationship with its prototype, and thus through it the believer approached God. A scriptural basis for the joining of prototype, image, and believer was readily available: "God created man in His own image, in the image of God created He him." The creation of man as described in Genesis had always been understood in some sense as a sculptural image, so we must recognize that the doctrinal basis for Christian sculpture owes much to the iconoclastic controversy of the eighth and ninth centuries.

As the sculpted image assumed a place again in Western art two themes were dominant: the Virgin and Child and the Crucified Christ, the representations of the beginning and the end of Christ's human life. The *"Essen Madonna"* (Fig. 47) is one of the earliest extant fully three-dimensional images of this subject in Western art. The piece was fashioned in the late tenth century in the Rhineland, a part of the old Frankish Empire where the social and economic structures had suffered somewhat less than they had in the Western territories (now France) from the invasions of the Northmen. The tenth-century Saxon rulers moved to unite the German peoples and to revive the idea of the Roman Empire, just as Charlemagne had tried to do in the eighth century. Otto I's system was to rule through a clergy which was ready to believe that in serving the Empire it served the kingdom of God. The men involved in this system had extraordinary power and were able to effect a revival of the arts. During the "Ottonian Renaissance," such sees as Cologne and Mainz (where the *Essen Madonna* may have originated) became thriving art centers.

A Madonna and Child sheathed in gold was truly a lavish image for a tenth-century person to behold. The sculpture suggests an origin within the best of cultural circumstances, yet the sculptor who made it worked in a time and place with virtually no history of sculpture. His patron must have supplied him with such riches as gold, enamel, and precious stones, and from them the sculptor made a work not carved in the old Mediterranean tradition but massed and assembled. First he shaped the pearwood core and then hammered and smoothed out the gold to articulate the bodies of Mary and Christ. As he laid the thin sheets one over the other and fastened them with small gold spikes the surface became a sequence of patterns in compressed relief and a lively, light-gathering sheath that is a rhythmic counterpart to the solid, simple cubic forms that compose the body. Because it is not simply a carved block or a modeled mass, something about the structure appears unclear, but weight and roundness are evident and we begin to have a sense of the somber monumentality Madonna and Child images were to assume in the eleventh century.

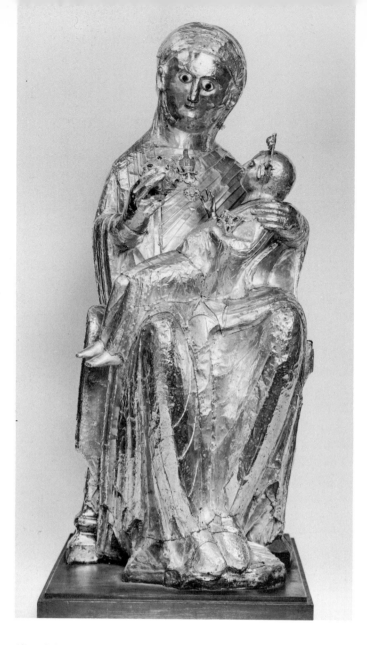

47. *Madonna and Child.* Late 10th century. Embossed gold, precious stones, enamel eyes, 20″. Essen Minster.

The *Essen Madonna* was a new kind of sculpture. It is a cult image but one whose meaning and purpose are not completely clear. Mary holds an apple; Christ stares at it with fixed gaze. She appears to be the new Eve, a sign of hope, a mother who has *remained* in the state of grace and through whom the Incarnation became reality. Christ is not solely the child Jesus; he holds the Book and is the "Word made man." Mary then becomes the Throne of Wisdom and mediator for the Divine Being. The sculpture is small (less than two feet high), of precious materials, and it has a hollow space in the bottom. These facts suggest that it might have been a reliquary—a container to hold something physical remaining from the earthly life of a holy person. If this is true, the work would have had much greater potency as a cult image, and the material preciousness of the *Essen Madonna*, the glow and dazzle of the light-reflecting surfaces, would have had the deepest symbolic significance.

Some of the most solemn, monumental, and finely crafted sculpture created in eleventh-century Europe was made by artists working in the German Empire. The powerful bishops

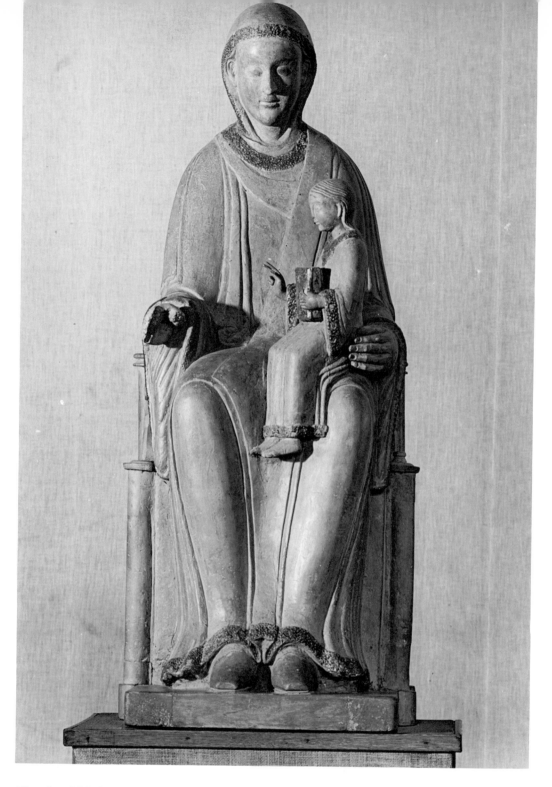

48. *Imad Madonna. ca.* 1060. Wood, formerly sheathed in gold, 44″. Diocesan Museum, Paderborn.

under the Ottonian emperors were avid art patrons. These men, who initiated far-reaching ecclesiastical reforms, gave their support to the building of churches, the collecting of relics, and the fashioning of beautiful objects.

Such a churchman, one Bishop Imad, lived in Paderborn, a rapidly expanding Saxon town. He commissioned a Madonna and Child (Fig. 48) for the cathedral some time after his

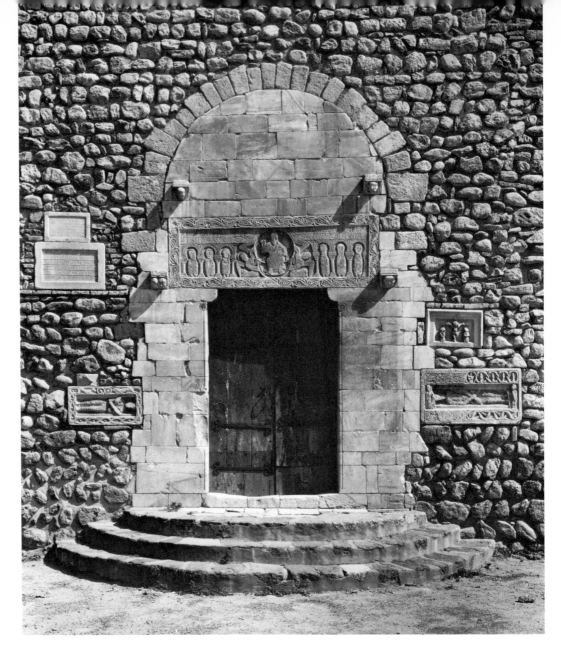

49. *Entrance portal of St.-Genis-des-Fontaines* (Roussillon).

consecration in 1051. The work shows how some of the conflicts regarding imagery during the past centuries were brought to a kind of resolution.

Like the *Essen Madonna*, the *Imad Madonna* was originally sheathed in gold. It is twice the size of the former and plastically more solid. The organization of horizontals and verticals, the symmetry, the parallel placement of figures and limbs, all give great clarity to the work. The geometrical shapes of the body forms are sharpened by the controlled sequences of relief patterns. From any angle, the profiles of the *Imad Madonna* are not only readable, but strong. The physiognomies of both Mary and Christ are vastly different from those of the *Essen Madonna*. The eyes are lowered and set back within the heads, in sharpest contrast to the enamel glitter of the bulging eyes of the Essen image. The tight, pursed, tense lips of Essen are now relaxed into slight, gentle smiles. The jerky gesture and halting movement of the *Essen Madonna* contrast strongly with the quiet dignity of posture, gesture, and glance of the Paderborn image. In place of mysterious magic we see new majesty.

50. *Christ in a Mandorla with Angels and Apostles.* Lintel. 1020–21. Marble. Detail of
Fig. 49.

The first three images of the Madonna and Child examined show the rejection of the ancient
Greek and Roman admiration for the human body. They are awkward and their proportions
irregular. Their attractiveness lies in their force as symbols, in their linear richness, and in their
material splendor, rather than in physical beauty. With Bishop Imad's Madonna, however, we
recapture the idea of a beautiful image because of the compelling geometrical ordering of forms,
the abstract rhythms, and the sensitive proportioning of all the parts, which puts this work in
closer relationship than any of the earlier Madonnas to classical ideas. Byzantine art may have
played an intermediary role in this. Earlier in the eleventh century Paderborn had become a
center of Byzantine influence when Eastern artisans and architects came to the city and taught
local artists. The effect of the Byzantine tradition on Western European art was a significant
factor in the consolidation of styles that took place in this century.

The eleventh century was a time of integration; migrations and invasions had subsided, and
European peoples found more successful ways of working together. The founding of the
Ottonian dynasty in Germany and the Capetian dynasty in France had brought new political
stability. Commercial activity opened up, the Mediterranean once again saw Western sea traffic,
and non-productive lands were brought under cultivation. Christianity became a vital faith for a
larger number of people than ever before. Nothing was more important than this for the new
monumental art. The number of people who took religious vows increased; monasteries grew,
intensifying their social and spiritual development through reform. Endowments to churches
and monasteries enriched these foundations. And people took journeys of faith—pilgrimages to
Santiago de Compostela in northwestern Spain to pray in the church that held the body of St.
James, or to Rome, that vast reservoir of holy remains. This spirit culminated in the Crusades to
the Holy Land, the greatest pilgrimage of all. Europeans were still mobile, no longer as
migrating tribes but as emissaries, merchants, and men of faith. Their society was constructing,
not simply shifting, and the finest expression of this consolidation was their buildings. Churches

in stone, with great variety in plan, methods of articulation, and ceiling structure, characterize eleventh-century architecture. The style was forceful and grand, expressed through powerful volumes and elaborate relief.

Architectural sculpture began awkwardly in areas such as Italy, northern Spain, and southern France, where there was both local stone and some vestige of a carving tradition. The earliest extant dated relief on a building is a marble lintel over the door of the small church of St.-Genis-des-Fontaines (Figs. 49, 50) on the north slope of the Pyrenees in the Roussillon. A large inscription tells that the relief was carved in the "twenty-fourth year of King Robert," which would have been 1020/1021. Robert was a Capetian, and politically the area was aligned with France. The proximity of the Roussillon to Catalonia, the northeastern region of Spain through which so many influences from the Moslem culture of Andalusia filtered into the Christian West, was equally significant, as we shall see.

The relief shows Christ enthroned in a mandorla—the almond-shaped light surrounding the Resurrected Christ—held by angels, and flanked by the Alpha and Omega, symbols for the beginning and the end. It was just as John spoke of him in Revelations. On either side of Christ, Apostles stand within the arches of an arcade. The large, hieratic figure of Christ is like the Pantocrator of the Eastern tradition—he is the all-powerful ruler of the universe. This became the central image of eleventh- and twelfth-century sculpture. The twelve Apostles are represented by only six. Although the carver made a limited effort to individualize them by varying hair style, beards, and gestures, he repeated the same expression from figure to figure. Immobile and solemn, the Apostles, like Christ and the angels, have big oval eyes and straight noses with firm, emphasized nostrils. Their mouths are formed of convex and concave arched planes, one above the other, that end in strong, downward oblique lines.

Inside the rectangular border the artist combined three elements—inscription, figures, and the enframing arches and mandorla. The placing of figures within an arcade was common in Eastern and Roman sarcophagi, but in those examples the arches served to create the space in which human figures could exist, while here the arches dominate the figures to the point of determining their shape. The horseshoe arches, colonettes, abaci, capitals, and bases are exactly like those found in marble tablets of the caliphs of Cordoba. Into the space left over in this sequence of forms borrowed from the non-figurative Moslem tradition the sculptor incised figures with identical silhouettes. The mandorla breaks into the inscription to provide the area necessary for the large figure of Christ. The most interesting part of the relief is the artist's treatment of the trapezoidal spaces between the mandorla and the nearest colonnettes: he activated the surface with the angels, centering their heads as hubs in a design of arms, wings, and bodies, outlined with pearling and subdivided into triangles, circles, and rectangles. The sculptor incised parallel grooves to delineate drapery, hair and wings. The area left between figures and borders is limited; here the sculptor scraped out a flat background plane to make a series of negative shapes—triangular and trapezoidal, echoing the patterns used for the figures. The relief is on two planes only: surface and ground, which are connected by the sharply cut edges of the forms. It reads as a series of flat shapes, side by side, divided by incised lines. This sculptor could not conceive of a relief as a succession of overlapping planes leading our eye into depth; he worked as if he were using a repoussé metal technique. Yet in his most inventive figures, the angels, he hesitantly went beyond the simple outlining of adjacent shapes, anticipating here the beautiful stratified planes of Romanesque sculptors. On the flat pleats of their forward arms and the feathers of their wings, he used parallel cuts perpendicular to the

surface instead of wide grooves and thereby developed overlapping planes that introduce a real relief sequence.

As architectural sculpture the relief of St.-Genis-des-Fontaines is modest but of considerable interest, for a stone lintel carved in the early eleventh century is rare. If there were no inscription we might think it was done later. But the way in which the artist has handled all his sources is consistent with the early date of the inscription, for they are not yet completely transformed and integrated fully into a new style. The shape and proportions are those of a sarcophagus. The arcade was used for centuries by designers of sarcophagi, but its form here derives from the Moslem tradition. And the squat, big-headed figures are like those executed by non-Mediterranean artists of the pre-Romanesque period. The theme of Christ in Glory is derived from Eastern iconography but its form resembles figures in the illuminations of Spanish Apocalypse manuscripts. The emphatic border with its vine and palmette motif is used in the spirit of the colorful borders found in Mozarabic manuscripts (works by Christian artists heavily influenced by Moorish forms). The effect of the whole, which would have been stronger still with the original polychromy, is of a bright decoration combining elements of the ornamental traditions of Eastern and barbarian cultures.

The St.-Genis relief, carved early in the eleventh century, anticipates the sculptural style being worked out in various parts of Europe in the late eleventh century. Many of the sources evident in the lintel were integrated into this new style, called Romanesque by nineteenth-century writers. The original sense of the term was parallel to that of the Romance languages—as they were vulgar Latin, so the buildings of northern Europe were debased Roman; today, however, we use the term simply to speak of the monumental art style that preceded Gothic.

Artists carved a fully developed Romanesque portal at the entrance of the abbey church of St. Fortunatus in Charlieu toward the middle of the twelfth century (Figs. 51, 52). The church belonged to the Benedictine congregation of Cluny, the most powerful monastic organization of the age. In 1088, six years before the consecration of the church at Charlieu, Abbot Hugh of Cluny had begun building the largest church in all Christendom; St. Fortunatus, only forty miles away, took its form within the shadow of Cluny.

The designer of the St. Fortunatus sculpture worked out a portal system in which all the parts are related to each other. It is quite unlike the lintel of St.-Genis, which was simply applied to the surface and bears little relationship to the size of the opening. At Charlieu the lintel, which is carved on both the front and the underside, runs the width of the opening and its adjacent jambs; the reliefs are continued above the next two sets of jambs, giving breadth to the doorway and integrating it into the fabric of the wall with each sharp step in the forward progression of planes. Above, each segment of the decorated arches corresponds to the door jamb below, and the whole ensemble becomes a rich frame for Christ and his companions. The decorative borders are just as important as at Saint-Genis, but the sources of the motifs and the way they are displayed varies considerably. Cluniac builders, especially in Burgundy, looked to classical sources, which were readily available both in Roman ruins and in early Christian sarcophagi. Motifs associated with the Roman Empire had great significance for a society that prided itself on its civilizing mission. Rosettes, palmettes, Corinthian capitals, rinceaux, and ribbon designs all appear in these borders.

The richness of Charlieu is further enhanced by the sculptor's use of new techniques. The twelfth-century artist had more varied tools available; he undercut his forms to a considerable

51. *Entrance portals of St. Fortunatus, Charlieu.*

degree and marked the joining of parts with a drill instead of by simple engraved lines of varying widths. The result was complex surface patterns of light and shade and varied textures. In spite of all the decoration the Charlieu door does not appear overabundant. The designer had a feeling for moderation, interspersing the patterned bands with flat, uncarved surfaces. As a decorative unit the Charlieu door is more harmonious and less intense than the small lintel of St.-Genis. This, too, reflects the classical approach of the Burgundian carver.

Although the arches and jamb reliefs of Charlieu are composed of classical motifs in measured arrangement, the impression given by the whole is anything but classical. The figures particularly are anti-classical. The theme here is Christ in Glory, shown with the Apostles as in the relief of St.-Genis, but now the idea is enriched and amplified at the same time that it is clarified. Not only is Christ borne aloft by angels, but he is shown as he was described by St. John in the fourth chapter of the Apocalypse—in the fullness of his power and glory surrounded by the "four living creatures." The scene is placed in the tympanum, the area enclosed by the arches above the lintel, which became the focus of the Romanesque façade. On the lintel the Virgin Mary is flanked by an angel on either side and shares a long bench with the Apostles, who are slightly smaller than the three central figures. The St.-Genis relief showed the Apostles and Christ in simple juxtaposition; here their relationship is more formal, and the enlarged view

52. *Christ in Glory with the Virgin Mary and the Apostles.* ca. 1140. Detail of Fig. 51.

of the Apocalyptic Christ in Glory also alludes to Christ's Ascension to Heaven. Mary and the Twelve are thus present as witnesses of the Ascension, and the angels holding the mandorla are posed as if engaged in action, further suggesting the Ascension. The lintel thus becomes a thematic as well as a visual transition between the worshiper standing in the door and the vision of God presented in the tympanum, for here we all become witnesses. Through such relationships showing the degrees of subordination to the Divine and through the use of symbols, the Romanesque artist was capable of making a didactic statement more complete than that of earlier Christian artists.

The individual figures in the tympanum do bear some relationship to the types in the St.-Genis relief. Their abstract forms are conceived as sequences of complicated patterns and the drapery is composed of ovoids and slender v's. But there are two significant differences from the St.-Genis figures. Since the Charlieu sculptures are undercut, bodies can be detached from the background; they have become plastic and powerful, far more substantial than the flat cutouts of the eleventh century. Wrapped in fantastic drapery, they push and pull against one another. A further change is the lack of reliance on external architectural divisions; the relationship between the figures is worked out dynamically with interlocking forms and diagonals in parallel sequences: the legs of Christ, the beasts, and the angels turn outward and echo the curve of the

53. *Jeremiah*. 1107–1110. Marble.
Cathedral, Cremona.

54. *Jeremiah* (?). 1120–1130. Stone. 59″.
St. Pierre, Moissac.

mandorla in the lower part; in the upper part bodies and wings of beasts and angels push inward toward the center. Tension and energy are the striking qualities of the Charlieu tympanum; its master worked in a style perfectly suited to his visionary subject. Another artist carved the lintel, one who admitted more repose—through the placement of the figures and the patterns created by their limbs and garments. But the contrast in style between the vision in the tympanum and the witnesses in the lintel introduces no discord in the unity of the whole.

The Charlieu portal shows a combination of elements particularly characteristic of twelfth-century Romanesque. The forms are more assertive, more plastic, than any sculpture created in the West since the sarcophagi of late antiquity, and the composition is more strictly organized and is better related to the architecture than any earlier ensembles of Christian sculpture. The figures are unnatural and abstract; yet the Christian could understand them and decipher the symbols without difficulty. The spirit and content of the carved images are made clear to us through rhythms, the controlled alternations in spacing, and the emphatic energy of the relationships.

In 1931, when comparatively few people had looked attentively at Romanesque sculpture, Henri Focillon published a remarkable book which has helped many to see better the forms of Romanesque art.[1] He emphasized the special relationship between sculpture and architecture, for he felt that it was particularly difficult for modern viewers to grasp this, since we have grown accustomed to seeing sculpture as a totally self-sufficient art form. Focillon pointed out that this was not a natural or a spontaneous relationship; rather, it was a question. How it was answered by sculptors and architects in different parts of Europe during the eleventh and twelfth centuries presents a complex study of endless variations within a given range of possibilities. The answers were always far removed from the classical ones that also used narratives and decorative accents on friezes, panels, and pediments created as special fields for sculpture. The medieval artist used sculpture as a life-giving force for the church building; he integrated his forms into the structure rather than applying them to neutral fields reserved for adornment. Monumental Romanesque sculpture is never freestanding; resistance to three-dimensional images was deeply ingrained. Architecture was always the superior force, holding the sculpture in check. The building established the limits, and the carved figures complied—turning, twisting, or standing frozen. But it was not just the "law of the border" which brought about the peculiar distortions we see in Romanesque figures. The Greeks had had any number of ingenious ways of realizing canonically proportioned figures in such awkward areas as pediment angles. But in Greek art the figures were conceived in space; in Romanesque art only the area matters, and we never lose sight of its limits. Focillon speaks of *l'homme chiffre*, cipher man, who can bend in any direction, enter into any combination. This was an unnatural order—one that presented the figure as symbol in the visionary telling of superhuman events.

Compare two figures of the Hebrew prophet Jeremiah (Figs. 53, 54). Both were planned for church entrances, a fitting place for the prophet who told of a new covenant and thus bore witness to Christ's entry into the world. The first was made for the cathedral of Cremona during the first decade of the twelfth century. Cremona was one of the emerging communes of central and northern Italy which boasted a commercially successful middle class. Her citizens decided to build up the center of the city, and they began in 1107 with a new cathedral. The master carver must have begun work on the marble slabs flanking the entrance shortly thereafter. He carved four prophet figures (Jeremiah, Isaiah, Daniel, and Ezekiel), two on each side, one above the other, rigidly perpendicular. The *Jeremiah* is one of the lower figures. The four figures, very

similar in style, are carved out of the marble blocks that serve as door jambs. These blocks determine their shapes as compact rectangles, with only heads and feet emerging beyond the confines of the rigid outline. By stressing the flatness and verticality of arms, feet, scrolls, and repeated folds, the sculptor created thoroughly architectonic forms. The style is very direct; simple spaces are rhythmically repeated between crisp zigzags of drapery folds and linear plaits of hair. Though the trunk and limbs of man's body are not represented, the body's power is expressed through the strong shapes of head, hands, and feet. The faces are geometrized more than distorted, with broad, rigid planes and solid forms for the cheeks, ears, noses, eyes.

At St.-Pierre in Moissac another *Jeremiah* (Fig. 54) stands, like the Cremona prophet, at the entrance to the church. (The words once painted on his scroll have been washed away, so his identity is not entirely certain.) The figure is carved on the side of the trumeau—the stone post supporting the door lintel at its mid-point—so the pilgrim must turn as he enters in order to face the prophet directly. *Jeremiah* gazes down intently as he unfurls his message for the visitor.

In contrast to the severe Cremona portal, the Cluniac abbey church at Moissac has a grand entrance with an enormous carved tympanum, decorated archivolts (the arches around the tympanum), a florid lintel of lacy rosettes, scalloped-edged jambs, and panels with narrative scenes. Probably the trumeau was one of the last surfaces to be carved. It was done in the second quarter of the twelfth century to replace an earlier one; the rich, elegant carving and figure style speak of the sureness of the accomplished master working in a well-established tradition. The trumeau is a great monolith but it is hard to think of it as primarily an architectural support because it is so deeply carved and so covered with figures. The front decoration consists of superimposed lions and lionesses whose pointed noses and tails re-create the scalloped pattern of the jamb. The concave sides form the narrow frames into which figures of the prophet Jeremiah and the Apostle Paul have been squeezed. Although the figures are locked into this frame, they are not in any way overwhelmed by its restricting limits. Their body proportions are extreme in length and thinness; it is not just proportions that contrast so sharply with the work of the Cremona master, however, but the whole manner of presenting a plastic figure as an expressive vehicle. The Moissac *Jeremiah* is possessed by a strange and delicate corkscrew movement: his head is bent, the tresses of his hair fan out over his shoulders, his right shoulder is lost behind the form of the top-most lioness, and his right hip pivots as his right leg crosses over the left. We can not exactly say that he crosses his legs because the movement appears to be something that happens to him more than something that he does. The Moissac *Jeremiah* is a more plastic figure than that of Cremona, and though the forms are thin, they are rounded, and the drapery patterns are more three dimensional through the use of deeper carving. The plasticity is further emphasized by the figure's placement on the side of the trumeau so that in this darkened area the contrast between shadowy pockets and light-capturing surfaces is heightened. The surface becomes at once delicate and alive. Again unlike the Cremona figure there is an elegance in the anatomy and in the thin, clinging drapery, and a richness in the complex hair patterns and jeweled decoration on the tunic. Both figures are forceful, but the earlier work, consisting of broad planes and simple, abstract features, made a steady, direct statement; the Moissac *Jeremiah*, with his expressive face set on the strangely moving body, enters into the delirious state of the visionary.

In the work of these two twelfth-century sculptors we find different solutions for single figures, each bearing a particular relationship to its setting. Equally important in Romanesque ensembles are narrative scenes. A lucid telling of the story of "Doubting Thomas" (Fig. 55) was

55. *Doubting Thomas. ca.* 1100. Marble. Pier of the cloister, Monastery of Santo Domingo de Silos.

worked out by a master at the Castilian monastery of Santo Domingo de Silos late in the eleventh century. At that time, in the aftermath of Moorish withdrawal from the region, Silos was experiencing a period of rapid growth, and its population was being significantly increased by Gascon immigrants from southern France. The monastery housed the body of its own abbot, Domingo, whose recent canonization made it worthy of a pilgrim's visit.

56. *West façade of St.-Gilles-du-Gard* (Gard). Detail.

The church has been destroyed, but the cloister and its remarkable capitals and corner piers remain. The most complete scene, on the northwest pier, shows Thomas putting his finger into Christ's side while the rest of the Apostles look on. The scene is enclosed in an arch which is carved with crenellations and thus turned into the battlements of a city. This contemporary setting acts both as background and as frame. The figures appear to be in front of the frame, though this is not entirely clear. Though he allowed occasional ambiguity in the structure, the artist was very concerned with clarity in the narration. He isolated the main participants, Thomas and Christ: by the bend of his head and the thrust of his arm, a Christ of superhuman size defines a place in which Thomas can reach out and touch him. Their figures are injected with stronger rhythms than the others; for the rest the artist emphasized horizontals and verticals, repeating shapes, gestures, and expressions. This regularity gives the scene an ordered calm unusual in Romanesque narrative sculpture. At first glance it seems that the continuous axis formed by Christ's long body and the figures of the Apostles above establishes an asymmetrical composition. But the figure of St. Paul is used to give the composition a center; unlike the bodies of Peter and Andrew (the Apostles at the right in the front row), Paul's body extends in various directions: the head is turned left toward Christ, the upper torso is frontal, and the lower portion is turned toward the right. His unfurled scroll and pensive face with heavily wrinkled brow and tightly curled beard also vary the formulae used for the other Apostles. Iconographically, as well as formally, his presence is a foil for the narrative. Meyer Schapiro has pointed out that Paul was the only one in the group who was not present when Christ revealed himself to Thomas, and that Paul did what Thomas did not—he believed blindly, having never seen Jesus.[2]

Usually overlapping figures create a sense of space. In the Silos relief the second row of Apostles are full-length figures with their feet showing in the narrow spaces between the figures of the first row. And yet the effect is spaceless. It remains a beautiful Romanesque surface design dependent on zigzag patterns, crisp drapery lines, and strong silhouettes.

The angular shapes, the silhouettes, the ornamental surface, and the absence of space here make a combination characteristically Romanesque, but it is not the only possible one. In Provence, Romanesque sculptors approached relief in a very different manner. A large number of fine Roman monuments survive in this part of southern France, and these were very

57. *Peter, Malchus, and the Guards at Gethsemane.* Detail of a frieze showing the Life of Christ. Second quarter of the 12th century. Marble. St.-Gilles-du-Gard.

important to the Romanesque tradition that developed there. This is evident on the west façade of the Cluniac church of St.-Gilles-du-Gard, whose three broad portals resemble the openings of a triumphal arch (Fig. 56). Sculptors came to this center from various parts of France in the twelfth century, when St.-Gilles, near the Mediterranean port through which the crusaders passed and a station on the pilgrimage routes to both Rome and Compostela, was at the height

of its prosperity. The workshops where the large figures of the Apostles, the narrative frieze, and the tympana were carved were places where styles and ideas were exchanged throughout the first half of the twelfth century.

A long frieze with scenes from the Passion extends the width of the façade. To the right of the lintel over the main door the betrayal of Christ in Gethsemane is depicted; part of the relief shows the approach of the guards and the moment when Peter cuts off the right ear of Malchus, the high priest's servant (Fig. 57). The body proportions are different from those of any other Romanesque figures we have looked at. The limbs of the short figures relate naturally to the rest of their bodies; the shoulders are broad and the feet seem almost to bear the weight of their bodies. Although again the size of the figures was determined by an architectural area, in this case the sculptors were working within the format of a long classical frieze, and the proportions of the figures and the space in which they exist are in accord with the classical tradition. The first row of overlapping figures has been set diagonally into the relief space without concern for silhouette. But the second row becomes awkward. The soldiers seem to be gasping for breath rather than pressing forward to see Judas identify Jesus. Even in Late Antique reliefs, when artists showed little concern with classical concepts of space and filled out their groups by back rows of bodyless heads pressing in from behind (for example, in the Lateran sarcophagus, Fig. 43), there was not the kind of tension in grouping figures in overlapping rows that we find in this frieze. Here gifted sculptors were struggling for a mode of expression even as they were absorbing influences from extremely diverse sources.

The St.-Gilles Frieze conveys a physical sense of the human body in a manner not found in the sculptures of Cremona, Moissac, or Silos. We see it not only in the proportions and space but in the roundness of the bodies, in the rendering of the garments both to cover and reveal the forms underneath, and in the representation of explicitly conveyed gestures—grasping, holding, cutting, flexing. How different this is from the Silos relief, where physical touching is shown tenuously, though it is central to the narrative. At St.-Gilles each figure is developed individually, especially the facial expressions—Peter's controlled concentration on his own victim, Malchus's pain, the soldier's brutish stolidity, and the shock and fear of the guard (at right in Fig. 57) who sees that Judas has actually led them to Christ. In spite of the repetitious lining up of figures and the rhythmic modeling of the drapery, we see here that it was possible for Romanesque masters to portray individuality, to put forms in space, and to diminish stress on surface patterns.

The Romanesque style was international; forceful regional styles arose simultaneously in many centers across the European continent. When another style began to be formed, it first appeared quite specifically in a limited geographical region: in and around the Ile-de-France in northern France. Here sculptors shaped a new kind of figure and changed its relationship to the building. We call this style "Gothic," a word Renaissance humanists had used when they wanted to express their disdain for the arts of earlier Northern cultures. The term "Gothic" was applied to painting and sculpture only in the nineteenth century when its previous use as a synonym for barbarism was more or less forgotten.

The most important and beautiful sculptures in which we can see the new style emerging are at the cathedral of Chartres, where the west façade, damaged by fire in 1134, was rebuilt and its great portal (called the Royal Portal) was decorated between *ca.* 1145 and 1155 (Fig. 58). The façade decoration looks different from Romanesque works, but not unfamiliar. Each element can be found on earlier portals—three entrances; monumental figures on the jambs;

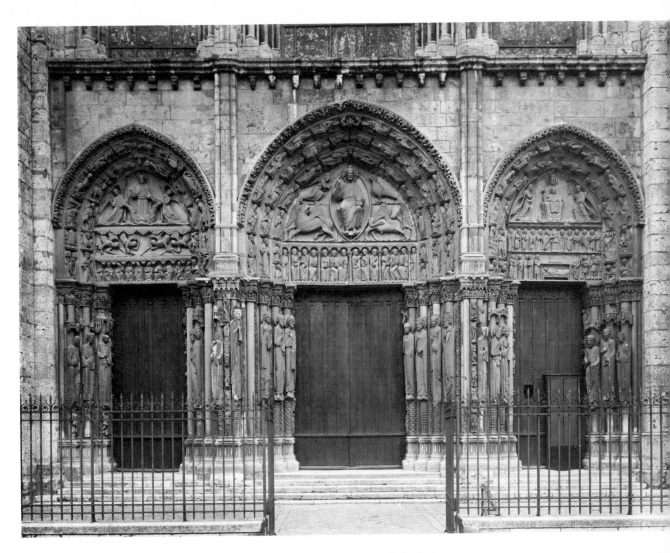

58. *Royal Portal. ca. 1145–1155.* Limestone. West façade, Chartres Cathedral.

sculptured tympana, archivolts, and lintels. But the general appearance is unlike that of the great Romanesque entrances in its compact and harmonious integration of sculpture and architecture. If we compare the Christ of Revelations in the tympanum and the Apostles on the lintel of the central door at Chartres with the same composition on the roughly contemporary Charlieu portal (Fig. 52), we find that the terrible and brilliant tension of Romanesque has been replaced by spaciousness, simplicity, and a new plastic quality. The relationship of the figures to the surface of the wall is altered. Forms are not shown as flat, sharp, parallel planes but are organic and full, and in substantial contrast to the background. The portals seem deeper. Human forms replace angular decorative bands in the archivolts and soften the transition from the exterior wall to the tympanum's flat background plane, just as the figures on the columns below establish a gradual progression inward to the opening door.

These column statues, representing the ancestors of Christ, are the most significant forms on the portal (Fig. 59). They begin a monumental sculptural type that is central to the development of Gothic sculpture. What makes them so different from the Cremona prophets—not just in style, but as sculptural types? They, too, are frontal, rigid, insistently vertical, and carved of the same material as the building they adorn. But the Cremona prophets were carved from blocks that are part of the fabric of the building, while the Chartres figures are

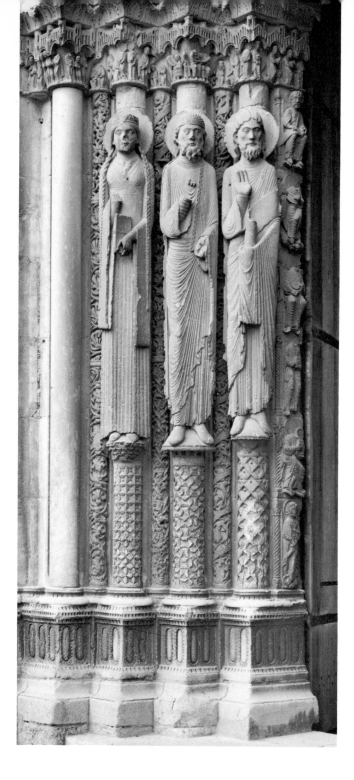

59. *Old Testament Kings and Queen*. Detail of Fig. 58.

attached to the front of the building columns. They resemble the columns, and in that they are architectonic; but they are round and curving in a way that makes them appear quite human. Thus they fulfill dual roles—as images of Christ's ancestors and as visual supports in an architectural system.

At Chartres one presence stood out among the many sculptors and stonecarvers at work there: this was the Head Master who was responsible for the column statues and the tympanum of the central doorway. His style is remarkable for its quiet perfection; though his column statues are the most outstanding component, they do not draw attention away from the whole.

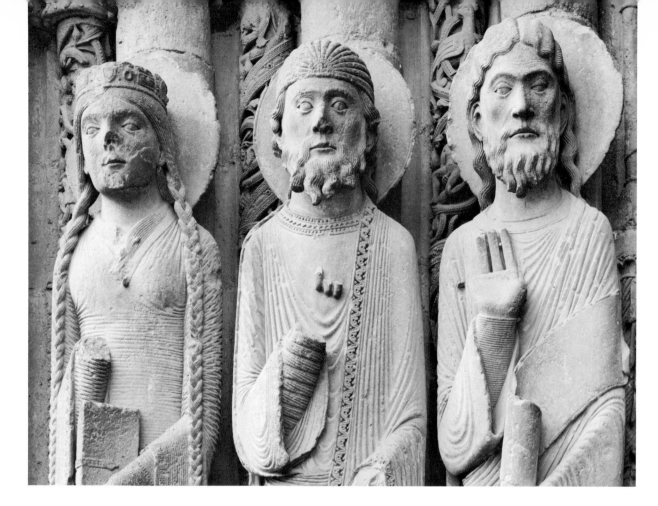

60. Detail of Fig. 59.

A new kind of synthesis is evident in the Head Master's style. The King and Queen of the central portal show an extraordinary degree of refinement. Drapery is thin, rhythms altering subtly without the sharp and measured distances between folds seen in Romanesque sculpture. The folds become part of the fabric. All the surfaces are simpler, less ornamental and textured than those of Romanesque figures. Proportions are as long and thin as those of the Moissac master, but the tension is gone; these monarchs are the essence of serenity. And even though they are extremely formal, with blocky heads set squarely on rectangular bodies and very restrained gestures, there is something deeply human about them. This is particularly evident in the broad, almost fleshy faces with closed eyes held in prominent sockets and gentle responsive lips (Fig. 60). Almost imperceptibly these hieratic figures make visible an interior life.

Artists at Chartres worked in different circumstances from their counterparts at Moissac, Charlieu, and St.-Gilles. The church was not attached to a monastery nor was it a station on a pilgrimage route. It was an intellectual center, and its cathedral school was among the best of twelfth-century Europe. The studies of its schoolmen were central to the Platonic revival and the reconciliation of Plato's metaphysics with Christianity; they worked out an interpretation of man in his physical world more coherent than that of any previous generation. This is the climate in which the Head Master developed his lucid, serene concept of the human image.

The figures of the Royal Portal initiated a century in which sculptors sought a more human image, one free from the earlier Christian concept of man's "evil" body. So startling and powerful was this new approach that one scholar has spoken of the "re-awakening in the twelfth century of the incarnational aspect of the image of man. . . ." [3]—that is, a renewal of the sense

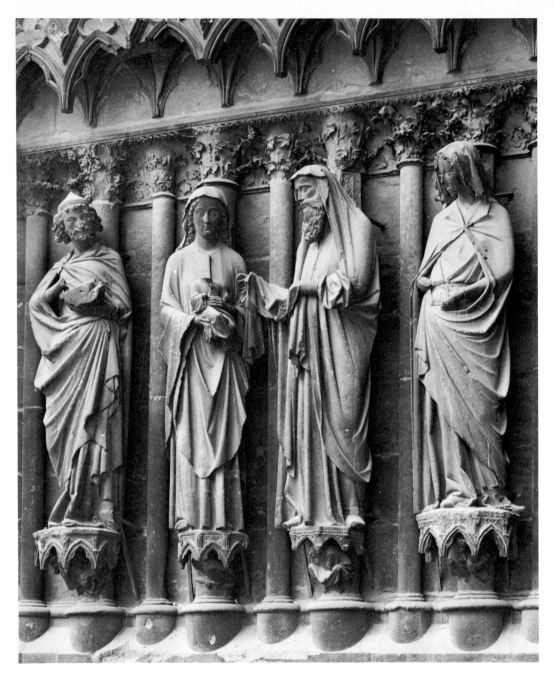

61. *The Presentation of Christ in the Temple. ca.* 1230–40. Limestone. Central portal of the west façade, Reims Cathedral.

of a divine spirit alive in human form. This progressive unfolding of a more humanized image was at its most vital and consistent in the Ile-de-France, the area around the royal domain, a region that until this time had been without much sculptural tradition. The best parallel to this systematic search for a new figure type in twelfth century France is to be found in sixth- and fifth-century Greece.

A number of factors contributed to this exceptionally dynamic probing: the security afforded by a strong monarchy under the Capetians, whose administration was better organized than any France had ever known; the economic prosperity that came with expanded production and trade; and the growth of urban centers, which in increasing numbers acquired the status of free

commnes. The intellectual life of the cities quickened. Scholastic thinkers of the thirteenth century, seeking to give Christian truth a more rational and human expression, moved from Plato to Aristotle, whose writings were gradually being translated; their approach became increasingly logical and systematic. It was a kind of "mental habit" (in Erwin Panofsky's words[4]) that affected both builders and artists, arousing a passion for clarification and systematization. The sculptors of the cathedrals worked in close collaboration with various architects, moving from project to project as the individual towns initiated building programs. With each move a sculptor became the bearer of a style that would affect his new setting.

The four major sculpture workshops of the first half of the thirteenth century were at the cathedrals of Chartres, where the transept portals were designed and decorated between 1205 and 1230; Paris, whose west façade was carved during the reign of Philip Augustus (d. 1223); Reims, rebuilt after a fire in 1210; and Amiens, also burned and built up again beginning in 1218. In all of these buildings forceful plastic figures were disposed to the left and the right of deeply splayed entrances. Often the jamb figures related to each other in a narrative situation rather than acting as immobile witnesses in the manner of Early Gothic figures.

On the west façade of Reims Cathedral, to the left of the central entrance, is the scene of *The Presentation of Christ in the Temple* (Fig. 61). Mary and the Christ Child face the High Priest Simeon, who extends his hands covered with a cloth to receive the Child. The relationship of the figures to the architecture is different from that of the column statues of Chartres West. The architectural surface and membering is more spacious and spread out; there is a rhythm of major and minor columns lining up across the deep embrasure. The broad column statues, attached to the larger columns, accent this alteration, and the width of their bodies give a horizontal definition to the whole area. Their feet take a broad stance on the platforms, bearing down with their full weight. Their movements are slow and quiet; their gestures and the inclination of their heads are enough to establish spatial relationships between the figures. The drapery is distributed rhythmically across the figure, but the linearity of the drapery of the early statues at Chartres has given way to thick, voluminous folds, broken only occasionally with an angular pleat. The Reims faces have not changed to the same degree as the bodies, but they have become less stony, more flesh-like, and some new details are rendered, such as Mary's cleft chin and Simeon's wrinkled brow, which add life to the narrative. These figures retain the serenity and restraint of the Chartres sculptures, but they are more clearly defined as self-sufficient human beings who are distinct from the cathedral.

At the cathedral of Amiens the builders began with the west façade. They literally covered it with sculpture. There must have been a very large workshop there in the 1220's and 1230's; after that, most activity on figure sculpture was suspended. The final stages of building the transept and choir were carried out after a fire in 1258. Then another shop opened, and the sculptors of this group carved the figures and scenes on the south transept entrance in the 1260's (Fig. 62). This entrance has always been known as the "Portal of the Vierge dorée" because of the Madonna on the trumeau whose robe was once brilliant with gilding.

The portal exemplifies a situation not uncommon in large Gothic architectural-sculptural complexes: it was begun according to one idea, completed according to another, and includes statues left over from an earlier project. Even cursory study reveals awkward joinings and strange proportional relationships, such as that of the tympanum to the lintel and that of the Madonna on the trumeau to the weightier, larger clerics and angels on the jambs. In spite of irregularities, thirteenth-century designers had a way of unifying an ensemble with moldings and spiky decorative outlines that make the whole coherent. The proportions of the south portal

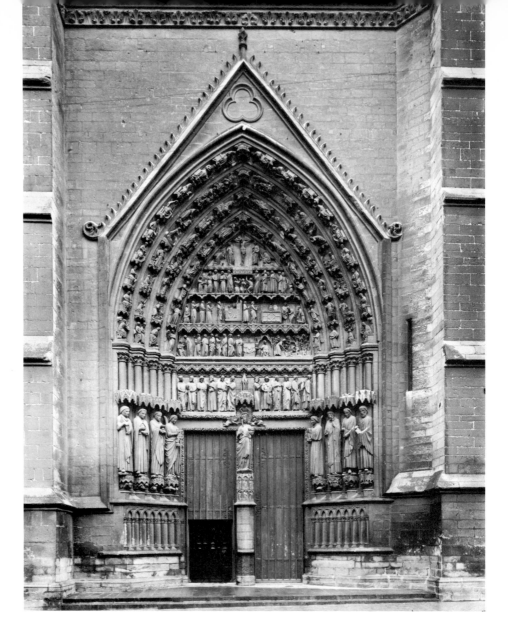

62. *Portal of the Vierge Dorée.* Between 1259 and 1269. Limestone.
South transept entrance, Amiens Cathedral.

decoration are tall and thin, quite different from the broad, spreading effect of the west façades of both Amiens and Reims. This is a later phase of the Gothic style.

What we see in the tympanum are the miracles that took place in the life of St. Honoratus, bishop of Amiens in the late sixth century. This honor bestowed on a local saint was a characteristic thirteenth-century choice. The cultivation of local legends and heroes was an outgrowth of the evolving personalization of the Christian experience, as well as of the growing sense of regional and national identity. The more readable the stories were, the more significance they had in this context. The designer of the tympanum must have had some awareness of this when he composed it, setting off space for the figures in four broad zones divided by the powerful borders. He emphasized the center of the tympanum by the placement of figures and furnishings, and in the lower zone he split the narrative in two parts, left and right. The space, the proportions of the figures, the ease of their movements, the numerous homely details, all contribute to the sense of a lively telling about the miracles of Honoratus.

63. *The Vierge Dorée*. Detail of Fig. 62.

Most of the figures are carved individually, undercut enough so that they stand out from the background. Even so, the sculptor did not lose the sense of the surface: his figures and the narrative props (altars, arcade, coffin) are parallel to the surface with no play of illusionistic diagonals or overlapping.

The twelve figures on the lintel, also carved during the 1260's, are larger and portrayed more individually than the tympanum figures. They are the Apostles, shown in pairs as though conversing. The scene is usually interpreted as the gathering before the Apostles' departure on their missions throughout the world. It is unique and it has unusual details, such as the Apostles being shod when usually they are barefoot (does this relate to the journey ahead?). No matter what the exact subject, the artist was totally taken up with the problem of showing, yet differentiating, twelve very similar figures engaged in the same activity. The Apostles move out with lithe, supple grace (their feet even extend over the lintel edge); they gesture with controlled animation, shift, nod, and glance at each other's pinched, elegant features. It is an extremely lively, though somewhat mannered, scene.

On the trumeau is the Madonna and Child (Fig. 63). St. Honoratus probably should have been there but that design was changed. The *Vierge dorée* was placed on an earlier base and

under an earlier baldachin, the canopy sheltering her and the angels holding her halo. She is a most gracious Queen of Heaven. Such representations were related to a century-long search for a truly human ideal in the person of the mother of Christ. Twelfth-century theologians had pondered the important questions about her nature—whether she had come into the world free of original sin, and whether she now resided bodily in heaven. But for the thirteenth century she was co-redemptress: as Christ had redeemed in his Passion, she had done so through her compassion and understanding. This image had great popular appeal. The new image also responded to contemporary understanding of the temporal ruler, of his kingdom, queen, and court: the king ruled by divine right as Christ ruled in heaven. The reign of Louis IX (1236–70), a man of both extreme piety and power, appearing to be the perfect Christian king, gave substance to the merging of the two myths. The *Vierge dorée*, imbued with human warmth and royal splendor, was deeply rooted in these beliefs.

If we compare the *Vierge dorée* with the jamb figures on either side (sculptures that remained from the earlier workshop at Amiens), we can see the new proportions and the formula of the Late Gothic figure style. The Virgin is slighter and her head is smaller. The stability of most High Gothic figures, such as the jamb figures and Mary and Simeon at Reims, has given way to movement. The axis of the body turns into an open "s", with the head inclined so that the mother can look at the child. He rests on her left hip, which is thrust out and emphasized by the piles of heavy mantle folds caught beneath him. The distended arc of these folds continues to form the lower segment of the "s". This drapery, which creates the movement around and across the body, is deeply undercut, with sharp ridges and angular breaks along the Madonna's right side and at her feet, where the heavy stuff piles up upon the base. The face has always attracted attention. The short veil falls softly away to make a spacious frame for her unusual features: crinkled, almond-shaped eyes, sharply arched eyebrows, and a steady, almost enigmatic, smile. The features, drapery, turning body, and gesture combine to give the image of an assured and graceful sovereign; it is fitting that three attendant angels should be very busy with a jeweled halo.

The feminine tenderness and regal beauty radiating from the *Vierge dorée* delighted nineteenth-century enthusiasts. They were particularly sensitive to it because of the dozens of exaggerated and anecdotal versions of smiling, "s-curved" madonnas created in the wake of the *Vierge dorée* during the fourteenth century. And though the nineteenth-century critic John Ruskin called the Amiens Virgin "a Madonna in decadence," he knew it was for reason of "her prettiness, and her gay soubrette's smile . . . ," and he took pleasure in both. He believed she anticipated the fourteenth century, when people "devised a merrier faith for France, and would have bright-glancing soubrette Madonnas everywhere." [5] The fourteenth century was not quite that merry. It is true, however that several thirteenth-century sculptors, especially the masters at Reims, Paris, and Amiens, provided models of the mother of Jesus that satisfied the spirit of the time, that responded to a growing notion about a new ideal of womanhood. The widespread devotion to Mary was the highest expression of this feeling. Fourteenth-century sculptors continued to elaborate the thirteenth-century vision in a way that is comparable to the effect of Praxiteles' *Aphrodite of Cnidus* in antiquity. They took up the theme and repeated it in endless variation: many of the images are decorative and superficial, but some enrich the theme in a truly marvelous way.

One of these was carved late in the fourteenth century for the trumeau of the Chartreuse of Champmol, the Carthusian monastery near Dijon (Figs. 64, 65). It is the work of the

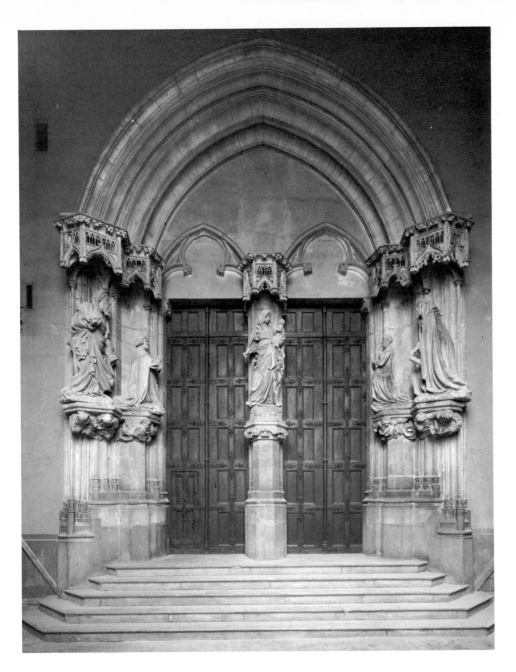

64. CLAUS SLUTER. *Portal of the Chartreuse of Champmol.* Late 14th century. Limestone. Dijon.

Netherlandish sculptor Claus Sluter (active *ca.* 1379–1406), who went to Burgundy in 1385 and worked at this charterhouse founded two years earlier by Philip the Bold. Philip was one of the new princely patrons who emerged during the fourteenth century. These secular lords were assuming the role previously held by churchmen and their patronage was on the most lavish scale. Philip as art patron competed with his nephew, the king of France, and his brothers, the dukes of Berry and Anjou. Such a prince was profoundly conscious of his position as ruler of a vast domain, and of his enormous authority. In his court high artistic standards prevailed; this in itself was attractive for the exceptional artist, but even more important to him was the recognition given to the individual creator. Thus, we now find ourselves speaking about specific artists rather than anonymous masters.

65. CLAUS SLUTER. *Madonna and Child.* Detail of Fig. 64.

The whole ambient of Sluter's work at Champmol indicates a new sensibility. Philip built the Chartreuse as a burial place for himself and his family; its decoration was a personal matter. Jehan de Marville, the Flemish sculptor who had been Philip's official *imagier* since 1372, began working in 1384 on the Duke's tomb and on the entrance to the church. He planned five over-lifesize figures: on one side of the portal, Philip and his patron saint, John the Baptist, and on the other, Philip's wife, Margaret of Flanders, with her patron, Catherine; both groups faced the Madonna and Child on the trumeau. The "Presentation of the Donors" had been a popular theme in fourteenth-century painting, and churches bearing stone portraits of rulers were not unusual. Jehan combined two traditions and integrated his invention into a new concept of the portal. But it was Claus Sluter, successor as *imagier* and *valet de chambre* to Philip after Jehan's death in 1389, who carved the figures and gave the whole program its dramatic content.

In making the *Madonna and Child* (Fig. 65) the focal point of this highly personal and monumental scheme, Sluter converted a traditional, almost worn-out theme into one of the most moving images of the later Middle Ages. If we compare it with the *Vierge dorée* we find that the whole scheme has been set in motion—the open "s" has become a serpentine movement in space; we recognize that a real body—cinched waist, swelling breasts, a large foot pushing over the edge of the base—tugs and moves under the fantastic sweep of voluminous drapery. The medieval sculptor, with his reticence toward the human body, had long been expressing his sense of rhythm and design primarily through draperies. Sluter excelled in this tradition, creating a splendid display of countless deeply undercut folds turning and twisting—mantle, veil, and gown, each distinct—in unbroken movement. The spiral doubling back of drapery ends cascading from the Madonna's hip and the intricate pressed folds under the feet of both the Madonna and the Child add to the insistent linear beauty, which is very clear in the profiles that change with each shift of view. The humanity of the Champmol Madonna is particularly clear in the face, with its broad features, high forehead, full oval cheeks of soft skin-textured surfaces. The Child, too, is fleshy and natural, and the height of the drama comes in the exchange taking place between Mary and Jesus. The position of his body on her arm is both an answer to and an echo of the line of her body, and it is elaborated by the serpentine folds of his long robe. But at the same time as he responds he also opposes her with all the power of his small body, twisting about, thrusting his chest up and his head back. The meeting of their glances is strong and serious. There is none of the gaiety of the *Vierge dorée*. Sluter chose to represent with greater realism a psychological state, a feeling of intensity, almost anxiety. The restlessness of the drapery, the sharp backward thrust of Christ's head, the brusque swing of Mary's arm, reinforce the feeling. The combination of exquisite virtuoso richness and penetrating realism in the monumental works on the Champmol portal are the key to the style that Sluter and those around him worked out in the court of Dijon. It was the most inventive and powerful sculpture style to be created in Europe in the late fourteenth century.

France, with universities and cathedral towns, a troubadour's language, and a generally rich culture, was the most advanced and sophisticated place for an artist to work in at the beginning of the thirteenth century. During the same period in Germany, Spain, Italy, and the Low Countries most of the best artists were still carving Romanesque images, and they did not share the spirit of progressive change that was evident in French art late in the twelfth and early in the thirteenth centuries. Part of the reason lies in the absence of political and cultural unity in the other regions. In Italy, where warring popes and emperors dominated political life, where

alliances were hurriedly built and then severed, there was so much fragmentation that no dominant direction appeared in the visual arts during this period when the Early Gothic style was flourishing in France. This situation began to change in the middle of the thirteenth century, not as a result of political factors or of new church patronage, but because of the artists themselves; they began to work out personal solutions and to exchange ideas and to teach each other. This happened first in Tuscany, and there, during the second half of the thirteenth century, we can for the first time follow the careers and monuments of a few sculptors known by name.

Nicola Pisano (active 1258–78) begins every chapter on Italian Gothic sculpture. A few decades ago he was seen as the single-handed initiator of a magnificent classical revival that culminated in the work of Michelangelo.[6] Today his work does not seem to be such a radical departure from earlier thirteenth-century Italian sculpture as it once did. In the south, working at the court of the Holy Roman Emperor Frederick II (d. 1250) at Capua, there were artists who showed a finely developed classical style and who used extremely plastic forms: masters from the Eastern Latin Empire working at the baptistery in Pisa carved a lintel with the most elegant classical forms; sculptors in Lucca displayed the ability to fashion big, firm images; and Guido da Como carved a pulpit in Pistoia in the 1240's in which he combined classicism with a fresh and clear narrative style. When Nicola Pisano made his pulpit for the baptistery in Pisa (dated 1260), he worked in a style that was not alien to the creations of these Romanesque masters; however, his forms and the way he assembled them are so distinctive that we must recognize in them a new vision.

Documents concerning Nicola's life are few, but two of them speak of him as a Southerner—"Nicola de Apulia"—and his work reveals knowledge of the gifted classicizing sculptors who worked in the court of Frederick II in the south of Italy. When he moved to Tuscany around 1250 he was immediately in contact with another prominent group of modern sculptors. He chose to settle in Pisa, a city whose political loyalties were compatible with the climate from which he had come, for Pisa was loyal to the Imperial cause. Frederick died in 1250; Pisa must have been in mourning when he came. Further, she was a proud community, only beginning to realize that at that moment she was losing her position of leadership in the region. During the twelfth century Pisa had been the most vital center of art in Tuscany; the scale and richness of the works were related to the city's position as a maritime and commercial leader. But even in her economic decline (Florence forced her into a treaty in 1254 by which the inland city was able to use Pisa's port without custom duties) Pisa's tradition of impressive artistic programs continued, and in the middle of the thirteenth century Pisans were busily furnishing their twelfth-century baptistery. Guido da Como had finished the font in 1245, only shortly before Nicola came to design the pulpit.

Certain surfaces of church furnishings were often treated as fields for carvings and given great importance in Italian churches. Significant sculptural work is more likely to be found on a pulpit in Italy than at the church entrance. In this respect it is interesting to remember it was in Italy that clergymen first began to preach in the vernacular and that members of the new thirteenth-century orders, the Franciscans and the Dominicans, vied with each other in giving popular sermons. In the modern Italian church every eye was to be directed toward those raised lecterns where Biblical truths were made available through image and word.

Nicola planned his pulpit as a monumental freestanding hexagon raised on columns, three of which rest on lions' backs (Fig. 66). His new way of combining traditional elements was

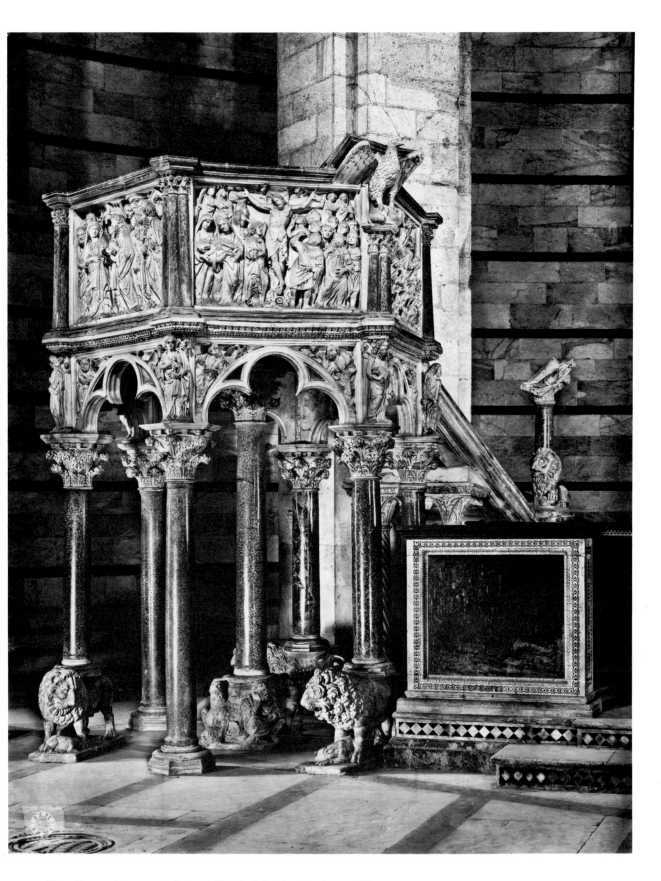

66. NICOLA PISANO. *Pulpit.* 1259–60. Marble. Baptistery, Pisa.

67. NICOLA PISANO. *Adoration of the Magi.* Detail of Fig. 66. Marble, 33½".

complicated, but the result was lucid: the narrative scenes were carved in oblong panels divided
from each other by small clustered columns and supported by cusped trefoil arches born by the
polished marble columns. The scenes represented are the *Nativity, Adoration of the Magi,
Presentation in the Temple, Crucifixion,* and *Last Judgment.* The *Adoration of the Magi* is the
simplest scene with the fewest figures (Fig. 67). Their enormous bulk is packed into the
rectangle so that no area remains uncarved. It is a very different kind of relief space from that of
the Amiens tympanum, where the active little figures were cut away from the ground and ample
space was opened up above the heads and around the bodies (Fig. 62). Nicola followed a
completely different principle. He related the figures to the height of the panel, making them as
large as possible so that an implied space resulted from their volume and placement. In this
respect Nicola's relief has more in common with the Romanesque lintel at St.-Gilles than with
the contemporary relief at Amiens. Both the St.-Gilles master and Nicola had learned from
Roman monuments in which they had seen solid figures overlapping in planes across the entire
surface of friezes and sarcophagi. The *Adoration of the Magi,* in fact, shows Nicola's study of
the *Sarcophagus of Hippolytus and Phaedra,* a second-century Roman work which had been
reused in the middle ages as a tomb for Countess Beatrice and is still to be seen in the
Camposanto of Pisa, near the baptistery (Fig. 68). Nicola's figure of Mary was inspired by

68. *Sarcophagus of Hippolytus and Phedra.* Second century A.D. Marble. Camposanto, Pisa.

the large matronly figure of Phaedra seated in front of a temple, and Hippolytus' horse was the source for the Magi's mounts. More important than the specific relationships is the fact that the comparison makes evident the new way in which Nicola revitalized the spirit of classical sculpture: he took the large dignified forms and established them in vital tension within the limits of a rear and frontal plane. Northern European sculptors of the thirteenth century, particularly at Reims and Chartres, had also been fascinated by classical sculpture, but they were most interested in contrapposto, movement, and drapery; Nicola, on the other hand, concentrated on the heavy forms and rigorous construction. The composition here depends on two great pyramids—one formed by the Magi, the other by the Madonna and Child—which balance each other, with Joseph and the horses serving as lateral foils and the angel as a link between them. The narrative is effective, not only because the composition is clear and the bodies powerful, but because the faces—with polychromed eyes and features framed by the vigorously worked hair—have a concentrated intensity.

When comparing Nicola's carving to that of his Northern contemporaries, material and technique are important factors to keep in mind. He worked in marble—probably from the nearby Pisan mountains—an entirely crystalline stone, different from a stratified stone such as limestone in having the potential of being carved in any direction. Thus it offered Nicola far greater flexibility than limestone offered the carvers of northern Europe. We are not sure exactly what kind of chisels he used, but we do know that the tempering of tools gradually improved during the thirteenth century and they became sharper, better instruments. Nicola used his tool broadly, carving wide angular runs and swaths to make the thick voluminous folds. He is outstanding in the second half of the thirteenth century for his assured carving. This accomplishment also involved the study of antique works. Using a drill technique similar to that used in Roman reliefs, he pushed into the hair, beards, nostrils, mouth-corners, and manes to create the expressive flicker of light and shade that we see on the luminous marble surfaces.

Nicola Pisano's position as an innovator remains unchallenged, even if we recognize that earlier Italian sculptors had been interested in bulky forms, readable narrative, and classical types. His powerful figures, which are imbued with an authentic humanism, are unsurpassed in terms of their strength by the work of any other medieval sculptor.

Nicola's son Giovanni (*ca.* 1250–died after 1314) became a sculptor no less original than his father. He grew up in the midst of Nicola's marbles, going with him to Siena when he was still a young man to help on the pulpit his father carved in that cathedral. (For Siena, Nicola worked out a second, more elaborate scheme with seven narrative panels using smaller, livelier figures in scenes that have great emotional impact.) From this training Giovanni developed a capacity to combine powerfully structured human figures in movement with a strong sense of personal psychological existence. These qualities became particularly evident in the sculptures for the exterior of the Pisa baptistery and for the façade of the Siena cathedral (executed during the 1290's).

69. GIOVANNI PISANO. *Adoration of the Magi.* Detail of Pulpit. 1298–1301. Marble, 33″. S. Andrea, Pistoia.

In 1297 Giovanni received his first commission for a pulpit, for the church of S. Andrea in Pistoia. The commune of Pistoia near Florence had come partially under the control of her powerful neighbor as a result of a recent civil war. Giovanni worked there for four years during this critical period.

In the general organization of the pulpit Giovanni followed his father's schemes, but he gave his work a more vertical appearance through slender proportions. There are five narrative panels, as in the Pisa pulpit, and four of the subjects are identical with Nicola's. But for the peaceful scene of the *Presentation in the Temple* he substituted the tragic *Massacre of the Innocents*, which Nicola had already introduced among the panels for his Siena pulpit. A comparison of Giovanni's work in Pistoia with Nicola's in Pisa is startling, revealing the great difference in their aims. Two things are most striking about Giovanni's *Adoration of the Magi* (Fig. 69)—the dramatic turbulence of the scene and the multiplicity of incidents; Nicola's *Adoration* is majestic, and it is focused on a single event. Giovanni put the kings and the Holy

70. *Adoration of the Magi*. Detail of Fig. 69.

Family at the top of the panel so that there would be room for the secondary narratives—one angel instructing the sleeping Magi not to return to Herod, the other angel warning Joseph to flee with his family into Egypt. The moment in the narrative differs slightly from that in Nicola's Pisa relief (though not from his Siena relief). The eldest king has already presented the gift and kisses the Child's foot: the tender homage gives the scene a touching warmth (Fig. 70).

Giovanni also gained space for the multiple narrative by using more slender figures than Nicola's, and by treating the illusionary space of the panel as a larger entity. And he synthesized as well as separated the scenes: Nicola had used massive, erect bodies parallel to the frame and tightly grouped; Giovanni, however, wanted something less static, and he distributed the figures over the whole surface at the same time that he built a readable narrative. No figure is self-contained; each relates to another, to a group, or to the whole through rhythm and movement. The Virgin and Child bend to the old king and their movement initiates a diagonal that flows down his back across to the sleeping kings in the lower left corner. This diagonal is intersected by a similar diagonal flowing from the hand of Joseph (asleep at lower right) through the contours and draperies of the sleeping kings and up through the body of the gesticulating angel. The Holy Family is unified by the architectural panel behind them; at the same time Mary and the Child form a triangle with the kneeling king, while he is linked to his companions as one of them repeats his gesture and the other moves forward. This responsive chorus of gestures and rhythms is found throughout the panel.

The treatment of surfaces enlarges the emotional quality of Giovanni's work beyond that of his father's. He carved shadowed areas into deep voids, creating strong contrasts with the light falling on the adjacent areas that project. Although he was extremely able and carved elegant passages such as we see in draperies and gestures, much of the carving is harsh, particularly in the details such as the thick fingers, beak-nosed faces, and strange furrowed outlines around the lower figures. Giovanni's surfaces are uneven because of the different degrees of undercutting. And the contrasts created by these deeply undercut forms against the background would have been intensified by the colored glazes that originally covered the ground.[7] Further, the draperies were edged in gold and the crowns were gilt, in the manner of thirteenth-century French ivories. Historians have speculated on Giovanni's knowledge of French sculpture, since his slender, active figures and his expressive undercutting are closer to work done in the French tradition than to anything in contemporary Italy. If he did not actually travel to France, then it must have been imported small works like ivories that brought him knowledge of the new Northern style.

In spite of the elegant embellishments, Giovanni's work is less decorative than Nicola's, and his portrayal of the human body is far more forceful and legible than his father's. True, Giovanni's bodies are less massive, but where in Nicola's work is there such an understanding of thighs and elbows, bellies and backs? Giovanni felt that with the Pistoia pulpit he had outshone his father; the inscription at the base of the pulpit reads: "Born of Nicola, but blessed with greater science, Pisa gave him birth and endowed him with learning in visual things greater than any seen before." [8] Giovanni's sense of his own worth was in keeping with the growing esteem of the artist as an individual. Beyond that, he had an extraordinary sensitivity to strong emotions and to suffering. We find it revealed throughout the *Adoration* panel in the glances and gestures, as well as in the very idea of changing a traditional scene of homage into one combining delicate devotion with anxiety and leave-taking. Much more than Nicola, Giovanni created a sense of human encounter.

The pulpits of the Pisani are unique. No one ever did anything quite like them again, but narrative sequences of Biblical scenes on fonts, altars, and building exteriors were important in fourteenth-century Italian sculpture, just as in contemporary mural and panel paintings.

The first major relief series of the fifteenth century was the second pair of cast bronze doors for the baptistery in Florence. Pisa's great rival did not really emerge as a center of cultural and artistic activity until the fourteenth century, although the developing myth of Florence as destined for greatness in all endeavors was already current in the thirteenth century and was generally accepted by its citizens in the fourteenth century. Florentines regarded their baptistery with enormous pride. Here they could pay homage both to their Christian patron saint, John the Baptist, and to their Roman heritage, for they believed that this great octagonal edifice, which was built in the eleventh and twelfth centuries, was on the site of a temple of Mars at the center of the ancient Roman city of Florentia. The building was maintained for the commune by one of the wealthy guilds. Through their patronage the mosaics of the dome were finished in the early fourteenth century; the sculptural groups—to be the largest in Florence—were commissioned for over its entrance; it would have the first decorated cast bronze doors in the city before the middle of the fourteenth century, and a rich silver altar before it ended. The first bronze doors were finished by Andrea Pisano (no relation to Giovanni) in 1335; talk of a companion set began two years later, but it was not until 1401 that the guild proceeded, and in an unprecedented way: they announced a competition. This method of securing the best work, used in antiquity, was appropriate to the spirit of the time in Tuscany, where the citizens of Florence, Lucca, Pisa, and Siena strove competitively for excellence in many aspects of their lives.

Seven artists submitted trial pieces to the *Operai*, a committee of thirty-four acting for the guild. They chose a young, relatively unknown artist who had been trained as a goldsmith and a painter—Lorenzo Ghiberti (1378–1455). He signed a contract late in 1403 and then began to expand his stepfather's goldsmith shop to make a large foundry where many assistants could work on the enormous project.

Ghiberti followed the scheme Andrea Pisano had used in the earlier doors for the life of St. John the Baptist. For each of the two panels he planned ten scenes from the life of Christ above four seated figures, each figure and scene placed within a quatrefoil (a four-lobed frame). The *Adoration of the Magi* (Fig. 71) was one of the earliest completed, in 1410. The scene of the Holy Family resting within an arcaded structure as the kings approach with their entourage is extremely elegant in comparison to the two reliefs of the same scene that we have already looked at. This quality is enhanced by the exquisite gilt surface. The easy movement of the slender figures is complemented by the swinging circles of drapery, and the features are tiny and faultless. The softly modulated arabesques and the sequence of unbroken linear rhythms that rise and fall throughout the scene are characteristic of Ghiberti's early style.

Ghiberti had a particularly refined sense of composition; here he balanced two groups of figures: eight on one side, three on the other. The three figures of the Holy Family adequately offset the throng of visitors, for their presence is enlarged by architecture. The groups are linked by movements flowing from the figure of the aged king kneeling before Christ; his gesture, cradling the foot of the child, is the focus of the narrative and figures to the right and left gaze at this point.

Ghiberti was faced with the problem of how to set the entire scene in this unusual quatrefoil shape: with rocky ground, architecture, and curving, rhythmic bodies he succeeded in filling and

The text visible in the image: **TII · FLOREN** ... **TINI ·**

71. LORENZO GHIBERTI. *Adoration of the Magi.* 1404–1410. Gilt bronze, 20½″ x 17¾″.
Panel of the north door of the Baptistery, Florence.

complementing the frame. And he was fascinated by the problem of creating illusions of space within the shallow physical space of a relief. In order to achieve this extension in depth, he placed the arcaded structure at an oblique angle, massed the figures of the royal entourage so that they stand behind one another. He also built up the ground and figures to extend in front of the frame. (As Ghiberti modeled in wax, this was easier to achieve than it would have been had he been working in marble, as Nicola and Giovanni had.) This extension of the scene both in front of and behind the quatrefoil makes the relationship to the frame extremely complex.

More than a century separates Ghiberti's doors from Giovanni's pulpit. What does a comparison of the two *Adorations* show us? Giovanni told his story with enormous tension, suggested in the shapes of his figures, their forceful features, and their exchange of glances and gestures. Ghiberti concentrated on a single event, making a simpler, more readable narrative. His melodious rhythms and refined detail are in striking contrast to Giovanni's work. His greatest originality is in the treatment of space, in providing an architectural setting and subsidiary figures to suggest extension in depth, a gentle ebb and flow moving between the front and rear planes.

Looking at the panels of the north doors of the Florentine baptistery, we recognize the tradition from which the scenes emerge. During the first decade of the fifteenth century Ghiberti did not make a radical break with his predecessors when he designed the individual panels. If we compare them to earlier works—to the forceful, deeply felt narratives of Romanesque and many Gothic sculptors—we find their heritage, but we are forced to see an easing up of the medieval intensity: the miraculous events of Christ's life are clearly and gracefully related in the twenty panels, but they are not invested with that quality of the marvelous. We can read them in human terms alone.

"To me was universally conceded the glory without exception. At that time, after long deliberation and examination by the experts, it seemed to all that I had surpassed every one of the others."[9] Ghiberti wrote this about the competition in his autobiography, the first by an artist. It marks a beginning. Ghiberti's first doors for the Florence baptistery also may be seen as introducing a new chapter in the history of art. They were cast in bronze, a technique we associate more with the Early Renaissance than with the Middle Ages, and they were assigned to the artist through a competition, a method that recognized individual merit in a manner unheard of in the medieval period. But it was not until he executed a second set of doors for the baptistery, the doors that have come to be known as the "Gates of Paradise" (1424–52), that he totally synthesized a more natural view of the world with the ideas of Christianity. It was such a synthesis that became fundamental for a new period, a new style in art, and a new image of man.

What harmony of limbs, what shapeliness of figures, what figure, what face could be or even be thought of as more beautiful than the human?—thus when those ancient and most wise men became aware of this, they dared to portray the gods in the likeness of man, and many of our own religion, imitating their remains, wished to paint God in the image of man in certain basilicas of the apostles and martyrs and other saints in order to help rude and ignorant men in some way toward divine contemplation.

Gianozzo Manetti, *The Dignity of Man* (1452–53)

FOUR
Renaissance Sculpture

Spirit and Form
in the Human Figure

In Greek and Roman antiquity the similarity of a god's image to man was not questioned. A partial acceptance of this physical likeness continued in Early Christian times, but the Fathers of the Church saw the relationship of man and God as primarily spiritual. The Christian found he was most like God in mind and spirit, and so dematerialized the images he made of himself. Later, in the High Middle Ages, as physical existence again assumed a more meaningful place in man's view of the universe, he came to value his own human frame more, until finally he sought to create an organic image fusing the ideas of his body and his spirit. With the Renaissance—the cultural movement that grew in Italy during the fifteenth century, when Western man's self-consciousness and self-affirmation were at their most intense—he found another way to demonstrate that he was created in the image and likeness of God.[1] Man most resembled his creator through his ability to shape himself and his world. To create an image accurately representing his own body and to do it in a beautiful form became a sacred task for Renaissance man.

As man became surer that it was he who determined what took place in the earthly portion of God's universe, he was more able to concentrate on building a secular society. The underlying ideas of this society were articulated by the Italian humanists, who defined the intellectual disciplines of the time and established the *studia humanitatis*, the study of man and his achievements, as a worthy alternative to theology. Florence, now wealthier and more powerful than her neighbors in Tuscany, was the city where the new culture first became manifest. It was Florence, whose vernacular tongue was chosen as the model for formal Italian speech and whose milieu provided a real experience of urban life, that attracted the majority of humanists. The historian Leonardo Bruni was the first to speak clearly of Florence's special position:

> . . . the *studia humanitatis* themselves, surely the best and most excellent of studies, those most appropriate for the human race, needed in private as well as public life, and distinguished by a knowledge of letters befitting a free-born man—such *studia* took root in Italy after originating in our city.[2]

72. Lorenzo Ghiberti. *St. Matthew*. 1419–22. Bronze, 8'10". Or San Michele, Florence.

Bruni recommended that man's energies be directed to studies that dealt with his own existence. He and his contemporaries wanted to analyze every aspect of man's nature in order to arrive at a new vision of themselves. In this context sculpture had an important role to play. During the first quarter of the fifteenth century more audacious steps in the portrayal of man's image were taken by sculptors than by painters. As Charles Seymour has pointed out: "The primacy of sculpture in early fifteenth-century Italy was no accident." [3] The sculptor, after all, was working in the round in nature's own space.

In Florence the most exciting new sculpture was being carried out at two sites: at the Duomo—on its façade, on the fourteenth-century campanile (the bell tower) adjacent to it, and at the baptistery across the street—and at Or San Michele, a fourteenth-century guild hall where the major guilds were erecting statues to their patron saints. Communal and guild patronage of the arts was at its height during this time. The leading sculptors at both sites were

73. DONATELLO. *Prophet*. 1415–20. Marble, 6'4".
Opera del Duomo Museum, Florence.

Lorenzo Ghiberti and Donatello (*ca.* 1386–1466), and the single most important sculptural problem that concerned them during the second decade of the century was the creation of a monumental religious image that would be self-sufficient though related to a given architectural setting. The images they created were decisive steps away from Gothic art, and their reliance on classical antiquity was indispensable in their formulation of the new Renaissance style. Yet the solutions of these two artists—men fairly close in age who had already worked together between 1404 and 1407 when Donatello was an assistant in Ghiberti's shop—were vastly different.

A comparison of two statues (Figs. 72 and 73) shows this. In 1415 Donatello received a commission to carve two marble prophets for niches in the campanile beside the Duomo. Sixteen niches had been planned by Andrea Pisano and eight had already been filled with figures

by the middle of the fourteenth century. The identities of these prophets have been lost, but for the 1415 commission Donatello executed one bearded figure (Fig. 73) and one unbearded one, finishing them both by 1420. At the time Donatello received the commission he was recognized as a highly gifted young stonecarver; his reputation depended primarily on the marble statues he had executed for the exterior of the Duomo and for the niches of Or San Michele (where he worked on a *St. George* at the same time he was carving the campanile prophets).

During these years Ghiberti was working on his last panels for the baptistery doors and on another important commission for the Guild of the Calimala—a bronze statue of their patron saint, John the Baptist, for Or San Michele. Decades spent working on the doors had made Ghiberti the leading expert in bronze work and a natural choice for the Or San Michele commission. Yet even for him an over-lifesize bronze figure was a new experience; nothing like it had ever been done in Florence. The *St. John the Baptist* was finished in 1416, a fairly showy, extravagant piece of work. Three years later, in the spirit of competition, the bankers' guild contracted with Ghiberti for an even larger bronze, a statue of their patron saint, Matthew (Fig. 72).

It is important to bear in mind when we compare the figures of Donatello and Ghiberti that they were made to be seen from different vantage points. Donatello's *Prophet* was intended for a third-story niche of the campanile, high above eye level; the Or San Michele niches are at street level and Ghiberti's *St. Matthew* was to be viewed close up. Some of the most innovative aspects of Donatello's statue resulted from the compensations and adjustments he made because of the figure's placement at a great distance from the spectator. Today this is difficult to understand; the *Prophets* were removed from their niches in 1940 and placed in a museum, where most photographs of them have been taken.[4] Originally Donatello's *Prophet* appeared in a foreshortened view. The observer looking up from the street could not see the right foot at all and only the sole of the left one. From the level at which we see the figure today, much of the drapery's depth has been lost; turning back on itself three times, the mantle was undercut in such a way that one could see beneath each separate edge as it stood out against dark shadows.

The different perspectives from which the two statues were to be seen is only one aspect of their dissimilarity. Ghiberti's *St. Matthew* was conceived as an extremely organic and unified whole; the suave movement and curvilinear draperies echo the soft, swinging series of diagonals that fall in a graceful sequence down to the saint's right toe. In the *Prophet*, however, Donatello wanted a more angular and blocky image: instead of unifying his figure, he created two distinct areas through his handling of the drapery—in the upper part the drapery is used to give the figure great breadth, while in the lower thick vertical folds strengthen the supporting aspect of the legs. The lack of unity between the upper and the lower parts is strong enough to cause some scholars to wonder whether the more rigid lower part might not have been carved by one of Donatello's assistants. Ghiberti's *St. Matthew* is taller than Donatello's figure by more than two feet. The added height was required by the niche, but the proportions favored by the artist emphasize this difference between the two statues: Ghiberti emphasized a long, leggy look while Donatello's figure is stocky. This contrast extends to other aspects of the statues as well. In the *St. Matthew* there is a sense of ascending movement—in the flexed knee and the gesture of the hand away from the body with the elbow held high; the *Prophet* stands firmly rooted to the earth by his large left foot at the corner of the base. The arms pressed close to the chest add to the compactness of the figure. Donatello draped his figure in thick stuff, while Ghiberti's figure wears a thin, fine robe. All the details of the *St. Matthew*—anatomy, drapery edges, and

sandals—are in fact elegant compared to the roughness in corresponding parts of Donatello's figure. This makes sense in view of the varying distances at which the two works were intended to be seen, but it is also consistent with the opposing styles of the two sculptors. Ghiberti worked surfaces with much more variety and carved the head in greater relief—the hair, eyebrows, and beard stand out fully and are richly worked. Donatello sought cohesiveness, keeping the beard and hair close to the head, using the chisel in the most cursory way in broad areas of the prophet's flowing beard.

What counted for Donatello was strong and powerfully expressive shape. Ghiberti favored solemnity and eloquence, but as in the doors of the baptistery, the figure is not overly expressive. The bankers who commissioned his *St. Matthew* were surely proud of this beautiful image; Ghiberti gave them a completely new type of Evangelist, gracefully garbed and standing in partially gilded splendor. Nevertheless, it was a somewhat abstract type of figure. Donatello's *Prophet* was a solid stone figure whose individualized physiognomy endowed it with a psychological component quite absent in the *St. Matthew*. The *Prophet* foreshadows his later, more famous campanile figures, the *Zuccone* and the *Jeremiah*, in which the realism was so unprecedented and marvelous that many contemporaries interpreted them as being actual likenesses.

The heads of Donatello's prophets have often been compared with Roman portrait busts, while Ghiberti's *St. Matthew* has been seen as a reflection of Greek and Roman orator figures. Specific classical prototypes have not been suggested for either, but there is evidence of both sculptors' interest in and study of Roman monuments during the second decade of the fifteenth century.[5] The humanists put great emphasis on the style in which ideas were communicated; when they turned to the ancients they looked for forms that were relevant to what they wanted to say. This is how Donatello and Ghiberti proceeded. And quite naturally, since sculpture was the figurative art of which the greatest number of classical monuments survived.

The use of different media is one of the most evident contrasts between the work of Ghiberti and Donatello until 1420. Ghiberti was one of the best modelers in Florence, had a superb casting technique, and maintained his own foundry; Donatello, though he learned to cast in Ghiberti's workshop, had always been hired as a carver of stone. In the 1420's, however, Donatello received important commissions for works in bronze, beginning with one for an over-lifesize statue of St. Louis for the tabernacle of the Guelphs at Or San Michele. In his early marble work Donatello had consistently shown his concern with physical description. He was able to pursue this interest further in bronze sculpture, since it depended on building up a surface in an additive technique, thereby allowing for continual improvement and enrichment. From this time onward the bulk of his work was in bronze and his concern with textural qualities never subsided. This interest is readily apparent in his bronze *David* (Figs. 74, 75).

No fifteenth-century statue was more astonishing than Donatello's *David*—this nude statue that you could walk around; no one had made anything like it for more than a thousand years. So more is the pity, then, that there is no document to tell of its origin—nothing of the circumstances of the commission, or the patron, or when it was made. The first reference to it, in 1469, establishes that *David* adorned the center of the courtyard of the new Medici Palace, which had been begun in 1444. Most scholars now agree that this was not its first home, that Donatello had created it earlier—in the 1430's.[6] Its placement in the Medici courtyard, however, indicates something about its innovative character, for it was meant to be seen from all sides. Here, as in antiquity, is a lifesize statue conceived completely independent of architecture.

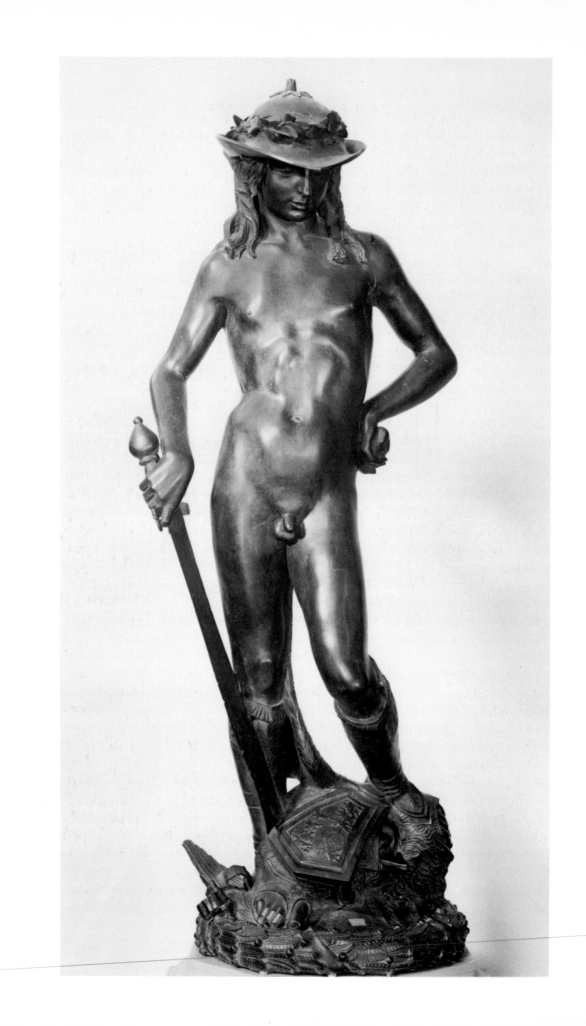

74. DONATELLO. *David.* 1430's. Bronze, 5'2¼". Bargello, Florence.

75. DONATELLO. Detail of Fig. 74.

More surprising is the nudity. Instead of choosing a subject in which the convention of the naked body was established—Adam or St. Sebastian, for example—Donatello chose an Old Testament prophet who had never before been depicted in this manner.

Early in his career (1408) Donatello received a commission for a marble statue of David for the Duomo. In that version he conceived of David as a youth wrapped in a cloak and holding a sling, with Goliath's head at his feet. The young David, the victor, rather than the old David, the Psalmist, was a new concept. At some point (probably in 1416, when the work was moved to the seat of civic authority, the Palazzo della Signoria) it became a symbol of Florentine patriotism, and an inscription was added: "To those who bravely fight for the fatherland the gods will lend aid even against the most terrible foes."

Donatello's later bronze is quite unlike the marble statue. It is a strange work: the sculptor fused a self-conscious portrayal of a nude youth with the image of a boy dressed in elegant apparel—broad-brimmed hat with laurels and high, tight-fitting, ornate, open-toed boots. David's weapons—the long blunt sword and the small stone in his left hand—do not look as if they have been used. And for a hero who has just emerged victorious from a deadly battle the features of the face are remote and expressionless. This in itself is unusual for Donatello, who had a reputation for skillfully rendering features with great individuality and expressiveness. At David's feet is the head of Goliath. At first it looks like a mere prop lying on the splendid wreath at the base; but the helmet has an almost macabre, sensual relationship to David's body: the giant's long mustache flows over David's toe and the organic-looking wings of the helmet softly caress the whole inner surface of the youth's thigh. David lowers his head, his face cast in the hat's shadow, but does not look at his victim. His reflective manner suggests extreme emotional distance.

Nothing about the statue seems to refer back to the idea conveyed by Donatello's earlier marble version—David as a proud national hero. He is no longer the young victor in a contest wherein the odds were against him, but is now an introspective youth contemplating the beauty of his own body. No one has satisfactorily interpreted the iconography of Donatello's bronze *David*, though every scholar recognizes it as both unusual and complex. One thing is clear, however: Donatello wanted to make a statement about the beauty of the human body. When the English art historian Sir Kenneth Clark looked at Nicola Pisano's nude *Fortitude*, done after a Roman Hercules, on the pulpit of the baptistery at Pisa, he noted: "What is lacking is the belief in physical beauty. . . ." [7] It was not until Donatello's time that the perception of man's body was completely revised. The descriptions of man's appearance and his ability to experience sensual pleasure made by the Florentine humanist Gianozzo Manetti (1396–1459) argue against the medieval notions of man's physical poverty and are elegant testimonies to the new concepts (see p. 108). To Pope Innocent III's dictum in which nudity and poverty are equated he replied that it was "necessary for man to be born nude for the sake of fittingness and beauty" (Trinkaus, 256).

Donatello had gone in 1432 to Rome, where he had ample opportunity to study ancient statues. Most scholars agree that he had some antique source to aid his conception of David (searches for specific sources have not been fruitful). The harmonious proportions, the Polyclitan stance, and the generally classical air would seem to confirm this; however, close study shows how different the *David* is from its ancient predecessors. The body is not idealized but is a particular type of adolescent body with a slender torso, shoulder blades protruding in the rear, and soft, small breasts swelling in front. The whole body is in fact a curious combination of

angular projections and rounding, sensuous curves. Both the design and the modeling are more fluid than in most comparable ancient figures. The *David* is also a more complicated figure, with a rich, continuously changing silhouette. The spatial compartments resulting from the relationship of the arms to the trunk and of the legs to each other are more interesting as shapes than is usual in antique statues and are completely new for the Renaissance.

When Donatello combined in his *David* a classically proportioned body type with elements taken from a specific live model, he had created a perfect exemplar of the ideas of his friend Leon Battista Alberti (1404–72). Alberti, a Florentine humanist and architect, was the principal art theorist of the Early Renaissance. His treatise *Della statua* was the first theoretical writing on sculpture. In it he described a modular system for measurement to determine the proportion of the parts and the contours of the human body. Like Polyclitus he sought a canon through which the artist could see and project an ideal beauty. At the same time he strongly emphasized that an artist should work from nature, that a sculptor should not be without a model. He was to start with the individual, the particular, and by means of a mathematical ratio bring unity to the total form. It is uncertain when Alberti wrote *Della statua*, though it was probably after Donatello cast his *David*.[8] However, he must have been formulating the ideas contained in it during the early 1430's—years when he was in contact with Donatello in both Rome and Florence.

The *David* has always been recognized as a spectacular figure of great innovative quality—bronze, freestanding, nude, imparting a new image to an Old Testament prophet. It is difficult to imagine the effect it must have had on the Florentine humanists and artists of the mid-fifteenth century. It was not really imitated immediately, but it became the starting point for figures of David from the mid-fifteenth century through the nineteenth.

Although the tendency to create freestanding statues was strong in the fifteenth century, interest in the problem of integrating sculpture and architecture certainly did not subside. In monuments for church interiors—tabernacles, fonts, pulpits, galleries, and tombs—sculptors found the perfect situation in which to fuse them harmoniously. Of these types, the Renaissance tomb was one of the most powerful. The humanists had articulated a new view of the dignity of man's life and the beauty of his physical being. When they spoke of death, they found it necessary to emphasize his double nature—spiritual as well as corporeal. It was through his spirit that man would find not only life in another world but also immortality. Like those before them, the humanists held that life's real achievements issued from the soul, not the body, and that physical death was not to be regretted if immortality was assured. "Do not Plato and Aristotle seem to be alive today with us?" asked Aurelio Brandolini in his *Paradoxa Christiana*.

New types of classical tombs evolved in the Renaissance that gave greater emphasis to the idea of commemoration. The most splendid of these was the great wall sepulcher. One of the earliest was carved in Florence before the middle of the century for a man who did not in any way seek such glory. Leonardo Bruni (1369–1444), the historian who had also been Chancellor of Florence and done so much to transmit the wisdom of Aristotle and Plato to his contemporaries, asked to be buried under a plain marble slab in Santa Croce. Yet when he died he was given a state funeral imitating ancient customs; he was borne about in the robes he wore when alive, carrying his great work, the *History of the Florentine People*, and crowned with a laurel wreath. This was the image his contemporaries wanted to retain of Bruni; contrary to his wishes, they ordered a magnificent commemorative sepulcher for Santa Croce, and on the sarcophagus was inscribed: "After Leonardo departed from life, history is in mourning and eloquence is dumb, and it is said that the Muses . . . cannot restrain their tears."

76. BERNARDO ROSSELLINO. *Bruni Monument. ca.* 1445. White and colored marble.
20′ (to top of the arch). Santa Croce, Florence.

77. BERNARDO ROSSELLINO. Detail of Fig. 76.

The sculptor chosen to carry out the commission for Bruni's tomb was Bernardo Rossellino (1409–64), younger than Ghiberti and Donatello, not of their gigantic talent and productivity, but trained in both architecture and sculpture. He used both abilities to best advantage when he created his monument to Bruni (Figs. 76, 77), which became the prototype for countless fifteenth-century tombs. He designed a triumphal arch as the setting for the effigy and the sarcophagus to be placed against the aisle wall of Santa Croce. In the lunette above the Madonna and Child are flanked by praying half-length angels that provide the tomb's only religious reference. At the very top, in totally different proportions, classical putti hold the Bruni coat of arms in an enormous wreath from which garlands unfurl to unite this crest with the arch. The crown of the ensemble appears somewhat heavy, but, aside from this, the effect is pleasing; the combination of ornate base, fluted pilasters, panels of red porphyry in the background, entablature, and arch establishes a spacious, articulate, and balanced frame for the effigy of the humanist. The tomb's structure has the harmonious proportions and the crisp, elegant details characteristic of mid-fifteenth century architecture in Florence, particularly that of Alberti.

Rossellino applied the same disciplined restraint to the effigy. The sarcophagus, the two eagles supporting the bier, the brocaded cover, and the effigy are all angular, parallel, and simple. Even though Bruni is shown in a soft garment with the folds of the ample sleeves falling

gracefully, the body has a measured architectural regularity. The feet, the drapery, and the hands crossed over the large book on Bruni's chest are perfectly symmetrical. The most personal element in the whole ensemble is the strong face—a portrait likeness, probably made from a death mask. Even so, the emphasis is not on the specific facial features but rather on the nobility of the whole image. Bruni was over seventy at the time of his death, but Rossellino did not portray such an elderly man. The flesh of the hands is firm and full; even the face does not look so old. Both the image and the monument are idealized, static, elegant (and were still more elegant in the fifteenth century, before the gilding on the garlands, the effigy, and the angels had worn off).

Bruni's wish that he be buried without fanfare was not heeded, for the socio-political climate of Florence had changed considerably since Bruni's formative years. After Cosimo de' Medici's return from exile in 1434, Florence was dominated by Medici rule, and the aristocratic impulses of its people had grown steadily. Bruni's political ideal had been the Republic; he wanted to be part of a corporate state. Under the Medici this image changed, as the individual aristocratic ego became the leading force in public life. The change was evident in the way people lived—in the kind of homes they built, the art they collected, the manner in which they married and were buried. The great works of art created in Florence were increasingly less often under the patronage of civic-minded groups such as the guilds; more and more the large commissions came from members of the elite.

One sculptural type that appealed to the Florentines' new desire for expressing their individuality was the portrait bust. Donatello, in the first part of the century, had been interested in the problem of portraiture, but whether he ever made an actual portrait of an individual is not known.[9] The best demonstration of his feeling for portraiture was in the profound characterization he imparted to his campanile prophets. True portraits are associated more with the second half of the fifteenth century,[10] when they became immensely popular in Tuscany. The portrait bust, in addition to satisfying the growing urge for owning private works of art and for acknowledging the status of the individual, was yet another way to emulate antiquity.

To do what the ancients had done bore with it a certain social distinction in the urban centers of Italy during the latter part of the fifteenth century; it did so to a degree that would not have pleased the early humanists, who had humbler notions about their relationship to the past. The most expressive and naturalistic experiments in fifteenth-century portraiture were busts of members of Florence's foremost families—the Medici and the Strozzi, for example—and of statesmen, physicians, merchants, and other leading citizens. Like the Romans, Florentines commissioned not only the portraits of illustrious men, but of women and children as well. Yet when a sculptor was commissioned to execute a bust of a female patron he usually rendered a very definite type, experimenting less than in portraits of his male clients, and also being less open to classical influence. The difference in approach was rooted in the ancient belief that women were spiritually of less significance than men. Nevertheless, the dignified, graceful female portrait type that emerged does show that the Renaissance held a more positive attitude toward the physical appearance of women than had the Middle Ages. In the late fourteenth century Cennino Cennini had written in *Il Libro dell'arte*: "I will give you the proportions of a man. Those of a woman I will disregard for she does not have any set of proportions."

One Florentine sculptor, Desiderio da Settignano (*ca.* 1430–64), in the course of his brief mid-century career, established a reputation as an artist who could carve marble with the greatest subtlety, a gift which had particularly splendid results when women or children were his

subjects. A number of female busts have been attributed to him; none are documented and many are probably not his. One of the most outstanding (Figs. 78, 79) is a portrait in Berlin that historians have linked to his name and to a line in Vasari, who wrote that Desiderio "made a marble bust of Marietta degli Strozzi from life, and as she was very beautiful, it proved most successful." [11] The bust is a masterpiece of austere understatement, with simple, compressed volumes, unbroken profiles, and a delicately modulated surface on which the textures of flesh, hair, and drapery were worked with the finest chisels and drills. The bust is characteristic of

78. DESIDERIO DA SETTIGNANO. *"Marietta Strozzi." ca.* 1455. Marble, 20½". Berlin-Dahlem, Museum.

79. DESIDERIO DA SETTIGNANO. Rear view of Fig. 78.

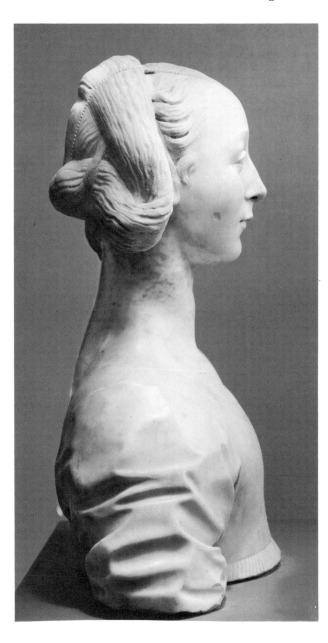
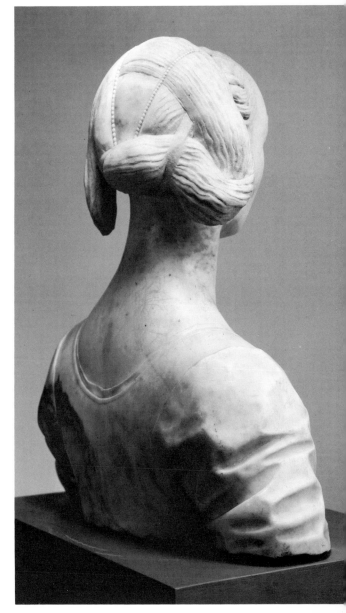

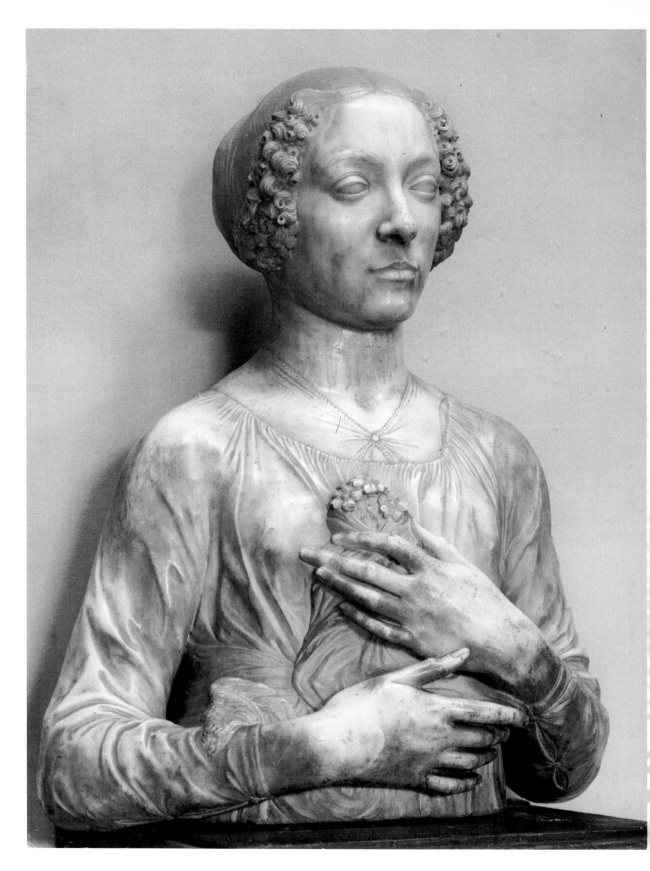

80. ANDREA DEL VERROCCHIO. *Lady with Flowers.* 1470's. Marble, 39″. Bargello, Florence.

Early Renaissance portraits (both painted and carved) in being sharply cut off at mid-chest, in its perfect symmetry, and in having its most impressive view the profile. Desiderio exaggerated certain features—the high forehead, rounded eyeballs, the pronounced extension of the upper lip over the lower—but he never relinquished the sense of control that seems appropriate to such a *gentildonna*. The neck, unencumbered by hair, drapery, or jewelry, appears smooth and long; the hair is done in an elegant coiffure of mid-fifteenth century style, with its twisted plaits graced by a tiny band of pearls that dips down over the forehead. The closed lips, thin eyebrows, and small breasts all contribute to the effect of a high style, but one of enormous reserve. In it we can perceive something of the elegance and richness of life that would have been appropriate to such a personage as a Strozzi daughter. No wonder historians, seeing this beguiling combination of youthful warmth and dreamy, aristocratic aloofness, have wanted to give a name to this sitter, not to leave her designated as "Unknown Lady," the characteristic fate of the subjects of contemporary busts.[12]

If we look for an antidote to the delicate reserve of Desiderio's portrait, we can find it in *Lady with Flowers* (Fig. 80), which is probably the work of Andrea del Verrocchio (1435–88). Verrocchio was the most gifted sculptor in Italy after the death of Donatello and in many ways he wanted to rival his great predecessor. Technically he was accomplished, being versatile enough to work in different materials, on various scales, and in both painting and sculpture. If *Lady with Flowers* is indeed Andrea's, it is one of the few marbles from his hand surviving. Here again the identity of the sitter is unknown, though the bust has usually been linked to a member of the Medici family. The lack of information on the subject is regrettable since we are tantalized by the personal characteristics depicted. This new portrait type conveys a special feeling for the force of the human body as it moves; it has been achieved by extending the body to the waist and by the presence of the arms and hands. There was Roman precedent for this, but it was not usual in the Renaissance except in painted portraits (a slightly later example is the *Mona Lisa* by Verrocchio's famous pupil, Leonardo da Vinci).

In *Lady with Flowers* Verrocchio, like Desiderio, has worked with strong solid forms (particularly the head), but he has not given them such an abstract quality. The precise shapes of the body are lost in the movement, the asymmetry, and the complicated shifting of soft drapery. There is not the same degree of emphasis on the single view as in Desiderio's work. The bust is finished in the back and the sense of movement and the overall spatial character invite us to look at the sculpture from all views. The carving technique is varied; in places Verrocchio cut into the marble fairly deeply in his desire to show the numerous details of the anatomy, the drapery, and the flowers in the woman's hand. Desiderio had played down contrasting textures and the physicality of the body; Verrocchio instead delighted in showing the soft breasts beneath the dress; the difference between the gauzy undergarment, the dress, and the sash around the waist; and details of the hair style, with clusters of curls picturesquely framing the face. This bust tells us how interested Verrocchio was in recording his experience of nature. Studio practices such as dipping cloth in plaster and then draping it around the preliminary models in clay to better study the forms, reinforced this. But he went far beyond a mere recording of observations, for he welded the whole into a most expressive work. The woman in Desiderio's portrait could be taken as a representative of a style, a class, or a period; Verrocchio's sitter, through her features, her clothing, and her gesture makes known to us her uniqueness as an individual.

While working on this unusual bust of a Florentine lady, Verrocchio was probably already planning what was to be his last sculpture—the equestrian figure of the great *condottiere*

Bartolommeo Colleoni. The Venetian Republic requested Verrocchio's participation in a competition for the design of this commemorative statue; he won the commission and moved to Venice but died before his monument was cast. Verrocchio's work for Venice continued the well-established tradition by which foreigners, particularly Florentines, contributed heavily to the Adriatic city's artistic glory. Venice had long held a unique position in Italy: it was a maritime power, with access to the Orient, and extended its empire beyond the sea. With regard to the rest of the Italian peninsula, it maintained a policy of relative isolation except when moved by concern for protecting its domination over the Adriatic. During the fourteenth century the Venetian concept of its territorial boundaries began to change, and from that time on, more often than not the Republic was involved in maneuvers to extend its limits.

Their familiarity with Eastern taste and its love of color, intricacy, and decorative surfaces made Venetian artists very reluctant to give up the Gothic style. When Florentines came to work in Venice during the first half of the fifteenth century, the art they found around them in the Adriatic Republic looked startlingly different from that they had known in Tuscany. The contrast became less marked as the century progressed, and by the time Verrocchio arrived in Venice some works of sculpture had been created in an authentic Renaissance style, most of them by Jacopo Sansovino and Antonio Rizzo. Rizzo (active after 1465; d. 1497/1500) was working on a pair of spectacular figures for the Doge's Palace during the 1480's. This ducal residence next to the Cathedral of San Marco is a Gothic structure, but architects began to add Renaissance features to its courtyard in the course of the fifteenth century. One of the additions was the so-called Foscari arch, designed during the second quarter of the fifteenth century and incorporating both Gothic and Renaissance forms. For the niches flanking this large Roman arch Rizzo carved the first monumental nude statues in the history of Venetian sculpture—*Adam* and *Eve*.

The choice of subject could not have been more traditional. Adam and Eve were the only nude figures frequently carved by Romanesque and Gothic sculptors, and one of the last medieval representations of the pair had been carved into a corner of the Doge's Palace around 1400 (Fig. 81). The two earlier figures stand straight, rigid, their weight evenly distributed, and their bodies attached to the architectural background; between them, at the building's angle, is the Tree of Paradise, supporting the snake of temptation. Adam plucks the forbidden fruit with his left hand and in a tight, symbolic gesture raises his right hand flat against his chest as though to give warning. By adopting the new Renaissance naturalism, Rizzo was able to impart a much greater dynamism to his *Adam* (Figs. 82, 83), who shifts his body uneasily, clasps his chest, and looks up in fear. The head is large, stylized, and linear, set on a thick muscular neck. It is unclassical but very expressive with its curly hair, prominent nose, projecting upper lip, carefully carved teeth, and enormous eyelids. The figure is freestanding, even though conceived within the context of architecture and not as a statue to be viewed from all sides. The body is classical in its contrapposto and Praxitelean proportions, but exhibits little of the overall classical atmosphere that governs Donatello's *David*. Its spirit is neither pagan nor Roman, but distinctly Christian. Donatello had developed a slow, languid body type in which he could dwell upon the physical beauty of the human body; Rizzo used the classical nude to convey the Christian notion of original sin.

We know that Donatello traveled to Rome and took measurements of antique works. We have no such specific knowledge about the source of Rizzo's knowledge of antiquity; we know only that Venice as part of the Byzantine world had remained open to the influence of Greece,

81. ANONYMOUS ITALIAN. *Adam and Eve. ca.* 1400. Istrian stone. Palazzo Ducale, Venice.

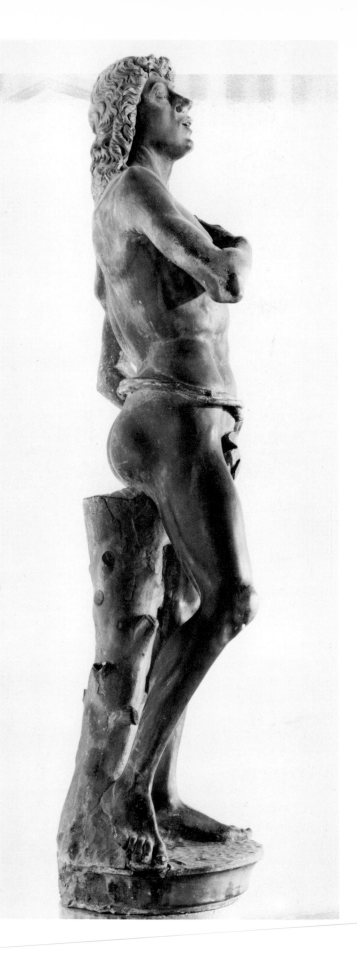

82. ANTONIO RIZZO. *Adam. ca.* 1485. Istrian
 marble, 6′. Palazzo Ducale, Venice.

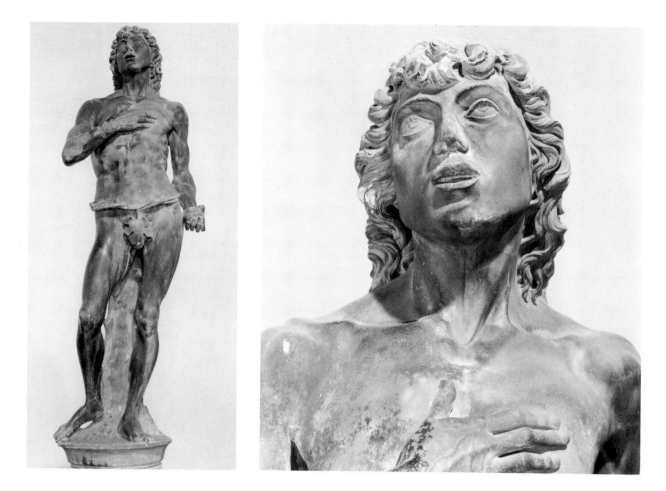

83. ANTONIO RIZZO. Front view and detail of Fig. 82.

that the Early Christian sculpture in and around San Marco was quite classical in style, and that Rizzo's art has much in common with that of the leading antiquarian among North Italian artists, Andrea Mantegna (1431–1506). Mantegna was a tireless student of classical works; they led him to create the most heroic, stately figures in North Italian painting during the second half of the fifteenth century. Rizzo's *Adam* is extremely close to the figure type Mantegna created in his *Martyrdom of St. Sebastian*, which was very sculptural in its effect. Both artists placed emphasis on long, flexible limbs with rippling muscles and created convoluted, changing silhouettes that yield rich, varied surfaces.

Rizzo's *Adam* is the Venetian parallel to Donatello's *David.* These two works are the most monumental images of the nude figure realized by fifteenth-century sculptors. During this period humanist philosophers answered with a resounding "yes" the question, "Is the human body endowed with such dignity that it deserves to receive an immortal mind as its guest?" [13] During the second half of the fifteenth century the humanists were refining their new image of man as they worked out a synthesis of the relation between body and soul and man in his universe. In countless ways they acknowledged man's striving toward divinity, and very often in their writings we recognize the desire to compete even with God:

God is everywhere . . . and always. Man desires to be everywhere. . . . No wall dulls or weakens his glance. He is content with no frontier. He yearns to command everywhere and to be praised everywhere. And so he strives to be, as God, everywhere.[14]

84. MICHELANGELO. *David*. 1501–4. Marble, 13′5″. Accademia, Florence.

85. MICHELANGELO. Detail of Fig. 84.

No group of philosophers has ever spoken with more elation about human beauty than those of the Renaissance. It was sculpture's power to give three-dimensional form to their proud ideas, and it was at this time that the most singular sculptor in the history of Western art appeared to give palpable representation to the force contained in man's naked body.

Michelangelo Buonarroti (1475–1564) created his gigantic *David* (Figs. 84, 85) just after the turn of the century. The fact that he carved it from a famous block of Carrara marble, over thirteen feet high, out of which another sculptor had attempted unsuccessfully to make a figure during the second half of the fifteenth century seems significant. Giorgio Vasari, Michelangelo's friend and biographer, said in his *Lives of the Most Eminent Painters, Sculptors, and Architects* that it was "a miracle on Michelangelo's part to resurrect a thing considered dead." Michelangelo received the commission for his *David* from the *Operai* of the Duomo of Florence

on August 16, 1501. When he considered precedent for the work he looked to Donatello's famous bronze, since that had set the pattern for other fifteenth-century sculptors' interpretations of the Hebrew victor—adolescent, arms akimbo, Goliath's head at his feet, sometimes nude but more often in a short tunic (Verrocchio, Pollaiuolo, Bellano). Michelangelo saw his subject very differently, and there was no doubt that he would render his hero in the nude. Though he was only twenty-six when he began carving, he had had a great deal of experience making nude figures, small and large, pagan and Christian, for almost a decade. (As a teenager he had purchased a large piece of marble for an over-lifesize *Hercules*.)

When the *David* was finished and placed on the terrace of the Palazzo della Signoria in June of 1504, Michelangelo's fellow citizens were confronted with a more naked, more monumental, and weightier figure than they had ever seen before. Only in Rome was there a comparable grandiosity in stone—as Michelangelo had himself witnessed just before returning to Florence and making the *David*: the images of the colossal antique sculpture of the *Horse Tamers* on the Quirinale and the huge marble fragments from a figure of Constantine on the Capitoline were still vivid in his memory.

Compared to Rizzo's *Adam*, the *David* is a return to a more classical figure type. We see this in the proportions, the longer, more powerful torso, the greater overall stability of the figure, its clearer outline, and in the avoidance of the high-pitched emotionalism of Rizzo's interpretation. In one respect, however, Michelangelo's figure is parallel to Rizzo's: in both an idealized body is combined with a head rendered in more personal manner. The neck, facial features, and the hair of the *David* all suggest a contemporary feeling and show evidence of the model from which Michelangelo worked, as do the enormous hands that exhibit carefully defined anatomy (Michelangelo had been making anatomical studies, which included dissection, since 1492).

When considered in relation to Donatello's earlier figure, Michelangelo's *David* tells us a great deal about the new approach to the image of man. His is a simpler, more direct interpretation—the left leg bends only slightly, the right arm hangs straight down, the left arm bends back sharply to the shoulder, and the head is held high and turned to show the profile. Michelangelo gave his *David* a continuous, unbroken outline, avoiding the complicated spaces of Donatello's fifteenth-century version. The handling of contrapposto by the two sculptors could not be at greater variance, considering that they were both inspired by the same type of classical figure in repose; Michelangelo was interested in the strong contrast between the left and the right side of the figure, while Donatello sought a subtle interplay of the two. The easy swinging rhythm in the earlier figure is an invitation to walk around the statue; Michelangelo planted his figure firmly on the ground and thereby stressed a frontal view (even though the back is beautifully finished). Consequently, it is not surprising that the governing body of the city of Florence decided to place *David* before a wall of the Palazzo della Signoria, permitting only a frontal view of the work. (The statue stood there until 1873, when it was moved indoors and replaced by a copy.)

The torso of Michelangelo's statue is more closely related to classical prototypes than is that of Donatello's *David*, but the figure as a whole is not; the stance is wide, there is a great deal of space between the legs, and the non-weight-bearing leg does not come forward in the way of figures of the Praxitelean tradition. The body is firmer, more muscularly taut; its solid bulk is particularly appropriate in marble, just as Donatello's fluid, sensuous, and elegant figure worked well as a modeled and cast piece. The faces of the two figures contrast just as decisively: instead

of a beautiful but impassive boy, Michelangelo showed a young man of strong character and emotional depth. The face is set beneath a massive cap of curly hair, each feature slightly asymmetrical; the expression of tension culminates in the deeply carved eyes, bushy eyebrows, and wrinkled forehead. Michelangelo's *David* is simpler not only in body type, but also because all attributes save the sling have been stripped away. Donatello conceived of David as the victorious young giant-killer and Goliath's head figures prominently in his statue; Michelangelo's maturer figure has slain no one—he betrays the tension and anxiety of a man on the verge of a struggle whose outcome is not yet certain. His stance is open and his preoccupied stare extends into a distant space, with the result that the statue is not as self-contained as Donatello's. Michelangelo's *David* is neither so self-interested nor so self-satisfied as the fifteenth-century version: we are not so much invited to contemplate David's personal beauty and heroism as we are to become involved in his fearful psychological and physical state of anticipation.

Traditionally Michelangelo's *David* has been seen as an allusion to the strong and just man of the people, a fitting hero for Florence—the city that had recently expelled the Medici and restored its republican constitution. Vasari wrote that "Michelangelo . . . portrayed a young David with a sling in his hand: as he had defended his people and governed them with justice, so might whoever governed the city defend it bravely and govern it justly." [15] The idea of regarding David as a civic hero existed before Michelangelo's time, along with the traditional Biblical concept of him as Fortitude, a parallel to the pagan image of Hercules. Michelangelo had both notions in mind as he worked, yet there are also highly personal elements in the *David* and there seems little doubt that the sculptor identified with the statue. The feeling that emanates from the work—a supreme nobility, a stringent moral content—must in some way relate to Michelangelo's own character. Robert Clements has suggested that the young artist was dwelling here upon his own commitment to serve God through his art as David had committed himself to vanquishing Goliath.[16] It is one of those strange paradoxes that this artist—whose Christian humility was genuine, who saw himself as God's servant or, at his best, as God's collaborator—was the one to epitomize in the *David* the superhuman and highly individual image of Renaissance man, so that he himself as creator of these marble giants came to be called *Il Divino*.

Subsequent generations have been fascinated by the variety of ways Michelangelo was able to treat the figure and by the vast range of human experience with which he was able to invest it. An early work, the *David* was a particularly direct depiction of man's image. It was a kind of figure he did not carve again. If we consider his *Victory* (Figs. 86, 87), of approximately twenty years later, we can see the degree of complexity which Michelangelo would reach. The group, originally planned for the tomb of Pope Julius II, was in the tradition of *David* insofar as it shows a youth who has conquered through the force of his body. Before considering *Victory* as a group, it is instructive to look at the figure of the youth alone as another expression of Michelangelo's image of the human body. It is taller, more slender than the *David* figure, with long legs and a small head. The difference in proportions is less important, however, than Michelangelo's new view of the body as a flexible, moving organism. Planned as a niche figure, *Victory* clearly displays a frontal view. Nevertheless, when we look at it frontally we have the feeling that we are not seeing everything. By moving to the right or the left we are able to see more—the cloak, the left arm, the profile of the face—but when we do so the design weakens: the figure's right side shows a heavy and awkward sloping at the buttocks; the left side of the torso is too rigid and rectangular; and the figure in general is too thin for the broad base created

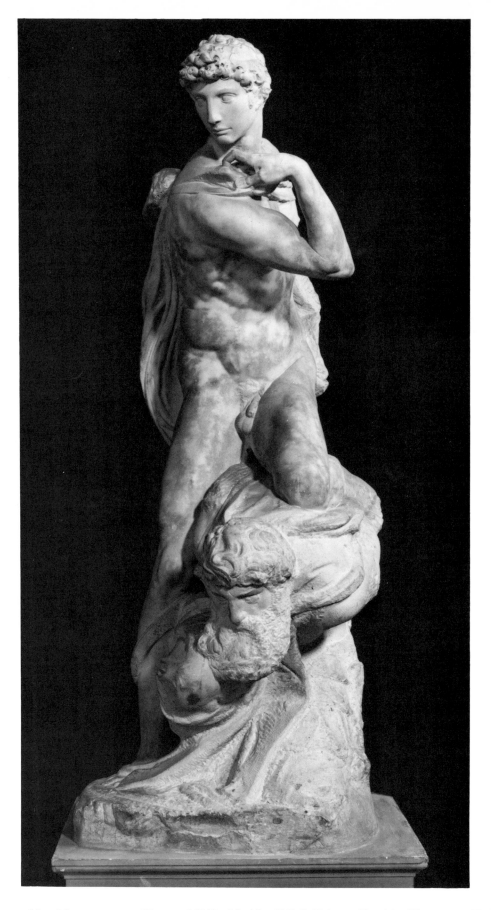

86. MICHELANGELO. *Victory*. 1520's. Marble, 8'6¾". Palazzo Vecchio, Florence.

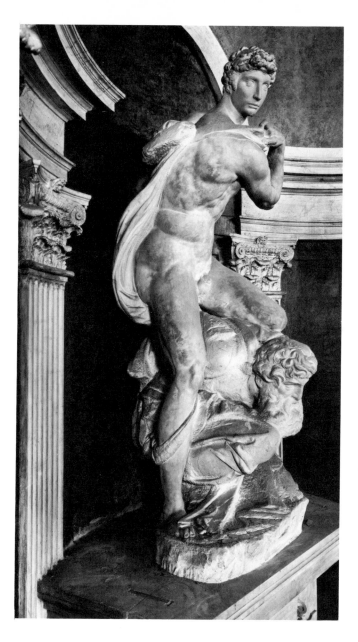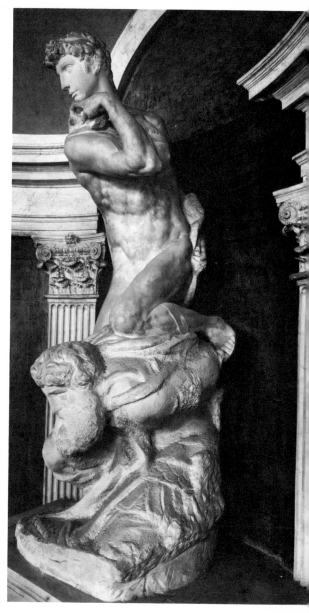

87. MICHELANGELO. Side views of Fig. 86.

by the old soldier squatting beneath it. There is a tension and conflict here that did not exist in the *David*; there the viewer was neither deprived of something essential when he looked at the statue frontally, nor displeased with the overall design as he moved around the figure. The two sides of the body of the *David* were clearly differentiated: his right firm and vertical, his left open and functioning. In the *Victory* the figure's right side is emphasized; the leg is squarely planted in front, but nothing is parallel to it. The left leg, drawn up and foreshortened, begins to radiate along with the twisted body, a tortured spiral formed by the left hip and shoulder pulled back to the point of strain, the right shoulder thrust forward, and the right arm, drawn up so that it is seen (in frontal view) in perfect profile. The turn of the head opposes that of the body and points beyond the right shoulder. The glance would have echoed this direction, as we see from the cornea carved into the corner of the right eye only. No direction is left undeveloped by this statue, but its cohesive form is only evident from one view. All gestures and movement in

the *Victory* are peculiarly flattened out, artificial, and strained. Michelangelo was grappling here with a problem that fascinated him—namely, a new manner in which to phrase the contrapposto of the human body.

Fifteenth-century sculptors had preferred a rather restrained type of movement in order to indicate the body's potential for energy; Michelangelo favored more radical possibilities. A great deal of the subsequent sixteenth-century experimentation with contrapposto came in the wake of his endeavors. The corkscrew movement he used in his *Victory* was fundamental to the new figure type. In the second half of the century the artist and theoretician G. P. Lomazzo reported that Michelangelo had once advised a disciple that "he should always make a figure pyramidal, serpentine-formed. . . ." [17] Lomazzo wrote further: "All motions of the body should be represented in such a way that the figure has something of the *serpentinato*. . . ." [18] It was Lomazzo and theorists like him who set the rules for composition and for bodily postures; but their inspiration was the figures of Michelangelo.

The *Victory* is the first group introduced into our discussion of Western sculpture. With the exception of *Madonna and Child* groups and late medieval devotional groups such as the *Pietà*, freestanding groups of two or more persons were not created after antiquity until the Renaissance. There were some monumental fifteenth-century groups—for example, the *Judith and Holofernes* that Donatello carved for the terrace of the Palazzo della Signoria (it was later moved to make way for Michelangelo's David)—but they were not common. In the sixteenth century, however, sculptors produced such works in abundance, and Michelangelo's *Victory* was key to the new type.

Michelangelo's sculpture shows an old soldier being crushed into subjection by a youth. It is a strange, haunting piece, not merely because of the contortions of both bodies, but also because of the relationship between them: they are wedged rather than woven together, the two bodies presenting complementary unnatural postures that create a solid, tall pyramid—the *piramide serpentinata*. Part of the strangeness results also from the absence of movement and energy that are commonly associated with the idea of physical struggle. The bodies are frozen; so too are the faces, both turning in the same direction.

The faces are similar in their unfinished simplicity as well as in their unemotional expressions. Varying degrees of completion are common in Michelangelo's work: thus, the old man's body and beard are roughed out, the youth's face and neck show the marks of a fine-toothed chisel, and some parts of the youth's torso are finished with a high polish. The lack of finish in Michelangelo's sculptures is rarely disturbing because of the nature of his work, with form and contour being the essentials, and the relationship of the whole design to the mass of marble being of greatest consequence. Finish was secondary; the absence of detail and the presence of chisel and point marks do not diminish the quality of the work nor our ability to appreciate it.

The unusual relationship between the figures in *Victory*—psychological as well as physical—has resulted in widely diverse interpretations of its subject and meaning. It has been termed a moral allegory of Good against Evil and seen within a Christian context, or even a political allegory (the youth has oak leaves in his hair, which were the symbol of the Delle Rovere, the family of Pope Julius II, for whose tomb the group was originally destined); some scholars view it as a highly autobiographical work that sheds light on Michelangelo's relationship with the young Tommaso Cavalieri.[19] Whatever its true theme, Michelangelo created here two figures displaying a new sense of weight distribution and of contrapposto; he

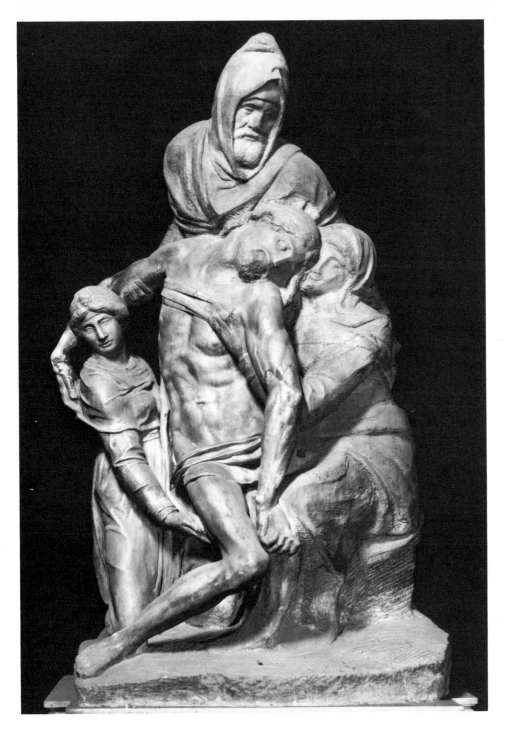

88. MICHELANGELO. *Pietà*. 1540's–1555. Marble, 7'8". Duomo, Florence.

enclosed their complexly interwoven bodies within a pyramidal block and clearly made the bodies the bearers of some meaning that we feel compelled to search for.

Many of the same features are found in a work that is extremely different from the *Victory*—the *Pietà* in the Duomo of Florence (Fig. 88), one of Michelangelo's most personal works. He made it for his own tomb and worked on it over a number of years in Rome, where he lived after 1534. Michelangelo, then in his seventies, wrote sonnets in those years that are

filled with images of fear about imprisonment in matter, of a yearning to change this state and to renounce earthly things: "The soul gains more the more it's lost the world,/And death and art do not go well together. . . ." [20] These feelings became particularly strong after the death of Michelangelo's dear friend Vittoria Colonna during the winter of 1547. Was it in that state of grief that he began work on his own sepulcher? He was still working on it in 1552; Vasari tells us that during some periods he carved on it every day, but that sometime before 1555 he attacked his marble, apparently with intent to destroy it. His servant, Antonio, intervened and Michelangelo gave him the work, which was subsequently repaired by one of the sculptor's pupils.

Three figures—the Madonna, Mary Magdalene, and Nicodemus[21]—form a wreath of human compassion about the heavy, twisted body of the dead Christ. As in the *Victory*, the human figure is conceived in the most complicated fashion, but whereas in the former the body was depicted as a tight vertical coil of potential energy, here it is open and vulnerable—with the head, the right arm, and the leg (Michelangelo destroyed the left leg) extending the direction of the downward movement across the entire breadth of the composition. The body of Christ is top-heavy; it seems as if the great weight of the sinking form needs every direction in order to realize fully its descent, and its proportions are larger than those of the other figures (if Christ were standing he would be a head taller than Nicodemus). Again Michelangelo chose to emphasize the human torso and did so through size, positioning, and a rich handling of the anatomy. Christ's body stands out further by its finish, for it alone is fully carved and polished. The figure is so convincing and moving, and Michelangelo's understanding of the human body is so organic and total that one hardly notices that both arms are patched, that the breast has been repaired, and that one leg is even entirely missing.

In the *Victory* group one figure rested upon the other, yet each remained separate; they affected, but in a curious way did not seem to recognize, each other. In the *Pietà* the four figures are emotionally and physically welded together into the pyramidal block by their respective acts of touching, supporting, or looking. Christ's mother is a hulking, firm, unfinished seated figure pressing her grief-stricken face (one of the most emotional Michelangelo ever carved) into his hair. Kneeling on the opposite side is Mary Magdalene (this figure was finished by Tiberio Calcagni, a Florentine pupil of Michelangelo; Calcagni also mended Christ's shattered arms and repaired his chest and the Virgin's hand). Nicodemus forms the apex of the pyramid, one arm resting gently on the Virgin's back, the other holding Christ's right arm, his own body echoing the great concave sweep of Christ's figure. The face of this old man, partially hidden by a monk's cowl and looking down with profound compassion at the dead Christ, is Michelangelo's own image. Figure and face are extremely simple—an unfinished, changing mesh of chiseled lines over the whole surface. In this group, as elsewhere, Michelangelo considered the broad compact masses above everything else, but nothing remains too rude or abstract; the human and the organic are always present even in so unfinished a figure as the Madonna. Again it was the frontal view Michelangelo had in mind in the *Pietà*; the back is not finished, but even if it had been (as in the *Victory*), it would have been clear that the front was meant to be the principal point of view.

Vasari called this work a *Deposition*, but today we have come to refer to it as a *Pietà*. Actually it partakes in some way of all the themes relating to the Passion: the *Deposition*, which since the Middle Ages showed the vertical body of Christ being removed from the Cross, often with Mary's head pressed to Christ's; the *Lamentation*, with saints crowding around Christ's

outstretched body after its removal; the *Pietà*, with Mary holding the dead Christ on her lap (a very popular image in the fourteenth and fifteenth centuries which Michelangelo himself had rendered in a flawless marble before he had reached the age of twenty-five); and the *Entombment*, which usually showed Joseph of Arimathea, the Madonna, St. John, and others—sometimes Nicodemus—placing Christ's body in the tomb. Despite Vasari's reference, it is really not clear which scene Michelangelo intended his group to be; as we look at the figures we recall the entire Passion sequence, and it may indeed have been precisely this cumulative effect that Michelangelo wanted to suggest—not a single moment, not a static, eternal *Pietà*, but the movement involved in the transition from life to death, like the movement of Michelangelo himself carving in life the tomb he was to occupy in death. The atmosphere of suffering is authentic and intense. As in his late poetry, where he dwelled upon the renunciation of material things and of the physical side of life, in this work the sculptor is no longer preoccupied with the body's perfection or with a desire to express the equilibrium between body and spirit as he had earlier in the *David*. The heavy, angular body of Christ with its distended muscles is the symbol of his own old age. Into the group he inserted his own idealized image clutching Christ to his breast. It is this that is so impressive about the work—the personal poetry inherent in the large, blunt forms, the sloping shapes and touching bodies that reveal a man's concern with his own grief and anticipated death.

Unfortunately the *Pietà* did not ultimately adorn Michelangelo's tomb. In the end it was Vasari who designed the spiritless monument we see today in Santa Croce, with its three allegorical figures of Sculpture, Painting, and Architecture executed by undistinguished young pupils of Baccio Bandinelli. Bandinelli (1493–1560) considered himself to be Michelangelo's major rival and it was he who assumed leadership among Florentine sculptors after Michelangelo's departure for Rome. It is a peculiar twist of fate that the taste typical of the work that issued from Bandinelli's studio should mark Michelangelo's funerary monument.

Something of Bandinelli's rather crass personality can be understood from one notable instance of the rivalry with Michelangelo that he continually provoked. Bandinelli's son, also a sculptor, had been at work on a group of *The Dead Christ with Nicodemus* (Fig. 89). Vasari tells us that Bandinelli decided to finish the work himself:

> . . . for he had heard that Buonarroti was finishing one in Rome, which he had begun on a large block of marble, with five figures, intending to put it on his tomb in S. Maria Maggiore. In emulation of this Baccio set to work on his with great keenness and with the help of assistants, until he finished it. Meanwhile he was going round the principal churches of Florence, looking for a place where he could set it up and make a tomb for himself.[22]

This anecdote also allows us to understand the climate governing sculpture in the wake of the gigantic Michelangelo. Though Bandinelli's work was not perfectly executed—begun by his son, finished by the father with the aid of assistants, and probably meant to incorporate two additional figures, Saints John and Catherine—the tomb we see today in SS. Annunziata is complete as a concept and a design. And though it owes nothing to Michelangelo's *Pietà* (Vasari explains that Bandinelli did not actually know the group in Rome, but had simply heard of it), it is enormously influenced by other works of Michelangelo—the early *Pietà* in St. Peter's and the great seated *Moses* made for the tomb of Pope Julius II.

It was typical of Bandinelli's generation to execute detailed, finely finished works with carefully structured compositions. In Bandinelli's group everything fits into a right-angled

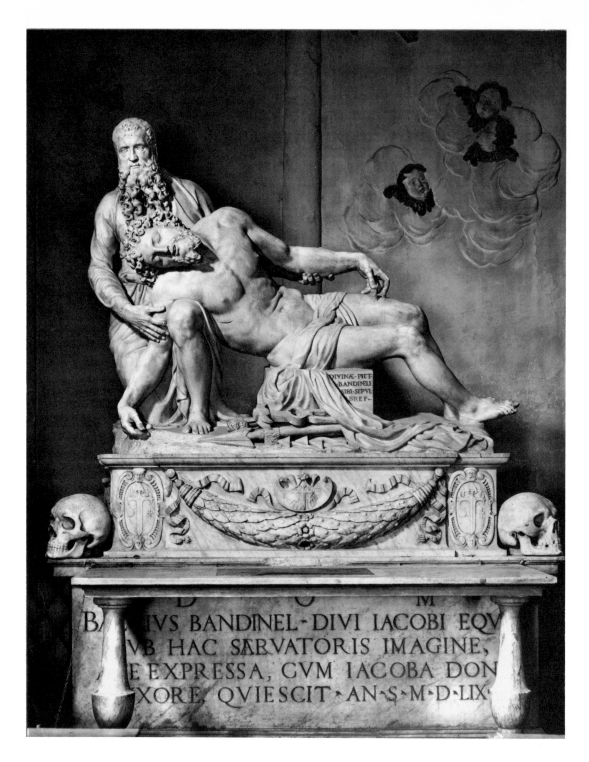

89. BACCIO BANDINELLI. *The Dead Christ with Nicodemus*. 1554–59. Marble. SS. Annunziata, Florence.

triangle not unlike Michelangelo's pyramid, but the effect is more intellectual, more contrived. Bandinelli placed his figures unnaturally, putting the weight of Christ's head and shoulders on Nicodemus's knee, arranging the lower part of the body perpendicular to Nicodemus's and parallel to the ground. Nicodemus lifts Christ's left arm so that the arm and hand echo the direction of Christ's leg. The gesture is dictated by the design; it does not have real emotional

value. For Christ's body to take this position it had to be forced into an artificial posture in a foreground plane so that the whole left side of the body is visible (if it were a natural pose that portion would tend to fall back). The pose also necessitated the addition of the strange block beneath Christ's hips, which with the aid of the drapery Bandinelli made into another right-angled triangle to serve as a prominent field for his signature. The crisscrossing of the drapery over Christ's loins creates a beautiful pattern, and the way it falls onto the ground becomes a reverse echo of the bend of Christ's legs—together they form a diamond shaped void into which the signature stone has been inserted.

The more we study Bandinelli's *Dead Christ with Nicodemus* the more we recognize these conscious formal relationships. This was Bandinelli's main concern as an artist; he was not, as was Michelangelo, seeking to describe a personal exchange between himself and his Saviour. If there is any work of Michelangelo's to which we might compare it, it is the *Victory*, with its two figures betraying the same kind of psychological distance as exists between Christ and Nicodemus; this is true even though Bandinelli carved his own features into the face of Nicodemus. The degree to which Michelangelo embodied deeply felt ideas in his forms and the absence of a similar interest in Bandinelli's treatment of the same theme is striking. After the High Renaissance it became increasingly customary to consider aesthetic qualities before content. This was often done quite consciously, the artist being most concerned with developing his own *maniera*, or personal style. In the middle of the sixteenth century style was supreme: *how* a thing was done—whether it was the way a man moved his body, wrote a poem, or carved a statue—was paramount. The word *"maniera"* indicates something of the importance given to the notion of personal style, and it has been appropriated by modern historians as a label for the art of the period following the High Renaissance.

In spite of Michelangelo's departure for Rome in 1534, Florence remained the most important center of sculpture in Italy in the sixteenth century. The courtly atmosphere of the city under Cosimo I, who ruled as its absolute monarch from 1537 to 1574, was perfectly suited to the new style. Cosimo, who became Grand Duke of Tuscany in 1569, was a connoisseur of art; but he also needed art as propaganda in his campaign to make his court acceptable to the democratic-minded Florentines and Tuscans. Bandinelli, with his strong anti-republican sentiments, served him well and never lacked commissions. But even though Michelangelo had left Florence, even though he carved little after his departure and was not entirely understood by his contemporaries, he was looked to as the most singular genius of the time. His work of the first three decades of the sixteenth century was central to the new style in sculpture; its vocabulary was established through his treatment of the nude figure alone, with its potential for enormous variety in contrapposto and movement. His artistic choices and solutions were essential to the whole next generation of sculptors.

The work by Michelangelo that had the greatest influence was his *Victory*. Shortly after his death it was moved out of his Florentine studio and installed by Vasari in the grandiose Salone dei Cinquecento in the Palazzo Vecchio. In the following year, 1565, Cosimo de' Medici commissioned a companion group based on the theme of Florence's triumph over Pisa. Oddly enough, he chose a foreigner to execute this highly patriotic work—Jean Boulogne (1529–1608), a Fleming who had arrived in Florence around 1556 and who had the most exquisite *maniera* of any contemporary sculptor. Giovanni Bologna (as he was called in Italy) interrupted his work on the great Fountain of Neptune in Bologna to take on the commission, and before the end of 1565 he exhibited a full-scale model in the Palazzo Vecchio. The final marble version of *Florence Triumphant over Pisa* was not completed until 1570 (Figs. 90–92).

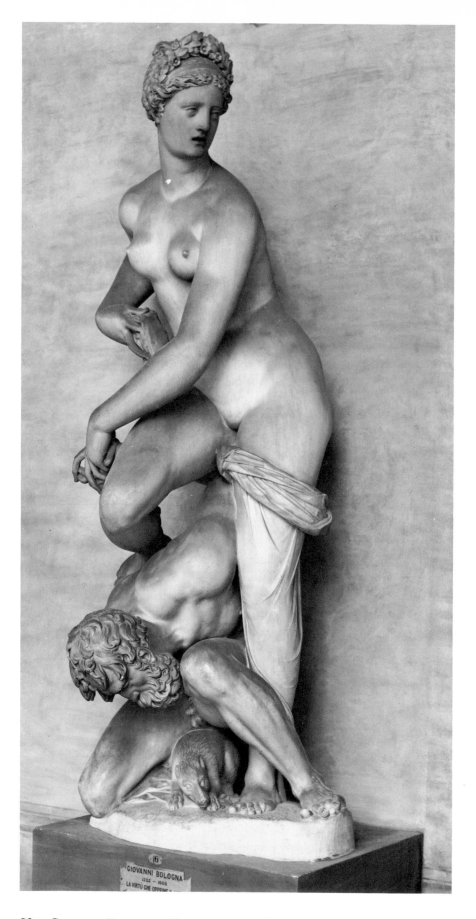

90. GIOVANNI BOLOGNA. *Florence Triumphant over Pisa.* 1565–70.
Marble, 9′4″. Accademia, Florence.

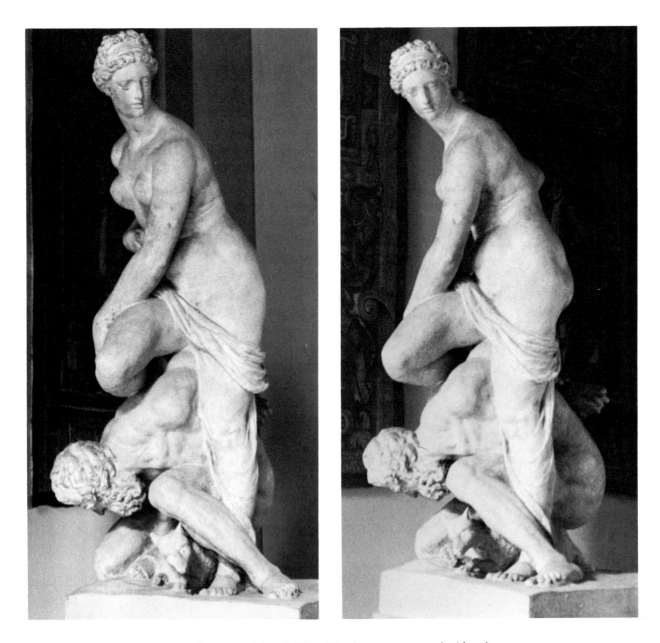

91–92. GIOVANNI BOLOGNA. Gesso models of Fig. 90: three-quarter and side views. Accademia, Florence.

Giovanni Bologna organized his group according to the composition of its celebrated companion piece, putting two figures into a pyramidal design but reversing the stance so that the figure of Florence stands on her left leg with the figure of Pisa under her right leg. Part of the concept of the commission was that the primary figure in Giovanni's complementary group was to be a female. This may in fact have been one of the reasons Giovanni was chosen for it, since shortly after his arrival in Florence he carved a *Venus* in alabaster that was surely known and appreciated by the Medici. Female nude figures were created even more infrequently than male nudes in the fifteenth century, but with the increased interest in myth and allegory during the sixteenth century they became quite popular. Michelangelo's great allegories of *Night* and *Dawn* for the Medici tombs were the outstanding examples of monumental female nudes and they had a profound influence on sculptors, particularly in Florence. The taste of sculptors in

the latter part of the century was not for such huge, muscular figures, however, but they really understood the concept of torsion in Michelangelo's bodies and used it to advantage as they transformed their own female nudes into decorative, svelte, seductive images. No one surpassed Giovanni Bologna in the creation of this type of figure, embodying a true formula for grace and refinement. His figure of Florence is one of his earliest versions of this cool, yet voluptuous female type.

Michelangelo's allegorical group of *Victory* dealt with contrasts of vertical and horizontal, movement and static balance, drapery and nudity, youth and old age; the result was provocative, even if its meaning remains somewhat elusive. In the case of Giovanni's group the subject is known; yet the knowledge that these figures symbolize the ascendancy of Florence over her coastal neighbor does not add much to our appreciation of the work, for Giovanni's concerns were primarily decorative and the forms and poses of his figures were intended to delight or surprise us. As in Michelangelo's *Victory*, the main figure is upright and vertical. Giovanni has so conceived the lower figure that its limbs join with the upright figure to provide a complicated pattern of parallel, upward-moving diagonals. A frontal view shows the captive Pisa's shoulders, the victorious Florence's right leg, the lower part of her left arm, and the lower part of her right arm as parallel forms. If one looks at the group from a different point of view a similar pattern emerges, though it is made up of a different combination of elements. Michelangelo often emphasized the bending of a limb, the angles of the body, and the movement of the hand in the act of holding. Here we find the same emphasis, but enormously exaggerated: Giovanni gave special prominence to the extremities, placing them in full view and repetitiously close to each other. When he designed the hands of the female figure he bent every finger and widely separated each one from the next.

The decorative quality in Giovanni's group is enhanced by the highly polished marble surface that continuously picks up glints of light. Unlike Michelangelo, Giovanni enjoyed details, lavishing minute attention on the carving of the complex hair style, the facial features, the weasel on the base (identified by one author as a symbol of Pisa's deceit), and the folds of the drapery. For him drapery provided the same advantages that it had for the Hellenistic sculptor who carved the *Aphrodite of Melos*—its surface and texture contrasted with the smoothness of flesh and emphasized feminine sensuality; here (in the finished marble) it is wrapped around the female figure's left leg and then pulled back between her legs to echo the form of her right buttock.

Giovanni Bologna, like Bandinelli, rejected Michelangelo's way of composing within a closed block. The victorious Florence rests her leg lightly on the back of a submissive Pisa, and when one moves to the right a triangle of space opens between the two bodies; the same happens with her arm, which barely grazes her thigh. Throughout the composition triangular and trapezoidal spaces open up in decorative patterns. Furthermore, though the principal view was a frontal one, as in Michelangelo's *Victory*, the side and back views of his group are more successful than the frontal, and the altered patterns of limbs presented by these secondary views are rich and interesting. This was Giovanni's first experiment with a vertical group, a problem that fascinated him as it did many sixteenth-century sculptors. By the time he created his last great work in this category, *The Rape of the Sabine* (which included three figures in complicated poses), he had fully worked out a sculptural group with no single principal view, but one intended to be experienced from all sides. This multiplicity of views became one of the most important aspects of sculpture in the latter part of the century and essential to the ultimate liberation of sculpture from architecture—a triumph that was realized by Giovanni's generation.

The new sculptural style based on the *figura serpentinata*, on patterned movements and elegant, graceful designs, began in Italy but did not remain confined to the peninsula; for the first time since the Late Gothic period the countries of western Europe shared similar stylistic impulses. Some of the finest works in this new style were created in France—a fact that is not surprising, for French sculptors working in a Late Gothic style through the fifteenth century had explored a decorative, linear style of carving to the highest degree. The sensibilities of the French were thus well prepared for the reception of the new style.

Early in the sixteenth century France found herself with a young sovereign who had both a sincere love of beauty and a sure taste. The reign of François I (1515–47) coincided with the years during which France absorbed the new Italian trends and began to use classical art forms on a broad scale for the first time. Under the patronage of François I, Leonardo da Vinci spent his last years in France. Later, when François decided to introduce contemporary taste into the design and decoration of the old royal château at Fontainebleau, Italian artists were summoned to France. During the 1530's Fontainebleau became a center of unbounded hospitality to the arts and eventually rivaled the splendor of the Italian courts at Florence and Mantua. The emphatically Italianate decorative style of the School of Fontainebleau was one of enormous complexity and grace, fitting expression of the glory of the reign of François I.

In 1540 two events took place that had an impact on the history of French sculpture. Primaticcio, one of the Italian artists working at Fontainebleau, was sent by François to Rome to have casts made of famous antiquities; in the same year Benvenuto Cellini arrived at the court of Fontainebleau. Cellini (1500–71) was a Florentine whose personality and sculptural style had a brilliant virtuoso quality. In his autobiography he recorded some of his exchanges with François, and they are most revealing about contemporary art and its relationship to the court. Cellini shows himself to be the perfect courtier when he presents to the king his design for a colossal fountain:

> "The figure in the middle is meant to stand fifty-four feet above the level of the ground. . . . It is, moreover, meant to represent the god Mars. The other figures embody those arts and sciences in which your Majesty takes pleasure, and which you so generously patronize. . . . I have attempted to portray your Majesty, your very self, in the great central statue; for you are truly a god Mars, the only brave upon this globe, and all your bravery you use with justice and with piety in defense of your own glory."

> Scarcely had he allowed me to finish this oration, when he broke forth with a strong voice: "Verily I have found a man here after my own heart." Then he called the treasurers who were appointed for my supplies, and told them to disburse whatever I required, let the cost be what it might.[23]

Cellini's principal work for François was the bronze relief of the *Nymph of Fontainebleau* for a portal of the château. He did not spend much time at Fontainebleau itself, preferring to live and work in Paris in a house just across the Seine from the Louvre. The Louvre was an out-of-date medieval structure that in the sixteenth century still served as the official residence of the royal family, although they seldom stayed there for long. François wanted to have it transformed into a more dignified and modern palace. To this end he engaged a sculptor and an architect whose collaboration came to have considerable significance in the transformation of the newly imported classical style of Italy into a native French idiom. The sculptor was Jean Goujon (*ca.* 1510–65?), who worked on the first wings of the new Louvre, effectively combining his

decorative relief style with the architecture of Pierre Lescot. The two had already collaborated on the altar screen for St.-Germain-l'Auxerrois, the parish church of the kings of France that stands beside the Louvre. Lescot's screen has been destroyed, but Goujon's sculptured bas-reliefs have been preserved. The central panel—a *Lamentation* (Fig. 93) with a diversity of poses and a complex interaction of many figures—is the most complicated relief he ever made.

When he took up the subject of the Lamentation he must have been keenly aware of it as a popular theme with a rich recent tradition. Many three-dimensional versions existed in France in the late fifteenth and early sixteenth centuries, multi-figured groups composed like *tableaux-vivants*. The spirit of these works was highly religious and their style anti-classical; Goujon took nothing from them. Instead he borrowed compositional aspects and numerous details from the very moving *Pietà* by Rosso Fiorentino (one of the best Italian painters at the court of Fontainebleau), and from an engraving by Parmigianino of the *Entombment*.[24] But these models only helped him to form a partial image, for Goujon was aiming at something quite different from the extreme emotionality of his predecessors.

Goujon divided his panel into two main groups, with the Virgin at the center and a strange, contorted figure beneath the tree. He did not establish close relationships between these sections through the usual methods of connecting gestures, glances, and pictorial space. And instead of viewing the subject as a cohesive narrative, he concentrated on the composition in terms of the surface and the rectangular shape of the relief. Goujon placed his figures parallel to the frame, with verticals repeated across the entire surface. He flattened out the volumes so that no rounding convex forms could disturb the surface continuity. The unity of the two principal groups is achieved by the complementary poses of Joseph of Arimathea on the left and Mary Magdalene on the right, both of them masterfully elegant figures in their serpentine poses. Mary Magdalene appears to be not so much a mourner as a splendid lady-in-waiting, her arabesque form fitting perfectly into a right-angled triangle and dominating the right half of the composition.

93. JEAN GOUJON. *Lamentation.* 1544–45. Stone, 31½″. Louvre, Paris.

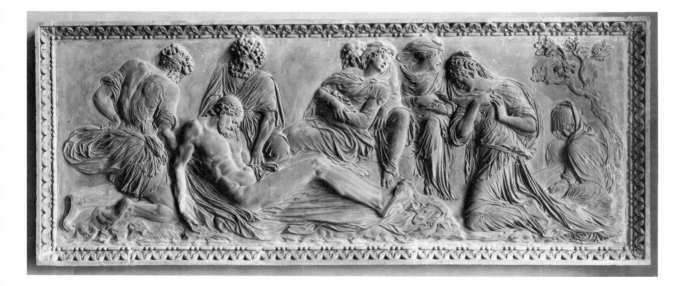

Goujon's panel has something of the orderly, rhythmic quality of a classical frieze rather than the highly concentrated narrative unity that had interested a great number of Renaissance sculptors. Another classical aspect is evident in his drapery. Few sculptors in modern times had been able to fashion such exquisite parallel folds; they are repeated in quick succession and cling to the bodies much like the drapery in Classical Greek sculpture. The drapery is linear, continuously varied in its movements and turning around each figure with wonderful ease. Goujon sharply defined the silhouettes of the figures with precise carved outlines. Many characteristics of his carving, particularly the use of the drill, are reminiscent of the techniques of Roman sculptors. With the drill Goujon, like his ancient predecessors, was able to achieve great variety of light and shade. The result of his highly controlled approach to both design and technique is a richly carved bas-relief in which the surface takes on a decorative quality that is extraordinarily cohesive. It is this that Goujon wanted to emphasize rather than the expressive potential of the religious scene.

Narrative bas-relief panels in combination with classical architecture, as the ancients knew them, were not found in France before the sixteenth century; Goujon devoted most of his creative life to exploring the possibilities afforded by such a combination. He worked continually with a low relief that would emphasize the surface, and he used monumental figures to carry the full weight of his imagery. Goujon hardly ever explored pictorial space or atmosphere. His style evolved as one of cool grace; the skill and elegance of his works became a model for later French sculptors of everything that was classical, harmonious, and aristocratic within the French tradition.

We have no record of Jean Goujon after around 1562. In the spring of that year the Duc de Guise had come upon the Huguenots of Vassy in prayer and murdered them all. Following the massacre, Protestants battled Catholics in what became a long and bloody conflict. In Paris the Huguenots were outlawed; it is generally believed that Goujon, a Protestant, went into exile at this time. The responsibility for governing the debt-ridden kingdom of France, divided by savage hatreds based on religious differences, lay upon Henri II's widow, Catherine de Médicis. As she considered all the ways to consolidate the Catholic advantages and to reinforce the position of her husband's family, the Valois, she did not forget the importance of sculptural commissions as a means of expressing dynastic and political sentiments. A sculptor she often turned to was Germain Pilon (1536/7–90), the son of a Parisian bourgeois family and a firm supporter of the Catholic cause. Pilon had a talent and a reputation in the second half of the sixteenth century equal to Goujon's in the first. The artistic background of the two men can be found in similar sources, but their styles were quite different in spirit.

Pilon also executed a relief of the *Lamentation* (Fig. 94). It is smaller than Goujon's version and was done in bronze. We are not sure how Pilon originally placed the relief, but we do know that it comes from the Parisian church of Ste.-Catherine-du-Val-des-Ecoliers, where Pilon created a double tomb for René de Birague and his wife. René, Chancellor of France under Charles IX and Henri III, took holy orders after his wife's death and died a cardinal in 1583. The king and his followers astonished the people of Paris by expressing their sorrow in public flagellation at the funeral. Now in the Louvre, Pilon's tomb for this unique couple is an ensemble of enormous individuality and power. The *Lamentation* was probably originally in the Birague chapel, but since the church was demolished in 1783 and the tombs damaged, the way the parts of the tomb were assembled remains unclear. An interesting conjecture arises from the catalogue Alexandre Lenoir made shortly after the French Revolution of art works appropriated

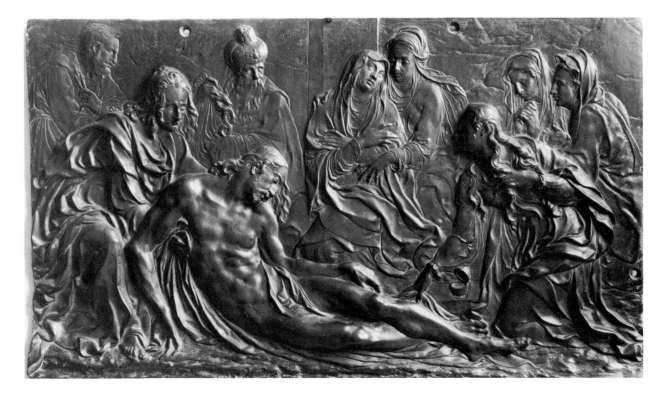

94. GERMAIN PILON. *Lamentation.* 1583–85. Bronze, 18½″. Louvre, Paris.

from churches for a new state museum. He spoke of this relief as part of Pilon's own tomb.[25] If this were true, Pilon's indebtedness to Michelangelo was even greater than is betrayed by the appearance of the relief. To have used the scene of the most precious burial to mark his own grave would not have been at all unlikely for a man of such evident passion.[26]

Pilon must have known Goujon's *Lamentation* well, but it influenced him very little, for Pilon's is a highly emotional work. The body of Christ occupies considerably more of the relief's total space, and the surrounding figures bear a more direct relationship to Christ through their placement and their gestures. By indicating the foot of the Cross with Mary in front of it, Pilon firmly established the center of the composition. He then placed his figures in depth at either side of the Cross by use of the *stiacciato* relief technique—in which the forms of the background are flattened out in order to give a pictorial effect of receding space, a device he must have learned from Italian reliefs. In this way the well-defined body of Christ in the foreground clearly becomes the focus of the group; by flattening the other figures to varying degrees and by developing only the body of Christ in a fully plastic manner, Pilon rejected the evenness of Goujon's surface and the balance of Goujon's figural sequence. Pilon's Christ takes its cue from Michelangelo's *Pietà* rather than from Goujon's more classically composed figure. There is an extremely fluid quality to the design that comes from the use of diagonals—particularly strong in the lateral figures—and from the agitated drapery moving restlessly in every direction. The glitter of light as it falls on the uneven bronze surface, which Pilon handled with superb technical facility, heightens this dynamic quality.

The tormented pathos of Pilon's interpretation, his willingness to explore expressive physiognomy to the point of ugliness (witness the fierce-eyed St. John to the left), the absence of classical beauty in his forms—all this separates him from Goujon, a fact that can be partially

understood when we compare their lives. Goujon was a Protestant, working at a time when the French court was able to give stable support to a new kind of sculpture; Pilon, a Catholic, worked during the most bloody religious upheaval in French history before the Revolution, under a court led by a succession of weak monarchs and a foreign regent. Pilon's times probably influenced his expressionistic approach to subjects and powerful individualization of figures.

The three works of the second half of the sixteenth century that we have examined—by the Florentine Bandinelli, by Giovanni Bologna, a Fleming living in Florence, and by the Frenchman Pilon—all took their inspiration from the work of Michelangelo, as was true for a large percentage of the sculpture created in Europe in these years. Our last example from this period comes from another great center—Venice, a city that remained relatively stable through the mid-sixteenth century. The Republic of Venice had not succumbed to a tyrant as the Tuscan Republic had, and her leaders looked down at the ruling class of Florence, whom they felt had been too democratic and therefore deserved their fate. The Venetian solution had been to keep power in the hands of a few patrician families who dominated the life of the Adriatic city both politically and culturally. The types of sculptural commissions called for in Venice during the second half of the sixteenth century reflected the taste of these aristocratic families: most often they commissioned their own altars for the important Venetian churches, along with portraits and funerary monuments.

Alessandro Vittoria (1525–1608), a sculptor from Trent, was a leading recipient of such commissions after 1552, when he left the workshop of Jacopo Sansovino. In the 1560's he executed a large altar for the Zane family in S. Maria dei Frari which Vasari (1568 ed.) described as "the best work he has produced till now." The only large marble piece from the altar that has survived is a six-foot statue of *St. Jerome* (Fig. 95). St. Jerome was the Venetians' chosen Church Father. His attribute was the lion, also identified with Venice's patron saint, Mark, and thereby the city's most pervasive symbol. Here the lion at Jerome's feet is clearly an attribute and is treated in a more archaic manner than the figure itself. Vittoria depicted St. Jerome, a familiar subject in Venetian painting, in a most unusual way: instead of the slender and ascetic man of the desert, he showed a gigantic figure rushing forward while beating his athletic chest with a rock (symbol of his penitential life) and furiously reading the book he grips in his immense hand (a reminder that he was the scholar who translated the Bible). This is hardly a naturalistic vision; rather it is an intensely personal interpretation of the early Christian saint.

Vittoria's concept of the human figure as a strong and abruptly moving plastic form derives from his appreciation of Michelangelo. A document of 1563, just about the time he received the Zane commission, informs us that he purchased a model "by Michelangelo's hand of the foot of *Day*," [27] one of the male allegorical figures in the Medici chapel. Vittoria introduced a serpentine movement into the torso of his *St. Jerome*, less dynamic than that of Michelangelo's *Rebellious Slave* (Fig. 1) but related to it, and also introduced a ponderous, angular movement into the arms that echoed the contrapposto in Michelangelo's *Moses* (S. Pietro in Vincoli, Rome). The intensity of expression, the long twisting beard, and the rendering of anatomical details are also reminiscent of *Moses*. In combination with these Michelangelesque forms, Vittoria worked out his own uniquely dramatic and coloristic carving style with surfaces sensitive to light and shadow. The great diagonal swath of drapery over the saint's hip acts as a foil to the body; the legs stand away from it, and the arms protrude from the torso. The entire figure is much less block-like in effect than a Michelangelo figure.

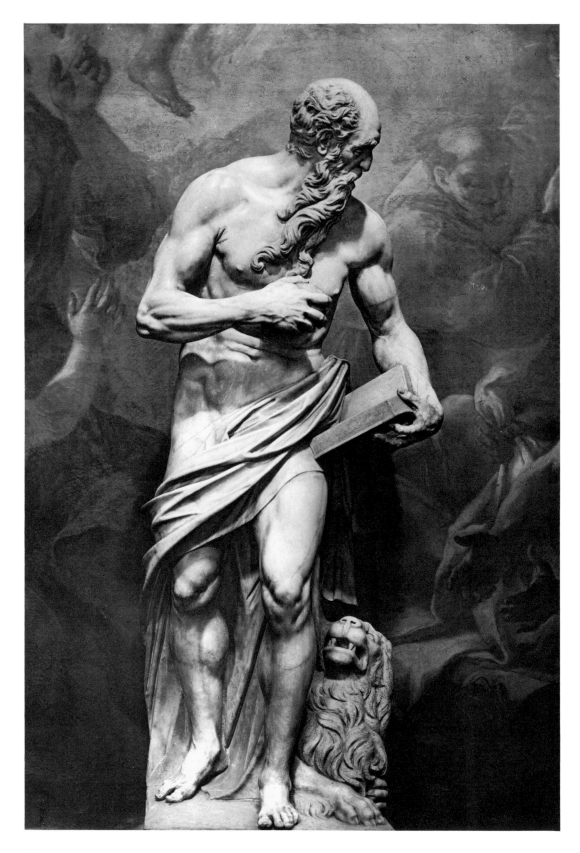

95. ALESSANDRO VITTORIA. *St. Jerome.* 1560's. Marble, 6′3″. S. Maria dei Frati, Venice.

Because of Vittoria's interest in pictorial elements, especially light and shade, he eventually began to model and cast his works—a process more conducive to producing coloristic effects than is the carving of stone in Michelangelesque fashion. By combining strong physical forms with dramatically modeled surfaces he was able to render religious and mythological figures with enormous feeling and poetry.

To sum up the sculpture of the sixteenth century we must return to Michelangelo himself. His *David* of 1501 brought something distinctly new to sculpture—man conceived in a heroic form and acting as a vehicle for an idea in a singularly expressive way. Michelangelo worked in different styles throughout his long career, but in all of them he showed that contrapposto offered the widest possibilities for infusing meaning into the human form. The ancients had known this, but Michelangelo expressed a very personal view of it, and it was his perception that had the greatest influence on Western sculpture down to the nineteenth century. The sculptors of the sixteenth century affirmed in the most positive way since antiquity the sense of sculpture as a plastic force with great tactile value; they made this clear primarily by emphasizing the massiveness of the body—head, shoulders, chest, stomach, buttocks, and thighs. They freed sculpture from architecture in order to concentrate on its three-dimensionality. The majority abandoned color and relegated all accessories to a secondary position. The impetus for the primacy of the human figure lay, of course, in humanist doctrine, and even survived the collapse of the humanist movement, retaining its force and validity right through the period of the Counter-Reformation and the wars of religion.

. . . nature teaches me that my own body is surrounded by many other bodies, some of which I have to seek after, and others to shun. And indeed, as I perceive different sorts of colors, sounds, odors, tastes, heat, hardness, etc., I safely conclude that there are in the bodies from which the diverse perceptions of the senses proceed, certain varieties corresponding to them, although, perhaps, not in reality like them; and since, among these diverse perceptions of the senses, some are agreeable, and others disagreeable, there can be no doubt that my body, or rather my entire self, in as far as I am composed of body and mind, may be variously affected, both beneficially and hurtfully, by surrounding bodies.

René Descartes, *A Discourse on Method*, 1637.

Does your bosom then bear more livid traces of the marks of the stone's repeated blow than were ever stamped on St. Jerome's? . . . Where are the cheeks, more wrinkled through fasting? Where are the knees, more hardened through praying? Where are the arms, more wearied with scourging? Where are the eyes, more swollen with floods of tears? Do the midnight vigils, which you have regularly observed, either in meditating upon the Scriptures or in writing comments upon them, surpass the vigils kept by St. Jerome?

Padre Paolo Segneri, "On Avoiding the Occasions of Sin," *Lenten Sermons*, 1679.

FIVE

The Seventeenth and Eighteenth Centuries

The Search for Forms
to Reveal Feeling and Experience

Pope Clement VIII declared 1600 a Jubilee Year. Three million pilgrims came to Rome to witness the splendor of the papacy and the grandeur of the city. Clement's recent predecessor, Sixtus V, had worked to re-establish the physical magnificence of Rome, giving her a modern plan, bringing in water, and erecting new churches and monuments. Clement now worked for the restoration of the glory of the Church, overseeing the reconciliation between France and Rome; during his papacy the Roman Catholic Church regained the position of power which the northern reformers had shaken so severely during the sixteenth century. But the stern spirit of the Council of Trent, which had established an arsenal of doctrinal weapons for the Counter-Reformation, was not forgotten, even in a holy city celebrating the threshold of a new century. The Inquisition continued to thrive and to brand creative contemporary thinkers as heretics.

This fate overtook Giordano Bruno, who had responded to the challenge of Copernicus' scientific inquiries by recognizing that the Copernican theory gravely altered the status of the earth and of man in the universe. To medieval man, the earth—the center of the universe—was totally different in kind from those distant, perfect, unchanging spheres of the heavens. Copernicus proposed a view of the cosmos in which the earth was not the center but merely part of the whole, sharing with the heavens an indivisible nature in an infinite space.

The Copernican view inspired Bruno's statement that "man is a mirror within a mirror," thus adding a new dimension to the humanistic concept of man. In the "erroneous" book for which he was condemned and burned in the Campo dei Fiori in Rome in 1600, Bruno described the universe:

> . . . the flaming bodies of space are the messengers of God, declaring his excellent glory and majesty. Thus our vision is enlarged to behold the infinite effect of the infinite cause, and we are taught to seek the divinity not far off but closer to us than we are to ourselves.[1]

He wandered throughout Europe speaking of these concepts, and his martyrdom was in the cause of intellectual freedom. Bruno's scientific writings contained new ideas about physical substances and sensory experience, yet they were infused with the poetry of his own emotions.

This combination of subjective and objective insights was to appear frequently in the work of many seventeenth-century artists.

In the history of ideas the seventeenth century is significant as a period when scientists made great strides toward an understanding of nature, particularly of human physiology and of the motion of bodies in space. Yet despite their quest for more certain knowledge about natural phenomena through empirical as well as scientific methods, they wanted to explain physical existence in terms of mathematical patterns that could serve as a universal interpretation of life. Descartes offered the period's most comprehensive description of man's body: he saw it as a beautiful machine. This way of viewing the human form had little in common, however, with the images set forth by the most inventive artists of the time. Descartes' system, it has been pointed out, gave greater support to the theorists of academic art than to those of any other persuasion; indeed, both Descartes and Galileo were quite partial to idealist art forms.[2] It is not surprising, then, that the scientists' new interpretations of nature appear to have had little effect on the way men revealed themselves in the visual arts. Nevertheless, it should be kept in mind that in the seventeenth century there was a general climate of belief that nature could be understood, for it was a time when all physical phenomena held a profound interest for every curious mind.

By and large, artists working in Rome during the seventeenth century favored art forms in which the depiction of physical experience was fundamental. This was even true (perhaps we should say especially true) when they were depicting an event or a state of being that was neither normal nor fully comprehensible—such as a miracle or an ecstatic trance. Baroque artists were preoccupied with explaining man's being at the moment he experiences mystical union. The man who did so most successfully in visual terms was Rome's leading artist, Gian Lorenzo Bernini (1598–1680), a sculptor who served eight popes during his long life. Vision, transport, and ecstasy—the most extreme manifestations of faith—these were themes Bernini explored in three-dimensional form in his mature years.

Upon seeing his *St. Jerome* (Fig. 96), the first thing we are aware of is the saint's closeness to Christ. Vittoria's saint held a book and a rock; Bernini's holds only the Crucifix. Nor does he hold it simply as a symbolic attribute: he seems to breathe it into his very being. Bernini's treatment of this figure renders palpable Jerome's religious experience. His attenuated body bends in an arc around the beloved image, drawing our attention irresistibly to the left, where the Crucifix is cradled between the saint's fingers and head. The body's flexibility conveys the impression of activity, activity concentrated on the left side, the side of the Crucifix. Jerome's right leg is straight and is covered by vigorous folds of drapery; his right arm descends, the hand acting as a fulcrum at the center of the body, where diagonals—the arm, the Crucifix, and the drapery—converge from all directions. The broken folds of the thin drapery flutter lightly around the body, one loose fold protruding beyond the niche toward the spectator's space. Never before the seventeenth century has a marble surface been carved quite like this, with so much undercutting, so many angular indentations, such bold projections. The stone is transformed—it is no longer a solid mass of rock, but an ever-changing surface of color, light, and shadow. Bernini is unmatched in his realization of pictorial effects in a block of marble without the aid of polychromy. He was very conscious of these effects, and he once explained how he achieved such illusionism: "In order to render the bluish-black that some people have around their eyes, the marble must be hollowed out at the point where these darkenings are, in order to give the effect of this coloration." [3]

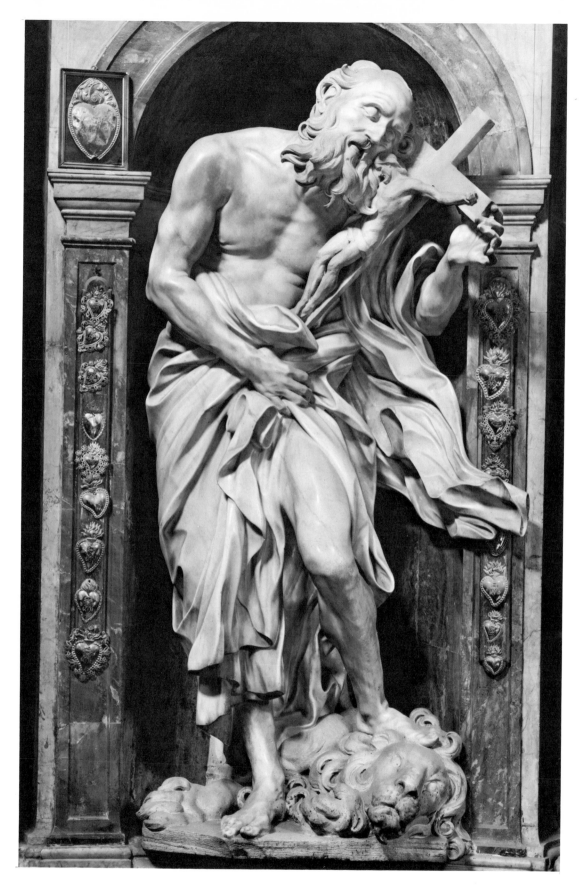

96. GIANLORENZO BERNINI. *St. Jerome.* 1661–63. Marble, 6′4″. Chigi Chapel, Duomo, Siena.

To create the animated chiaroscuro of the *St. Jerome*, Bernini utilized not only the effects of the carved surface but also the way in which the natural light strikes the statue. Since the chapel in which the *St. Jerome* stands was his design, he was able to control that light. This was the kind of artistic situation he favored, an environment totally created by him. He placed the statue within a niche, the most traditional setting possible, but by means of color and proportional relationships he significantly altered its orthodox character: the concave surface of the niche was covered with a dark marble so that it became a shadowy container out of which the transfigured saint moves, and the figure is over-lifesize, and thus it could not be shown standing erect in the niche. These devices give the saint's vision a feeling of urgency. Statue and niche can not be separated; though freestanding and thoroughly plastic in conception, the statue is totally dependent upon the background and, like a painting, can be seen only from a single point of view.

The image of the elderly penitent is treated in a highly naturalistic fashion: old wrinkled flesh combined with carefully depicted anatomy creates the impression of a figure at once frail and muscular. The face is particularly compelling—boldly asymmetrical, with a large nose, cavernous cheeks, closed eyes, and a toothless mouth emerging from the unkempt beard and mustache. And the lion crouching beneath the saint's foot seems not so much an attribute as a compassionate companion.

Bernini's statue contrasts sharply with Vittoria's *St. Jerome* (Fig. 95), both in the unity of its conception and in the powerful emotion represented. Vittoria's saint is a ponderous figure striding forward aggressively, with the clear forms of his limbs arranged in a measured contrapposto. The composition is orderly, each part being carefully described; the three separate attributes can be understood intellectually and viewed with detachment. Bernini on the other hand planned his statue around a single action, with every element contributing to that action. In his statue we see Jerome's face as we can not in Vittoria's, and its psychological component is intense. The entire spirit of this old man infused with divine light becomes immediately manifest to anyone who stands before it in the little Chigi chapel in the Duomo of Siena.

Bernini carved the *St. Jerome* between 1661 and 1663, when he was well advanced in his career. He created it for an old friend, the Sienese cardinal Fabio Chigi, who was but a year younger than Bernini. Chigi had become Pope Alexander VII in 1655 as the result of an extraordinary eighty-day conclave. This event was a stroke of luck for Bernini, for once again, as with Urban VIII, a close friend and protector had ascended to the papacy. Bernini's biographer, Filippo Baldinucci, tells us:

> The sun had not yet set on the day that was Cardinal Chigi's first in the office of Supreme Pontiff when he sent for Cavalier Bernini. With expressions of the utmost affection he encouraged Bernini to embark upon great things in order to carry out the vast plans that he had conceived for the greater embellishment of God's temple, the glorification of the papacy, and the decoration of Rome.[4]

During Chigi's papacy Bernini had not a moment to spare, so numerous were his commissions from the pontiff. Two results of this papal patronage were of particular importance: the maturing of Bernini as an architect, and his full exploration of the Baroque image of ecstasy. Immediately after Chigi's consecration Bernini began work on two statues for the pope's family chapel in S. Maria del Popolo, his titular church in Rome. At the end of the decade came the commission for the *St. Jerome*: the pope decided that his family chapel in the Cathedral of Siena should be completely redone; he entrusted the project to Bernini, who supervised its execution

from Rome, leaving for himself the carving of the principal statues—*St. Jerome* and *Mary Magdalen.* These were done in the space of about a year and a half, during the period when Bernini was most deeply involved with new projects at St. Peter's (including the colonnade, the Cathedra Petri, and the plans for the Scala Regia). His studio assistants must have worked on the two statues as well, but it is generally believed that Bernini carved much of the *St. Jerome* himself.

Bernini was the most influential artist of the seventeenth century. For a period so marked by genius, this statement might seem too sweeping, but not even Rubens inspired as many artists as did Bernini. The extraordinary range of genuinely imaginative changes that Bernini wrought in all the traditional sculptural types—religious images, equestrian monuments, tombs, fountains, and portrait busts—had the most far-reaching effects.

Portraits were among Bernini's first efforts in sculpture. Baldinucci records that he carved the head of a Roman monsignor into a pilaster in S. Prassede "shortly after he completed the tenth year of his age," and he was still a teenager when he made his first bust of a pope (*Paul V,* 1618).[5] From then on Bernini was flooded with commissions for portrait busts. He knew better than anyone else how to depict the face of a pope, a king, a minister, or a cardinal as the subject himself wanted to be seen.

In the busts of the 1620's the young sculptor experimented with surface variations and coloristic effects; he also mitigated the abrupt truncation of the traditional portrait bust by depicting his sitters in new asymmetrical poses full of movement. These innovative portrayals were so highly regarded that in 1635 Urban commissioned him to do a portrait bust of King Charles I of England, regarding it as an appropriate political gift for the Catholic Queen of that Protestant realm. Bernini based the bust on a triple portrait which Van Dyck had painted especially for the purpose. Though that sculpture has been destroyed, a copy and an engraving show how Bernini, working without the sitter, was able to develop his ideal image of a sovereign ruler—a proud face looking imperiously into the distance above a broad body, regally dressed and moving slightly.

In the early 1650's he was involved in a similar commission for one of Italy's most brilliant princes, Francesco I d'Este, Duke of Modena. Francesco, an ambitious and crafty man, was head of an old and powerful family that had recently suffered a sharp blow to its dynastic prestige through the loss of the city of Ferrara. Francesco used all his cunning to try to restore glory to the family's estate, employing every device within his reach, including war, diplomacy, marriage, and art. He commissioned artists from all over Italy and Europe to work for him—Velázquez, Sustermans, Salvatore Rosa, Guercino, and Guido Reni among them. A large number of portraits had been painted of this exceptionally handsome prince and three of them were sent to Bernini when he agreed to do a marble bust (Fig. 97). He worked on it for fourteen months and when he had finished declared that it was too difficult to work from a painting and that he would never do so again.

The Este commission lent itself to the creation of an idealized type more than to the portrayal of an individual. This type of portrait of the modern prince who reigned as absolute ruler over an opulent court had developed in the sixteenth century, first in Italy and then throughout Europe. An excellent example is Benvenuto Cellini's portrait of Cosimo I de' Medici, Grand Duke of Tuscany (Fig. 98), in which we see this portrayal of power. The head, with its imperious gaze, turns abruptly to the right in a tense movement; the body is greatly stressed, due to Cellini's remarkable ability to describe the anatomy of the chest beneath the

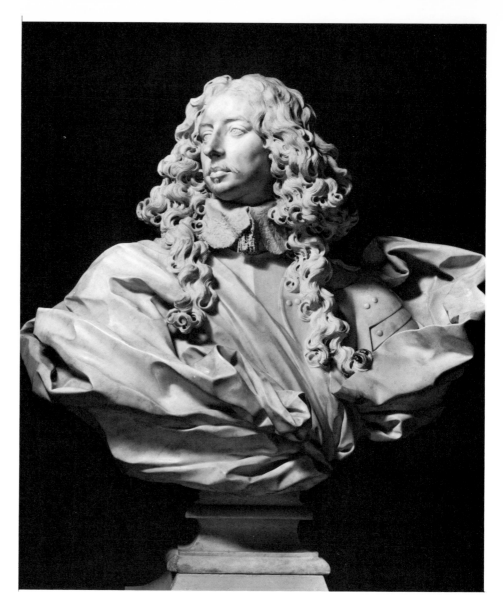

97. GIANLORENZO BERNINI. *Francesco d'Este.* 1650–51. Marble, 3′2½″
(with base). Pinacoteca Estense, Modena.

elegant Roman armor. A cloak falls over the left shoulder and then is tucked up under the right
arm, helping to stress both the breadth and the asymmetry of the composition.

Sixteenth-century Florentine portraiture, especially as practiced by Cellini, was influential in
Bernini's search for a type of heroic portrait bust that would be imposing, asymmetrical, and
would show the body in movement.[6] In the Este bust Bernini broadened the whole design,
adding a flowing garment over the Duke's armor, which—like Cosimo's—was obsolete and
symbolic (it is highly unlikely that such a garment was portrayed in any of the paintings Bernini
worked from). He exaggerated the wig as well, expanding the volume of curls on either side of
the face and attenuating the tresses cascading down the chest.

The most important aspect of Bernini's composition is the relationship of the head to the
body. Here, as in his full-length figures, he stresses torsion, showing the head—with chin held
high—turned fully in a direction running counter to the body. Not only is there more
movement than in Cellini's work, but its very nature is more fluid; Cellini's *Cosimo I* looks
frozen and strained by comparison. The heightened sense of movement in Bernini's sculpture is

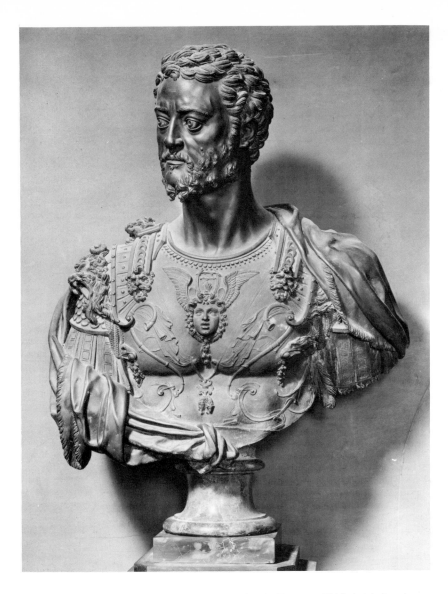

98. BENVENUTO CELLINI. *Cosimo I.* 1545–47. Bronze, 3′6″ (with base).
Bargello, Florence.

particularly enhanced by the drapery; the right side of the body is entirely covered with long irregular folds which are lightly caught up under the left arm and then released in a loosely fluttering mass around the smoothly armored upper arm. The resulting outlines are thus in extreme contrast, and the dissimilarity of the right and left sides anticipates that of the *St. Jerome.*

Bernini did not know his sitter well; the Este commission was political in nature, and Bernini did not stress Francesco's private character. The bust he carved appears to float on a billowing cascade of drapery and creates for us the vision of a triumphant leader, the secular equivalent of saintly ecstasy. Thus it is not difficult to see why this kind of image became so desirable to Divine Right rulers, ever seeking to reinforce popular belief in the legitimacy of their power. Even in England, where the social and political climate of the court of Charles II was far removed from that of the courts Bernini served—England with its Divine Right king who was under obligation to consult Parliament, its diversity of religious beliefs, and its economy based upon a growing mercantile empire—sculptors found it possible to create portraits in the style we identify with continental pomp.

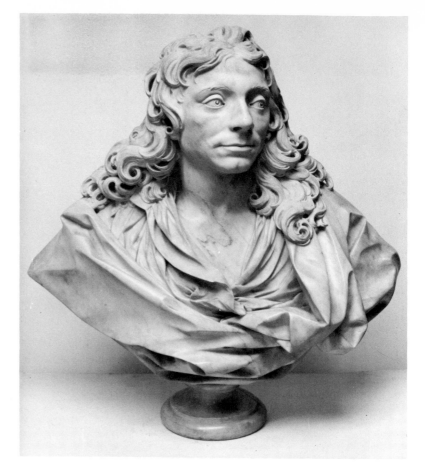

99. EDWARD PIERCE. *Sir Christopher Wren.* 1673. Marble, 2'1".
Ashmolean Museum, Oxford.

Edward Pierce (*ca.* 1630/35–95), though primarily a mason-sculptor who designed buildings and carved their ornaments, created some portrait busts in the new Berninesque style. His finest work, and one of the outstanding sculptures created in seventeenth-century England, is the bust of Sir Christopher Wren (Fig. 99). Pierce, the son of a painter, had learned his art in the traditional apprenticeship system and worked as a mason for Wren when the latter, as Surveyor of His Majesty's Works, was directing the rebuilding of London after the Great Fire of 1666. Charles II knighted Wren in 1673, and perhaps it was that honor that decided the architect to ask his subordinate Pierce to carve the portrait, which was done about this time. Wren was just past forty; he was a frank and even-tempered man, slightly built, with an unusually wide mouth and steady gray eyes. The remarkable thing about the bust is that Pierce was able to capture the qualities described by the sitter's contemporaries, his intelligence, his reticence, and his lack of affectation, and yet do it in the lively Baroque style of the continent, one that was not at all typical of English sculpture of the 1670's.

Pierce's bust is unified; the body is broad, as is often the case with Bernini's busts, and the general outline is diamond-shaped and asymmetrical. A quiet, understated stress is given to the left side by the turn of Wren's head in that direction, as well as by the fall of his hair and the folding of the voluminous cloak thrown lightly over his open-necked shirt. Through skillful handling of the cloak and its irregular edges Pierce avoided any sense of truncation in the chest. He carved deep channels and angular grooves into the drapery, sensitively contrasting the thin shirt with the heavier cloak. In order to animate the natural-looking curls, Pierce made liberal

use of the drill, and he carefully recorded the details of the facial features—the eyes, with deeply incised irises, looking up and off into the distance; the high cheekbones; the diagonal wrinkles across the cheeks; the slightly cleft chin. But the high style, dramatic interplay of diagonals, and brilliant surfaces characteristic of Bernini's mature portrait busts are not found in this quiet work; indeed, they would have been in the spirit of neither Pierce nor Wren.

Pierce combined careful study of a man he knew intimately with the new seventeenth-century portrait style, which lent itself to a portrayal of the sitter as an assured and energetic human being. That this was a conscious stylistic choice is made clear by his earlier portrait busts, which are restrained, flat, and symmetrical, with sharp edges and crisp details (his posthumous portrait of Oliver Cromwell—created shortly before the bust of Wren—is in this more old-fashioned style). It is tempting to see the sculptor's choice of style as being partly influenced by the highly developed taste of his sitter. Wren had spent almost a year in Paris in the mid-1660's, during which time he had met briefly with Bernini, who showed him sketches for the bust he would make of Louis XIV. Whether or not it was under the influence of Wren and Berninesque portraiture that Pierce developed his own unified and flowing image, it is also true that there were in London at that time two well-known portraits by Bernini for him to study—the bust of King Charles I and that of Thomas Baker, both done in the 1630's. Once Pierce had created his portrait of Wren, he found the new style eminently suited to portraits of bourgeois professionals—who seem to have been his primary clients. For them he developed an English version of the Baroque bust.

The English had a strong tradition of personal and family prestige that was to be found in both the middle class and the aristocracy. It was comparable in many ways to ancient Roman tradition, and like the Romans, the English were inclined to commission sculptors to carve their tombs and their portraits. Quite the opposite was true of the culture of England's traditional enemy, Spain—a society little given to recognizing the individual, his family, or his accomplishments within the social order. Painters were occasionally called upon to execute portraits of persons outside the royal circle; sculptors never. But more than any other group of artists in seventeenth-century Spain, the sculptors gave visual expression to the intense fervor of the Spaniards' religious experience and to the extreme orthodox position taken by Spain during the Counter-Reformation.

Religious requirements totally dominated seventeenth-century Spanish sculpture. Not only were images fundamental to devotional practices, but their emphatic use was part of Spain's orthodox posture against Protestant iconoclasm. In the fifteenth and sixteenth centuries a national style of sculpture had developed in the great wooden *retablos*, which fused architecture, sculpture, and painting in the narration of the essential Gospel events. Needs changed in the seventeenth century, and sculptors were now called upon to make large figures and groups in the round (though again carved in wood and painted as realistically as possible). The new imagery was linked to the mood of contemporary Franciscan and Carmelite reform movements and to the search on the part of a large segment of society for a real sense of the Divine in their everyday lives. Many Spaniards at this time joined secular confraternities and lived in conventual houses, dedicating their lives to God. Participation in religious processions, especially during Holy Week, became a way in which man could relive Christ's Passion and ultimately know God. The *pasos*—groups of exceedingly realistic sculptured figures representing the characters in the story of the Passion—played a central role in these emotional

extra-liturgical celebrations of the people. In seventeenth-century Spain, as in no other European country, a powerful sculptural style was created that was accessible on all social levels.

Gregorio Fernández (1576–1636) was one of the sculptors instrumental in popularizing the story of the Passion in simple, direct, and vividly dramatic terms. A northerner from Galicia, he moved to Valladolid at the beginning of the seventeenth century. When he arrived, that city was the cultural center of Castile, with Philip III's court in residence there. Philip, Europe's most pious monarch, promptly commissioned a *Dead Christ* from Fernández. When the court departed for Madrid in 1606, the sculptor remained in Valladolid to work primarily for convents and confraternities. Fernández rapidly emerged as the region's foremost artist. Working in a monastic environment was probably quite to his taste, for his own faith was sincere and profound. Though he did not himself carve many *pasos*, his sculpture was essential to the development of a style suitable for that kind of popular imagery, and his best-known group—the *Pietà* (Fig. 100) carved for the Confraternity of Charity in 1616—was created for use in processional celebrations.

100. Gregorio Fernández. *Pietà*. 1616–17. Polychromed wood. National Museum of Sculpture, Valladolid.

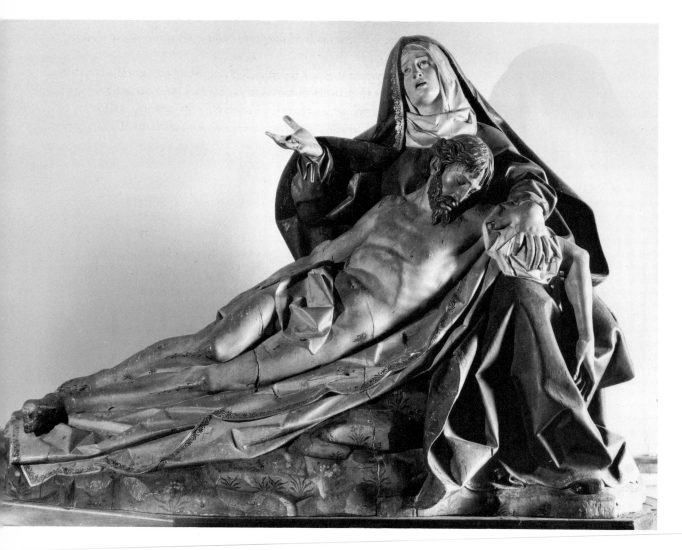

Here is the Pietà in its most essential form, a spiritual descendant of the groups created in northern Europe during the Late Middle Ages, when it was first carved as a freestanding sculptural image. Christ's pale, blood-stained body lies stiffly on a white sheet spread across the rocky ground. We have little awareness of Mary's body, subordinated to Christ's, its broad, gesturing form covered by a billowing blue mantle. It is Mary's dramatic attitude that expresses sorrow with which the beholder can identify. Commentators have sometimes held that Fernández's abiding concern with the emotional aspects of Christ's Passion led him to neglect such purely artistic concerns as composition and proportion. From the point of view of Italian art and the classical heritage this might be true; nevertheless, the two figures here, established as opposing diagonals interlocking within a triangle, present a simple, stable, and coherent composition. The surfaces of Christ's body are unbroken and somewhat schematized; there is no detailed description of anatomy as there is in works previously discussed (Figs. 86–89). The smoothly outlined corpse and the white cloth stand out against the deeply carved blue mantle, while the color of the blood streaking Christ's face is echoed by the Virgin's red dress.

Color is essential in the heightened realism of seventeenth-century Spanish sculpture. The medieval tradition of polychrome wooden statuary continued unbroken in Spain. Now, however, instead of the unnatural harmonies set off by the lavish use of gold as in medieval art, sculptors sought naturalistic color effects. The sculptors usually carried out the final stages of a work in collaboration with a painter. Marcelo Martínez, a painter for whom Fernández had considerable respect, is mentioned in the contract for the latter's Pietà, and we may assume the painting of the group was his work. His skill can not now be fully appreciated because of eighteenth-century repainting of the draperies. Nevertheless, the gray-white color with which Christ's flesh is rendered is original and strongly reinforces the physical naturalism. The glass eyes of the Virgin, a usual feature of Fernández's work, also heighten the effect of reality. Creators of popular sculptural imagery in Spain used such combinations of materials—glass eyes and tears, real hair and eyelashes, cloth garments, metal crosses and halos—in a way that has few parallels except in primitive sculpture and twentieth-century assemblage.

Fernández was one of the first sculptors in post-Renaissance Europe to find a style that diminished the barrier between beholder and image. Bernini, working later and in a more complex Baroque style, also sought this immediacy. He too believed that pictorial devices and color helped to achieve this end, but he worked with them in a different manner. If we compare the head of Fernández's Virgin (Fig. 101) with the head of Bernini's St. Teresa (Fig. 102) from the group made for the Cornaro Chapel in the 1640's, we see something of that difference. The dramatic situation is similar: a young and beautiful female face is depicted in extreme emotion at a specific moment, the one in ecstasy, the other in lamentation. The uplifted faces with open mouths show the same impulse toward a Divine encounter; the eyes—one pair half-closed and fluttering, the other bright, open, and searching—rest in deep sockets. Fernández scraped his surface smooth, cleanly blocking out the features; he relied on paint and on the eyes to convey the emotions to their fullest. If we study the contours of the eye sockets—triangular, with an upward slant—we see that the painted eyebrows reinforce the shape and thus the direction of the glance. But Bernini's pure white marble eyes are no less effective. He fashioned a surface where color is achieved through the play of light and shadow—strong around the lips, in the middle of the chin, across the forehead, at the rims of the eyes. As Bernini himself explained, "the natural is not the same thing as imitation"; and "in order to imitate the natural [it is necessary to] create that which is not in nature." [7]

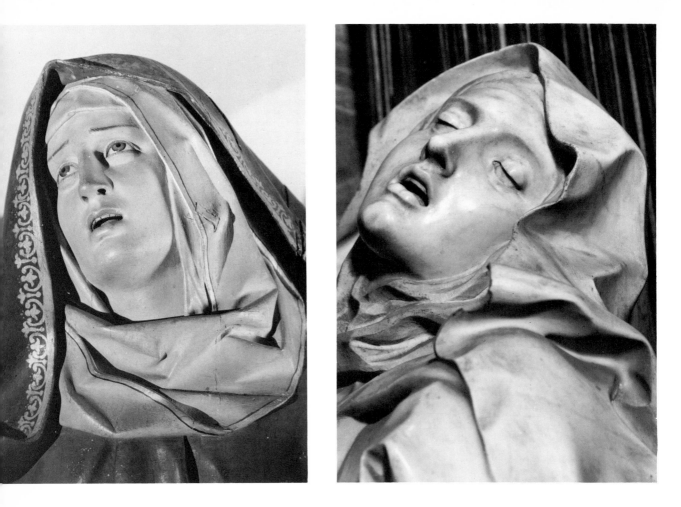

101. GREGORIO FERNÁNDEZ. Detail of Fig. 100.

102. GIANLORENZO BERNINI. *Ecstasy of St. Theresa.* 1642–52. Marble, lifesize. Detail of the head. Cornaro Chapel, Santa Maria della Vittoria, Rome.

When Fernández died in 1636, he had been the most prominent sculptor in Castile for more than a quarter of a century. His statues and groups became prototypes, and seventeenth-century Castilian sculptors continued to elaborate both his emotional approach to religious subjects and his naturalistic manner of treating them. All the same, as a center of sculpture Castile did not thrive during the seventeenth century. It was the southern province of Andalusia and the city of Seville that reigned supreme. The largest city in Spain and a center of industry and international commerce, Seville was also a city of high religious fervor. And there, as elsewhere in Spain, the Counter-Reformation had brought on severe persecutions; the plazas of Seville witnessed many autos-da-fé, which continued into the seventeenth century when Philip III's edict of 1609 called for the expulsion of the Moriscos—the Spanish Moors who had accepted Christianity but who were suspected of retaining their allegiance to the Mohammedan faith. It was an ambiance that included persons who were intensely Catholic as well as those who were "reconciled" to the Church, having been able to silence within themselves the profound questions that must have plagued their faith. In Seville, as in northern Spain, the sculpture that was best suited to the contemporary religious situation was based on a restricted number of devotional types, carved simply and directly in wood and painted as realistically as possible.

Juan Martínez Montañés (1568–1649) was the region's outstanding sculptor. Though he never left Andalusia, except for a brief visit late in life to Madrid, he had a national reputation by his thirtieth year. In that same year, 1598, Philip II died in his great palace of El Escorial near Madrid, and Montañés was chosen to make the statues for the monarch's catafalque "because he is so highly esteemed for his art and other fine qualities that are joined in his person." [8] Philip III became his regular patron, placing numerous orders for his celebrated tabernacles as gifts to missionary settlements in the New World. The monumental *retablos* Montañés made for the local churches and monasteries of Seville are mostly two- and three-storied structures with a central compartment reserved for a large image, usually the patron saint of the chapel or church, the Crucified Christ or the Virgin Mary. An image often required of Montañés was the Immaculate Conception, a theme of particular importance in Spain, where the controversial doctrine that the mother of Jesus was free of original sin from the moment of her conception found its most ardent supporters. When Montañés first represented this theme in 1606 for the church in the hill town of El Pedroso, the Feast of the Conception had only recently been elevated to the rank of a major feast day. The contract for Montañés's final version of the *Immaculate Conception* for the Cathedral of Seville (Fig. 103) was drawn up in 1628, six years after Pope Gregory XV, acting primarily in response to the hierarchy of the Spanish Church, issued a decree imposing silence on all those who opposed the doctrine.

Very often we find that a work of art with great aesthetic appeal also has great originality. Donatello's and Michelangelo's statues of *David* astonished Renaissance audiences not only because of their beauty but because nothing like them had ever before been done. The *Immaculate Conception* in Seville by Montañés, on the contrary, is anything but innovative: the general type, which was a creation of the artists of the sixteenth century, had been repeated over and over again. When Montañés began to carve the *Immacolada*, her appearance was completely formed in his mind. His vision was close to that of Francisco Pacheco (1564–1654), his friend and collaborator, who wrote: "In this loveliest of mysteries Our Lady should be painted as a beautiful young girl, twelve or thirteen years old, in the flower of her youth. She should have pretty but serious eyes with perfect features and rosy cheeks. . . ." [9] Though Montañés's Mary is more mature than this, the sculptor knew in advance that he would pose her standing on cherub heads in a classical stance, her weight shifting and one knee coming forward; that he would carve a rich mantle falling from her shoulders and encircling her body; that he would place her praying hands in front of her bosom and turn her head slightly in the opposite direction. The chief artistic problem was to make her more beautiful than anyone, including himself, had ever done before. In the end Montañés created a figure of great beauty, but it is so quiet, its beauty so reserved, that it is difficult to explain why it became the ideal representation of a theme which had been taken up by almost every major Spanish artist of the seventeenth century.

Though slightly under lifesize, the figure of Mary has great majesty. This the sculptor accomplished with judicious proportions—by broadening the form and extending it into depth, while keeping the verticals strong and coherent. Mary stands firmly on the ample base formed by cherub heads and a crescent moon. Her left foot advances to initiate the figure's extremely understated and delicate contrapposto movement. The drapery—in gold, red, and blue—is rich and classical, with multiple folds gathered softly and then released in long, radiating pleats. Beside this subtle rhythm, the drapery in Fernández's *Pietà* appears abrupt and angular.

The polychromy of the *Immaculate Conception* was executed by Pacheco and Baltasar Quintero (active 1606–38), who worked according to Montañés's instructions as to what should

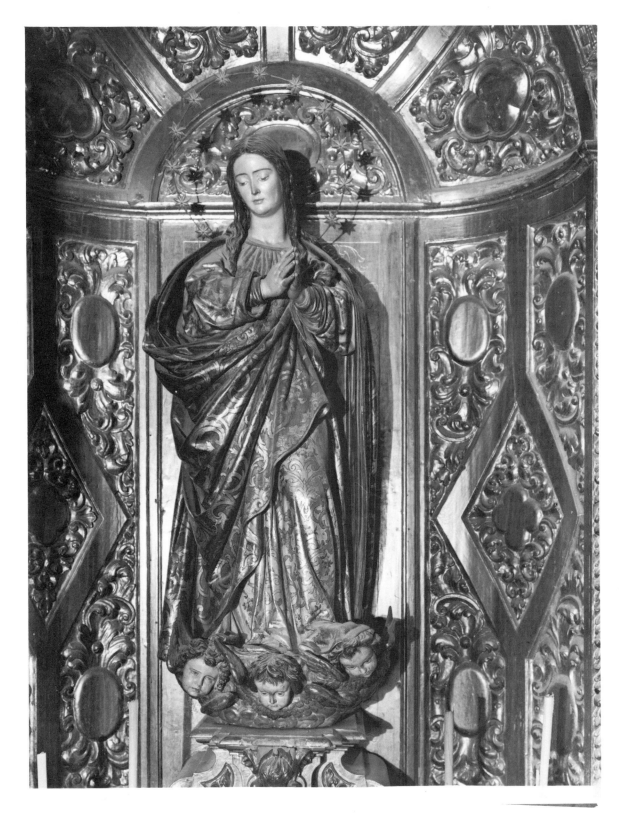

103. JUAN MARTINEZ MONTAÑÉS. *The Immaculate Conception.* 1628–31. Polychromed wood. Cathedral, Seville.

be gilded and what painted. Pacheco, whose painting academy was of primary importance in the cultural life of Seville, was one of the foremost practitioners of *estofado*, the technique of painting over gold on statues. (The arts of gilding and *estofado* were considered on the same high level as painting and sculpture in seventeenth-century Spain.) As we have already seen, Pacheco had a special interest in the theme of the Immaculate Conception; in 1620 he had written his first paper discussing the doctrine, and in the following year he executed two paintings of the subject, as he did again in 1624.[10] When Pacheco joined Montañés, he too had a fully formed concept of the figure that he would be working on, and his concept was considered of equal importance to that of Montañés. His work included the careful application of gesso on wood (it had to be thin enough not to blur the carved surfaces). Over this he laid the red bole to hold the gold leaf and then primed the gold surface with white lead before applying the egg tempera colors. The face was most important: "One must begin by outlining lightly the forehead and eyes. The eyebrows must be marked first in fresco preparatory to the detail work. I do not use eyelashes [of real hair] because they spoil sculpture, but rather strokes of color smoothly blended together." [11] One of Pacheco's special talents in *estofado* was his use of matte tones for the flesh. The final touch was a varnish—"an egg white varnish, applied twice, is very good for this because, as everything else is matte, the faces come alive and the eyes sparkle." [12]

Artists and their ecclesiastical patrons in the seventeenth century were confident that the powerful presence of sculptures such as Montañés's *Immacolada* could be understood by the people and lead them to greater spirituality. Montañés shared this idea with his contemporaries; like Fernández, he lived his Catholicism—fasting, prayer, and the taking of the Eucharist being part of his personal preparation for carving a statue. For both men religious fervor was a more decisive element in their work than the awareness of any foreign styles. But the direction it took in Montañés's work—a tireless search for a restraint and quietness that could nevertheless convincingly portray a holy person as utterly receptive to divine penetration—differed considerably from the emotionalism of Fernández's work. Montañés was guided in his search by his sense of ideal forms, balanced proportions, and his fluid handling of drapery—all elements associated with a classical style. "Classic" is indeed a term often used to describe Montañés's style; yet Montañés knew little of ancient sculpture—his classicism was of a personal order, incorporated into a style designed to show a noble human experience in harmony with God and nature.

Perhaps we can understand the nature of Montañés's classicism better by comparing his *Immaculate Conception* with a statue carved in Italy at the same time by a sculptor for whom the influence of classical antiquity was crucial. François Duquesnoy (1594–1643) was a northerner (from Brussels) and of another generation than Montañés. He was in his early twenties when he arrived in Rome in 1618, a student supported by the generosity of the Archduke Ferdinand. Within the decade a confraternity of bakers had asked him to make a statue of St. Susanna (Fig. 104) for their new church of S. Maria di Loreto near Trajan's Column. It was his first large commission, and one of the few he would ever receive: Rome under the reign of Pope Urban VIII (1623–44) was so dominated by the taste of Bernini that the fine talent of this foreigner seems to have been eclipsed. But succeeding generations saw it, and the antiquarian Giovanni Pietro Bellori wrote in his *Lives of the Artists* (1672) that if ever there was a modern sculptor who, like Michelangelo, was able to fashion marble comparable to the best examples in antiquity it was Duquesnoy.[13] Later, in the eighteenth century, both painters and sculptors were eager to make copies of his *St. Susanna*.

104. FRANÇOIS DUQUESNOY. *St. Susanna.* 1629–33. Marble, over-lifesize. S. Maria di Loreto, Rome.

Once Duquesnoy settled in Rome he developed a style that was completely distinct from the predominating exuberant Baroque of Bernini, though he even worked for some time under Bernini on the Baldacchino at St. Peter's. Duquesnoy found in Rome an environment where the inspiration of antiquity was never lacking, as well as a congenial circle of artists and intellectuals whose classical tastes he shared—among them Nicolas Poussin (with whom he shared a house in 1626), Andrea Sacchi, and the collectors Vincenzo Giustiniani and Cassiano del Pozzo. Throughout his lifetime Duquesnoy derived much of his livelihood from drawing and restoring antiquities in the Eternal City.

Thus, when the bakers asked Duquesnoy in 1629 to contribute an over-lifesize figure to the decoration of S. Maria di Loreto, he had already developed the classical style in which he chose to work. The program called for the four niches in the area around the main altar to contain statues of Christian women who were martyred in Rome during the Empire. Duquesnoy was assigned to create a figure of St. Susanna, a young virgin killed in her father's house in the late third century by order of Diocletian. The delicacy and grace of Duquesnoy's style distinguish his work from the other three, even though all four statues derive from a similar type of standing Roman portrait. Duquesnoy's figure is particularly close to antique prototypes—in the contrapposto; in the way drapery is used to give continuity to one side of the body and rhythmic irregularity to the other; in the manner of drawing that drapery across the body in a thick twist around the waist and then allowing it to fall in heavy folds over the right hand (which originally held the symbolic palm of martyrdom); in the contrasting weight of the cloth of the dress and that of the mantle; in the rippling edges of the dress as it descends to the base between the saint's feet.

Yet two things distinguish this statue from the prototypes Duquesnoy had consulted. First, he gave the body a slight twist—the left foot steps back, the shoulders are uneven, and the head turns sharply—in order to create a dynamic relationship between the image and the spectator as well as between the image and the setting; as originally installed, the statue turned toward the entering worshiper and with the left hand pointed in the direction of the altar (the figure has since been moved and in its present position points toward the church's entrance). The other unusual aspect of Duquesnoy's statue is the face: it has a sweetness, a dreamy quality, seen in neither contemporary nor ancient Roman works. The soft, regular face is framed by silken hair pulled up on the back of the head. The eyes are blank and the lips parted, emphasized by Duquesnoy's use of the drill in the corners. The face evokes the limpid beauty of Hellenistic creations. This quality was noticed even in the seventeenth century, when the biographer Giovanni Passeri observed that "Il Fiammingo [Duquesnoy was called "the Fleming"] has taken the best of Greek sculpture's fineness and subtlety; they are restated and epitomized in this Susanna." [14]

The quietness, refinement, and regularity of Duquesnoy's style has much in common with qualities we have seen in Montañés's *Immaculate Conception*, qualities that reveal their shared classicism. Nevertheless, the solid block of the Spanish work, Montañés's reticence in depicting the human body, and his pictorial use of polychromy were all quite foreign to Duquesnoy. He too, in *St. Susanna*, created a work that is pictorial, that demands to be seen from a single point of view and in a particular environment, but he valued a kind of harmonious relationship between body movement, drapery, and chiaroscuro patterns that was scarcely part of the sensibilities of a sculptor in the remote Iberian peninsula.

With his predilection for classical restraint, Duquesnoy achieved a gentler, more composed style than Bernini. About the time Duquesnoy began his *St. Susanna*, Bernini finished his

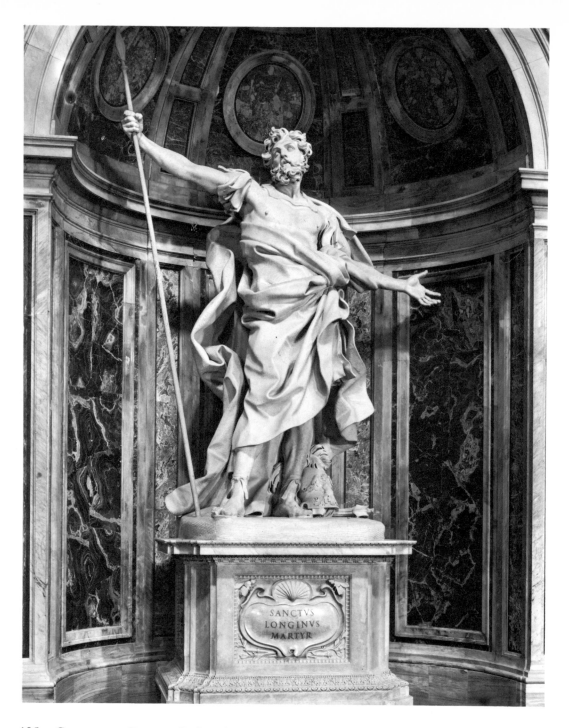

105. GIANLORENZO BERNINI. *St. Longinus.* 1630–38. Marble, 14′4″. St. Peter's, Vatican.

lifesize *St. Bibiana*, and the two works are often compared. Bernini's saint is agitated, her gestures restless, as she implores heaven with her eyes—a figure completely at variance with the Duquesnoy's Susanna, with her slow turn, purposeful gesture, and assured dignity.

The contrast between the styles of Duquesnoy and Bernini can also be seen clearly at St. Peter's, where both worked on statues for the niches of the crossing piers. In 1628 Urban VIII decided to give greater prominence to some of the famous relics in St. Peter's—including the Veil of St. Veronica, portions of wood from the True Cross, the lance of St. Longinus, and the head of St. Andrew—and to the saints they honored. According to Bernini's plans, balconies

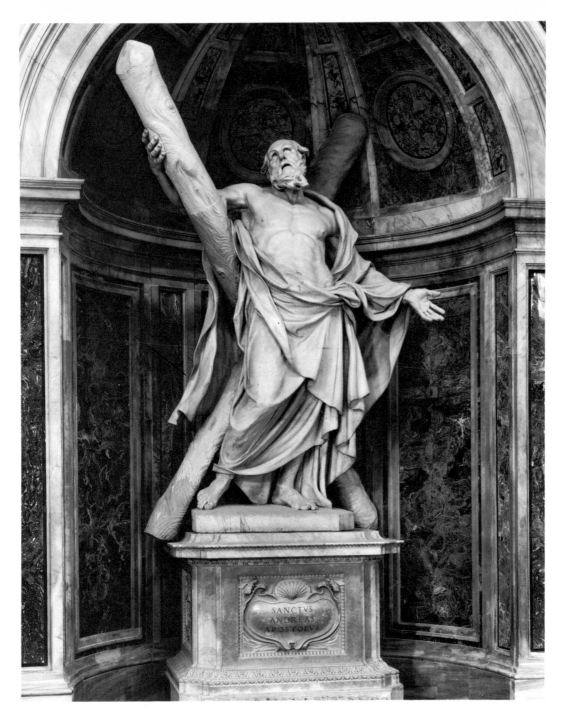

106. FRANÇOIS DUQUESNOY. *St. Andrew.* 1627–39 Marble, 14′11″. St. Peter's, Vatican.

and statues were to transform the piers into shrines, one for each relic. He himself carved the *St. Longinus* (Fig. 105), while Duquesnoy created the *St. Andrew* (Fig. 106); the two worked on these colossal marbles throughout the 1630's, Duquesnoy always a little in advance of Bernini. Duquesnoy relied on a refined classicism, apparent in the contrapposto and draperies and in the care he gave to establishing continuity in the silhouette. Bernini, on the other hand, made a great display of agitation in his figure, with its broken outlines and fluttering drapery—a feat made possible only through the use of separate pieces of marble for the lateral cascades of material. Duquesnoy's interpretation made possible the statue's direct relationship to the

spectator in a way that contemporary society had come to expect of its saints' images, but it is low-keyed compared to the emotional *Jerome* or *Longinus* of Bernini. It was the latter interpretation the Catholic Church in Rome preferred. They liked the means—movement and color—by which Bernini focused on powerful manifestations of Christian experience, and this was more important to them than careful adherence to classical values.

The exuberant taste of Roman churchmen was, however, by no means universal. In Paris, sculptors working in a classical manner could readily count on steady patronage decade after decade. In 1640 Paul de Fréart de Chantelou, a French connoisseur who often served the Crown in matters concerning art, went to Rome in order to bring the two classicists Poussin and Duquesnoy to the court of Louis XIII. Poussin returned with Chantelou, but Duquesnoy had to postpone the trip. He finally left for France in 1643 but died en route.

Bernini actually did visit Paris—more than two decades later—and left behind one of the most extraordinary Baroque portraits conceived, his bust of Louis XIV. But his sojourn in the French capital, however sensational, was not entirely successful. As the most prestigious artist in Europe, he had been summoned from Rome to present a plan for the Louvre, soon to be rebuilt in a fashion suitable for the court of the world's grandest monarch. Bernini remained in France for almost half a year and left only when his "definitive" plans were engraved and the cornerstone of his structure laid. The history of the subsequent rapid substitution of more conservative French plans is complex, but part of the reason for it can be attributed to fundamental reluctance on the part both of members of the French court and of leading French artists to embrace the grandiloquent style and spirit of Bernini's work. Nor did the French become any more receptive to it as the century progressed: throughout the 1670's Bernini was at work on a great marble equestrian statue of Louis XIV; it did not arrive in Paris until 1685, five years after the sculptor's death and three years after the King had moved his court to Versailles. Louis' aversion to this work was so strong that he considered having it destroyed; finally, he allowed it to be recarved by François Girardon as a figure of the legendary Roman hero Marcus Curtius and placed at the far end of the gardens of Versailles, at some distance from the palace itself.

Another factor in Bernini's failure at the French court was that as France rose to power in Europe it became increasingly important to the King and to his finance minister Colbert that native French artists gain a more exalted position. Something of this attitude is also seen in their resistance to Bernini, who spent his months in Paris loudly decrying how poorly the city compared with Rome. Colbert dreamed of the day when artists would come to Paris to be trained rather than going to Rome. He worked diligently on the reorganization of the Academy of Painting and Sculpture in 1663, hoping to attain his objectives by means of a privileged corporation through which artists could receive both professional training and recognition and, more important, could learn how to serve the State by creating monuments to glorify the monarch. The artist under Louis XIV became part civil servant and part courtier. The dominant spirit of the Academy was classical, and both the forms and the ideas put forth for artists were laid out according to doctrines that could be both taught and controlled. The founders of the Academy had deep respect for the surviving monuments of antiquity, and like the Italian artists of the Renaissance believed that if they wedded antiquity to nature the result would yield a universal beauty.

This beauty, as the French seventeenth-century artist conceived of it, was richest at Versailles. In 1682 Louis chose this palace as his residence in preference to the new Louvre in Paris, and it became the embodiment of his ostentatious image as the Sun King. Louis had a

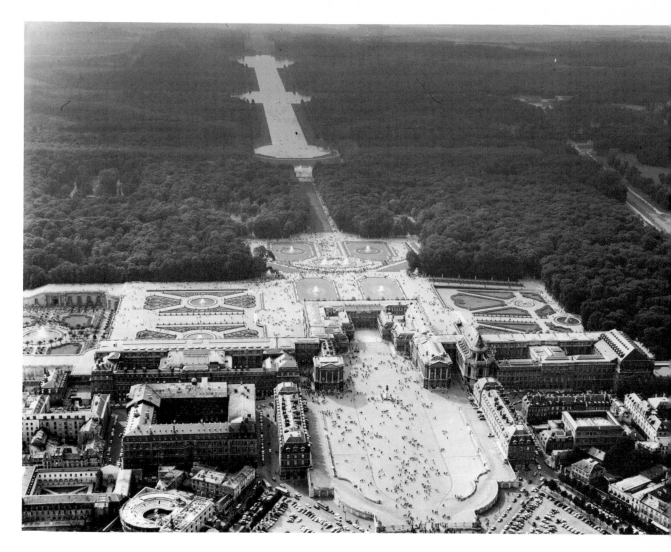

107. View of the gardens. Versailles.

genuine interest in and taste for the arts, but at the same time he never forgot what a building project such as that carried out at Versailles would convey to other nations and to posterity: he knew that it was in fact worth more than most victories on the battlefield. The gardens became his special passion; nature was to serve on a broad scale as background for his magnificence. Water was everywhere; acres of plants were disciplined into shape in order to frame the King and his courtiers, along with hundreds of ancient and modern sculptures—gods, bacchantes, nymphs, a vast population of other mythological and allegorical figures. The gardens and the statues gave Louis such pleasure that he himself prepared the first guide to the grounds—*The Proper Way to Show the Gardens of Versailles*, written in the last years of the century, probably in 1697 or 1698.[15]

The principal axes were already clearly established by 1682, when the King moved to Versailles. Louis could look out to the west for miles along the main axis—the Parterre d'Eau, the Basin of Latona, the Tapis Vert, and the Grand Canal (Fig. 107)—or he could turn to view the north-south axis extending south from the enormous rectangular mirror of the Lac des Suisses down the north hill with its Allée d'Eau to the Basins of the Dragon and of Neptune. A number of statues and bases for others were in place; many fountains were carved and cast—all work done in the 1660's and 1670's. Colbert issued his most extensive command for new

statues in 1674, and it was the King's First Painter, Charles Lebrun (1619–90), who directed the entire undertaking.

Lebrun, moving force of the Academy and director of the Gobelins tapestry factory, was the official interpreter of classical doctrine. In 1667 he had begun giving lectures at the Academy in which he outlined the theories he believed would lead to French mastery in the arts. By and large, they were based on sixteenth-century Italian art theories, but they showed considerable awareness of contemporary scientific work in Paris, especially the Cartesian theory of the universe, with its lucid, abstract beauty based on mathematical discipline. In his own studies of physiognomy and the character of the "passions," Lebrun was particularly influenced by Descartes's late work on the passions of the soul; Descartes too had sought to understand human emotions and show their relationship to man's body. Lebrun believed in approaching nature through reason and brought this attitude to bear on the layout of the gardens at Versailles. For sculptural subjects he depended heavily on Cesare Ripa's *Iconologia*, only recently translated into French.[16] This vast store of symbols and allegorical images was highly influential on French formulas for the expression of the nature of man and his world.

The cult of absolutism maintained at Louis' court extended to the gardens; since the King saw himself as supreme in the arts, he identified with Apollo, and so the Sun God became the central motif at Versailles. The principal groups along the main axis were already in place in 1671. One at the far end of the Tapis Vert showed Apollo in his chariot rising out of the water; at the other end, in the Basin of Latona, stood a marble group of Apollo, his mother, and his sister Diana, bathed in jets of water sprayed from the mouths of Lycian peasants who are shown metamorphosing into frogs because of their cruelty to Latona and her children. A host of allegorical statues, often grouped in fours as outlined in Cesare Ripa's book—the Seasons, the Elements, the Continents—extended from this central vista; around basins and along *allées*, they marked the visitor's passage from one area to the next with a regular rhythm and provided a focus for his distant gaze. The gardens developed collectively; single works assumed importance through their placement more than through any strongly individualistic style.

The problem for the planners—Lebrun and André Le Nôtre (1613–1700), chief architect of the gardens—was to get a great many artists to work as a team and to find men who would carry out their commissions with a high degree of craftsmanship and dedication to the planners' disciplined ideal of beauty. To achieve these ends they relied consistently upon the artistic vocabulary of antiquity. The newly founded (1666) French Academy in Rome was part of the system that created the style of the gardens. Sculptors were sent to Italy with specific instructions to measure and make plaster copies of ancient statues and to send these back to France to be used as the basis for marble and bronze versions. Later, when the artists made their own figures, they often incorporated that close study of the ancient works into original creations.

When Louis moved to Versailles, its extensive layout appeared relatively complete, and a less fastidious monarch might have considered the gardens as they were in 1682 to be ideal (Louis had been using them as a setting for his *fêtes* for over a decade). The King, however, was not satisfied and caused work to continue right into the 1690's. His workmen labored on the Parterre d'Eau in front of the château, rebuilt the Orangerie, changed the layout of the Basin of Latona, constructed the Colonnade—that idyllic setting for court suppers during royal promenades—and replaced Louis' retreat, the Trianon, with a much larger structure, altering the surrounding grounds to match its new grandeur. By the end of the 1680's a cool and ordered classicism was more than ever apparent in the new arrangements.

After Colbert's death in the fall of 1683, Lebrun's influence in the planning of Versailles was vastly diminished, but the general approach to the décor of the gardens in terms of a disciplined classicism continued as before. Antique treasures—both originals and copies—poured into Versailles and were judiciously placed. There were some exceptions, however, to this classical trend. One, a work carved in the south of France by a sculptor who had little direct knowledge of the artistic climate of Versailles, arrived there during the summer preceding Colbert's death. This was the *Milo of Crotona* (Fig. 108) by Pierre Puget (1620–94). On the day the monumental marble was uncrated in the gardens it caught some of Louis' courtiers by surprise. They were not entirely pleased with the work, considering it to be too violent and too naturalistic an interpretation of the legend of the Greek athlete who in old age tried one more feat of strength—tearing asunder a tree trunk—only to have his hand caught in the stump and then to become the prey of wild beasts. The Queen drew in her breath when she saw it and cried, "The poor man!" She liked the sculpture, nevertheless, as did the King and Lebrun. The latter hastened to write Puget: "The King paid me the honor of asking my feelings about it. I endeavored to point out all the beauties of your work. I only did this because it was your just due. . . ." [17] The King overrode suggestions from those whose lukewarm feelings toward the statue led them to propose placing it out in the park, and had it placed instead near the entrance to the Tapis Vert, one of the most conspicuous sites in the garden.

Puget was already sixty-three years old when this honor was bestowed upon his work, none of which had ever been seen before in the Royal Domain. His entire career had been spent in southern France and in Italy, and he had generally been excluded from the circle of the court. It has never been satisfactorily explained why Puget, with his enormous talent, had such limited success in his own lifetime and in his own country, although part of the reason is certainly to be found in the expressiveness of his style: its stress on dynamic movement and extreme naturalism was not to be found in the work of any of his more popular contemporaries working in the ateliers of Paris and Versailles.

The genesis of Puget's *Milo* is curious. While working on designs for ship carvings in the arsenal at the seaport of Toulon, he came upon two impressive blocks of marble. He wanted very much to work on them and managed to interest Colbert enough to look at sketches he had made and ultimately to give him authorization to use the blocks. It took twenty workers six days to dress the marble and Puget from 1672 to 1682 to bring it to completion. Puget chose the subject himself—a rare occurrence in the career of seventeenth-century sculptors, who worked primarily in response to specific requirements set forth in royal or ecclesiastical commissions. His choice of a dramatic story full of pathos is rarely seen in contemporary French sculpture and can better be imagined in the hands of an Italian Mannerist or Baroque sculptor, like Giambologna or Alessandro Vittoria. (In fact, Vittoria had created a *Milo*—in a much calmer interpretation—as had a number of seventeenth-century Italian painters.) Nevertheless, the source of the story—the tales of the Latin writer Valerius Maximus —had great popularity in Puget's day; indeed, the tales had been translated into French four different times in the seventeenth century. Their appeal was in their moralizing character in describing the wise sayings and valorous deeds of great men of antiquity. The story of Milo was part of a chapter on heroic deaths, and is not difficult to understand how an artist inclined to dramatic representation would be attracted to a tale of noble suffering. As Puget said in a letter to Louvois, Colbert's successor as Superintendent of Buildings: "I am nourished by great events and works; when I toil over them I am truly able to move freely. . . ." [18]

This taste for dynamic grandiosity which animated all of Puget's creative endeavors was rooted more in Italian than in French art. At first glance the *Milo of Crotona* is reminiscent of Bernini's carvings in that the Puget is also meant to be seen from a single vantage point, and has forms that are composed of interlocking diagonals and that create complicated spatial patterns and a great deal of movement. Yet Puget's work lacks the emphatic three-dimensional outreach of Bernini's figures. We recognize, as did Puget's contemporaries, that the *Milo* has its source in classical antiquity. Hellenistic groups such as the Laocoön, which Puget knew well, showed the kind of pathos and tortured athletic bodies we see here and made use of a similar parallel structure of diagonals for the parts of the human bodies. Despite this, there was something quite original in Puget's concept of sculptural form. This is particularly evident in the amount of activity he pressed into the tight framework, stretching the bodies of the athlete and the lion into a diamond-shaped configuration with each element parallel to another. The overlapping sequence of lion's paw, Milo's limbs, drapery, and tree stump is so compressed that the group almost reads like a relief without a rear plane. The combination of the powerful forms arranged at various angles, the great spatial voids within the piece, the rough textures, the horrific expressions of man and beast together, with the controlled regularity of the overall design, convey a strange and frozen violence. Thus it is easy to imagine that it provoked an adverse reaction among the promenading courtiers at Versailles, accustomed to sculpture which made even scenes of rape look like melodious choreographed dances (e.g., Girardon's *Rape of Proserpina*). But perhaps it also provided them with welcome relief from the endless Arcadian self-confidence and languor of the mythological groups that dotted the landscape in this extremely unreal setting.[19]

At the time Puget's group was installed, the Parterre d'Eau (directly in front of the main façade and in close view of the new Galerie des Glaces) was a single large basin with water jets held by Tritons and sub-basins at the corners. This complicated design was Lebrun's. In 1684 the architect in charge, Jules Hardouin-Mansart (1646–1708), decided to replace the Parterre d'Eau with the two basins we see today—simple, basically rectangular pools with marble frames (Fig. 107, center). They were part of a developing taste for serenity and symmetry increasingly apparent in the design of the gardens throughout the 1680's. When an embassy from Siam came to visit Louis at the end of 1686, their tour included the new basins, which were unadorned except for simple vertical jets of water. But the ambassadors were told how the basins would look when the splendid bronze groups on which so many artists were currently working were distributed along the borders. The ideas of both Lebrun and Mansart had gone into the sculptural program, which included river gods, nymphs, and putti. The river gods, those great reclining deities of ancient tradition, had been revived in sixteenth-century Italian fountain designs, and toward the middle of the seventeenth century Bernini made use of them in his Fountain of the Four Rivers in the center of the Piazza Navona in Rome. Lebrun surely had the old Roman symbolism in mind—the idea of expressing the territorial extension of an empire—when he thought about the various places where statues of river gods might be appropriate, but by the time they were worked into the scheme for the new Parterre d'Eau these figures had become more decorative than symbolic.

Seven of the best sculptors of Versailles worked on the project; some of them had been creating steadily for the palace grounds since the 1660's. It happened, though, that the finest work was that of a relative newcomer, Antoine Coysevox (1640–1720), who was almost a generation younger than Lebrun and Puget. Lebrun was particularly fond of Coysevox and was instrumental in establishing his successful academic career. The steps in his climb to fame were

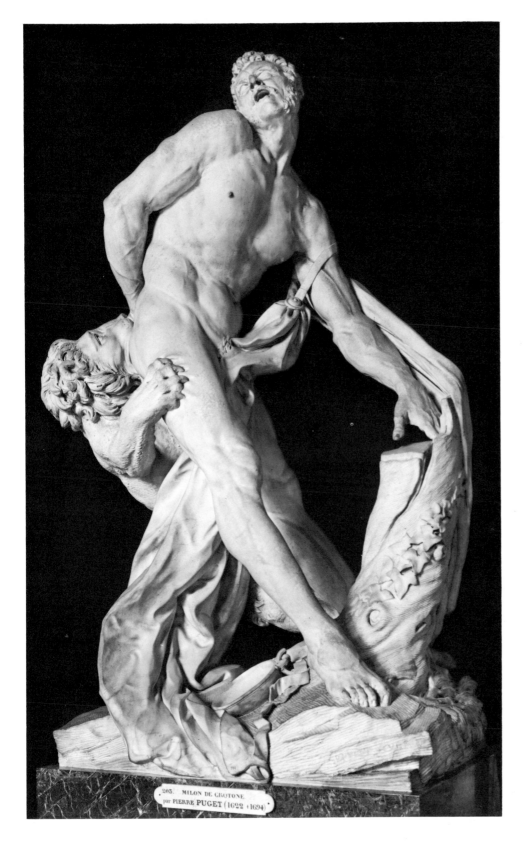

108. PIERRE PUGET. *Milo of Crotona*. 1672–82. Marble, 9′9″. Louvre, Paris.

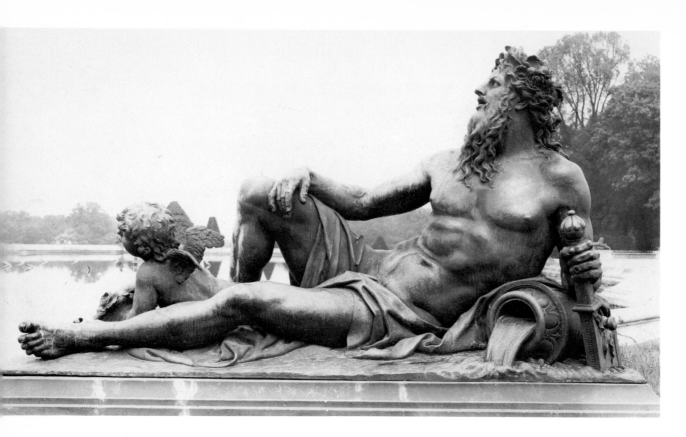

109. ANTOINE COYSEVOX. *The Garonne.* 1685–86. Bronze (cast by the Kellers in 1688).
Parterre, Versailles.

rapid: 1676, a beautiful bust of Lebrun; 1677, a bust of the King's first minister; 1678, a
professorship at the Academy; 1679, his first bust of Louis XIV and work on figures for the
garden façade of Versailles. In 1683 he began a series of outstanding copies after ancient works,
considered by many of his contemporaries to be superior to the originals. By 1684 Coysevox
was dividing his time between his spacious new atelier at the Gobelins tapestry factory (which
functioned as a center for the arts under Lebrun and Colbert) and Versailles, where he created
works for both the interior and the exterior of the palace.

The adjective "obedient" has been used to describe Coysevox; certainly everything about
his work indicates a man adept at learning the language of Versailles, of antiquity, and of
authority. Like a number of the other sculptors working at Versailles, Coysevox never went to
Rome; yet these men were the ones who created the most classical works of the seventeenth
century—works more classical than those of Puget, with his years of experience in Italy, and far
more classical than those of the artists of Rome itself.

In 1685 Coysevox was at work on models of his two groups for the new basins: *The
Garonne* (Fig. 109), which was represented as a male river god, and *The Dordogne*, the smaller
river, shown as a reclining female. They were not very different from the ancient copies he had
been making, and the relationship to famous Roman statues of river gods, particularly *The
Tiber* (a copy of which was then at Fontainebleau), is immediately apparent. But Coysevox's
Garonne is not nearly as close to the antique model as are works in the same series created by
his colleagues at Versailles, for he wanted to interpret the human body in a more expansive,
flexible, graceful manner than that shown by antique prototypes. There seems to be no rigid
geometry in *The Garonne*, even though the elegantly posed god and his companion—a putto
with cornucopia—fall into the traditional right-angled composition. The beauty of the piece is in

its ease of movement—the soft interlacing of bodies, draperies, and attributes—and in its refined, subtle modeling.

The virtuoso modeling is magnificently brought out in the cast by the Keller brothers. These Swiss artisans, recognized as the finest casters in France, were under contract to cast all the major bronze sculpture in the garden. From their studio in the Versailles arsenal came elegant bronzes cast by the *cire perdue* process—figures with fine, unified metal skin.

The Puget *Milo* and the Coysevox river deities were among the most important acquisitions made for the Versailles gardens in the 1680's, and they were placed in key positions on the main axis near the palace. In spite of their vastly differing styles (Coysevox never got involved with highly emotional subjects and never tried to develop a powerful personal style), both works met with genuine appreciation. Controversy around the *Milo* was not strong enough to inhibit Louvois from immediately arranging for a second work by Puget, *Perseus and Andromeda*, to be brought to Versailles as a pendant to the *Milo* at the entrance to the Tapis Vert. (The only other work Puget sent north, a relief of *Alexander and Diogenes*, ended up in an obscure corner of the Louvre.) Coysevox's sculptures, being more decorative, worked better within the setting; his enormous success was based on combining a rational approach to the legacy of antiquity with a decorative beauty that was in harmony with the surroundings. His work ultimately assumed the status of a criterion of taste rather than a passing style.

The atmosphere of Louis' court changed during the King's later years, as evidenced by his increased preference for a more intimate milieu—such as the one at nearby Marly. As a result Coysevox's late works were created primarily for Marly, and his style, like his sovereign's tastes, changed considerably. This is evident in his *Duchess of Burgundy as Diana* (Fig. 110), again a work with a famous Hellenistic source—the *Diana of Versailles* (now in the Louvre) that Primaticcio had brought to France in the sixteenth century and that Louis XIV had had installed at Versailles. But Coysevox did not simply base his composition or his figure type on its antique predecessor, as he had in the river gods; he paraphrased it in such a way that the relationship between source and portrait was evident and capable of enhancing the idea contained within this particular portrayal of the Duchess.

In this late work the stability of forms is de-emphasized; the sculptor was no longer so attracted to simple planes and slow movement. Instead he chose to enliven his figures through agitated profiles and restless drapery. Coysevox imagined this modern noblewoman in the traditional running pose of Diana and then turned the pose into a courtly gesture, one of pretty affectation. The Duchess, her breasts almost bare, twirls a lock of hair and fingers the head of her elegant hound (which replaces the leaping deer of the antique prototype). There is a rich naturalism in all of the details, particularly evident in the face, whose features Coysevox carved without idealizing them beyond recognition (Marie-Adelaide was not a great beauty, nor has the sculptor shown her as such). Coysevox felt that the realistic aspect of the statue deserved special notice, and so along with his signature and the date (1710) on the base he carved the words "*Ad vivum.*" In earlier portraits he had not bothered to point out that he was working from life.

With this portrait of the Duchess of Burgundy, Coysevox extended to a member of the royal court the special way of viewing the King as a *demi-dieu*. Throughout Versailles, Louis' traits were glorified by invoking the gods—his was the strength of Mars, the majesty of Jupiter, the beauty of Apollo. Painters occasionally depicted the personalities of courtiers in a similar fashion, but sculptors had not. Coysevox now opened the way for many sitters to share these Olympian honors.

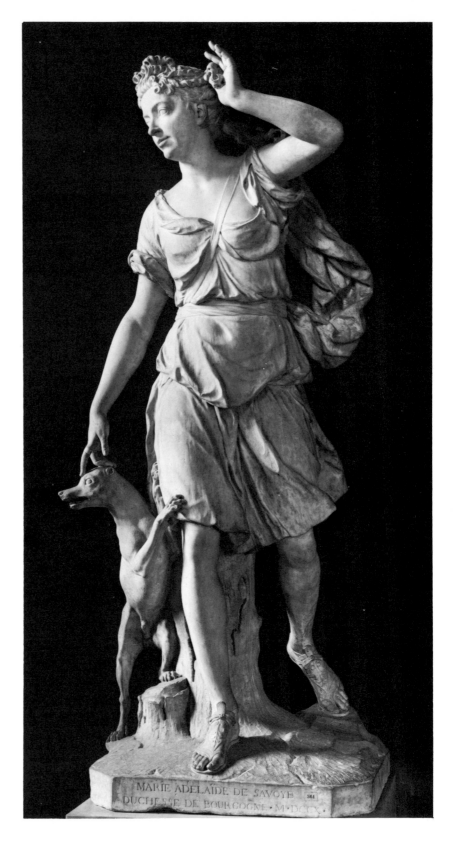

110.　Antoine Coysevox. *The Duchess of Burgundy as Diana.* 1710.
Marble, 6′1″. Louvre, Paris.

What, we may ask, moved Coysevox at the age of seventy to innovate so boldly? The answer is best sought in the personality of his sitter. Princess Marie-Adelaide of Savoy had come to France at the age of eleven to marry Louis' grandson, the Duke of Burgundy. This girl from northern Italy, who was being educated to be a future queen of France, became the delight of Louis XIV's later years. Her premature death at the age of thirty inspired the courtier Saint-Simon to write:

> With her death all joy vanished, all pleasures, diversions and delights were overcast, and darkness covered the Court. She was its light and its life. She was everywhere at once; she was its center; her presence permeated its inner life, and if, after her death, the Court continued to subsist, it merely lingered on. No princess was ever more sincerely mourned. . . .[20]

A great deal of the work done in the garden of Marly was created especially for the pleasure of the Duchess of Burgundy; it was noticed that "at Marly she used to roam around at night with all the young people, sometimes staying in the gardens until three or four in the morning." [21]

Though the King cherished Marie-Adelaide dearly, it was not he who commissioned the statue of the Duchess from Coysevox. His faithful courtier, the Duc d'Antin (the legitimate son of Louis' former mistress, Madame de Montespan), commissioned it from the sculptor, probably during his first year (1708) as the King's Superintendent of Buildings. This gesture was surely made to pay compliment to the Duchess, and even more to give pleasure to the King. Whether or not D'Antin intended the statue for Marly is not clear (it is known that he planned a grove in the gardens there to incorporate statues of Diana and her companions); when it was finished in 1710, D'Antin had it set up in his own garden, and then it was moved to Marly later in the eighteenth century.

Thus, out of a particular set of circumstances involving intimate relationships between members of the French court came this fanciful and decorative portrait type that was to have enormous success in all the courts of Europe. Knowledge of the way of life and the personalities of the individual sitters becomes as necessary to an understanding of eighteenth-century portraiture as a knowledge of Counter-Reformation dogma is to an understanding of Baroque portrayals of saints in ecstasy.

The number of French sculptures with highly personal content increased as the century progressed, since both patrons and artists lived in their sheltered, self-absorbed world. Louis XV and his queen, Marie Leczinska, showed only fleeting concern with the disturbing political and economic events of the day. Not surprisingly, the art created for them was hardly universal in character. The Christian tradition no longer inspired ideas in art that might have transcended the narrow atmosphere at court, for eighteenth-century society in France was experiencing a deepening process of secularization in which mythological subjects were far more useful than Christian ones for explaining what its members felt about their lives.

The most esteemed patron of art in the eighteenth century at Versailles was the Marquise de Pompadour. Some have regarded her as Superintendent of Buildings in all but name during the reign of Louis XV (it was actually her brother who held that important position). The fact that Madame de Pompadour emerged as the principal patron of the time tells us a great deal about the place accorded to individuals in the eighteenth century. As a woman, as a member of the bourgeoisie rather than the aristocracy, and as the King's mistress rather than a member of his family, her influence was anything but automatic, yet she continually used her intelligence and gifts of taste and energy to best advantage within the context of her special relationship to

King and court. She had imagination enough to devise innumerable schemes for buildings, gardens, and objects of visual delight.

Two sculptors served her best—Jean-Baptiste Pigalle (1714–85) and Etienne-Maurice Falconet (1716–91), artists with unusually parallel careers who nevertheless maintained the most distinct styles in their work as well as in their relationship to the Marquise. In the early 1750's both were working at her château in Bellevue. It was new, halfway between Paris and Versailles, and the only large house for which Madame de Pompadour took full responsibility, down to the smallest detail. The King and the court had made their first official visit on November 25, 1750; we can think of this visit as the public inauguration and sanctioning of Madame's delicate taste, which was to become a model for contemporary art. Pompadour's relationship to the King at this time is curious. It seems that she was no longer Louis' mistress in the traditional sense; what is more interesting is that she apparently wanted this altered relationship understood among courtly circles. One way she insured such understanding was through a sensitive use of sculptured images, and the most important artist to work with this unusual iconography was Pigalle. In 1750 she asked him to do her portrait in the guise of Friendship—L'Amitié (Fig. 111)—for the gardens of Bellevue. Pigalle's lifesize rendering shows her advancing, bending, extending herself, and pointing to her heart. Every feature and gesture—the sloping shoulders, the turn of the wrist, the relaxed, open palm—is one of warmth, and it was precisely this graceful image of open-hearted generosity that Madame de Pompadour wanted projected in her statue. Even though lifesize, this statue of the barefoot Marquise wearing her fanciful tunic in slight disarray conveys intimacy rather than monumentality.

Pigalle probably finished working on L'Amitié in 1751. It was placed in the "Arbor of Love" at Bellevue, a sheltered grove covered with jasmine and roses. The open pose and gesture obviously called for a pendant statue, and some time that year Pompadour commissioned Pigalle to carve a lifesize statue of her "friend." Pigalle designed it to contrast sharply with the informal image of Pompadour; through antique dress and symbols (the armor of the military, the fasces of authority, the horn of plenty) he portrayed Louis XV as the very image of regal dignity.[22] But even an all-powerful ruler may receive the human gift of friendship; this gift was to be an enduring kind of love, which the sculptor symbolized by the ivy-covered tree trunk behind the figure of the Marquise and by the flowers of every season woven into a garland at her feet.

Like Louis XIV's artists, Pigalle relied upon such manuals of symbol and allegory as Cesare Ripa's Iconologia. And like Coysevox when he created his Duchess of Burgundy as Diana, he too wanted to personify a special relationship to the King and at the same time to transcend the mere details of that relationship at any one moment. How then do we distinguish the styles and the artistic intentions of these two sculptors as well as of their patrons? Simply to compare the sizes of the statues is telling: Madame de Pompadour's own petite measure is in strongest contrast to the over-lifesize monumentality of the Duchess of Burgundy. Pigalle did not just put a portrait head of Madame de Pompadour on a beautiful body; it is Pompadour's own figure. Nor did he stress affected gestures and stylized movement. Unlike Coysevox, Pigalle did not create drapery to move in an imagined wind nor force complicated spatial patterns into the composition of limbs, trunk, and drapery. The new style he espoused (and, ironically, the new affectation) is one of simplicity: a barefoot, artlessly coiffed Pompadour moves forward slowly, her gestures open and direct. The representation carries a powerful personal revelation, but one that was intimate and private, with little potential for a universal meaning. Only those who were

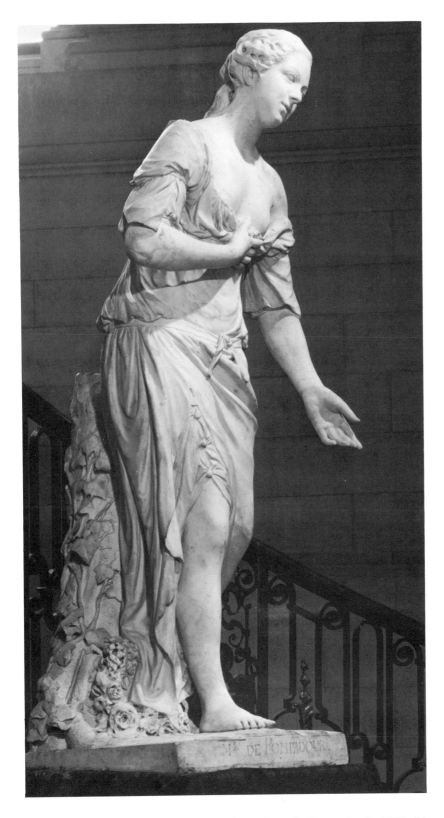

111. JEAN-BAPTISTE PIGALLE. *L'Amitié* (Madame de Pompadour). 1750–51.
Marble, 5′2″. Rothschild Collection, Paris.

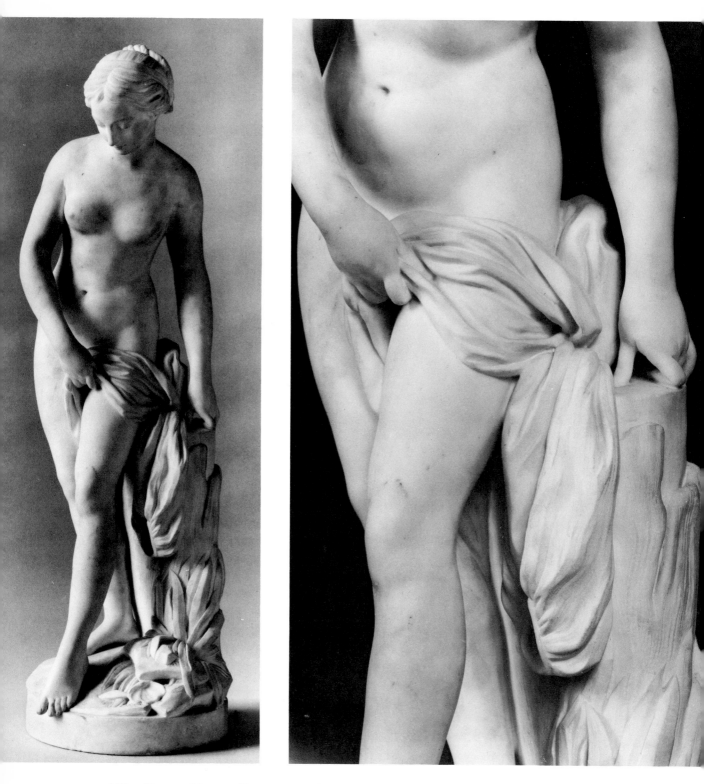

112. ETIENNE-MAURICE FALCONET. *Bather.* 1757. Marble, 2′7″. Louvre, Paris.

113. FALCONET. Detail of Fig. 112.

aware of the relationship between Louis XV and the Marquise could fully appreciate this statue, as is true of many other works created in the circle of Madame de Pompadour.

Although Pigalle executed a series of sculptures for the Marquise that were both impressive and charming, Falconet is the sculptor who has been most identified with her and with what the French call the *style Pompadour*. Only two years Pigalle's junior, he was nevertheless much slower in working his way through the academic stages that were the prerequisites for formal artistic recognition and lucrative commissions. He was not made a full Academician until 1754, a decade after Pigalle received that honor. Falconet was a passionate man, and his youthful artistic taste had been particularly stimulated by the kind of strong, even terrifying, subjects favored during the seventeenth century. He adored Bernini's sculpture, and in his early *Milo of Crotona* (begun in 1744) paid homage to Puget. His writings indicate that he was a fiercely proud artist, eager to press his claim for the superiority of modern sculpture over that of antiquity. How surprising, then, to find that it was this difficult intellectual who was best able to accommodate himself to the tastes of Madame de Pompadour. She invited him to create an allegory of Music for the vestibule of Bellevue, in reference to her gifts in this area (at the feet of the figure is the score from a contemporary opera in which the Marquise had sung the leading role at Versailles in 1750).[23] Though more grandiose and more animated than Pigalle's *L'Amitié*, Falconet's bare-breasted figure was related in spirit to the new "simplicity" (he must have finished his over-lifesize model around the same time that Pigalle was completing *L'Amitié*).

A small plaster model of *Music* was shown at the Salon of 1751, where it was much commented upon by the connoisseurs of Paris. The exhibition of smaller works at the Salon became an important factor in Falconet's successful emergence as a significant modern artist during the 1750's. These exhibitions at the Louvre definitely favored painters, since monumental sculpture could not be shown in the galleries at all, and the busts and statues that were shown had to be put on tables and so could not exceed three feet. Sculptors like Falconet learned to create specifically for this milieu and by 1757 Falconet had become a great success at it. That was the year that Parisians were able to see his *Bather*, a small marble measuring only 2'7", and his *Menacing Cupid (L'Amour menaçant)*, the latter destined for the Hotel d'Evreux, Madame de Pompadour's Paris residence. Both these works—deliciously sentimental, graceful in the extreme—enjoyed the most enthusiastic acclaim from Salon visitors.

In the *Bather* (Figs. 112, 113), Falconet adopted the Hellenistic subject of Venus preparing for a ritual bath. Venus had become an enormously popular figure in eighteenth-century art. Falconet revealed his own ideal of feminine beauty in this figure, continually understating parts of the anatomy in order to stress delicacy and grace—the slenderest ankles, wrists, and waist; the smoothest knees and elbows; the tiniest breasts; the long oval face with smooth and precious features. There is not a single protuberance, no roll of flesh in the belly such as seen in the statues of female nudes by the seventeenth-century masters Falconet admired. His minute carving and careful polishing subtly animate the textures of the drapery and of the reedy support so that they contrast with the body's smoothness. Falconet's artful and cohesive refinements deflect the beholder from the kind of curiosity about the model engendered by Pigalle's *L'Amitié*, yet the model was a specific person—probably Mademoiselle Mistouflet, a woman with a real place in the sculptor's life, perhaps even his mistress. And if we study the work carefully we find that it does have a specifically contemporary quality: look at the chemise with a narrow neck band and the neat coiffure, both clearly of the time. The entire

conception is an inspired combination of a Hellenistic Venus and a pretty eighteenth-century woman, brought to life by the most refined carving. The small scale permits the viewer to enjoy it close-up, to let his eye linger on the beauty of luxurious marble placed upon a table in a music room or salon.

Falconet's *Bather* was a great success; contemporary copies in every available material—marble, wood, terra cotta, and bisque—could be seen in the apartments of many wealthy Parisians. Falconet became for a time the eighteenth century's impresario of this kind of delightful beauty. In the same year that he finished his *Bather*, Madame de Pompadour named him chief of her beloved porcelain factory at Sèvres. Her ideas about national artistic products were formed along the lines of Colbert's: she wanted the French to buy porcelain made by Frenchmen and not the Meissen ware made by Saxons. Falconet directed the factory for almost a decade, during which time he realized unending variations on the theme of playful love in small but superb decorative sculptures. Under Pompadour's bourgeois patronage, this style of sculpture—which could easily be translated from one medium to another—became available to more people than had ever before owned sculpture in the history of the Western world. The Sèvres porcelains introduced new possibilities for sculpture—greater accessibility through variations in size, material, and number of casts—that were to remain of crucial significance until modern times.

The only other type of sculpture in the eighteenth century that was as prominent as were these decorative figurines was the portrait bust. The busts were of a manageable size for the Salons and also worked well in the more intimate interiors that were being designed by contemporary architects. The importance of portrait sculpture in eighteenth-century France was a reflection of that period's reverence for "great men," which replaced the cult of saints of earlier times. The sculptors who created for Louis XV were the direct heirs of the tradition of Coysevox, whose lively yet grandiose style had been so suited to portraits of Louis XIV.

Jean-Baptiste Lemoyne (1704–78), an extremely hard-working artist, gained special prominence in working for the monarchy, emerging as creator of the most complete ensemble of portrait studies of Louis XV and his entourage. Born into a family of artists, he worked in sculpture from an early age and was educated entirely in France. His taste led him to choose the most vivacious and picturesque Baroque sources of inspiration (he had a cast of Puget's *Milo* in his atelier), and his mature style continued traditions established in the seventeenth century. Although his work was not very innovative, it was carefully executed and always appealing, making Lemoyne the most sought-after portrait sculptor of his time. He was continually busy at court and his busts were regularly on view at the Salon for over thirty years (1737–71).

Lemoyne's official portraits were the most conservative of his works: nothing sharply distinguishes the style of the busts of Louis XV that he made year after year during the 1740's and 1750's (Fig. 114) from the portraits that Coysevox carved of Louis XV as a child earlier in the century. Lemoyne's busts can be dated more by Louis' age, costume, and hair style than by any stylistic clues. In this bust we see the type of elegant portrait that Lemoyne could create—the bust animated through diagonal drapery folds, counterposed head and body, and irregular terminations of the base—all qualities in the grand tradition of seventeenth-century portrait sculpture. What makes it more than a tired reiteration of a conventional formula was Lemoyne's ability to translate closely observed physiognomic traits into elegant portraiture. Through this he was repeatedly able to depict a not very impressive monarch as an alert and vital human presence. The realistic details are fine—folds of flesh, the curl and pull of the hair,

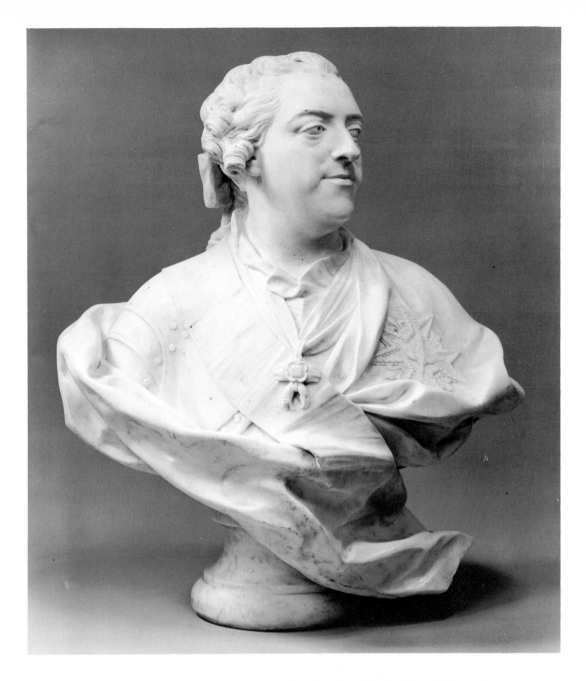

114. JEAN-BAPTISTE LEMOYNE. *Louis XV*. 1757. Marble, 34¼″. The Metropolitan
Museum of Art, New York (gift of George Blumenthal).

the deeply carved eyes focused sharply to the left, the ruffled shirt, the Cordon Bleu around the
neck and the emblem of the St. Esprit on the shoulder. But Lemoyne's sensitive recording of
observed nature was always within the context of a traditional style: Diderot, the outstanding
exponent of the new form of art criticism, would never have accused him, as he did other
contemporary sculptors, of casting from life, even though he did not like Lemoyne's art.[24]

Lemoyne's own character assured his successful career. By all accounts he was exceptionally
charming and easygoing; this fact probably enabled his sitters to reveal more of their personality
to him than might have been possible in another artist-sitter relationship. His attractiveness
certainly touched Louis XV, who once offered to be godfather for one of Lemoyne's daughters.

Not only did the sculptor have special access to the King, but it appeared that by the 1760's he was "the only artist who is now free to model after the King, and who, consequently, is able to represent him as he actually is, with great fidelity." [25]

Lemoyne must have seen the King often to execute the bust illustrated. It was an important portrait—Louis intended it as a gift for Pompadour. Lemoyne probably worked with the King in person both during the preparatory stages (when he made drawings and wax sketches) and during the actual carving of the marble. And he must surely have consulted his monarch about its final appearance: a note of exasperation is evident in his remark that "On October 26, 1757, I finished for the fifth time at Choisy-le-Roi the bust in marble of the King, given by His Majesty to Madame de Pompadour." [26] Lemoyne made this portrait when Louis was forty-seven years old, over twenty years after he had carved his first image of the King. Of his many royal portraits, only a few remain (most were destroyed during the Revolution), but those that do testify to the increasing weight and signs of aging on the face of the monarch who led his nation into a deep financial and political crisis in the second half of the eighteenth century. The 1757 Lemoyne bust of Louis XV was carved at a time when the authority of kingship was waning; it does not reveal the self-confidence and majesty of Cellini's *Cosimo I* (Fig. 98) or of Bernini's *Francesco d'Este* (Fig. 97).

Eighteenth-century portrait sculpture was most interesting when the sitter was neither monarch nor aristocrat; particularly in the second half of the century we find that the subjects of the most brilliant works in this genre were the *philosophes* and members of the bourgeoisie. It is not surprising that this should have been so in the period of the French Revolution, when the monarchy was being supplanted by these men and women. Yet this phenomenon may also have been the result, in part, of the influence of one artist—Jean-Antoine Houdon (1741–1828)— who carved more great bourgeois portraits than any other artist in the second half of the eighteenth century.

Houdon was born in the town of Versailles and educated in Paris during the years when Falconet was creating his models for Madame de Pompadour's porcelain figurines, when Pigalle was working on a monument to Louis XV in Reims, and when Lemoyne was turning out his royal busts in rapid succession. None of these artists was his master, but all of them influenced his development. Houdon would have been happy to have had the royal patronage that they enjoyed, and surely Pompadour would have liked his work—but she died in 1764, only months before Houdon left for the French Academy in Rome to complete his education. He spent four years there at a time when the city's spirit was most cosmopolitan and when the passion of cultured Westerners for archaeology and for the monuments of antiquity was particularly keen. Nevertheless, the dominant visual impression of eighteenth-century Rome was made by its great Baroque works. An extraordinary variety of influences presented themselves to the young artist: Houdon copied both Baroque and antique monuments; the latter he could not have avoided even if he had wished to, for like every scholarship student at the French Academy, he was obliged to make copies of antiquities for the King. One very interesting thing Houdon did with his time in Rome was to study the corpses at the hospital of S. Luigi dei Francesi. With a surgeon as his companion he learned about anatomy and about what lay beneath the surface of the human form. *L'Ecorché—The Flayed Figure*—was done at this time; Houdon later based his first large works on it.

Houdon was twenty-seven when he returned to Paris. He used his Roman works to obtain as quickly as possible the status of *agréé* within the Academy, for this conditional acceptance was

necessary in order to show works at the Salon. By July of 1769 he had achieved this status, and one month later his work was first displayed in Paris at the opening of the Salon.[27] This swift entry into the circle of Salon artists seemed to foretell a future rich in royal commissions. But—although he did execute a flawless *Diana* for the gardens of the Duke of Saxe-Gotha in the 1770's and did attain the rank of a full Academician in 1777—Houdon received only three court commissions between his last year of formal education and the Revolution (even his own bust of Louis XVI, done in 1787, was not a royal commission). Thus, by default, he became a *bustier*—by academic standards less important than those artists who carved equestrian figures, tombs, and mythological and allegorical figures. Yet this fate suited his artistic temperament, for Houdon was most successful when he was able to study nature closely, as he did so superbly in his bourgeois portraits.

Lacking royal patronage, Houdon spent much time with the intellectuals, politicians, and fellow artists who were his major clients. One of his first busts was of Diderot (Salon of 1771); this was followed by his series of Voltaire portraits, begun immediately after the writer's return from exile in 1778. When Jean-Jacques Rousseau died in the same year, Houdon went at once to Ermenonville and prepared the death mask that was to become the basis for his bust of the philosopher.

Houdon was a man comfortable among men who stood apart from the conventional order of society. When the Revolution came he welcomed the Bastille insurrection and hoped that he would be the one chosen "to raise a monument to Liberty on the place where slavery has reigned until this time." [28] This hope went unrealized, and just as before, Citizen Houdon continued to be known for his naturalistic busts. One of the finest is his portrait of the Comte de Mirabeau (Fig. 115), who had died on April 2, 1791. Houdon was called to make the death mask, and he proposed to translate it into a marble or a bronze for the *Amis de la Constitution*. They did not accept his offer, preferring the more democratic method of an open competition. Houdon did not enter the competition, but he did have his bust ready for the fall inauguration of the first Revolutionary Salon.

Houdon wanted to convey the power and the strength of this aristocrat-turned-revolutionary, who toward the end of his life had played such a strange role as intermediary between the Jacobins and the King in the hope of establishing a democratic monarchy. The sculptor emphasized Mirabeau's large head and broad brow, his large nose jutting out between finely rimmed eyes, and his thin, tight lips curved in disdainful superiority. Even though he emphasized the pock-marks on the skin, the firmness and severity of Houdon's portrayal projects a feeling of greatness that distracts us from the ugliness so often commented upon by the political leader's contemporaries. Comparing the *Comte de Mirabeau* to a similar type of portrait bust by Lemoyne, we find that the strength of the *Mirabeau* lies in the new tension Houdon gave to the body and to its relationship with the head, a tightening of forms and surfaces and a directness of gaze. These are the qualities of Houdon's best portraits—the *George Washington*, the *Voltaire*, and the *Jean-Jacques Rousseau*, all of which give us real insight into the characters of the men portrayed.

Houdon had considerable sympathy for Mirabeau's political beliefs: both men thought it best for France to preserve her monarchy and combine it with a democratic system along English lines. Within a few years this stance became totally unacceptable and Houdon was soon regarded as being not fully sympathetic to the true Revolutionary spirit. He remained in Paris, however, not leaving as so many artists did when they felt the potential danger there. His

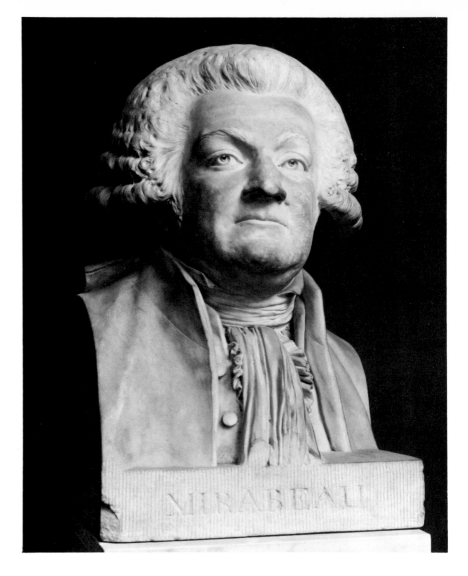

115. Jean-Antoine Houdon. *Comte de Mirabeau.* 1791. Plaster. Louvre, Paris.

sculpture continued to show the same quality of steady commitment to a new social order, while not representing a total break with the past. In seeking to create simpler, more direct images, Houdon stripped away inessentials in order to arrive at the essence of his sitter's personality. At the same time he avoided any elimination of characteristic details or surface quality that would make his likenesses less accurate or naturalistic. Although the portraits he made during the Revolutionary years were not a radical departure from tradition, they represent a fundamental altering of the way the human face was perceived.

While pre-Revolutionary French sculptors concentrated on conveying the individuality of their patrons and the pagan atmosphere pervading the court, sculptors in the rest of Catholic Europe made many works still in the spirit of the Counter-Reformation. Outside France the greatest number of sculpture commissions continued to be for religious works; Bernini survived as a major source of inspiration long after his death in 1680. One of the difficulties in looking at the eighteenth-century sculptures filling the churches of Austria, Germany, and Italy is to describe in precisely what way they represent a new style and are not merely an elaboration on

that of Bernini. If we take two roughly contemporary works—one carved in Rome, the other in Dresden—we can, at least in a limited way, consider this question. Camillo Rusconi (1658–1728) made his *St. Matthew* (Fig. 116) during the second decade of the century, and Balthasar Permoser (1651–1732) carved his *St. Augustine* (Fig. 117) in the middle of the third decade. In the usual manner of Baroque schemes of decoration, both figures were made as parts of series; from the initial conception they were seen as relating to other statues as well as to a particular setting.

Rusconi's statue was made for S. Giovanni in Laterano, the great Constantinian basilica in Rome that had been rebuilt under Pope Innocent X in the middle of the seventeenth century. The inventive architect Francesco Borromini preserved the form of the Early Christian church, but altered it with the gigantic white piers that he erected to carry the long nave arcade. Into these piers he set colored marble niches with crowning pediments that swing forcefully into the nave. Just as the rebuilding of the church had been the most important architectural project of the mid-seventeenth century in Rome, so the filling of its marble niches with statues of the Apostles was the most important sculptural project in the city in the first part of the eighteenth century. In 1700, the dean of S. Giovanni, Cardinal Benedetto Pamphili, convinced the newly elected pope, Clement XI, to set aside funds for the great sculptural project. Camillo Rusconi, a middle-aged artist from Lombardy who had been working with stucco decoration and carving groups of putti and angels all over Rome for nearly twenty years, dominated the project. However, Rusconi's approach as well as that of the other sculptors participating was determined to some extent by the respected Vatican court painter Carlo Maratti (1625–1713), to whom Pamphili turned in 1703 for designs for the sculpture. This is a notable instance of the superior position so often granted to painting during the eighteenth century.

Rusconi's first commission was for a statue of the basilica's patron, St. John. He did not finish it until 1713; in the meantime he completed a *St. Andrew*, and before the *St. John* was in place he tried out a full-size model of a third apostle, *St. Matthew*, in its niche. By 1718 Rusconi had finished his fourth work in the series, *St. James the Greater*, and had become a papal favorite.

The four statues are close in style, though the *St. Matthew* has always stood out a bit more than the others. Matthew, with his exaggerated contrapposto, voluminous draperies, enormous book, and broad body, fills the space between columns and pilasters and fits obliquely into his niche. As in seventeenth-century Baroque statues, diagonals dominate the composition, and the juxtaposition of limbs and folding drapery moving in and out establishes a distinct and constant rhythm, yet this statue has a ponderousness that is quite unlike the incredibly rapid tempo that animates such figures as Bernini's *St. Jerome* (Fig. 96). Rusconi's concept of drapery differed considerably from Bernini's, for he worked with broad planes and continuous profiles. He also had a far greater interest in revealing the human body beneath the drapery. Not that Rusconi described anatomy better than Bernini—in fact, he did it less accurately; but his drapery was not endowed with such vivid life that it obscured whole areas of the body. Thus, in relating drapery to body, Rusconi preferred a more classical solution than Bernini's.

Another characteristic that distinguishes Rusconi's *St. Matthew* clearly from earlier Baroque work is the uniform treatment of texture. His final carving tool was a toothed chisel that he used on every surface, creating an overall, closely tooth-marked texture of even opacity. Bernini, too, had used such a finish when he carved the *St. Longinus* (Fig. 105) for the pier of St. Peter's; in fact, that is probably where Rusconi got the idea.[29] But Bernini's toothed chisel on broad marble

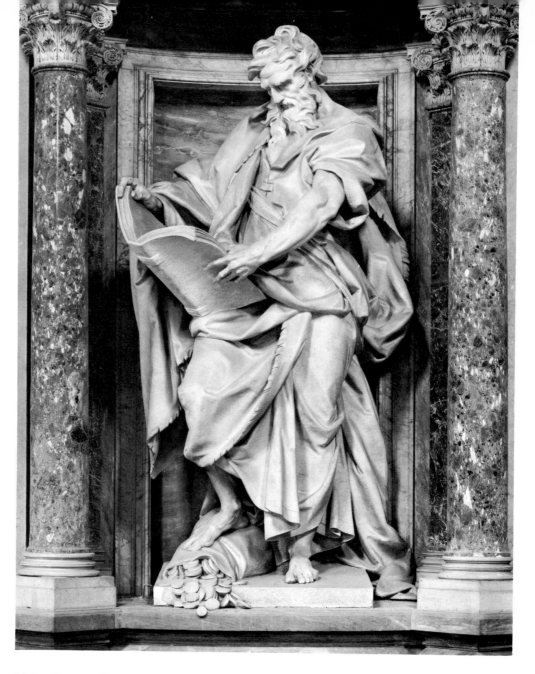

116. CAMILLO RUSCONI. *St. Matthew*. 1715–18. Marble, 11′5″. S. Giovanni in Laterano, Rome.

surfaces resulted in contrasting textures, while Rusconi's did not. In his approach to details Rusconi lacked the fluidity of seventeenth-century Roman sculptors; his is a hard, angular carving that makes forms appear particularly prominent—as is evident in Matthew's nose, feet, and fingers.

Duquesnoy had more influence on Rusconi, and his *St. Susanna* (Fig. 104) might provide a better comparison. The Flemish artist's figure is finely balanced, the contrapposto is classical, and there is an even distribution of light and shadow. Rusconi's figure is also balanced, but in addition to this his *St. Matthew* is more self-contained, more solid, more autonomous in character—to a degree unknown in truly Baroque statues. Rather than suggesting the implied spirituality or the subtle psychological states, as had earlier masters, Rusconi depicted a stern Matthew in a state of intense concentration, an effect that is more dependent on the position and

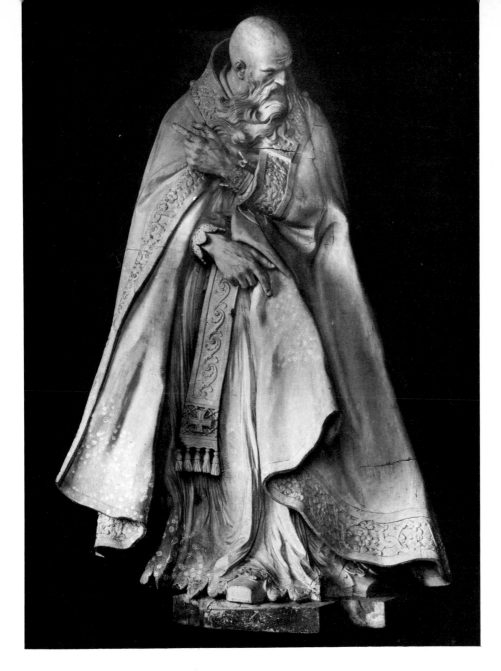

117. BALTHASAR PERMOSER. *St. Augustin.* 1725. Wood, lifesize.
Stadtmuseum, Bautzen.

the size of the head than on facial expression. The Saint's attributes are straightforward and traditional—Matthew holds a gospel in his hands and the coins that he abandoned to follow Christ are scattered beneath his foot. Thus Rusconi chose a classical approach to his subject.

As classical and anti-classical positions came to be more clearly defined, sculptors of the seventeenth and eighteenth centuries were increasingly conscious of the choice to be made between portraying an individual by presenting society's general notion of the subject, or by showing a significant moment, imbuing the figure with a narrative quality more akin to the painter's approach. Awareness of this choice grew sharper. The sculptors of the San Giovanni niches clearly chose the first approach and worked with an impersonal and generalized symbolic language, as well as reflecting the classicism of Carlo Maratti's designs. Rusconi's statue testifies to the changes that had become apparent in Catholicism, no longer given to the spiritual

excesses of Bernini's times. The demanding religious spirit of the seventeenth century had yielded to a more accommodating and secular tone, and Rusconi's stately Apostles were far better suited than ecstatic Baroque saints to participation in the courtly ceremonies that took place in S. Giovanni during the eighteenth century.

Furthermore, the sculptor's distinct taste for classical forms indicates the growing awareness during the eighteenth century of Rome as a rich source of antique remains and not merely as a papal city. Foreigners came to Rome in increasing numbers for the purpose of viewing antiquity. The papacy itself extended its recognition to pre-Christian Rome: Clement XI issued edicts in 1701 and 1704 prohibiting the export of antique statues. The majority of sculptors working in eighteenth-century Rome copied ancient works (Rusconi's best-known copy had been of the *Laocoön*); this practice culminated at the end of the century in the works of Antonio Canova, who fashioned a true rebirth of antiquity.

Balthasar Permoser was as much inspired by seventeenth-century Roman art as Rusconi had been, and in his *St. Augustine* (Fig. 117) he was especially influenced by Bernini's sculptures at St. Peter's. But Permoser, a Bavarian who did his finest work in Saxony, displays a far more Baroque spirit than his Italian contemporary. His over-lifesize wooden figures of the *Fathers of the Church*, made in 1725 for the high altar of the first Catholic church built in Dresden for the court of the newly converted Augustus the Strong,[30] were directly inspired by Bernini's four bronze figures supporting the Cathedra Petri. Permoser and Bernini were both less interested in the human body for its own sake than in its possibilities for movement and gesture. The hands, head, and features of the *St. Augustine* are all the more powerful because their connection to the corporeal frame is so slight. And they are expressive in themselves—the carving of the anatomy, the shape and bend of the head, and the depiction of the rugged, wrinkled features of old age. Permoser loved color and texture, light and shade, and all the decorative effects that could be achieved with those combinations: he made the strongest possible contrast between the multiple lines and ridges of the thin linen alb and the broad shifting expanse of the heavy cope over Augustine's shoulders; on all the edges and down the stole hanging from Augustine's neck he carved rich patterns combining floral and abstract motifs. What particularly distinguishes this statue from Italian Baroque work is Permoser's choice and handling of material. He clarified his large planes and crisp edges with the gouges of a woodcarver, then smoothed out the surfaces with flat chisels, sanded them, and laid on opaque white paint. The result is unlike anything we have looked at before—monumental and white, like marble, and yet not marble at all. For all its volumetric mass, the figure's effect is light and airy; though the saint stands and his feet are visible, he looks practically weightless, for Permoser has hollowed out the solid wood beneath the great cope. Thus *Augustine* appears at once ample and ethereal.

Permoser's approach to the interpretation of Augustine's character was to show him as an individual at a specific moment in time, the legendary moment in which Augustine compared his attempt to comprehend the Trinity to the child he saw trying to empty the sea into a sandhole. (Permoser originally carved the figure of a child holding a shell at the saint's feet; this figure has been lost.) Although using different means, Permoser wanted to create, as Bernini had in his *St. Jerome*, a sculptural figure that was neither static nor isolated and with which the viewer could empathize; his statue is neither so idealized nor so classically balanced as Rusconi's *St. Matthew*.

When Permoser carved his *Fathers of the Church* in Dresden he was already in his seventies. It had been many years since his fourteen-year sojourn in Italy (1675–89), but clearly what he had learned there had never left him. During his intervening years in the Saxon capital

he had developed a free and personal style that is best exemplified by the bucolic mythological figures he created for the Zwinger pavilions, the splendid new wings of Augustus the Strong's palace, yet never was he more original than in his carvings of the Church Fathers. He transformed memories of Bernini's majestic and dynamic *Fathers of the Church* for St. Peter's into something more spiritual, more inward, lighter, and yet filled with grandeur. In so doing he depended to a great extent on his own understanding of the German tradition of woodcarving, a factor that grew in importance in the latter part of his career. The hollowed-out effects and broad swinging surfaces of the figures of the Church Fathers (now at Bautzen) show how creatively he was able to work in this old tradition.

When Permoser was invited to the Protestant court of the Elector of Saxony in 1689, the feeling there was for a new and highly personal kind of Christianity called Pietism. This had all changed before the century ended: in 1697 Augustus the Strong (Augustus II) became Elector and two years later was converted to Catholicism. Augustus was passionately interested in establishing a public image and a court to rival those of Louis XIV: territorial expansion, festivals, the Meissen porcelain factory, large-scale palace buildings and the amassing of an art collection were all high on his list of concerns. Permoser, as the outstanding sculptor at court, was able to work on a splendid range of decorative architectural work, garden sculpture, small precious objects, and major religious commissions (including the *Fathers of the Church*) for this newly established Catholic court. Ambitious Augustus turned his capital at Dresden into a beautiful modern Baroque city, one that was to be sought out by many eighteenth-century travelers and compared favorably with Berlin and Prague. His zeal for collecting led him during the 1720's to acquire the Brandenburg Collection from the Elector Frederick William I and other works from Prince Agostino Chigi and Cardinal Albani. He soon had one of the best picture galleries outside Italy, as well as a superb library and the foremost collection of antiquities in Germany. The latter was to be a crucial factor in the emergence of the Neoclassical style in the last years of the eighteenth century, for it was in the Dresden collections that the aesthetic principles of Johann Joachim Winckelmann were formed.

Winckelmann (1717–68), an archaeologist and early art historian whose theories were fundamental to the formation of that radically different art style, moved to Dresden in 1754. There he was able for the first time to study modern Baroque art; it was there too that he first lingered over the ancient sculptures in the Antikensaal, the Elector's museum of antiquities. The year 1754 was significant for Winckelmann on two counts: it marked his conversion to Catholicism and to Greek art. The following year he published an essay, "Reflections on the Imitation of Greek Works in Painting and Sculpture." He dedicated it to Augustus III (the Elector's son and successor), and he acknowledged the benefits accruing to the city of Dresden resulting from Augustus the Strong's collecting mania, but at the same time he discredited the grandiose art style that both rulers loved best and criticized Augustus III for preferring painting to sculpture.[31] Before he had ever set eyes on Rome, Winckelmann set forth his eloquent vision of its rich heritage and exhorted his contemporaries to search for perfect beauty in the example of Classical Greek sculpture. This was an idea fundamental to the development of an aesthetic that had a far more lasting effect on sculpture than on any of the other arts.

This Apollo exceeds all other figures of him as much as the Apollo of Homer excels him whom later poets paint. His stature is loftier than that of a man, and his attitude speaks of the greatness with which he is filled. An eternal spring, as in the happy fields of Elysium, clothes with the charms of youth the graceful manliness of ripened years, and plays with softness and tenderness about the proud shape of his limbs. . . . Neither blood-vessels nor sinews heat and stir this body, but a heavenly essence, diffusing itself like a gentle stream, seems to fill the whole contour of the figure.

Johann Joachim Winckelmann,
description of the *Apollo Belvedere*
in *History of Ancient Art*, 1764

We must, however, acknowledge, as it seems to me, that man with all his noble qualities . . . still bears in his bodily frame the indelible stamp of his lowly origin.

Charles Darwin,
concluding sentence of
The Descent of Man, 1871

The sight of human forms feeds and comforts me. I have infinite worship for the nude. . . . Sometimes it seems that you can find nothing in a model, then, all at once, a bit of nature shows itself, a strip of flesh becomes visible, and that shred of truth gives the whole truth, and allows itself to be raised by a leap to the absolute principle of things.

The human body is like a walking temple, and like a temple it has a central point around which the volumes place and spread themselves.

Auguste Rodin,
statements made in the early twentieth century

SIX

Neoclassicism and the Nineteenth Century

Greek Splendor Versus Human Imperfection

Winckelmann set out for Rome at the beginning of the third quarter of the eighteenth century. Italy was to be his home until 1768, when a strange murder ended his life in Trieste. For thirteen years he was absorbed in the world of archaeology and classical scholarship then flourishing in the Eternal City, and his life-style was envied and imitated by connoisseurs throughout Europe. Rome, with little temporal power left, grew steadily firmer in her sovereignty over the past as new finds were brought to light and ever finer collections of antiquities assembled. It was one of the paradoxes of the late eighteenth century that what was most "modern" in art was most indebted to the past.

By contrast, few connoisseurs were eager to visit the world's newest capital—London. At the end of the Seven Years' War in 1763, Great Britain, with dominion over the whole of North America, the West Indies, the Philippines, and India, was clearly the modern counterpart of the Roman Empire. It was a country of enormous wealth and enterprise, well on the way to becoming the world's first great industrial nation, but in the visual arts it had not produced enough to be considered in any way a center of creativity.

Nevertheless, the beginning of George III's rule in the 1760's was a significant time for the development of the arts in England. Artists found ways of organizing themselves, for the first time regularly bringing their work to public notice. Annual art exhibitions began at the Strand in 1760; the following year the most important artists went to Spring Gardens in Charing Cross. They called themselves "The Society of Artists of Great Britain," and printed a catalogue with a cover illustration showing a bust of George III watching Britannia as she waters three fertile trees labeled "Painting," "Sculpture," and "Architecture." The new importance attached to the visual arts in Great Britain was not without its problems, however, as a poem of 1764 attests. Its last verse ran:

> Go abroad then—in *Italy* study *vertu;*
> No reward *here* your labours will crown;
> Ev'ry *Dauber* from Rome *is brought forward* to view,
> But an *Englishman's* always *kept down*.[1]

By the end of the 1760's, a relatively peaceful and stable decade, George III had informed the members of the Royal Academy (created in 1768) that he considered the arts to be of national concern and that he would actively assist and patronize them. Thus pride in native art came to Great Britain as the nation began to assume an imperial role.

The period appears complicated and full of contradiction from a twentieth-century point of view. Journals of the 1770's reveal a peculiar mixture of concern over widows' benefits and relief for the poor while death sentences for minor thefts were enthusiastically approved; discussions about the price of corn and the price of Africans were held simultaneously; and descriptions of London's inordinate elegance were followed by tirades against its incredible filth. And throughout the news was dominated by talk of the conflict between the American colonies desiring independence and the mother country insisting on sovereignty.

English artists had their own battles at this time, struggling with the prejudices of the Continent. In May of 1775 a writer published these "Thoughts on the Capacity of the English for the Polite Arts":

> There are many people who seem to have persuaded themselves, and are desirous of persuading others, that the Arts of Painting, Sculpture and Architecture, are naturally and inevitably confined to particular ages; and further, that they are, like plants, only the growth of certain soils and climates. If all that they have advanced . . . be admitted as true and decisive, it must be acknowledged that the people of the British dominions are labouring in the Arts to little purpose, and they must in the end find themselves disappointed in their aims, and that they had been endeavouring to do what the order of Nature and the situation of their climate had pre-determined they should not do.

He pointed to those critics who were the most harsh:

> Abbe du bos, President Montesquieu, and Abbe Wincleman, have followed one another in assigning limits to the genius of the English; they pretend to point out a certain character of heaviness and want of fancy, which they deduce from physical causes. . . . Because we have not hitherto done it, they choose to find out that the thing is impossible to us; and that we are eternally incapacitated by the clouds that hang over our heads, the nervous system of our bodies, our soil, our food.[2]

But among the sculptures shown at the Royal Academy in the very month this article appeared was one that did exhibit the kind of new forms that thrilled Winckelmann and other connoisseurs on the Continent. Joseph Nollekens (1737–1823) had submitted a small model for a *Venus Chiding Cupid* to the exhibition. Though it represented something new in sculpture north of the Alps, we can not be sure how many Englishmen were able to recognize its novelty, particularly under the circumstances of the exhibition. The situation at the Academy was similar to that at the Louvre: art was crowded into every available space, with sculpture holding an inferior position to painting. The sculptor's sole advantage was that he could repeat a piece, displaying it at the next exhibition if he changed the material. Thus, when Charles Anderson (later Lord Yarborough) asked Nollekens to re-create his *Venus Chiding Cupid* as a large-scale marble (Fig. 118), it was seen again at the Academy in 1778—an impressive piece now, one that must have made at least some British connoisseurs notice its new style. Nollekens signed his name on the base with the latest affectation—big, bold Greek letters.

At first glance it does not appear to differ greatly from Falconet's *Bather* (Fig. 112). In spite of its size, it too is pretty and sentimental and must have impressed the public that way. The primary difference between the two would seem to be that Falconet's *Bather* is the more

attractive; her delicate beauty, graceful movement, and perfect proportions are even more appealing in juxtaposition to Nollekens's *Venus*. But in the history of artistic style the latter work represents a significant change. Nollekens moved away from the Baroque concept of the human form, renouncing the kind of torsion and space fundamental to Falconet, Pigalle, and their successors—among them Clodion (1738–1814) and Augustin Pajou (1730–1809), who were the outstanding French contemporaries of Nollekens. Nollekens's figures show a minimum of flexing, bending, overlapping; most portions of the bodies can be seen well from a single view, and there are no draperies to disguise the edges or to provide colorful contrasts of light and texture. The feet of both his figures stand close together; through the unaccentuated contrapposto he induced his Venus and Cupid to stand motionless in their exchange of glance and touch. Parallel limbs and angular turns make their profiles clear and distinct. European sculptors of the seventeenth and eighteenth centuries rarely showed the body this way; indeed, the postures have far more in common with figures by Giovanni da Bologna (Figs. 90–92)—whom Nollekens admired enthusiastically—than with the nearly contemporary *Bather* by Falconet.

Key to the new kind of work that Nollekens showed to Londoners in the 1770's was his Roman experience. He was twenty-two when he went to Rome in 1760 to begin a decade of sketching, measuring, "restoring," and copying the best antiquities available. He also did independent work, developing subjects such as "Regulus Returning to Carthage" and "Timocles Conducted before Alexander." And he made busts of his compatriots living in Italy. There were plenty to be made, for Rome was the goal of every cultured Englishman. No one made the Grand Tour with more passion than the British and no group of foreigners was more active in Rome. Being a people in the process of establishing an empire, they felt a special affinity for ancient Roman traditions.

By the time Nollekens arrived in Italy the high taste-makers of eighteenth-century English art—men like Robert Adam, William Chambers and Sir Joshua Reynolds—had already returned to England. Most prominent among contemporary British artists still in Rome during the 1760's was the Scotsman Gavin Hamilton (1723–98). He was renowned not only for his classical paintings but for excavating and restoring ancient marbles, which he sold profitably to English collectors. Nollekens conducted the same business, though on a more modest scale; the future Lord Yarborough became one of his clients for antiquities in Rome.

When Nollekens returned to England in 1770 it was with enough capital to lease the house of the Secretary of the Royal Academy and to set up a large studio. Most of his time was now spent making busts that fashionable Londoners loved. But his personal aesthetic preference is best seen in works such as the *Venus Chiding Cupid*. His approach to the subject was similar to Falconet's: both began their studies with nature. J. T. Smith, Nollekens's contemporary biographer, tells us of an encounter the sculptor had with the model for his *Venus* some years after the work had been completed. Nollekens apparently did not recognize her: "What! Sir . . . do you forget Miss Coleman . . . why I have been with you twenty times in that little room, to stand for your Venus?" [3] Yet the study of nature did not yield the same results in Nollekens's work that it did in Falconet's. Even though he began with nature, with a model always in view, and made preliminary small clay studies (". . . no one equaled him in his time as a modeller, particularly in his Venus" [4]), Nollekens's final marble looks unlike most eighteenth-century goddesses. For, like so many of his countrymen, Nollekens had worshiped at the feet of the great pagan Venuses such as the *Venus de' Medici* (Fig. 119), before which

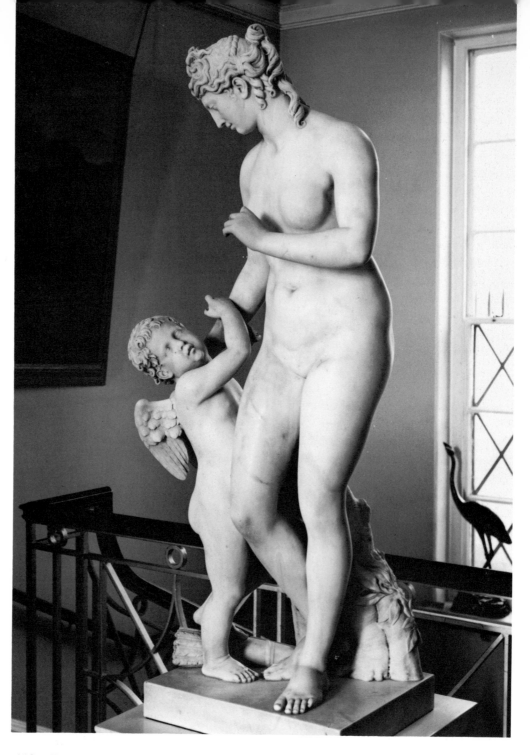

118. JOSEPH NOLLEKENS. *Venus Chiding Cupid.* 1778. Marble, 4′8″. Usher Art Gallery, Lincoln.

Edward Gibbon "first acknowledged . . . that the chisel may dispute pre-eminence with the pencil, a truth in the fine arts which cannot on this side of the Alps be felt or understood." [5] And the corrections that Nollekens imposed upon his nature studies were derived from this other idiom—the visual language of classical antiquity. His studio walls were

> covered with heads, arms, legs, hands, and feet, moulded from some of the most celebrated specimens abroad, together with a few casts of bas-reliefs of figures . . . all were hung with little

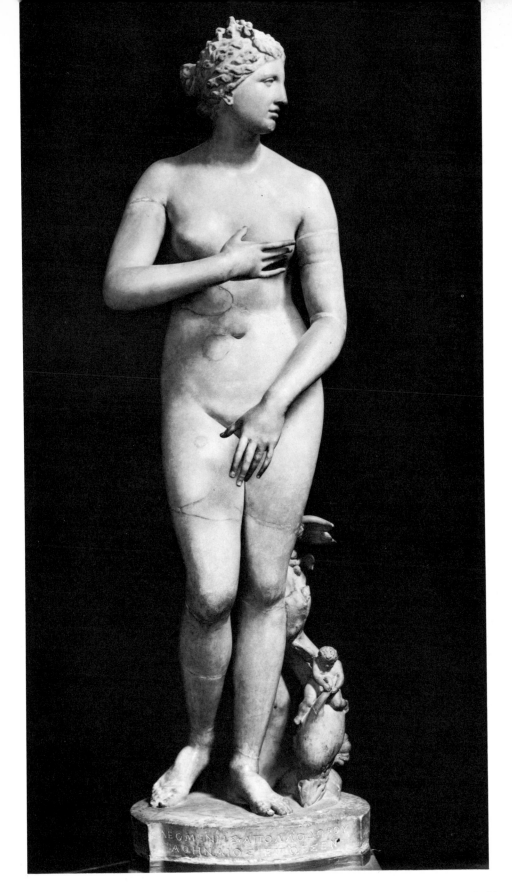

119. *Venus de' Medici.* Roman copy after a Greek original of the 4th Century B.C. Marble.
The Uffizi Gallery, Florence.

reference whatever to each other. He paid but little attention to the productions of the ancients; though, indeed, I have seen him finish up the feet of his female figures from those of the statue of the Venus de Medicis; the English women, his constant models, having very bad toes in consequence of their abominable habit of wearing small and pointed shoes.[6]

We begin now to understand some of the difficulties encountered by Nollekens and certain of his fellow artists: he simply was not very consistent as he worked back and forth between nature and the antique. He wanted to make statues that would be pretty, but the manner in which he suppressed individual beauty usually resulted in a slightly saccharine abstraction; he sought grandeur, and he made his figure of Venus large, yet the effect is not particularly monumental. Nollekens's style is thus not a coherent one; still, it has enough of the Neoclassical so that it takes on considerable interest when we study the style that was to dominate all the visual arts in Europe by the end of the eighteenth century.

If Rome was an inspiration for Nollekens, it affected another Northerner even more profoundly. Johan Tobias Sergel (1740–1814), son of a German artist, was born in Stockholm at a time when Sweden was just beginning to awaken to the Enlightenment. Though Sweden's monarchy did not reign in the same absolutist style as the French Bourbons, it was quite willing to support lavish art and building projects of the type that were so dear to eighteenth-century royalty. When the palace of Adolphus Frederick was ready for rebuilding at mid-century, its vastness demanded the assistance of foreign as well as native artists. Many were French, and it was they who gave Sergel his schooling. First he studied with Pierre-Hubert L'Archevêque, learning to translate his teacher's models into large figures. Then he became the Frenchman's collaborator; he acquired a true facility for injecting stylish Rococo life into a surface and giving rhythmic movement to the figural decorations of the palace.

Once in Rome Sergel repudiated this work. Later in life he described how he had been struck by an entirely different artistic climate and a completely fresh view of antiquity upon his arrival in Rome:

> I left for Rome in 1767 in June and arrived in the same year on August 12 at the age of twenty-seven. I can say that day I began my studies. My eyes were opened to my ignorance, full of regret that I lost the years of my youth. I became melancholy and discouraged to see the talented younger men all around me. I was so affected that I was not able to undertake anything for three months. My very love for my work was hurt. I had such a reputation at home. Totally content with me, L'Archevêque continually praised my work. . . .[7]

Sergel's experience was quite unlike that of Nollekens, who had arrived in Rome seven years earlier. Sergel—older, more formed by previous experiences in Stockholm and Paris—must have been even less prepared than the Englishman for the modern Neoclassicism which in the years between the two sculptors' arrivals had become far more defined and visible in Rome. No recent event had been more important in the growing movement than Winckelmann's publication in 1764 of *The History of Ancient Art*, which became the gospel of the later 1760's. Being written in German, it was more accessible to Sergel than it would have been to Nollekens; Sergel moved quickly into a world where he was able to associate with those "beautiful young men of good taste" whom Winckelmann had recommended as proper companions for cultivating the new Neoclassical sensibility. The world they revealed to Sergel was so diverse from the one he had known that, as we have seen, the experience was painful for

him. It seems likely that sometime in the fall or winter of 1767, through mutual Scandinavian friends, Sergel was able to make the acquaintance of the great antiquarian himself, only a few months before Winckelmann's departure on the trip that ended with his death in Trieste.

Sergel's conversion from a world of Rococo enchantment to one of classical grandeur came about as a result of intense devotion to the kind of critical studies Winckelmann had described as essential for young artists. He traveled to Naples, Herculaneum, and Pompeii; Sergel's first years in Italy were ones of deep concentration and looking. Once back in Rome he began to put together a new vocabulary, drawing from live models, from Renaissance paintings, Hellenistic and Roman sculpture. But personal taste would not allow him to exclude the Baroque either: in 1770 he made a copy of Duquesnoy's *St. Susanna* (Fig. 104). Winckelmann, who spoke of Bernini's figures as "those vulgar people," would probably not have endorsed this choice either, but copying was at least the method he felt proper for the modern artist. He had spoken of how he believed the ancients, "those wise artists," had proceeded—"as a bee gathers from many flowers, so were their ideas of beauty not limited to the beautiful in a single individual, but they sought to unite the beautiful parts of many beautiful bodies." [8]

Sergel's new understanding became apparent in a series of remarkable works executed during the 1770's—*Faun, Achilles and Cyron, Diomedes,* and *Cupid and Psyche* (all in Stockholm, National Museum). They were stronger and more lucid than his Stockholm works, though he never completely gave up his earlier sense of movement and expressive force. The loveliest of the series is the traditional *Venus* (Fig. 120). He first worked out his ideas for it in a small terra cotta. The body was broad, its weight partially borne by a small altar, the foot delicately placed upon the symbolic shell, and a wreath of drapery encircling the body, clasped in multiple folds across the figure's breast. For some years Sergel left the little sketch undeveloped, but early in 1778 he came back to it and began work on a large plaster to serve as the model for a marble version. However, he was unable to carve immediately the beautiful block of Carrara marble that he had selected for his *Venus*: in Stockholm, L'Archevêque had died, leaving Sergel as Gustavus III's choice for First Sculptor to the King. Sergel was back in Stockholm in 1779, and it was there that he finished his last Roman work.

This modern *Venus* was probably even more startling to eighteenth-century Swedes than Nollekens's figures were to Londoners during the same years. Not only would they have had less exposure to the new style, but Sergel's work was more powerful than Nollekens's. The two artists' *Venuses* are of the same size, yet even in a photograph Sergel's appears fuller, more monumental. He was a better artist, and had also profited by arriving in Rome at a slightly later date, when Neoclassicism was more fully ripened. He absorbed more from his archaeological studies and was able to convert these lessons into an energetic style, one that was more wholly his own. Both Nollekens and Sergel found their sources in the antique descendants of Praxiteles and the *Aphrodite of Cnidus* (Fig. 32), but Sergel moved beyond the noticeably archaeological flavor of the English sculptor's work. At first glance the pose of Sergel's *Venus* appears very like the contrapposto of the Praxitelean type, with that gentle combination of asymmetry and balance in the body's volumes. But further study reveals another kind of tension in this long-limbed figure: unlike the antique prototypes, Sergel's goddess lifts her left shoulder and elbow high, pulling them back while moving her right hand across her body to the inner surface of the right thigh. The transitions are suave and graceful, as we can see in the dip of the shoulders and the elegant turn of the head on the long neck. Some of Sergel's revision of the Classical type recalls the stylized sixteenth-century figures of Giambologna (Figs. 90–92). [9]

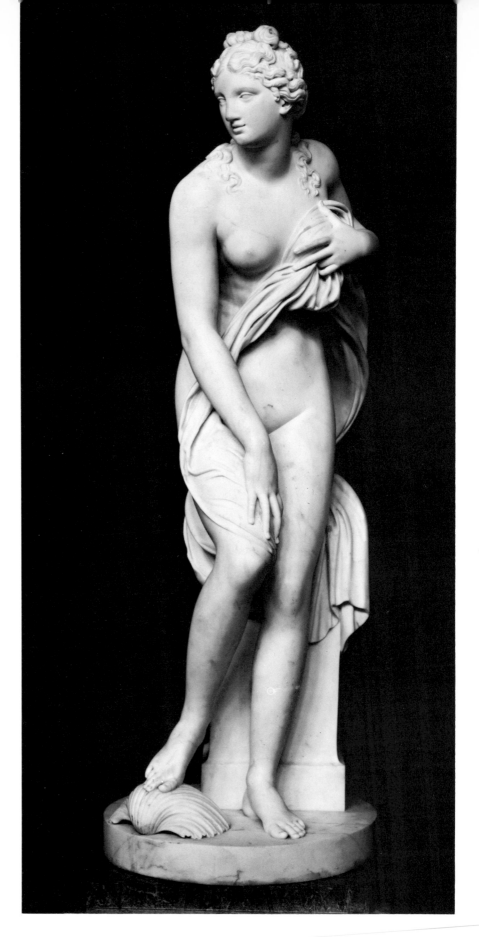

120. Johan Tobias Sergel. *Venus.* 1770's. Marble, lifesize.
National Museum, Stockholm.

Beyond the greater grace and monumentality that distinguish Sergel's brand of Neoclassicism from Nollekens's is his ability to inform his *Venus* with a special kind of sensuality—soft and voluptuous, yet simultaneously remote. He accomplished this by making his forms full and round, and by enfolding his figure in draperies clasped tightly to her breast and thigh. He thus transformed the modest gesture of the ancient goddess, meant to recall fertility, into a cool, tantalizing one. He made the face round and gave it what he conceived of as Classical features—fleshy skin without sharp angles, rather boneless contours in the areas of cheek and jaw, a tiny chin, and small pursed lips drawn into a strange smile.

Sergel was the outstanding sculptor in Rome during the 1770's. Once home he also became one of the most forceful personalities in modern Swedish art, but never again did he execute quite as fine a group of works as his Roman sculptures. Later he looked back on Rome, claiming that it was the "only true home of art where an artist ought to be born, live, and die; for all the other countries of Europe are barbaric." [10]

By the time Sergel left Rome, Neoclassicism was undeniably the dominant artistic style in Europe; it had transcended national boundaries and was being established as a universal standard of beauty—just as Winckelmann dreamed it would be. Its proponents saw in this more than a simple shift in taste: they regarded it as a profound moral victory, with the energy once given to Rococo excesses now being directed toward loftier, purer pursuits. Rome, the acknowledged center of a living contemporary archaeology, became an irresistible magnet for artists.

A little more than a year after Sergel's departure from Rome a young sculptor arrived there who was to intensify Neoclassical principles and bring the art of sculpture to new heights. This "modern Phidias," as Antonio Canova (1757–1822) was to be called, arrived from Venice when he was twenty-two. His training there had reinforced an inborn skill at fashioning elegant and moving figures based on a combination of naturalism and sentiment. Like Sergel, Canova drew inspiration from his new environment—antiquities, Renaissance and Baroque painting and sculpture all attracted him. He was even able to appreciate medieval works. Within a few months of his arrival he made the trip south to Naples and Pompeii as Sergel had, with the same sense of searching for a new vision. In Rome itself, he was particularly drawn to the sophisticated English community; he formed a warm friendship with Gavin Hamilton and through his circle discovered the work being done by Nollekens and Sergel, which he considered finer than anything any contemporary Italian had made. His own works of the 1780's—two great papal tombs in the new pure, severe style—were thoroughly classical and hugely successful. When Francesco Milizia, the harsh and respected Roman critic, had his first look at the monument to Pope Clement XIV in SS. Apostoli, he declared that the figures "appear to have been carved in the best period of Greek art."

As the eighteenth century came to an end and Canova's reputation grew, he was working with some of the same themes that Sergel had explored: *Venus and Adonis, Cupid and Psyche, Hebe, The Pugilists.* Canova would have liked to remain in his Roman studio to concentrate on such themes, but few who lived in Italy during the years in which France and Austria competed for domination of the peninsula were unaffected by contemporary events. By the spring of 1798, the year the Pope was ousted and the Roman Republic created, life in Rome had become so insecure that Canova returned to his home in Possagno, north of Venice. It was in that spring too that the treasures he loved most—the Vatican's *Apollo Belvedere*, the *Laocoön*, and the *Antinous*—left Rome; they were offered as tributes from the victorious French army to the city of Paris and to the glory of the French Republic.

Anxious to return to work, Canova went back to Rome in late 1799. During the first decades of the nineteenth century he created the most powerful and heroic sculpture made by any contemporary artist. Crowds came to look at these creations in the same manner that they visited the great sites of ancient Rome. In Mariano Vasi's guide of 1817 the Roman tourist is told to take himself to Canova's studio on his first day in the Eternal City, since the works there "surpass all the eulogies that one can make; su^fficient to say that the name of Canova will pass into posterity as those of Phidias and Praxiteles." [11] And it was during these years that the most notable group of works ever made for the Bonaparte family was produced by Canova—who, like most contemporary Italian artists, made his private peace with Napoleon's Empire in order to keep working in Rome.

The circumstances surrounding the creation of the *Venus Italica* are quite revealing of the sculptor's methods. Unlike Nollekens and Sergel, Canova did not simply select a beautiful and traditional figure from the classical repertory for the purpose of exhibiting it in a modern art show. In fact, it seems that he did not even consider doing a single figure of Venus until 1803, when he was approached by Maria-Luisa, regent of the Kingdom of Etruria (as Napoleon chose to call Tuscany for a brief period in the early nineteenth century). Since one of the most revered antiquities in her realm, the *Venus de' Medici* (Fig. 119), had been removed to Paris, she felt that a copy should be placed upon the empty pedestal in the Uffizi. Canova said he had too much respect for this most singular of antique figures to attempt making a copy (an irony, since the *Venus de' Medici* is itself a copy of an older antique statue). It was a gracious way of refusing Maria-Luisa, though actually the request was probably repellent to him. When he first arrived in Rome, Canova was most sensitive to the fact that in the Italian sculptors' studios the main activity was copying and imitating Greco-Roman statues. He scorned their activity and saw that foreign artists were dealing far more imaginatively with antique themes. The principal idea of the new Neoclassical movement as defined by Winckelmann had been emulation of older work, the entering into its spirit, but not mere imitation.

By 1804 Maria-Luisa relented and said that Canova could execute a statue of Venus as he pleased, and thus the *Venus Italica* was created (Figs. 121, 122). It turned out to be more distant from its famous model than Sergel's *Venus* had been, for Canova—who had studied nature and who had used the same sculptural sources as his Swedish counterpart—had developed a much more individual and radical style. This is fully evident in a comparison of their two versions. Canova's *Venus* is larger, taller by a whole foot; he put particular stress on the size and shape of the head, with the face in a neat profile parallel to the front of the body. The shoulders are of even height, as are the breasts, hips, and knees. Canova had little interest in movement and did not develop the kind of body vitality and contrapposto that artists usually showed in such a figure (Figs. 32–34). His *Venus* is exceptionally upright, with the stress on long vertical lines; the diagonals in the drapery and arms form the most delicate kind of minor counterpoint, resulting in a peculiar stillness. And there is little space: there are no openings anywhere; the figure is solid, complete within itself.

The details reinforce this conception of the statue: the exquisite hair style with each coil sharply defined, the precise tapering fingers and nails, the single tassel on the drapery edge, the clearly cut ornamental details on the coffered base. Everything is exact and more decorative than illusionistic. The surface is brilliantly carved, for Canova developed every possibility for translucence in the marble. He gave the work a high polish, which is in sharpest contrast to antique works. Visitors to his studio described how he would give the finishing touches to

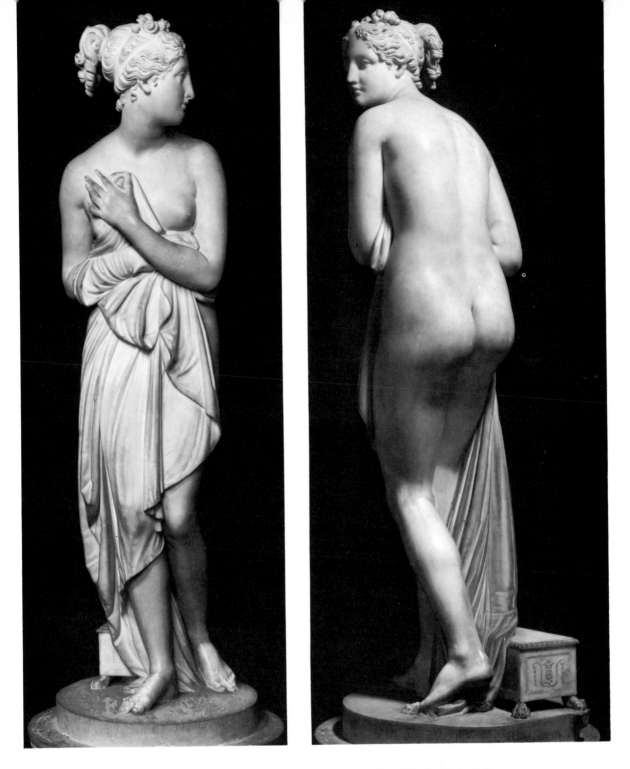

121–122. ANTONIO CANOVA. *Venus Italica.* 1805–1812. Marble, 5′8¼″. Pitti Gallery,
Florence.

statues by candlelight so that no surface subtlety would be lost. Art historians generally agree
that Canova did most of his work on the *Venus Italica* in 1805, composing the figure in small
clay *bozzetti* and probably also making a large clay model to serve as the basis for the full-scale
plaster and marble versions. He finished the figure in April of 1812; it was installed in the Uffizi
on May 8, larger and more dazzling than the *Venus* it was replacing.

By late 1807 the Kingdom of Etruria had been absorbed into Napoleon's Empire and Maria-Luisa sent back home to Spain. In the end it was Napoleon himself who paid for the final carving of Canova's beautiful *Venus*. After the Battle of Waterloo in 1815, when Canova went to Paris to retrieve the *Venus de' Medici* along with Italy's other antique treasures, French museum administrators felt that they ought to be given the *Venus Italica*, which had, after all, been paid for by French money, to replace the antique version they were about to lose. They did not insist on this, however.[12]

Canova's contemporaries adored the *Venus Italica*, and copied it as they would a famous antique. Naturally they compared it to the *Venus de' Medici* and often Canova's *Venus* was thought to be superior:

> The dimensions of his statue are somewhat larger than those of the ancient figure; she is in the graceful and attractive posture of one who issues dripping from the bath, when the freshness of the limbs, and the soft brilliancy of the skin, add an inexpressible charm to beauty. This delightful appearance has been lost (if indeed it was ever possessed) by the Venus De' Medici, whose present surface impaired, perhaps by long exposure to the air, or by the substances in which it has lain buried, contrasts with the porous and transparent skin of Canova's Venus very much to the advantage of the latter. . . .[13]

This comparison was made by Canova's friend and biographer Count Cicognara, who recognized not only the freshness of Canova's statue but also a kind of sensuality in it that was not found in the antique example. This view of the *Venus Italica*, however, was rapidly lost. An English author, who wrote a laudatory biography of Canova soon after the sculptor's death, also noticed the difference in dimensions between the *Venus de' Medici* and the *Venus Italica*, but the latter had a very different effect on him than she had on Cicognara:

> . . . Canova's Venus being in every part larger, and also of a stature naturally more lofty. This latter change appears by no means an improvement; it may, to use the words of an admirer, "la rende men donna, e più dea,"—"render the figure more a goddess, and less a woman"; but though more majestic, it is colder, and without that feminine softness—that attractive loveliness which charm in the ancient statue.[14]

Canova's dearest friend among the French classicists, Antoine Quatremère de Quincy, published his biography of the sculptor over a decade after the Italian's death; here we find yet another interpretation of the *Venus Italica*, one that became standard in nineteenth-century art criticism. He emphasized that while the *Venus de' Medici* was portrayed as a goddess—with small cupids astride a dolphin on the base alluding specifically to her birth from the sea—Canova had simply represented a woman emerging from her bath and drying herself—more natural but less elevated:

> . . . without doubt, this would have seemed a bit unseemly in antiquity to the worshippers of the goddess, who, even though they assimilated their gods to earthly ways, desired their artists to make their images with a superior degree of nobility in their forms and a reserve in their action.

He felt that for the "purist," Canova's figure, shown in the act of drying herself, was too common.[15] Picking away at subject matter in this fashion—the correctness of attributes and the suitability of specific poses for certain types of figures—was of enormous importance to nineteenth-century critics and connoisseurs, but it was not relevant to Canova's work, especially

the *Venus Italica*. Canova and the other Neoclassical sculptors were generally less concerned with subject matter than with style. They did not find that the essence of art existed either in narrative substance or in psychological exploration, preferring instead to dwell on the language of style. Canova was not interested in gathering rapid impressions of the sensuous world to record them superficially in his forms. Though he showed in his terra-cotta sketches that he had the capacity to do this, he cared more for taking the sensuous elements he saw in nature and sublimating them in solid forms and smooth surfaces. The new sculpture represented, in effect, a reaction against the naturalism of post-Renaissance art. Sculptors agreed with Winckelmann that it is only in art that we find perfect beauty and that "nature could not bestow the precision of contour." Neoclassicists in Rome and elsewhere were convinced of the moral superiority of their concerns; their style was pure, unburdened with the sentimentality of the Rococo. The authority of Canova's pure forms rested not so much on traditional symbolism and narrative content as on their strength as well-delineated objects with recognizable links to the venerated statues of antiquity.

For the modern art historian, the recognition of great power and beauty in Canova's statues is relatively new, for Neoclassicism was a style easily reduced to a banal formula and rapidly became the property of the academic establishments—in no art more tyrannically so than in sculpture. All over the Western world for the remainder of the nineteenth century Greek and Roman models were held up to students as ideal images; it eventually became nearly impossible to see either the originality or the modernity of Canova's work, and sculpture in general came to be thought of as a second-rate, old-fashioned form of image making.

The commitment to a classical style during Napoleon's time ushered in one of the most unified stylistic periods in the history of art. Napoleon himself understood the political importance of ideal art and of the links contemporary classicism established between his world and the ancient Roman Empire. But his personal taste sometimes conflicted with the prevailing one, and he found much of the antique subject matter of contemporary art boring. Although he permitted Canova to make a colossal image of him in the "Greek" manner, when he saw the great white marble nude in 1811 it struck him as inappropriate and he never permitted the French public to see the work (it was sold to the English in 1816). Somehow its idealizing tendencies and ideological strength and purity escaped him. Napoleon, a man committed to his own deeds and to the drama of contemporary history, both enjoyed and inspired non-classical images. Thus, though the conditions of the French Empire fostered the Neoclassical movement in art, they also nourished new Romantic tendencies. But it was only after Napoleon's death (1821) and the collapse of the Bourbon Restoration in France (1830) that these tendencies came to the fore in contemporary sculpture.

François Rude (1784–1855) is the perfect example of a sculptor who absorbed the Napoleonic cult as a youngster in exactly those years when he was learning to draw and carve in the Neoclassical mode. But as a mature artist he was to reject the classical manner totally. A student in Paris during the Empire, Rude won the coveted Prix de Rome. He did not make the usual artistic pilgrimage to Rome, however: as a supporter of Napoleon, he chose to go into exile in Brussels after the defeat at Waterloo. There the great exiled Neoclassicist and First Painter to Napoleon, Jacques-Louis David, was holding court in his studio, making it a gathering place for all those opposed to the Bourbon Restoration. With David's help Rude was able to settle down and make a living by producing decorative busts and architectural reliefs of mythological themes. These were severe and orderly classical works, routine and a bit dull.

By the beginning of the second quarter of the nineteenth century one more Bourbon, Charles X, had ascended the throne; in many respects the old power of the Church and the monarchy appeared to have returned to France for good, and the arts and sciences flourished in the Parisian capital. Viewing all this from Belgium, Rude—little known outside the Low Countries—began to think of returning to his homeland and to Paris, where a new spirit was beginning to infuse all the arts. The most obvious way to reintroduce himself as a sculptor of merit was to make a major work for the Paris Salon. Rude's principal entry at the Salon of 1828 was *Mercury Attaching His Wings* (Fig. 123). It was received with great praise; later in life Rude could look back at his *Mercury* and recognize in it a pivotal work that rescued him from relative obscurity and made him a sculptor of considerable repute.

Here was a beautiful lifesize statue depicting a familiar subject—the messenger of the gods—with graceful long lines, carefully rendered anatomy, and rich surface detail. But it looked modern as well; it was nothing like the solid, static marbles of the Neoclassicists of Canova's generation. In making his *Mercury*, Rude did not entirely give up the classical tradition in which he had been educated; nevertheless, he worked with a new and daring kind of image for the 1820's, focusing on the figure's instability and posing Mercury just at the moment before flight. He shifted every limb and line of the human body from the more conventional verticals into diagonals so that all the lines appear to pull the body away from the small round base where Mercury touches ground. This work stands as an important example of the transition from Neoclassicism to a new style of far greater dynamism.

The critical acclaim given Rude after his successful showing of *Mercury* and other works at the Salons of the 1830's resulted in the commission for the relief that would become his most renowned work: *The Departure of the Volunteers of 1792* (also called *La Marseillaise*) for the Arc de Triomphe in Paris (1833–36). Its size, dramatic gestures, vivid expression, and dynamic movement have made it a standard example of French Romantic sculpture. Never before did Rude have the opportunity to draw inspiration from French history: here he was able to glorify the whole Revolutionary-Napoleonic period with which he identified so thoroughly; but here too he did not do away with the antique past, for he dressed his soldiers in Roman armor and put swords and shields into their hands.

Rude never received this kind of commission again from the timid, middle-class bureaucrats of Louis-Philippe's government, established by the Revolution of 1830. But he had found his own unique artistic vocabulary and when he worked with a subject that moved him, he soared. This happened when he made the tomb of the great Republican journalist Godefroy Cavaignac at his personal expense, and when he placed his highly romantic image of Napoleon, again at his own expense, on a lonely hillside south of Dijon. And we find it again in Rude's *Marshal Ney* (Fig. 124), one of the most successful public bronzes ever to adorn the streets of nineteenth-century Paris.

Every aspect of Rude's *Ney* contradicts Canova's approach to sculpture. It is not an abstract, idealized statement about military leadership and heroism, but it is specific and personal in the highest degree, having been designed for the precise spot where Ney was cut down by a Restoration firing squad in 1815. It is not the martyr, but the military hero who is commemorated, however. Uniforms and exact costume details were not new for Rude; he had worked with them all through the 1830's and 1840's. (When he had made his image of Napoleon for Dijon he used as models the hat, uniform, sword, and cloak once actually worn by the Emperor.) Rude created Ney's uniform with precision and skill: tight breeches and boots,

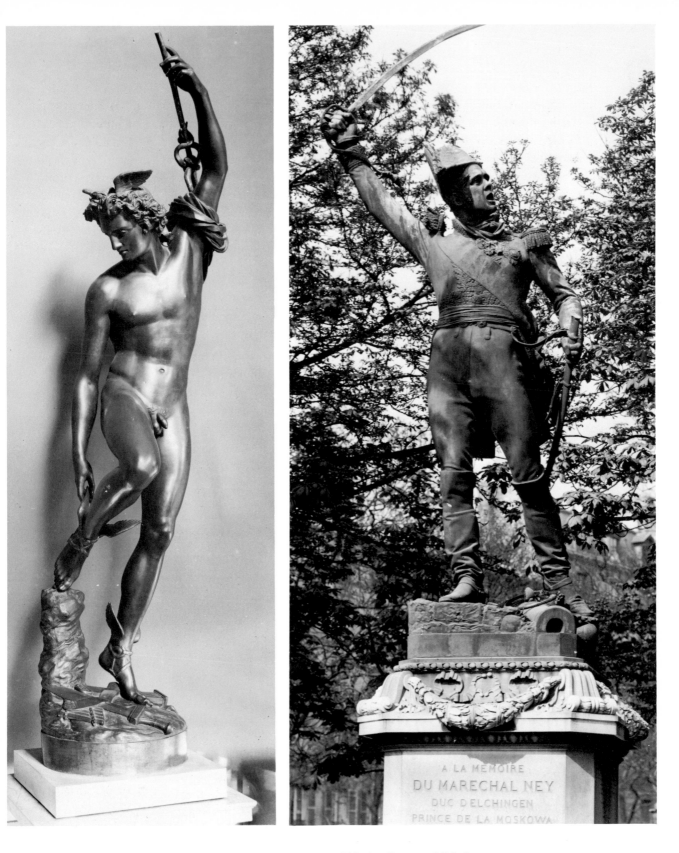

123. FRANCOIS RUDE. *Mercury Attaching His Wings.* 1828–34. Bronze, 8′2″. Louvre,
Paris.

124. FRANCOIS RUDE. *Marshal Ney.* 1852–53. Bronze, 8′7″. Avenue de l'Observatoire,
Paris.

wrinkled and creased at points of stress to suggest the soldier's muscles underneath; the waistcoat embroidered with oak leaves and hung with medals; the braided epaulets; and the old bicorne hat of the Revolution. In the entire history of sculpture so specific a costume is not found before Rude. Today it does not seem very radical—such statues are in public squares all over the Western world—but the *Marshal Ney* was an innovation of nineteenth-century sculpture. For the nineteenth-century viewer it was anti-classical and highly controversial. Recognizing that styles in clothing change rapidly, people wondered if a statue showing the fashion of a particular time might not quickly be outmoded: "A person's taste must really be strange if he can look at a statue of Washington or Napoleon dressed in the style of their epoch without laughing," remarked one of Rude's contemporaries.[16]

The reason Rude was able to avoid the obvious pitfalls of adopting historically accurate dress is that the essence of his portrayal depended on movement and expression rather than on clothing. He worked out his whole design with clay sketches of the figure in the nude before giving any attention to the costume. The gestures and voice of the impulsive, dynamic Ney were legendary in France, and Rude wanted them to live forever in the repeated swirling diagonals of his design—picking up momentum in the right arm and sabre and terminating in Ney's open mouth.

Rude's *Marshal Ney* was the greatest patriotic monument of the Second Empire, made at a time when Romantic nationalism was already going out of fashion. It was also a time when sculpture was in eclipse as an art form. Many believed that sculpture, having reached its zenith around the turn of the century and being firmly fixed in the art of the past, could not be a modern art in the way that painting, music, and poetry could:

> According to me, the epic side of Greek art . . . cannot return, the civilization which produced it being dead. Let our sculptors repeat this to themselves every morning . . . sculpture, as Greece understood it, has become a dead language for us. . . .[17]

So wrote Emile Zola. Another novelist, Joris-Karl Huysmans, came away from the Salon of 1879 thinking sculptors ought to abandon their art if they could not find a way to modernize it:

> If it can, sculpture should try to depict modern subjects and we will know what to expect. If it can't—well, it's perfectly useless to re-exhaust all the subjects which were better treated in past centuries. It's better for these sculptors to be simple decorators than to clutter the art Exhibition with their products.[18]

Huysmans focused quite accurately on the crux of the problem in nineteenth-century sculpture: subject matter. Sculptors intent on doing original work had to deal with this problem before they even confronted the issue of style. And in order to evaluate their work it is essential to understand their subjects. This has been a major difficulty for twentieth-century observers in appreciating the work of sculptors who worked before Rodin. Rude was one of those sculptors who chose subjects that held personal meaning for him, rendering them in a style that he hoped would capture the actual sense of an individual in history. But it is not easy today to recognize the startlingly innovative nature of a figure of a military hero cast in bronze and put upon a pedestal in a park.

It may be even more difficult to see why a tiny bronze group of fighting beasts (Fig. 125), one that might fit unobtrusively into almost any drawing room in Europe or America, should be considered a breakthrough in the history of sculpture. Yet the animal sculpture of Rude's

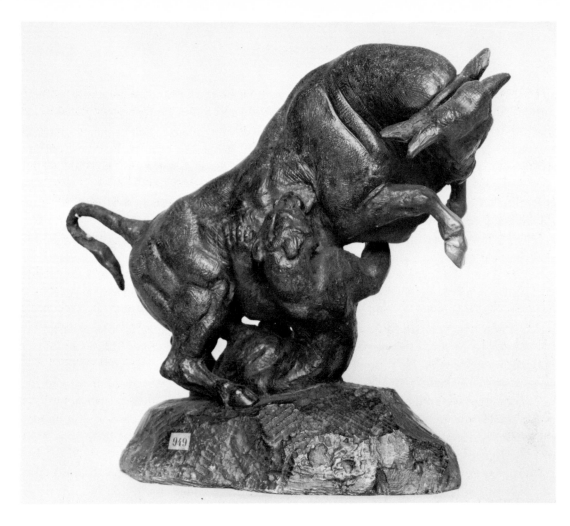

125. ANTOINE-LOUIS BARYE. *Bull Attacked by a Tiger. ca.* 1836–38. Bronze, 8½". Louvre, Paris.

contemporary Antoine-Louis Barye (1796–1875) represented an even greater break with contemporary norms. Barye made his public debut at the Paris Salon in 1827, one year earlier than Rude. He was already over thirty, and his three tries for the Prix de Rome had won him nothing. His entries at the 1827 Salon—a single bust and some medals—attracted no attention. But this never happened again: in 1831 he showed a *Tiger Devouring a Crocodile* and in 1833 a *Lion Crushing a Serpent*, pieces which were among the most widely praised sculptures shown in Paris during the 1830's. Despite their highly original appearance, many conservative visitors to the Salons reacted to them favorably: ". . . these two animals palpitate with life: never, before M. Barye, has anyone rendered nature with a more admirable expression, a more profound feeling." [19]

Of course, what most distinguished Barye from his contemporaries was his choice of animals, not humans, as his subject. This was not entirely novel, for a general interest in animals had been generated by recent scientific attempts to classify the species and to determine their origin. George Cuvier, the foremost French biologist, had been working on the relationship between the uses of animal organs and their appearance—a study that must have fascinated Barye. The Museum of Natural History in Paris was the center of zoological study in France, and this is where the sculptor spent much of his time. In 1854 he accepted the institution's offer to become Professor of Zoological Drawing, a post he held until his death. The Museum gave

him a large collection of skeletons and other material to work with; even more important, outside—in the Jardin des Plantes—he had a wonderful zoo full of exotic beasts to admire and study. Each new acquisition at the zoo was greeted with intense public interest and was considered significant enough for artists to be reported in the art journals. For the Romantic artist exotic animals were often the only living link to those distant lands that he so often portrayed, and thus their unusual colors, forms, and movements had an enormous suggestive power. (The painter Géricault, for example, had been attracted to beasts in the early 1820's and had recorded their movements in both pencil sketches and in clay.)

Barye's interest was thus a timely one; it was also a personal passion that dominated his whole life. He spent hours at the cages; when a beast died, he rushed to the Jardin des Plantes to draw, measure, skin, and even sometimes to cast the carcass on the spot. One of his nineteenth-century biographers tells the story of his American patron William Walters calling at his house in 1863, only to be told by Madame Barye: "Ah, sir, there is no use calling for three weeks. A new tiger has arrived from Bengal; until its wildness is gone—no Monsieur Barye!" [20] Yet as much as he loved the animals' being close at hand for him to study, Barye was uneasy about their confinement. He imagined them in their freedom and did not treat them as a lower genre as animal painters and sculptors had traditionally done; nor did he tame them into the docile creatures portrayed by eighteenth-century sporting artists. Barye created a whole world of savage beasts, and in so doing he abandoned the restraints of classical poses, self-conscious compositional relationships, monumentality—everything sculpture had stood for in the West since the Renaissance.

In spite of some favorable notices in the press, talk of public commissions, and considerable patronage by the King's eldest son, the Duc d'Orléans, Barye's work was rejected for the Salon of 1837. The taste of the leaders of the art establishment had grown progressively more rigid and repressive under the July Monarchy. The Salons of the 1840's were duller than anything ever seen in Paris and Barye decided no longer to participate in them. He worked, as Rude did in the years preceding the Revolution of 1848, in semi-seclusion and relative poverty. It was during this time that he began to experiment with the problems of bronze-casting.

Bull Attacked by a Tiger (Fig. 125) was the kind of sculpture Barye was doing in the late 1830's when opportunities for public exhibition of his works began to dwindle. Slightly earlier, between 1834 and 1838, he had executed his brilliant hunting and combat groups as table displays for Louis-Philippe's young son. This later, smaller piece relates to the style of those table ensembles; in it he took up again a favorite theme—the assault of a bloodthirsty predator on another beast of different size and body type. The dominant force of this coupling is provided by the bull's broad muscular body lurching up, head thrown back, hoofs pawing the air (Barye cast this animal separately as well as in the combination illustrated here); the tiger's serpentine form writhes beneath it, no less muscular but supple and tense as he tears at the hide and pushes with his rear leg into the soft underbelly of the bull. The drama of the continual movement and the irregular silhouette of bodies in conflict are reinforced by the dark green patina—colorful and changing, with reflections appearing and disappearing as the surface has been roughened.

In the 1840's Barye lived and worked in his own foundry on the Right Bank in the rue de Boulogne; there in the fall of 1847 he held a private exhibition and sale of 107 works, the *Bull Attacked by a Tiger* among them. He thus became the first French sculptor to campaign actively for independent exhibitions by artists. It was part of his total involvement with all the practical aspects of his art.

Visitors to Barye's studio found that even his clay and wax sketches were unlike those of other sculptors, for he discarded the traditional rigid armature, keeping everything—limbs, tails, heads—as separate parts flexibly connected by the use of wires until the last moment before the plaster cast was made. His background and training as an engraver and a jeweler stood him in good stead when his founder, the famous Henri Gonon, died in 1838; he decided to learn casting himself and acquired facility in every aspect of this craft. He knew how to use the new reducing machines, to make plasters, sand casts, and beautiful *cire perdue* casts. He could chase, and he knew how to produce the finest patina. In a century of industry and invention, Barye recognized that the hands of the sculptor were being gradually replaced by those of the workman who translated the artist's plasters into bronzes and marbles. Strangely enough, he was abused for his practical craftsmanlike approach—a "mere artisan," he was called, while one critic complained that "this inroad of beasts into sculpture is owing to their easy production and retailing."

In what light then should we see Barye's beasts? Are they artistic parallels to the rich knowledge acquired by modern zoologists? He was surely the first French artist of note to spend more time at the Jardin des Plantes than at the Louvre, and his dedication to naturalism led him to the most careful dissections and measurements. But the results of his studies do not look very scientific. Indeed what could be less scientific than to portray animals native to two different continents locked in conflict, as in the *Bull Attacked by a Tiger*? Barye did not choose these two beasts because they show a realistic aspect of nature; he chose them for aesthetic purposes—for their size, shape, and movements. He also chose with a deep awareness of the exquisitely carved animals on antique cameos and of the exciting animal compositions on ancient sarcophagi.[21] Yet Barye had little concern for style in Canova's terms; he was not preoccupied with formal abstractions such as line, contour, and composition. He wanted his figures to reveal what he had witnessed of animal life, so that even his dark little table pieces show something of the powerful conflicts in nature's realm.

Barye's small-scale multiples could be bought by art lovers for as little as 5 francs, yet their quality was exquisite. He thus made possible a vast production that was at once marvelous, violent, intimate, and cheap. Some found this vulgar; they felt the smell of the zoo following them as they left his exhibitions. Edmund de Goncourt watched a Barye jaguar devour its prey "with a gourmand's delight in blood," and the American novelist Henry James wrote in Barye's obituary for the *New York Herald Tribune* (December 25, 1875): "To have on one's mantel-shelf . . . one of Barye's business-like little lions diving into the entrails of a jackal . . . has long been considered the mark, I will not say of a refined, but at least of an enterprising taste." It was probably just this raw-edged vulgarity that accounted for Barye's broad popularity in the nineteenth century. His recognition was well deserved; Barye had attacked the narrowness of sculpture from unexpected directions: its scale, its techniques, and its subject matter.

As we have seen, subject matter was a constant problem in nineteenth-century art. To be a truly modern artist—to be a real Romantic—implied new experience and vision. It was necessary to explore subjects beyond the range of those employed by older artists; painters went to history and literature and to the lives of people beyond the European continent in order to find feelings and ideas that had not been put on canvas before. This too was what Barye was doing; it was the essence of his work and of his Romanticism. It was also the first objection usually raised against him. But his explorations were in one sense limited, and those who were

uncomfortable with his work could put it in a category: they called him an *animalier,* and with this term kept him at a safe distance from the central thrust of the modern movement.

This was not true of the experimental work of the slightly younger Antoine-Augustin Préault (1809–79), who was exploring new themes more vigorously than any other sculptor of his generation in France. Following his debut in the Salon of 1833 there appeared one unsigned article that sets the tone for the kind of criticism he was to receive throughout his life:

> Statuary is a monumental art, an art whose most decisive characteristic is to not be able to lend itself with impunity to mean or vulgar ideas, to deformed subjects, or to hideous sketches. A confused, wantonly tortured execution wounds our sensibilities far more strikingly in sculpture than it does in poetry, painting or in music. In antiquity statuary was called the art of heroes and gods, that is, the art of great actions and of elevated faith, and this is its mission—to exalt the imagination of people. . . .[22]

Préault was seen as the sculptor *par excellence* of "vulgar ideas" and "hideous sketches." His struggle for recognition was more intense than that of either Barye or Rude. And rather than following their quiet, hardworking ways, far removed from the glittering café life of the July Monarchy, Préault lived the life of a true bohemian, being constantly seen at the theater and on the boulevards of Paris. His attitude was one of confrontation: during the 1840's, when Rude and Barye retired to private work in disgust at the prevailing repressive art system, Préault showed up at the Salon doors year after year—only to be thrown out each time. The result is that we do not know enough about his most innovative work, for without financial support a sculptor often could not keep a fragile clay or plaster, let along have it cast. Yet Préault persisted in exploring most fully the possibilities of new feelings in sculpture, especially through literary images.

His greatest success with a literary theme was *Ophelia* (Fig. 126), created in 1843. It took him three decades to find a purchaser for it (it was cast and sold to the French State in 1876)—not surprising with such an unconventional piece. Préault's *Ophelia* is a lifesize, powerful, moving figure in relief. By traditional standards, relief is the portrayal of forms projecting forward from a flat ground. But here we have both figure and ground sinking below the rectangular frame. Préault thus appears to have been more faithful to his inspiration— Shakespeare's *Hamlet*—than to artistic tradition:

> But long it could not be
> Till that her garments, heavy with their drink,
> Pulled the poor wretch from her melodious lay
> To muddy death.
>
> *(Hamlet, IV:7, 179–182)*

Stranger still, he designed the relief not to hang on a wall, but to be placed on the ground at the viewer's feet. Recumbent figures on low pedestals, particularly female, were not new to nineteenth-century sculpture, but a lifesize relief figure to be placed as a tomb effigy when it was not one—*that* had no precedent.

Ophelia is further distinguished by the skill with which Préault worked the clay before it was cast. He created a robust figure with an oval head, columnar neck, smooth body, and a compact form revealed through wet drapery. He placed this body in an ambiance of ever-changing surfaces still betraying the pliable moist matrix in which they were first set. Ophelia's hair and clothes, "her weedy trophies," and "the weeping brook" merge without distinctness in a rhythm that beats and rushes and turns the body within its rigid coffin-frame.

There is a pulsating, hypnotic quality to the work, very different from the quiet lyricism of the Delacroix lithograph of *Ophelia Drowned*, done in the same year. It must have been through his friend Delacroix that Préault got the idea of representing Ophelia's death. Interest in Shakespeare was at its height during the late years of the Bourbon Restoration, and in 1827 *Hamlet* played to packed Parisian audiences. Delacroix led all the Romantic artists to a new consideration of the play through his sixteen-plate series of illustrations, published in 1843.

It is not likely that many persons saw Préault's *Ophelia* in the years after it was made, since the sculptor was not welcome at the Salons until after the Revolution of 1848 and his first opportunity to show his plaster relief to the public was in 1850. The theme—taken for granted in painting—was considered inappropriate for sculpture by some critics. In his journal entry of June 16, 1854, Delacroix wondered, "What would [Ingres] say of poor Préault, who does things like *Ophelia* and other eccentricities, English and Romantic?"

To speak of Romantic art invariably brings certain kinds of paintings to mind—a psychologically penetrating portrait by Géricault, a tumultuous scene by Delacroix, or a glowing Turner landscape. It does not usually make us think of sculpture. Yet sculptors did much that was new during this time, and they did it in the context of re-evaluating some of the most rigid precepts ever held in the history of art. The problems they grappled with concerned not only style and subject matter, but also materials, techniques, and scale. Though seldom as acclaimed as the painters of their time, the Romantic sculptors did, in fact, achieve a broadening of the concept of sculpture. Their jarring images and irregular visions were ultimately accepted, then diluted, and finally popularized. What Préault could realize but not exhibit in the 1840's would be the sensation of the Salons of the 1860's.

The sculpture created in France during the Second Empire reflected the regime whose buildings and salons it served to adorn—expensive, flamboyant, apparently progressive, but at its core conservative and based upon older ideas. With Louis-Napoleon's *coup d'état* of December 2, 1851, a dictatorial government returned to France. A year later on the same date, the forty-seventh anniversary of Napoleon Bonaparte's victory at Austerlitz, his nephew assumed the title of Emperor. As Napoleon III, Louis needed a court with its ceremonial life, and he began to emulate earlier imperial ceremonies in an effort to legitimize and strengthen his own claim to majesty. Bonapartism became the fashion and stately appearances meant everything. There was much for artists to do in France during the Second Empire, for whatever

126. AUGUSTE PREAULT. *Ophelia*. 1843, cast in bronze in 1876. Bronze, 29½″ x 79½″.
Musée des Beaux-Arts, Marseille.

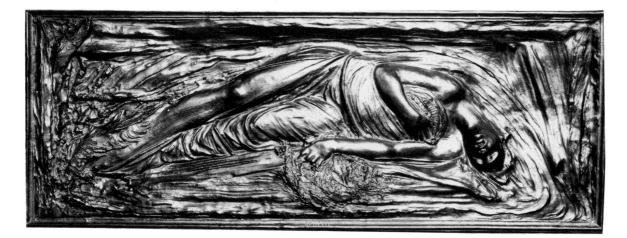

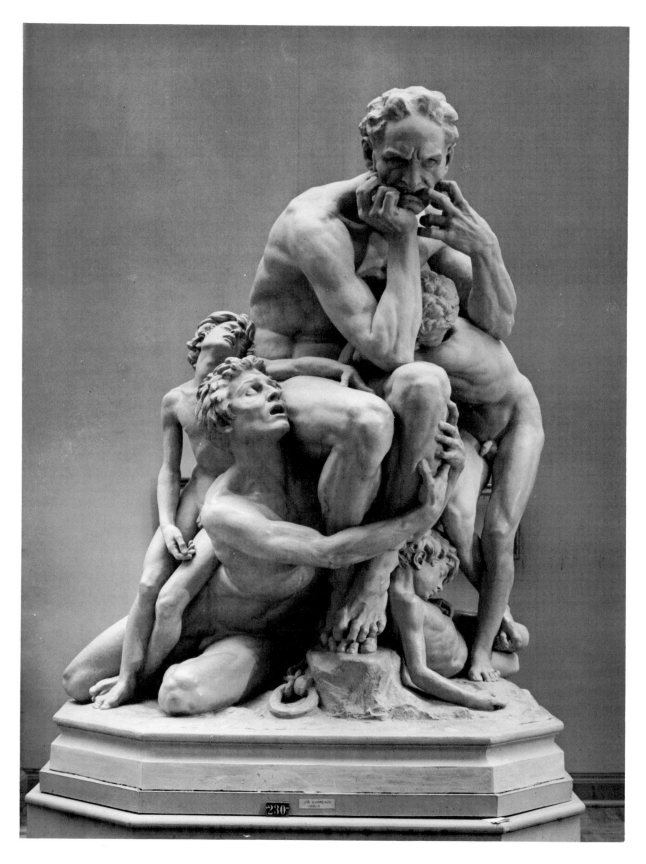

127. JEAN-BAPTISTE CARPEAUX. *Ugolino.* 1860–1862. Plaster, 6'5½".

progress or change was being wrought by the government, its leaders wanted it reflected visibly and materially. Paris had to be built up, ornamented, refurbished—and it was all to be done in a hurry.

There was no more gifted sculptor in Europe to reach maturity during this booming period than Jean-Baptiste Carpeaux (1827–75), who became one of Napoleon III's favorites. In spite of a simple background and fairly rude ways he was welcome at the Tuileries balls and invited into the imperial apartments to teach the Prince Imperial how to draw. Carpeaux had spent more than five years as a student at the French Academy in Rome and did not return to Paris until 1862. He found a city that was rapidly changing according to the grandiose plan of Baron Haussmann: beautiful broad streets were being laid out on both sides of the Seine; new apartments were rising; and theaters were opening everywhere (the cornerstone of the new Opera was laid in the summer of 1862). It was to this new and frivolous Paris, whose citizens were infected with a search for pleasure and anxious to capture a sense of *la gloire*, that Carpeaux brought back a sculpture on which he had lavished much time during his Roman years—*Ugolino* (Fig. 109).

This great work was shown at the Salon of 1863. Cast in bronze at State expense, *Ugolino* brought Carpeaux a first-class medal. Still, his success was far from uncontroversial; one critic wrote disapprovingly: "In the group of *Ugolino and His Children* by Carpeaux, Grand-Prix de Rome, I recognize the manner of M. Préault; extremes come together." [23] The most pointed objections to the group were directed at the theme itself, taken from Canto XXXIII of Dante's *Inferno*, in which Count Ugolino tells Dante how he and his sons were locked in a Pisan tower and left to starve to death because of his betrayal of his native city. This controversy over the theme had already been aroused in Rome when the director of the French Academy reminded Carpeaux that the only subjects permissible for Prix de Rome students were those taken from ancient history or the Bible. And when Carpeaux brought the group to Paris, critics flatly declared its subject unfit for sculpture, despite the fact that Louis Rochet had already shown a plaster group of *Ugolino and His Children* at the Salon of 1839. But probably the most important factor in setting the stage for the monumental group was the great popularity of the volume of engravings for Dante's *Inferno* published in 1862 by Gustave Doré.

Another objection to Carpeaux's statue concerned the number of figures and the complexity of the group: "What will we do with this pyramid of emaciated bodies?" (Dauban); "Ugolino is really not a subject for sculptors; sculpture is an art of great and simple compositions and not a hash of short intersecting forms as we see it in this group of many crouching figures" (Thoré-Bürger). It is unusual to find in Renaissance or post-Renaissance sculpture a freestanding group with more than two or three figures in it; Michelangelo's *Pietà* (Fig. 88) was one of the exceptions. Yet what attracted Carpeaux in the Ugolino story was precisely the opportunity it offered the sculptor for creating an anatomical tour de force in a subject that was familiar to the public at large, yet new and non-academic.

Carpeaux established a straight axis in a closed pyramidal composition with the figure of Ugolino defining the pyramid's apex. His body is a complex, tight combination of muscle and bone, of curves and angles. The carefully formed, lean young bodies broaden and loosen the composition as they bend, turn, yield, and die. Our attention is especially drawn to the anatomical details—hands, feet, knuckles, knees, elbows jutting out everywhere. The taut flesh and conspicuous muscles are precisely and forcefully articulated. Though a closed composition with five bodies drawn into a knot, the mass is continually pierced by openings and penetrated

by deeply carved shadows. The statue's total effect was, and still seems, exaggerated and melodramatic. But these qualities had wide appeal in the nineteenth century: the Princess Rospigliosi cried when she first saw the work in Rome, and the Princess Borghese fainted.

Despite the commotion in Rome and Paris over Carpeaux's *Ugolino*, and the debates about the subject and the number of figures permissible in monumental sculpture, in its essence the piece is deeply traditional. Contemporary critics recognized this as well: "It is almost a modern Laocoön" (J. Girard de Rialle); "One could say that a damned soul of the Sistine had been sculpted rather than painted" (Paul de Saint-Victor). And there is no doubt that in approaching this work Carpeaux made conscious choices that would elicit just such comparisons. The story of Ugolino, the father mortally punished along with his progeny for political reasons, was obviously a modern variation of the Laocoön theme. A Hellenistic sense of pathos is conjured up in the father's grimacing face, which becomes a mask of terror:

> . . . and when I recognized my own aspect in their
> four faces I bit my hands in my despair
> (Dante, *Inferno*, XXXIII, 56–57)

The powerfully rendered seated male figure is clearly Michelangelesque (Fig. 128). Carpeaux spent many hours copying Michelangelo's work in Italy. He wrote in his notebook: "When an artist feels pale and cold, he runs to Michelangelo to warm himself in the rays of his sun. . . ." [24] And in 1860 he wrote to a friend that he believed "a statue conceived by the poet of the *Divine Comedy* and created by the father of *Moses* would be the chef-d'oeuvre of the human spirit." [25] The *Ugolino* was to be in marble, the preferred material of Michelangelo and the ancients, not the bronze of modern French sculpture. The fact that the State had it cast in bronze rather than carved in marble for the 1863 Salon was very distressing to Carpeaux; he did not rest until he found a patron who would pay for a marble version.

Carpeaux's work delighted some, offended others, but during his brief moment of celebrity he was the darling of Parisian society. After the *Ugolino*, he no longer pursued themes of Romantic anguish but rather responded to the dazzle of the Second Empire. He was particularly adept at working with female figures, images that sparkled and danced with sensuous beauty. Like many of his contemporaries, his knowledge was encyclopedic and he could simultaneously draw inspiration from the most diverse sources—Correggio, Rubens, Michelangelo, Goujon, Houdon, or Rude. In an expanding society like that of the Second Empire the artist reached for everything within his grasp, the past as well as the present. Carpeaux did not hesitate to use all the new sculptural techniques for reducing, enlarging, and copying works. The less inventive artists of the period were merely eclectic, but Carpeaux—who seemed almost to compete intentionally with the great artists of the past in a manner that would never have occurred to Rude, Barye, and Préault—created a sumptuous naturalistic style that was very much his own despite its constant links with the past.

Carpeaux was an inspiration to the younger sculptors of the Second Empire, among them Auguste Rodin (1840–1917), who remembered his school days at the Petite Ecole where Carpeaux taught:

> In truth, he came there rarely; but—I don't know why, for we were too young to understand him—our admiration went out to him instinctively; it may have been that we had some presentiment of his greatness; the wildest ones among us were full of respect for him. Perhaps it was imposed on us by some illuminating corrections he made; I don't really know. Later, after having seen his work, I looked to no one else. [26]

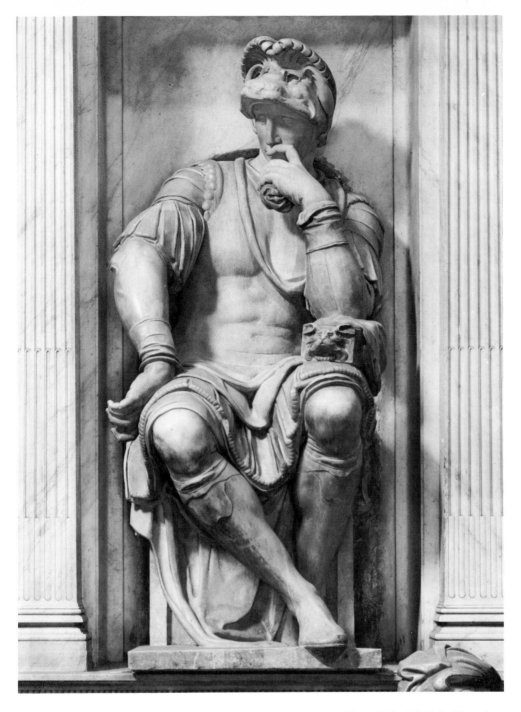

128. MICHELANGELO. *Lorenzo de' Medici.* 1525–34. Marble, 5'8". Medici Chapel,
Florence.

As a young man Rodin did not quite understand the aims of either Rude or Barye: he
confessed to having laughed at the *Marshal Ney* when that was the fashionable thing to do, and
when he first started dropping by Barye's studio he was as yet unable to recognize the
magnitude of the older man's gifts:

> . . . I stopped going after a while, because the man didn't seem like much to me. He was so
> simple in his speech and manner; he never thought about publicity. He was always looking and
> trying to understand more; I didn't think that I could learn a thing from him.[27]

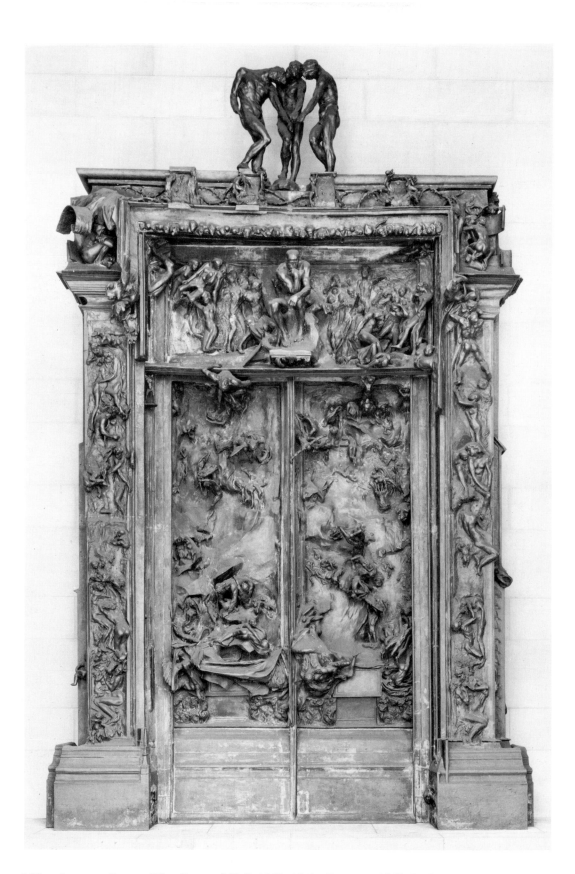

129. Auguste Rodin. *The Gates of Hell.* 1880–1917. Bronze, 17′5″. Rodin Museum, Philadelphia.

Later Rodin came to see that they were both men of enormous talent—particularly Barye, whom he referred to as the "master of masters," "the great man of our century." But Carpeaux, only thirteen years his senior, was his early inspiration. When *The Dance* by Carpeaux was unveiled at the Opéra in 1869 it was an event in Rodin's life.

Rodin was a child of the Second Empire: he haunted museums, acquired a comprehensive knowledge of Western art, and yearned to visit its homeland—Italy. Like Carpeaux he worked diligently to achieve that goal, but not through participation in Prix de Rome competitions; instead Rodin worked as a "practitioner," a hired hand who laboriously carved works for other sculptors, thereby saving enough money to spend two months in Italy during the winter of 1875–76. That was far short of Carpeaux's six years at the French Academy in Rome, but it was enough to instill in Rodin an unbounded enthusiasm for Michelangelo: "Before I saw Michelangelo, I was cold." He praised the Medici tombs as the most impressive works of art in his entire experience and Michelangelo as "my liberator." Yet he did not make copies as Carpeaux had done but spent his time looking intensely and then drawing from memory what he had seen in order to understand the principles underlying Michelangelo's figures.

When Rodin returned to Brussels (where he was living in those years), he responded to the Italian experience with the creation of *The Age of Bronze*. He also worked out a group that we know little about today—an *Ugolino*, which he himself probably destroyed. The same ideas that had inspired Carpeaux in Italy dominated Rodin's creative life over the next few years. When in 1880, at age forty, he finally received a major commission—the doors for the new Museum of Decorative Arts in Paris—his imagination was filled with a multitude of nineteenth-century Romantic ideas and most particularly with scenes from Dante's *Divine Comedy*. But he did not want simply to re-create incidents from the dramatic medieval poem; he wanted to evoke the essential spirit of the *Inferno*, and this he accomplished in the bronze doors known as *The Gates of Hell* (Fig. 129).

Rodin's encyclopedic knowledge equaled that of Carpeaux; in *The Gates of Hell* his own inventive powers rival those evidenced in the grandiose sculptural projects of the past to which he pays homage: medieval church portals, Renaissance doorways, Baroque tombs. His project for the doors was colossal, reflecting a true nineteenth-century urge to design vast comprehensive schemes, though Rodin himself was never able to complete it.

As worked out by Rodin's associates after his death, *The Gates of Hell* included 186 figures. The largest one, which dominated the entire scheme, is *The Thinker* (Fig. 130), and it has become far better known than the portal as a whole. It is also the most traditional figure in the portal, the one most bound to the works of Carpeaux and of Michelangelo. Though visually and thematically crucial to our interpretation of *The Gates of Hell*, *The Thinker* quickly assumed an independent existence, as did many other of Rodin's hell-bound figures. Perhaps Rodin's most significant contribution to the changing concept of sculpture was to show that compositions did not have to be conceived of as set aesthetic combinations: he revealed that the relationships between figures could be numerous and that new relationships could be found quite arbitrarily. He removed some figures from *The Gates*, rearranged them in new combinations, and tried them alone in all sorts of positions. This flexible attitude enabled Rodin to probe sculpture's potential as a subtle, shifting medium like poetry or painting.

The Thinker was one of the few figures from *The Gates of Hell* that was not later combined with other figures. Rodin's massive male form, bending in upon itself, is conceived in a relaxed frontal position with a subtle contrapposto. The lowered head, lips pressed back by thick

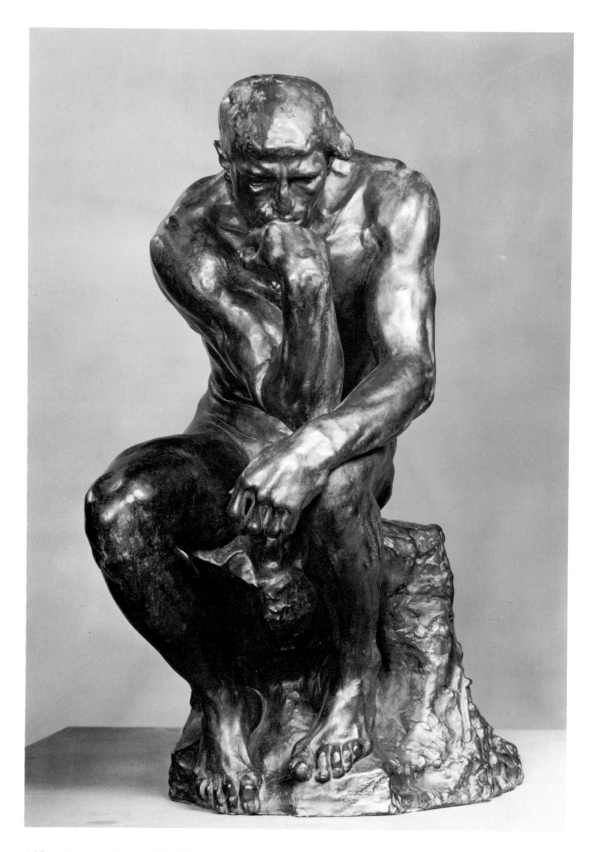

130. AUGUSTE RODIN. *The Thinker.* 1880. Bronze, 27½″. The Metropolitan Museum of Art, New York.

knuckles, and shadowy sunken eyes give the face its brooding, haunting quality. Ever since Michelangelo carved his figures for the Medici tombs (Fig. 128) and his *Moses*, and painted the Sistine prophets and sibyls, the kind of powerful seated figure he created had been a distinct figure type in Western art. Rodin knew these figures well and many of the later sculptures inspired by them, but his *Thinker* is especially linked to Carpeaux's *Ugolino*. He kept a cast of one of Carpeaux's studies for that group in his studio and he would often walk by the bronze cast of it placed in the Tuileries gardens not far from the intended site for his *Gates of Hell* at the Museum of Decorative Arts. Comparing the torsos of the two statues, we find that they are nearly identical. But Rodin suppressed two things that were of vital importance in Carpeaux's *Ugolino*: the descriptive details—such as the veins, teeth, hair, fingernails—and the incredible bodily tension. He did so by developing broader and weightier proportions; the muscles of Rodin's figure are ampler, less taut; the legs spread and relaxed; the arms create a movement inward and downward. By its very subject *Ugolino* demands intensity; it is the story of a man's anguish and guilt brought into focus by the nearby bodies of the innocent victims of his crime. Rodin's seated figure is, by contrast, isolated; in *The Gates of Hell*, even though he is surrounded by sufferers, he is alone. His position and form—concave, bowed, arms turned inward—are those of a solitary figure; he is the least active though the most powerful figure in the swirling mass of human bodies.

Since its creation people have speculated about the meaning of *The Thinker*. The public first saw it in its original size, just over two feet, in 1889 at the Georges Petit Gallery, where Rodin and Claude Monet had a joint exhibition. Its label read, "The Thinker, the Poet, fragment of the Doors." Many persons, especially those who visited Rodin's studio during the 1880's, referred to the figure as "Dante," which seems curious but is understandable given the nineteenth-century predilection for that literary giant and for specific illustration. Twenty years later Rodin tried to explain the evolution of *The Thinker* and said that he had indeed considered fashioning a Dante meditating in the midst of the people conjured up in his poem. He gave up that project because his concept of Dante would have called for a thin figure in a long robe:

> I conceived another thinker, a naked man, seated upon a rock, his feet drawn under him, his fist against his teeth, he dreams. The fertile thought slowly elaborates itself within his brain. He is no longer dreamer, he is creator.[28]

Some of Rodin's contemporaries understood this conceptual shift quite well:

> He is the perpetual dreamer who perceives the future in past events. . . . It doesn't make any difference if it is Dante or a humanized idea of Thought. His visionary look follows the evolution of weaknesses and passions from the fabled times of Olympian heroes to these last years in which he himself has participated.[29]

Rodin did what sculptors had been doing for the past two generations—he worked with literary ideas. Yet the universality of his sculpture, which is not to be found in the work of his predecessors, lies in his resistance to mere illustration. Rude's problems involving the choice of costumes simply had no meaning for Rodin, who liberated sculptors from the trap of becoming the creators of specific historical and literary tableaux vivants. Even in *The Thinker*, which many consider his most posed and artificial work, Rodin wanted to give the essence of a figure, carefully executed after close study of the model, natural, yet without details. For the first time since Neoclassicism, sculpture showed the potential for becoming a universal art, this time not

based on style and theory, but grounded in observation and feeling. Toward the end of his life Rodin explained:

> What makes my *Thinker* think is that he thinks not only with his brain, with his knitted brow, his distended nostrils and compressed lips, but with every muscle of his arms, back and legs, with his clenched fist and gripping toes.[30]

It is for this reason that *The Thinker* has come to be known throughout the Western world: large casts (the over-lifesize version was first made in 1904) are found in front of libraries, museums, and universities. The beholder can take from *The Thinker* what he will: that has not been common in the history of sculpture.

During the 1880's when he was working most intently on *The Gates of Hell*, Rodin worked simultaneously on a number of small figures as he collected a vast assortment of movements and gestures from the models he studied daily. The American sculptor Truman Bartlett visited Rodin's studio and reported the ideas Rodin expressed:

> A model may suggest, or awaken and bring to a conclusion, by a movement or position, a composition that lies dormant in the mind of the artist. And such a composition may or may not represent a defined subject, yet be an agreeable and harmonious whole, suggesting to different minds as many names. A model is, therefore, more than a means whereby the artist expresses a sentiment, thought or experience: it is a correlative inspiration to him. They work together as a productive force.[31]

As Rodin began to fix places for his myriad figures in *The Gates*—that great sea of rough plaster—he tried varying combinations, broke figures into pieces, cast portions of bodies, and manipulated them with incredible freedom (even in his earliest work Rodin showed a tolerance for the imperfect, the unfinished, and the arbitrary). For many he never found a place. Some of these can still be seen at his country home in Meudon, fixed in hard white plaster, with all their mendings and awkward irregularities: the balls of clay never smoothed out on a chest or a belly, members hastily amputated either with a sharp instrument or by blunt pulling fingers.

The fragmentary *Flying Figure* (Fig. 131) has this quality of immediacy. It may not have been created in its present form specifically for *The Gates of Hell*, but its lineage is there, and it shows, as do hundreds of other figures, a certain irrevocable quality about Rodin's figures: no matter what violence he did to human anatomy and flesh the result does not offend our sense of nature, for Rodin's naturalism was so deep, he understood the human form so well, that he did not err—he simply altered. He would take a form like the *Flying Figure*, set it in various positions—on its back, its chest, its stump—and each time the feeling of the piece would change. *Flying Figure* does not represent a specific model's body or even a specific moment in the movement of her body. Once it was a complete figure; in another instance it formed part of *The Gates of Hell*; it was also used with another figure in a group called *Greed and Lust*; today it bears in it traces of all these previous existences, of the movements Rodin recorded and of those he eradicated, yet there is no specific idea, no precise subject; the entire piece is form and movement. Divorced from context, freed from anatomical completeness (Rodin's manner of fragmentation was highly arbitrary and subjective), each altered view of the body-form evokes a new meaning.

Nineteenth-century sculptors excelled in modeling; most made exquisite sketches, but they were usually quite clear about the difference between a sketch and the finished work. Rodin was not. It is not certain when he ceased to make this distinction, for he was trained to work with

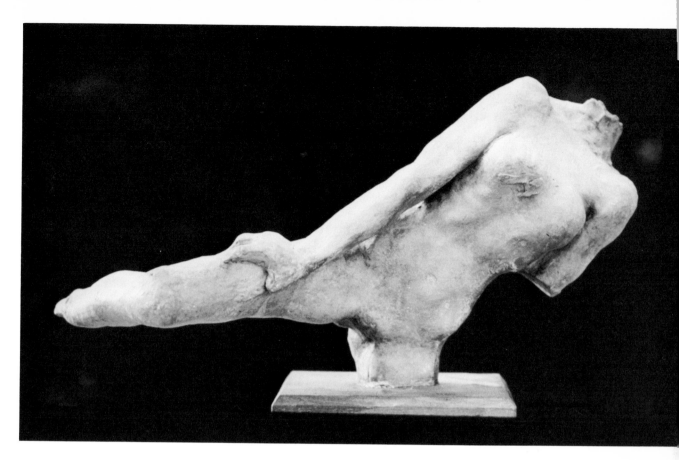

131. Auguste Rodin. *Flying Figure. ca.* 1890–91. Plaster, 20¾″. Rodin Museum, Paris.
Paris.

small preparatory sketches like any traditional sculptor. And he used such sketches many times, but at some point while working on *The Gates of Hell*—probably a few years before he set the *Flying Figure* (traditionally dated 1890) on its stump—he lost sight of any need to maintain that distinction.

Rodin opened up a way of looking at things that seemed impossible for sculptors before him. It now appeared that in clay and in plaster, even in marble, an artist could explore forms more intuitively, that his sensibility could be a shifting one and reach for effects not attempted by sculptors before. Rodin—master of the human form—showed how to do this with the bodies of men and women. For the most part his figures had no names, but they had something to say about the human condition—about solitude, longing, rapture, despair. By creating a truly avant-garde sculptural *oeuvre* he became a cultural hero recognized far beyond the art world. His defenders included such unlikely people as anarchists and radical writers who were able to find meaning for themselves in his conception of the human form. The cult of individual sensibility ran high in the late nineteenth century, when men held particularly subjective views of the world. A person could look at a Rodin figure and find there a responsive echo of his own feelings:

> The Woman flees; she does not turn around. All life's aspirations, all desperations are there, explained only by forms, by the modeling, by the wonderful invention of the line and the extraordinary concordance of curves. It brings to life and exalts the ballad of human suffering.[32]

So murmured the writer Octave Mirbeau upon seeing a Rodin group in an exhibition in 1889.

Man is an animal linked to inanimate matter; but human life transcends its earthly origin. Knowledge of the physicochemical determinants of life is of course essential for the understanding of man's nature. In their present state, however, the exact sciences fail to account for the phenomena which are of the most direct relevance to the human condition.

From one angle, man appears as an assembly of organic materials, very similar in composition and properties to those found in all other living forms. Present-day biology has gone far toward unraveling the structures and mechanisms of the body machine. From another angle, man is seen as an organism responding to stimuli in a manner which sets him apart from the rest of creation.

René Dubos, *Man Adapting*, 1965

I, of whom I know nothing, I know my eyes are open, because of the tears that pour from them unceasingly. I know I am seated, my hands on my knees, because of the pressure against my rump, against the soles of my feet, against the palms of my hands, against my knees. Against my palms the pressure is of my knees, against my knees of my palms, but what is it that presses against my rump, against the soles of my feet? I don't know. My spine is not supported. I mention these details to make sure I am not lying on my back, my legs raised and bent, my eyes closed. It is well to establish the position of the body from the outset, before passing on to more important matters.

Samuel Beckett, *The Unnamable*, 1949

Our human frame, our gutted mansion, our enveloping sack of beef and ash is yet a glory. Glorious in defining our universal sodality and glorious in defining our utter uniqueness. The human figure is the image of all men and of one man. It contains all and it can express all. Man has always created the human figure in his own image, and in our time that image is despoiled and debauched. Between eye and eye stretches an interminable landscape. From pelvis to sternum lies the terror of great structures, and from arms to ankle to the center of the brain is a whirling axis. To discover these marvels, to search the maze of man's physicality, to wander the body's magnitudes is to search for the image of man.

Leonard Baskin, *statement made in 1959*

Twentieth-Century Sculpture

Object and Kinetic Configuration

With a belief in progress and a hope for international understanding unparalleled by any previous age, fifty million people went to Paris in 1900 to see the most colossal exhibition ever assembled. Alfred Picard, its principal organizer, said: "The Exposition will be a synthesis of the nineteenth century and it will be the basis of the philosophy of the twentieth." Looking down the Quai des Nations, visitors were beguiled by domes, minarets, belfries, cupolas and by their iridescent colors—mauves, torrid reds, deep greens, and in the background the gleaming yellow of Eiffel's tower of 1889 (painted for the occasion). Paul Morand recalled that "the buildings were the masqueraders . . . a colored picture book, a cave filled by strangers with treasure." [1] This visual feast helped to divert attention from the political instability both in France and in the world at large. The aggressive competition for prestige at the Exposition was neither so overt nor so bloody as that taking place elsewhere in the world, and the gaiety of the situation allowed visitors to overlook the fact that so many of the exotic objects, pavilions, and people from the remotest parts of the world were there by virtue of a fiercely repressive colonial system.

Industrial and technological exhibits far outweighed those devoted to art. The greatest display of all was along the Champ de Mars, where all sorts of machines were shown, the automobile being particularly prominent. Strangely enough, despite all the optimistic rhetoric about a "new era in the history of humanity" being ushered in by the Exposition, the more serious observers recognized that "these discoveries, while enlarging our horizons, also reveal the narrow limits of our sensibilities." [2] For some the discoveries of science—discoveries like X-ray pictures and wireless messages, produced by means not perceivable by the senses—were frightening in their implications. The American historian Henry Adams spoke of "a new universe which had no common scale of measurement with the old." After looking at a forty-foot dynamo in the Gallery of Machines, he stated:

> The planet itself seemed less impressive, in its old-fashioned, deliberate, annual or daily revolution, than this huge wheel, revolving within arm's-length at some vertiginous speed, and barely murmuring. . . . Before the end, one began to pray to it. . . .
>
> Between the dynamo in the gallery of machines and the engine-house outside, the break of continuity amounted to abysmal fracture for a historian's objects. No more relation could be

discovered between the steam and the electric current than between the Cross and the cathedral. The forces were interchangeable if not reversible, but he could see only an absolute fiat in electricity as in faith.[3]

The fine arts were represented by thousands of works, shown at the Grand Palais (housing the *Centennale* [Fig. 132], art from 1800–89) and at the Petit Palais (housing the *Decennale*, art of the last decade of the century). The choices of the works in both exhibitions fell to the more conservative figures in the world of modern art, and little of what was exhibited looked inspiring or new. The qualities most valued by the members of the organizing committee lay in a work's subject and in its potential to instruct, edify, or amuse. When they found a work too vague or too unusual in style they turned it away or put it under the staircase. Their preferences in the French sculpture section clearly favored bombastic allegory: pieces such as *France Convincing Russia to Visit Her Capital* (Aubé) and *Nature Unveiling Herself Before Science* (Barrias) seemed timely.

132. Sculpture exhibition at the Exposition of 1900, in the Grand Palais, Paris.

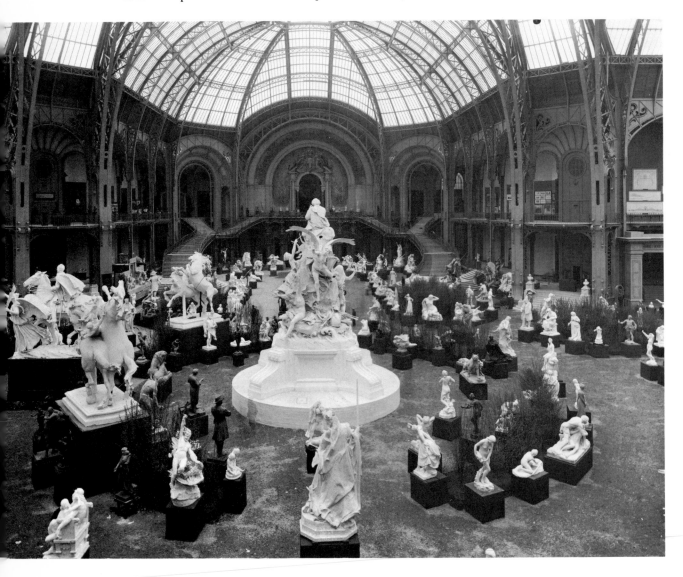

Rodin, the most renowned artist in Paris in 1900, was still smarting from the rejection of his *Balzac* by the Société des Gens de Lettres which had originally commissioned it, and from the massive abuse it suffered when shown at the Salon of 1898. He decided to follow the precedent set by the painters Gustave Courbet and Edouard Manet at the time of the Universal Expositions of 1855 and 1867: he mounted his own exhibition outside the fairgrounds, installing drawings, paintings, and more than 170 sculptures in bronze, marble, and plaster—including the unfinished *Gates of Hell*.

Rodin's bold gesture was handsomely rewarded, and his renown and financial success grew immensely. His unique position and the sheer volume of his production had such force around 1900 that all younger sculptors in Paris had to contend with it. The power of his influence remained through the first decade of the twentieth century, though he produced less with each passing year. By 1910 it would be possible to recognize new tendencies in sculpture, but in 1900 who could have foreseen their origin?

The movement toward a new style in sculpture was multi-national, but its breeding ground was Paris. Two French artists working there at the turn of the century who were very much part of this activity were Aristide Maillol (1861–1944) and Henri Matisse (1869–1954). In 1900 no one could have predicted this to be the case, for both had had an academic Beaux-Arts education as painters and their efforts in sculpture were very tentative. Maillol had spent the 1880's and 1890's alternating back and forth between his Mediterranean home in Banyuls-sur-Mer and Paris, and between his work in oil, terra cotta, wood, ceramics, and weaving. 1900 was probably the year when he decisively altered his direction toward sculpture (he had just met the dealer Ambroise Vollard, who suggested making a bronze edition of some of his terra cottas). Maillol visted the Great Exposition, and although we know nothing about his response to the enormous show of modern Western sculpture, he would have given "anything to have a little Indian elephant," found the Buddhas "very beautiful," and recognized the beauty of planes and the solidity of form in the works of Oriental sculptors exhibiting in Paris that year.

It took Maillol a mere five years to establish himself as a sculptor, accomplishing this through almost exclusive devotion to a single theme: the nude female form. He modeled it in clay, working outward from a solid central core, and variously called it *Kneeling Girl, Standing Bather, Seated Woman, Night,* and *Mediterranean.* Under the latter title he showed at the celebrated Salon d'Automne of 1905; it was his first work to be noticed and well received. Because Rodin's work was still the image of daring in modern sculpture, the contrast provided by *Mediterranean* was striking. The novelist André Gide described how he saw it that fall at the Grand Palais, where there was

> a special room on the main floor with the unequaled works of M. Rodin. Some are truly admirable; each quivers, is restless and expressive, cries out with moving pathos. Then we come to the first floor where in the middle of a small room reposes the great seated woman of M. Maillol.
>
> She is beautiful, she has no meaning. It is a silent work. I believe that you must go way back in history to find such a complete neglect of everything that is foreign to this simple celebration of beauty.
>
> Maillol does not proceed from an idea that he then tries to explain in marble. His point of departure is the material itself . . . the clay or stone, that we feel he has contemplated for a long time. . . .[4]

Gide recognized that Maillol's stable sculptural form, with its regular contours, was too much in

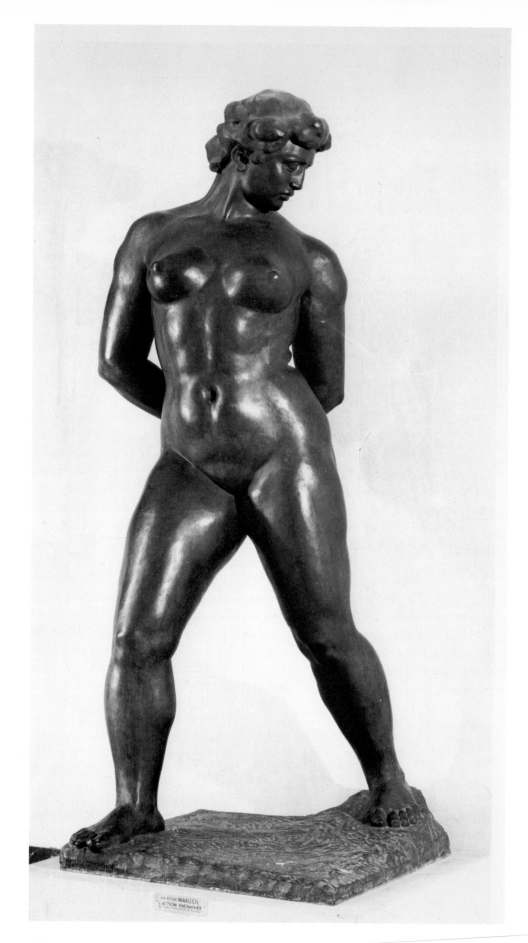

133. ARISTIDE MAILLOL. *Action in Chains*. 1905–06. Bronze, 7′.
Museum of Modern Art, Paris.

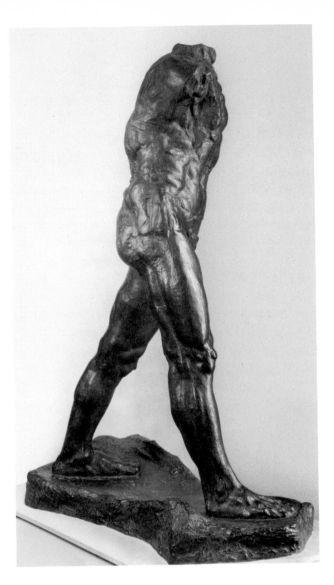

134. AUGUSTE RODIN. *Walking Man.*
1905–07. Bronze, 7'. Museum of
Modern Art, Paris.

the tradition of sculpture to be called revolutionary; but he also saw that its non-narrative quality constituted a reaction against what sculptors were making in 1900, whether in the academies or in the *atelier* of Rodin.

As early as 1902 Maillol had begun to articulate his dream about putting statues into public gardens, and in 1905 he received his first public commission. Under the leadership of the future premier, Georges Clemenceau, a committee had been formed to raise a monument in commemoration of the most consistent political martyr of the nineteenth century—Louis Auguste Blanqui—in Puget-Théniers, the little Alpes-Maritimes town where he was born in 1805. Maillol met Clemenceau on July 10, 1905, and the sculptor is reported to have said to Clemenceau: "Blanc qui? Blanc qui? Who is that? . . . They want a monument? I will give them a naked woman!" [5] The anecdote, though probably somewhat embellished, is valuable for emphasizing how differently Maillol approached the idea of a monument in comparison to nineteenth-century sculptors. When Rodin received commissions for commemorative works— *The Burghers of Calais, Victor Hugo,* or the *Balzac,* for example—he would explore in depth every idea and fact he could find concerning the person he was to portray. Maillol made a Maillol; it was *his* sculptural form slightly altered for the occasion.

The Blanqui monument has come to be known as *Action in Chains* (Fig. 133). It is a powerful seven-foot figure for which the sculptor's wife served as model. The scale was new for

Maillol, and scale seemed crucial to him at this point in order to explore further his inherent sense of massive volumes. He did all the work on the statue himself, and it was difficult; he prepared the enormous armature and built the weighty clay mass solidly around it. He had considerable trouble attaching the right leg to the torso, but finally it worked—his great striding figure. But it is a figure that does not really portray movement. Instead it is an accumulation of thick female contours in an equilibrated tension. The spread of the legs interested Maillol more as a broad base for the torso than as a way of creating the impression of movement. The diagonal turn of the head and neck complement the right leg and counterbalance the forward thrust of the upper torso with its large firm breasts, while following the direction of the arms tied behind the back. The whole sense of balance is based upon the use of a stable central axis, and the statue is best viewed from the front where the full breadth of the body and the profile of the stern, thick-set features can be seen. The smooth surfaces bind the form into a single and complete whole. Modern critics have generally recognized in Maillol's harmonious, non-naturalistic surfaces and in his pure profiles an aspect of the classical phase of early twentieth-century art. This is certainly true, but the early and ambitious *Action in Chains* with its emphatic female anatomy is as much a primitive goddess as she is a classical Venus. And yet in spite of her robust sexuality the figure remains aloof and impersonal.

When Rodin saw *Action in Chains* he had reservations, although usually he was enthusiastic about Maillol's work. Perhaps he held back his full approval because the statue is one of Maillol's works in which he was most influenced by Rodin, and in which it is clear that he was rethinking every aspect of the older sculptor's art. Maillol apparently took the idea for the stance and the uneven base from Rodin's *Walking Man* (Fig. 134), an animated figure in which the illusion of movement is fully conveyed. This fragmentary figure, begun in 1877 as a sketch for *John the Baptist*, has a suggestive and haunting quality, particularly in the over-lifesize version that Rodin was working on at the time Maillol was making *Action in Chains* (presumably Maillol knew of this monumental version). Maillol spoke of the *Walking Man* as having "a certain lack of balance, something of indecision. . . ." His own sculpture would not have these weaknesses—it would be a work of completeness, of equilibrium and coherence, and all rephrased in female forms. The last is an essential point: Maillol was one of the countless twentieth-century sculptors who found the female form to be more rewarding than the male in the struggle to reformulate the aesthetic basis of their art with form as the primary content.

The citizens of Puget-Théniers were no more enthusiastic about *Action in Chains* than those of Calais had been about Rodin's *Burghers of Calais* or the people of Paris about *Balzac*. But their reasons were different. People turned against Rodin's public work and that of a number of other nineteenth-century sculptors because they felt the artists had erred in interpretation of their stated themes. Maillol's critics were primarily concerned about the forthrightness of the nude female figure. As a political memorial to Blanqui, *Action in Chains* failed because it had no narrative meaning, but it was squarely within the new abstract trend by which sculpture would become more solely an object unto itself.

Action in Chains was the largest work Maillol had attempted to date, and its technical problems had often seemed insurmountable. He became so discouraged at one point that he destroyed the figure and asked his friend Matisse if he would not like to take over the commission. Since Matisse was a painter it seemed an odd choice. True, Matisse had made a serious investment of time to learn the rudiments of sculpture: in 1900, while laboring away on miles of painted laurel leaves at the Paris Exposition, he spent evenings at the Ecole Municipale

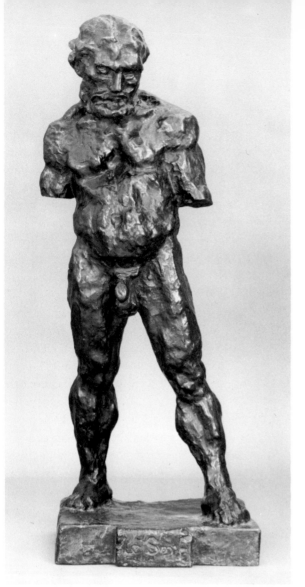

135. HENRI MATISSE. *The Serf.* 1900–03.
Bronze, 36″. The Hirshhorn
Museum and Sculpture Garden,
Smithsonian Institution, Washington,
D.C.

in a sculpture class. He started by copying Barye's *Jaguar Devouring a Hare*; in the year spent making this piece, he learned about anatomy, structure, and rhythm—the lessons Barye taught best—but he taught himself how to keep details from intruding on the essential form.

Matisse had been to see Rodin even before the turn of the century and in 1900 spent some time working under Rodin's most accomplished follower, Antoine Bourdelle (1861–1929). Also in 1900 he began a clay figure which he called *The Serf* (Fig. 135). His model was Bevilaqua, who in his youth had posed for Rodin's *Walking Man* and *John the Baptist.*[6] The choice of this model emphasizes the bond that existed between Matisse and Rodin. *The Serf* is a fragment, though that was probably not the sculptor's original intention. Either by accident or by calculation Matisse sliced off the arms above the elbows and ended up with a fragment that owes much to Rodin's *Walking Man*. Matisse's work is neither so mobile nor so energetic as the latter; it is aggressively rooted in place, with heavy proportions and an insistent equilibrium quite different from Rodin's piece. The blood line is in the clay, in the summary modeling and arbitrary finish that promote such varied profiles and light-capturing surfaces when cast in bronze. Matisse worked on *The Serf* for years; it is slightly over three feet tall and was the largest piece of sculpture he had made up to the time when the disheartened Maillol thought briefly of turning over to him the commission for *Action in Chains*.

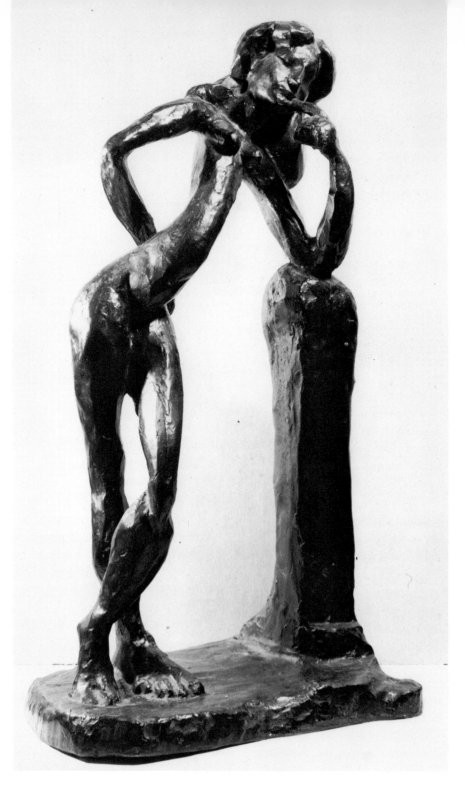

136. HENRI MATISSE. *La Serpentine*. 1909. Bronze, 22¼". The Baltimore
Museum of Art, Baltimore.

Although he did not develop a consistent sculptural *oeuvre* and seldom sought to realize
sculpture on a monumental scale, Matisse made some exceptional pieces. Around 1910 there
was a great deal of experimentation going on in sculpture; nevertheless, few artists were creating
anything more extraordinary than his small, conventionally modeled works. In these Matisse

depended on the same elements that were basic for Maillol: form was realized through the female figure and with an awareness of classical traditions. Both used models and both moved away rapidly from the individual model to work with problems of pure form. Maillol insisted that "to copy the nude is nothing. To reproduce a nude woman is not to make a statue." He felt that "the difficult thing is to get away from Nature." He knew it was an essential difference between his approach and Rodin's, remembering Rodin's constant question: "Have you models?" Maillol's reply was:

> As for me, I just take a walk on the beach. A young girl appears. From that girl walking there emanates a soul. That is what I want to give my statue, that thing alive, yet immaterial. In composing the figure of one young girl I must give the impression that there are all young girls. From the spirit, my feeling passes into my fingers. My statues are poems of life.[7]

Matisse, in his "Notes of a Painter," published in 1908, said, "What interests me most is neither still life nor landscape but the human figure. It is through it that I best succeed in expressing the nearly religious feeling that I have towards life. I do not care to repeat them with anatomical exactness." [8]

But, though the two friends followed a parallel course, their works ended by being quite dissimilar, as Matisse pointed out: "Maillol's sculpture and my work in that line have nothing in common. We never speak on the subject. For we wouldn't understand one another. Maillol, like the Antique masters, proceeds by volume, I am concerned with arabesque like the Renaissance artists; Maillol did not like risks and I was drawn to them." [9]

One of the boldest pieces Matisse made in the years around 1910 was *La Serpentine* (Fig. 136), which illustrates particularly well the manner in which he worked away from nature. It was not done from a live model but from a photograph taken in a studio.[10] Matisse had a book of such photographs, depicting figures—nude except for lively accents such as jewelry and fans—in various poses against scenic backdrops. Matisse's model for *La Serpentine* was a woman whom he described as "a little fat but very harmonious in form and movement." In the photograph she is shown standing on a rock and leaning against a balustrade. Starting with this unprepossessing picture, Matisse made a three-dimensional figure in clay that incorporated qualities of space and rhythm in a way that no other artist working in the early twentieth century could have imagined. He did this with full awareness of the great tradition behind such a figure; in some sense *La Serpentine* must be seen as part of the long line of sculptures based on the Classical Greek motif of a woman leaning against a pillar. Straightened legs looped around each other reverse the photographic model's dimensions, for the calves are now thicker than the thighs; now too we see through an oval hole where once there was solid flesh. Legs and pillar stand equal in height and are junctions of equal importance, where a sagging, skinny torso joins the hips and where a boneless elbow finds support. The large feet and the rough base of the awkward pedestal complement each other—placed apart on opposite ends of the base as if situated only to frame the broad obelisk of space between them. When we think of the total image in terms of moving rhythms and sinuous lines, the piece is an elegant arabesque; when we see *La Serpentine* as a mere girl, she is ugly and crude, too summary, with surfaces too devoid of verisimilitude to nature to make any sense (the latter view, in fact, corresponds to the reaction of most early critics to Matisse's little figure). But in it he showed his ability to reformulate some of sculpture's basic tenets: the relationship of volume to space and the value of descriptive, tangible sculptural surfaces. Unlike Maillol, Matisse remained close to Rodin in retaining a

sensitivity to worked clay and modeled surfaces. However, he shared Maillol's belief that sculptured images could exist without any of the psychological suggestiveness that intrigued Rodin.

Inevitably the question is asked: "Why did this painter make sculpture?" When Matisse was asked directly, he responded:

> I took up sculpture because what interested me in painting was a clarification of my ideas. I changed my method, and worked in clay in order to have a rest from painting where I had done all I could for the time being. That is to say that it was done for the purposes of organization, to put order into my feelings, and find a style to suit me. When I found it in sculpture it helped me in my painting.[11]

Most writers on Matisse have recognized that his sculpture cannot be separated from his painting. John Elderfield noted in regard to *La Serpentine* and other works for which Matisse used photographs as starting points:

> Choosing two-dimensional images as his sources and/or working from a restricted number of viewpoints when treating a sculpture suggest that Matisse's sculptural ambitions were essentially pictorial. And to look at almost any work is to see that it was conceived, in a special sense, as a view of a thing—as a visual motif.[12]

And Lawrence Gowing considered the first decade of Matisse's work as a sculptor as being of particular importance, since at that time he "used sculpture to draw off the formal solidity of art into its appropriate medium, so as to leave behind in painting the strictly visual residue, flat and still." [13]

Consideration of the relationship between sculpture and painting is important because of its special significance in twentieth-century art; among the artists discussed in this chapter, only three began their careers as sculptors (Brancusi, Lipchitz, and Calder); the rest were initially painters. This relationship is most interesting in the years before World War I, when Matisse was making his first attempts at three-dimensional form. It was a time when painters were able to be more exploratory than sculptors, who still carried a heavy burden because of society's notion of what sculpture ought to be. By 1912 avant-garde artists concerned about sculpture were beginning to complain: Raymond Duchamp-Villon was talking about sculpture's "museum sickness," and Boccioni was asking, "Why must sculpture remain behind, tied to laws that no one has the right to impose?" ("Technical Manifesto of Futurist Sculpture," April 11, 1912). The British sculptor William Tucker has looked back from the 1960's at Matisse's sculpture and concluded that its achievement "lies not so much in the realization of masterpieces but in the exploitation for sculpture of possibilities previously only accessible in painting." [14]

Many of the artists who arrived in Paris in the years before World War I came from great distances—geographically, artistically, and spiritually. Among the sculptors were Alexander Archipenko (1887–1964), born in Kiev and the grandson of an icon painter; Jacques Lipchitz (1891–1973), a Lithuanian Jew; and Constantin Brancusi (1876–1957), a Romanian peasant who came to Paris in 1904 with six years of solid training behind him at the Craiova School of Arts and Crafts and the Bucharest School of Fine Arts. Brancusi, who had a far better grasp of the technical craft of sculpture than either Maillol or Matisse, entered the Ecole des Beaux-Arts and modeled busts and heads of local children and friends.

By 1906 Brancusi felt that he was ready to show the Parisian public some of his heads: he did so in the spring at the Salon of the Société Nationale des Beaux-Arts (Rodin was chairman

of the sculpture section) and in the fall at the Salon d'Automne. Rodin must have assessed those works and recognized in them, as in many other works shown at the Salons, a further expansion of his own fruitful ideas in sculpture. The actual relationship between Rodin and Brancusi has never been clear, but we know that the following year they met at the opening of the Salon in the spring of 1907. Brancusi had entered three heads in plaster and one in bronze, and he had the courage to ask Rodin for his opinion. The reply was disappointing: "Not bad," said the Master. It has been suggested that Brancusi spent a short time assisting Rodin during that year, but nevertheless by then he was already beginning to move away from the powerful sphere of Rodin.

Brancusi's rejection of Rodin became evident in a commission he received in 1907 and in the adoption of a new technique and material—the carving of stone. The commission was for a monument to be erected over the grave of Petre Stanescu in the Buzau cemetery in Romania. Brancusi conceived a strange funerary monument: he modeled a nude female with a long delicate body whose graceful curves were intended to convey the idea of prayer. This anonymous stylized figure with its cool impersonal volumes suggests an elegiac mood; it is quite parallel to Maillol's solution to the Blanqui commission.

Brancusi carved at least four works in 1907—two heads, a figure, and a group in stone.[15] The last—called *Kiss*—was a small square block depicting a couple; three years later it grew in dimensions to become another tomb monument. Nothing prepares us for such a singular work, since no one in Paris had been interested in direct carving for generations. Sculptors like Rodin, even when they made marbles, had them done from plaster casts; the sculptor's hand usually found its way to the surface only for the final chisel strokes. An assistant further intervened to do the finishing, which usually rendered obscure the original nature of the block. Confronting hard stone, resistant marble, carving away at it with tools in order to find a form inside the block that might mirror the one inside the sculptor's head—Brancusi took this as his task in the *Kiss*.

In 1908 Brancusi took an irregular piece of marble about ten inches high and carved a woman's features into one side; he called the work *Sleep*. The woman's eyes are closed, her lips slightly open. Rough chisel marks cover the right half of the face, making it suggestive and moody, disembodied, sinking into the oblivion of sleep. Rodin had earlier developed this poetic form fully in similar female heads of marble: *Sleep, Thought, Convalescence,* and *Adieu*. Brancusi made his as Rodin had done; he copied a plaster of a few years earlier. In 1909–10 Brancusi made another pair of heads, starting in clay and then moving to marble. This time we know the model—she was Renée Frachon; Brancusi had a special feeling for her, but it is characteristic of Brancusi's life that we do not know in what way. In the second pair of heads the marble has less resemblance to the clay; it is crisp and firm, with angular ridge endings for abstract features and regular lines cut to form the stylish hairdo. At this moment, when Brancusi was concentrating on heads and working out his direct carve technique, he made a truly extraordinary piece: his first *Sleeping Muse* (Figs. 137, 138), for which Renée Frachon was again the model.

Focusing on the human head but disregarding its usual upright position was characteristic of Brancusi: in *Torment, Woman Looking in the Mirror,* and *Narcissus* the heads bend over on long necks. But with *Sleeping Muse* he found an even simpler solution, one that needed neither a bed of marble nor a bending neck; he severed the head high up, close to the skull. Now he could put his disembodied head wherever he wished; he could place it horizontally and watch it become a physical entity all by itself. *Sleeping Muse* was a timely offering in 1910, when there

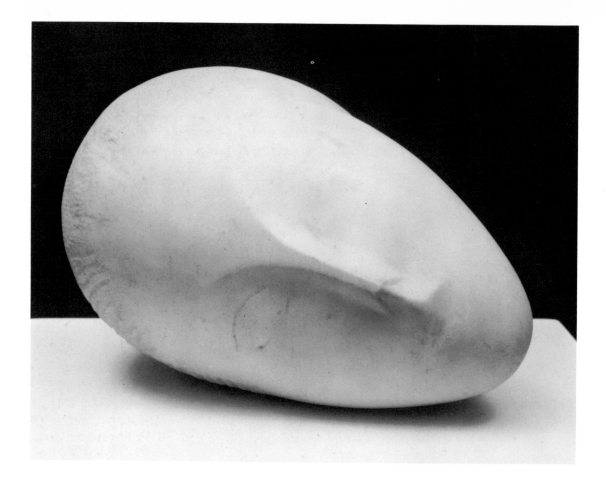

137. CONSTANTIN BRANCUSI. *Sleeping Muse.* 1909–10. Marble, 7 x 11″. The Hirshhorn
Museum and Sculpture Garden, Smithsonian Institution, Washington, D.C.

was a growing dissatisfaction among sculptors with Rodinesque fragments. What now became
paramount in Brancusi's work was pure shape, clear outline, and firm surface. To make place
for these elements he eliminated surface naturalism and the illusion of mobility and function. It
was a small price, for Brancusi was finding that for him truth no longer resided in naturalness.
The features of his *Sleeping Muse* are subtle abstractions: a swelling, a slit, an elegant sweep of
eyebrows, a single sharp ridge for nose and upper lip. Renée's chignon remains, but it is pulled
back so as not to disturb the continuity of the ovoid in the principal view, and the halo of hair is
also unified within the contours of the head. While stressing the dissimilarity between his own
abstract tendencies and the psychological values of older artists, Brancusi nevertheless retained a
sense of subject. There is a strong feminine quality in *Sleeping Muse*, a quality of deep repose
which lies like a mysterious silence upon the piece. Expression is not lacking here, but is so
subtly stated and so bound up with the form that it yields a new kind of concentration.

Brancusi made *Sleeping Muse* first in marble, then in bronze. Eventually there were five
casts. They seem to contradict the idea of an ovoid kernel carved directly from the marble
block, but as William Tucker has observed, "Bronze became a carving material for Brancusi,
something utterly different from a means of making clay permanent." [16] Through highly
polished planes and surfaces Brancusi's objects took on a translucency equal to that of marble. A
disembodied head, first in marble, then in bronze casts (each slightly different), then a second
version in alabaster, and more bronzes—this process made famous by Brancusi became a
characteristic way of working for twentieth-century sculptors. They would struggle with a

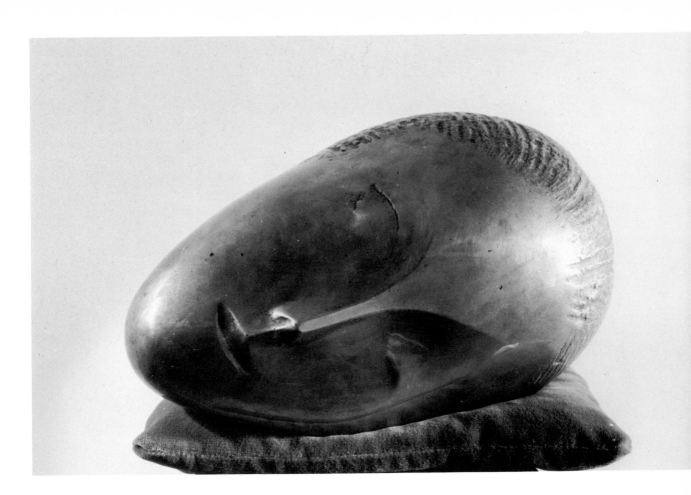

138. CONSTANTIN BRANCUSI. *Sleeping Muse*. 1910. Bronze with gold patina, 6¾″ x 10½″.
Museum of Modern Art, Paris.

plastic problem through a *series* of creations; this method became common as artists worked
more privately, without specific commissions, thus becoming free to define and solve their own
artistic challenges. By working in this way Brancusi was not merely making variations on a
single theme; he was involved in a search, a quest; he was looking for an essential form. That
quest had enormous influence, not only on other artists but in a general way on how people at
large saw and chose shapes in the twentieth century. For some sculptors Brancusi's way of
seeing has been a kind of salvation. The British sculptor Henry Moore has spoken of European
sculpture as "overgrown with moss, weeds—all sorts of surface excrescences which completely
concealed shape. It has been Brancusi's special mission to get rid of this overgrowth and to make
us once more shape-conscious." [17] From the point of view of some artists working after World
War II Brancusi's return to monolithic shapes was marvelous to behold, not so much as a
renaissance of plastic unity but "the last magnificence of a setting sun. The emphasis on it, and
the consciousness of the emphasis, were part of an effort to cling to something that was felt,
somehow, to be in greater jeopardy than ever before. Brancusi . . . pursued the monolith to an
ultimate extreme. . . ." [18]

In the years preceding World War I sculpture was neither as innovative nor as expressive as
painting; Maillol and Brancusi as well as others working in Paris—men such as Wilhelm
Lehmbruck from Germany, Antoine Bourdelle, Charles Despiau, Duchamp-Villon, even
Matisse and Picasso—created sculptures whose equilibrium and serenity almost seem like
echoes of the classical past. The precedence of painting over sculpture at this time was simply a

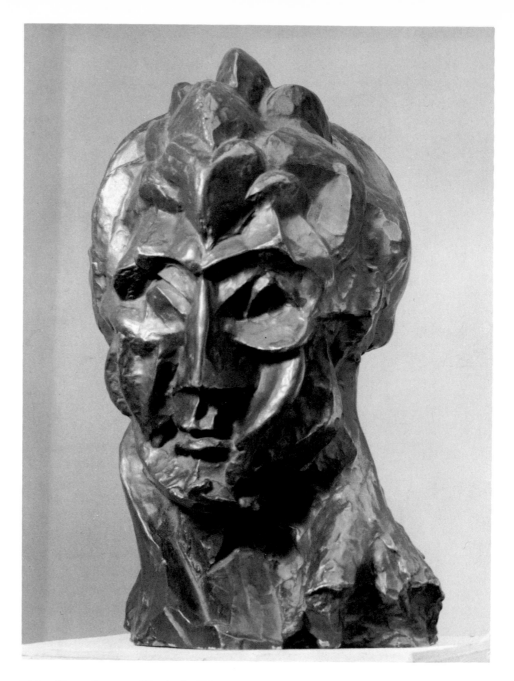

139. PABLO PICASSO. *Head of a Woman.* 1909. Bronze, 15″. Kunsthaus, Zurich.

continuation of the old ninteenth-century relationship, in which painting continued to influence sculpture to a far greater degree than the reverse. Even the innovative Brancusi was profoundly indebted to the painters around him: he felt deeply attracted to Cézanne's work and after 1912 he adopted forms and relationships that had their origin in Cubist canvases; it was also because of the interest of these painters in African sculpture that his own appreciation for such art grew.

With the development of Cubism, painting and sculpture at last came together in a sense. But it seems characteristic of sculpture's long history of domination by painting that an art movement in which the experience of the plastic reality of objects and of their relationship to space was central should have been created by painters. The Cubist movement, which so

changed our way of seeing things, was continually concerned with solid forms in nature and how they could be transformed visually. With this in mind it is fascinating to think back to the nineteenth century and to some of the reasons then prevalent for believing that sculpture could never again be a leading force in modern art. As Baudelaire put it (Salon of 1846):

> Though as brutal and positive as nature herself, it [sculpture] has at the same time a certain vagueness and ambiguity, because it exhibits too many surfaces at once. It is in vain that the sculptor forces himself to take a unique point of view, for the spectator who moves around can choose a hundred different points of view, except for the right one, and it often happens that a chance trick of light, an effect of the lamp, may discover a beauty which is not at all the one the artist had in mind—and this is a humiliating thing for him.[19]

If these were considered sculpture's defects, now that a style was being sought in which reality was to be depicted both in its literalness and with an enlarged capacity for multiple views of tangible objects, surely sculpture could be expected to contribute something of its own. The contribution was slow in coming, however, and the new vision of twentieth-century art was one opened up by the painters.

Picasso's work was the key: in his singularly important canvas of 1907, *Les Demoiselles d'Avignon*, he did not treat figures as concave, rounded human forms but as angular planes, taking Iberian and African sources as inspiration for three of the faces of his five large women. In the same year he carved some crude little wooden figures—primitivizing blocks in which the human body is totally schematized. By 1909 he was less interested in overtly African elements, preferring instead to analyze human presence by means of a complicated and rich system of facets through which he moved in and around the forms on the flat surface of his canvases. That same year he took a further step in trying to understand volume when he modeled *Head of a Woman* (Fig. 139). With the positive and negative facets of Cubist painting he analyzed the volume of a head, schematizing the features, the surface, the light and shade into jagged units. This head was the first Cubist sculpture. It was not completely successful; since it did not provide a direction Picasso wished to explore, it remained a unique essay.

It was left to others to discover the possibilities of Cubist sculpture in monumental form. Some of the most fascinating early explorations in this direction were carried on by two East Europeans who had barely arrived in Paris when Picasso made his *Head of a Woman*: Archipenko and Lipchitz. Archipenko came in 1908 and within four years had realized Cubist pieces that were so provocative and unusual that no less a personality than the great poet-critic Guillaume Apollinaire saw that his "bold constructions softly but firmly proclaim the unheard-of possibilities of this new art." (Fig. 9) When Lipchitz arrived in Paris he was not a trained sculptor. But in three years' time, between visits to the Louvre and study at the Ecole des Beaux-Arts and the Académie Julian, he learned how to create works in a contained naturalistic style respectable enough to be accepted at the Salon National in 1912. Lipchitz was in a position similar to Brancusi's five years earlier, for this exhibit gave Rodin the chance to see his work. When the two men finally met, Lipchitz's reaction was totally different from Brancusi's: "If Rodin likes my sculpture, there must be something wrong with it." Lipchitz's response has more to do with events in the Paris art world between 1907 and 1912 than it does with individual differences between the two sculptors, since by 1912 it was the painters who provided new direction, not Rodin. When Lipchitz met Picasso in 1913 the encounter was far more interesting to him than an old sculptor's praise.

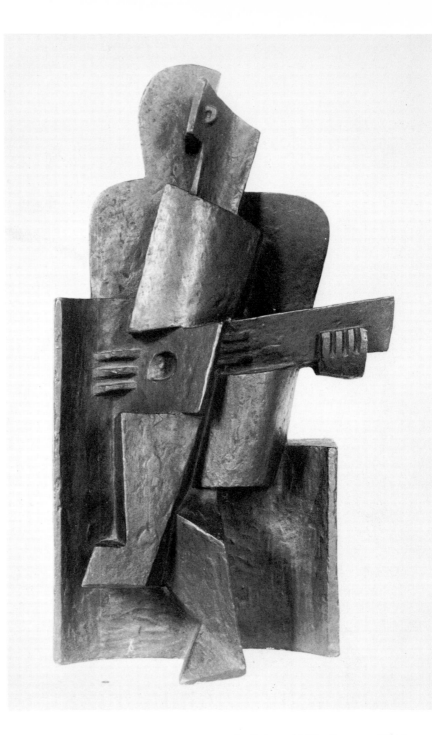

140.　Jacques Lipchitz. *Seated Man with Guitar.* 1918. Bronze, 23⅝".
Stadt Kunstmuseum, Duisburg.

One important aspect of Cubist art was its essential coolness regarding subject matter. Even Picasso, an artist for whom the expression of emotion has always come readily, showed increasing aloofness from specific thematic ideas as he developed his Cubist style. In this respect Cubism was totally harmonious with the attitude of twentieth-century sculptors, the majority of whom avoided the explicit subjects, symbols, and psychological values of nineteenth-century sculpture. Maillol's struggle to establish a freedom from thematic complexity was joined by many other sculptors.

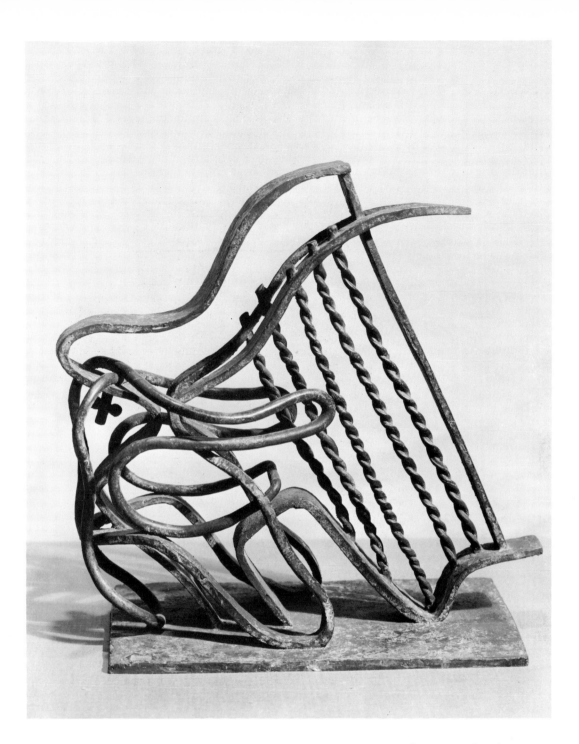

141. JACQUES LIPCHITZ. *Harpist.* 1928. Bronze, 10½″. Collection of Mrs. T. Catesby Jones, New York.

The Cubist painters confirmed the idea that it was possible to retain the human figure as a motif while maintaining a detached attitude toward man's image in general. Lipchitz explored this possibility as he worked out a fully Cubist style during World War I in figures of bronze and stone. Early in 1918 he made *Seated Man with Guitar* (Fig. 140). It is broad and stable, composed of flat planes, sharp angles, curving linear edges, robust concave and convex volumes; the figure is barely two feet tall yet has a monumental presence. It is a particularly measured and architectonic piece, appearing more to be built of rigid planes than modeled in soft clay. The

essential trait of Lipchitz's Cubism is the way he used voids to counteract the solid volumes: the head is an angular negative area played against the flat head-shaped plane and rising from a positive centralized volume locked into place by the rear plane of broadly silhouetted shoulders. The human proportions are readable and normal. In spite of the curving volumes and the negative spaces the work has an apparent flatness, reinforced by frontality; it remains pictorial and still takes its cues from painting. When Lipchitz looked at *Seated Man with Guitar* in the 1960's he considered that aspect of it and thought about its relationship to older traditions of sculpture, remarking, "In this work I was doing something comparable to the frontalized Greek Archaic and Egyptian statues which were among my first loves." [20]

The one characteristic that most distinguishes *Seated Man with Guitar* from Cubist painting is the way it responds to light. The use of negative space permits the subtlest changes of light to alter its appearance, and a radical change of light completely redefines the piece as other volumes come forward or are diminished by shadow. To make such sculpture well the artist had to be fully sensitive to this potential of light. Lipchitz has spoken of its meaning to him in the early Cubist years:

> I suddenly discovered that volume in sculpture is created by light and shadow. Volume is light.
>
> In a smoothly rounded or curvilinear sculpture the light washes over the surface and may even diminish or destroy the sense of volume, the sense of the third dimension. When the forms of the sculpture are angular, when the surface is broken by deep interpenetrations and contrasts, light can work to bring out the truly sculptural qualities. As I said, this was a tremendous revelation and it has affected my attitude toward sculpture ever since.[21]

It had once been painters, not sculptors, who talked about light. Leonardo da Vinci considered that the painter's ability to control light was the major reason that painting was superior to sculpture.

The reappraisal of the means of creating images, especially of space, has been a fundamental concern of twentieth-century sculptors. It was essential for Lipchitz in his *Seated Man with Guitar* to try, as he said, to wrap "the solid forms around a void to frame it." But by the mid-1920's he had discovered he could go further in this direction. He began making "transparents," works conceived like lines drawn in the air, without solid parts to weigh them down or impede the lucidity of our vision. The *Harpist* of 1928 (Fig. 141)—Lipchitz said it was "perhaps the most important transparent"—was born of a personal experience: "During that year my wife and I had a subscription to the Paris Symphony Orchestra at the Salle Pleyel, where we always had the same seats. In these seats we were close to the corner of the harpists and I became fascinated with them. I attempted to suggest the sensuality of the total musical experience. . . ." [22] He conceived a piece in wax (to be cast in *cire-perdue*) that looked like twisted wires, establishing a sequence of diagonals—a pliable sounding board to be held, stroked, caressed, and invaded by the action of the interlocking loops representing the human body. The whole piece comes alive with lines expanding rhythmically out over a slim bronze base. Such sculpture provided tremendous release for Lipchitz. He confessed:

> From the beginning one thing had tarnished my joy in working: an opinion—of Leonardo da Vinci on sculptors and sculpture. This pointed out to me how we are slaves of the material, and of the impossibility for the hands to follow the palpitations of our heart and the mad rush of our imagination. I was sad until the day when Providence inspired these airy things, these transparent objects which can be seen from all sides at once.[23]

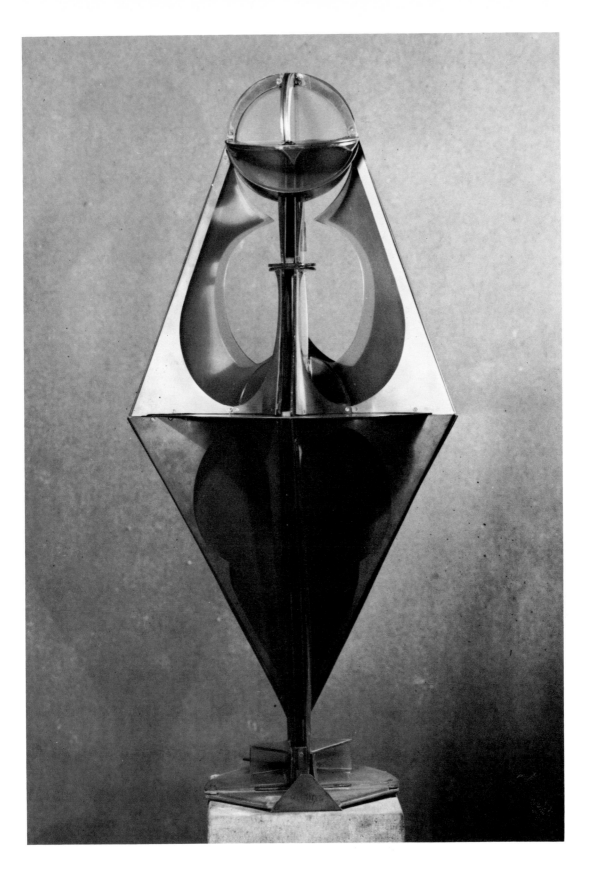

142. ANTOINE PEVSNER. *Dancer*. 1927–29. Celluloid and brass, 31¼″. Yale University Art
Gallery, New Haven (Gift of Collection Société Anonyme).

To free sculpture from opaque solidity became a special search for many sculptors in the 1920's. They rebelled against Maillol's static volumes bound to earth by gravity and mass. Antoine Pevsner (1886–1962), a Russian Constructivist working in Paris, wanted to capture space in sculptural form. At the behest of Russian impresario Serge Diaghilev, Pevsner and his brother Naum Gabo (b. 1890) made set designs and costumes for a new ballet, *La Chatte*. The audience was treated to a unique kind of geometric, transparent scenery presided over by a gleaming rhomboidal figure symbolizing the presence of Aphrodite. Pevsner took the design of that figure even further in the *Dancer* (Fig. 142), which he completed in 1929; he made it more deliberate, austere, and regular. From the front, the figure is a perfect rhombus evenly divided into quadrants and crowned by a circular head. Bilateral parabolic openings pierce the upper body to permit the penetration of space; below, complementary shapes are filled with celluloid. A side view presents another aspect of this pure geometry—triangular body and again circular head. The figure appears clean and simple, yet its construction is complicated and intricate, with numerous flat brass sections cut and merged with celluloid sheets that act as a translucent transition between the opaque metal and transparent space. Pevsner assembled his *Dancer* with small screws and set it up on the tiny base. He had made an image weightless in appearance, but stable and monumental with every inch of edge and surface precise, crisp, and clear.

Pevsner's *Dancer* is the antithesis of Lipchitz's spontaneous and organic little *Harpist*. The only thing the two sculptures have in common is space moving through metal forms. Pevsner's achievement in *Dancer* was based upon a radically different method of making sculpture, which was a result of the years he had spent away from, rather than in, Paris. Like Lipchitz, Pevsner had come from the East. An art student in Kiev and St. Petersburg, he came to Paris in his twenties. He had the same introduction to modern Western art as Lipchitz had had, spending time at exhibitions such as the Salon des Indépendants where the new Cubist works were hung. Pevsner was a painter at that time, and so perhaps even more intrigued than Lipchitz with the rich array of new forms that he saw on these canvases. What he liked best was the Cubists' treatment of line and edge: "Cubism worked to a certain extent according to classical form; at all times it gave importance to line, and the procedure of cutting out and superimposing objects was its principal revolt." [24] The sense of "cutting out and superimposing objects" became particularly strong in his work during the 1920's.

If Pevsner had remained in Paris, like Lipchitz, he might have spent the war years working with these new Cubist forms in traditional materials. But he was recalled to Russia and then sent to Norway to wait out the war with his younger brothers, and at this time Pevsner grew closer to his brother Naum, who had been educated as a scientist and an engineer. Naum was twenty-four at the beginning of the war and had amassed a knowledge of contemporary art astonishing in its scope, particularly for one who was not even an artist. He was personally acquainted with painters of the *Blaue Reiter* group in Munich, where he had studied, knew some of the Cubists in Paris, and also had a first-hand knowledge of Futurist work in Italy. Gabo spent the war years assimilating, speculating about what he had seen—and also applying the engineer's techniques of structure to sculpture. He made his first constructed head in 1915; throughout 1915 and 1916 he assembled pieces in wood, plastic, and metal, working particularly with female heads. They were not like Picasso's dense Cubist head, for there was no solid volume at all; their shape and features existed solely by virtue of intersecting flat planes. Gabo was repelled by sculpture that buried space in its mass; he did not want to *describe* space within a figure as the Cubists were doing; he wanted to *create* it. Much later, when asked what his conception of space was, he replied:

We not only live in space, and objects not only exist in space, but space is always penetrating every material body. And don't forget that it was neglected by artists before our time. In their work they only recognized the simple fact that bodies do exist in space and that space surrounds them, whereas in my constructive sculptures I am trying to show the penetration of space through everything—through every body, so that space becomes a part of the sculpture, a visual element equivalent to the actual material from which the sculpture is made.[25]

The 1917 Revolution brought Pevsner and Gabo back to Russia; they found the energy of the artistic community as moving and powerful as the Revolution itself. Younger artists believed that there existed in the Bolsheviks the potential to create a regime under which they could build a new Russian art. They transformed the academies, and the old craft institute—the Vchutemas—became a workshop for revolutionary art. Pevsner found a place as professor of painting at the institute, while Gabo taught sculpture privately. But the ideological battles of artists could be as fierce as those of politicians, and the brothers found themselves becoming progressively estranged even from artists with whom they felt in agreement. This estrangement led to the most significant art event in modern Russia: on August 5, 1920, with Gabo as initiator and Pevsner as co-signer, they posted a handbill titled "The Realist Manifesto" all over Moscow. In a tone of profound seriousness they renounced traditional means used by artists to describe nature—color, line, volume, and especially "the thousand-year-old delusion . . . that held the static rhythms as the only elements of the plastic and pictorial arts." [26] Gabo and Pevsner thought that they would rescue art from nature and make of it a "spiritual activity designed to order man's view of the world." Their new art—termed Constructivism— would be deliberate and exact; like scientists, they recognized precise measurement and careful calculation as having the potential to reveal ultimate reality, shorn of vagueness and subjectivity. Yet for that very reason, the new art was a difficult language that held little promise for the masses in war-torn Russia. It took the Bolsheviks no time at all to proclaim its unsuitability: the government closed Pevsner's studio in 1921, and he left Russia for good the following year. Gabo had preceded him into exile.

At this point in his career, with Gabo's prompting, Pevsner became a sculptor. Having settled in Paris, he began making sculptures based on the Russian experiments. For seven years he built dematerialized images out of transparent and reflecting planes. *Dancer* was one of his last anthropomorphic figures. It is surprising that Pevsner made as many heads and torsos as he did (they constituted about half his production during the 1920's), since the materials of industry and the methods of technology simply do not lend themselves as naturally to the creation of human form as clay and stone have always done. Though *Dancer* remains a recognizable figure, its relationship to the phenomenal world has been radically diminished. It no longer suggests a sensate body, but rather a world of mechanization, of space, and time—"the only forms on which life is built" (Realist Manifesto).

Pevsner's works embody the ideas of Constructivist doctrine. They are impersonal in the extreme—the opposite of Lipchitz's "transparents," which, though cast in bronze at a foundry, are so personal and convey such singular sensations that each must be described separately. Compared to the works of Lipchitz and others who had gradually moved away from early Cubism, the Constructivists' neutral forms and industrial materials looked radical. In the 1920's the two styles appeared as opposing paths, but in reality they were hardly mutually exclusive, and later sculptors worked out syntheses of the two in numerous variations.

Some of the finest sculpture produced in Paris during the 1930's resulted from just this synthesis—the exquisite wrought-iron pieces of the Spaniard Julio Gonzalez (1876–1942). It

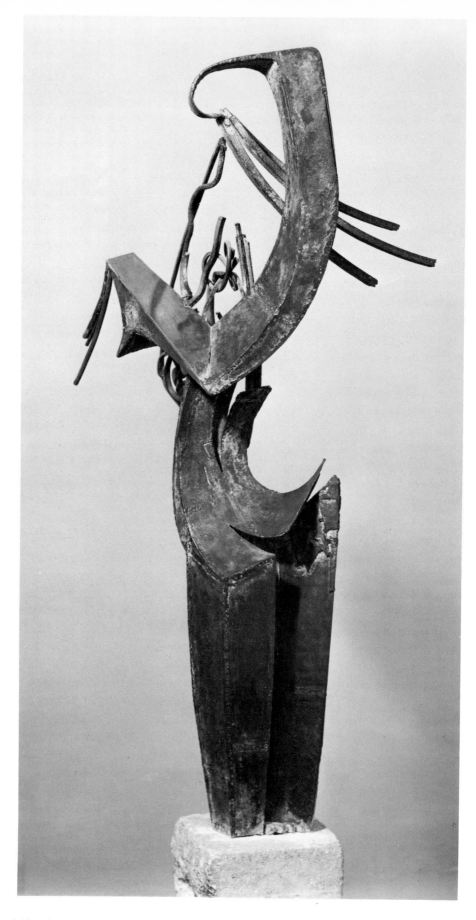

143. JULIO GONZALEZ. *Woman Combing Her Hair.* 1936. Wrought iron, 51½″.
The Museum of Modern Art, New York (Mrs. Simon Guggenheim Fund).

had taken Gonzalez a great deal of time to arrive at this solution—like Pevsner he had a long career as a painter before fully committing himself to sculpture. The results he achieved were unique, and *Woman Combing Her Hair* (Fig. 143) is one of his finest works. Its theme had always engaged him; he had represented it twice before in sculpture, many times in drawings. In this last version, made in 1936, Gonzalez gives us a great deal more "information" about his subject than in his earlier versions: he tells us about her proportions, her stance, the position of her arching back, and about gesture, though he does not actually describe it—indeed, the arms are least clearly defined, having been transformed into other parts. We sense an incredible excitement around the tangled growth in the figure's midst. This dramatic busyness is juxtaposed with the strong convex and concave contours of the spine, and the whole becomes comprehensible as spatial voids are brought to life.

Like Pevsner, Gonzalez "constructed" his figure, totally rejecting Lipchitz's modeling in clay and wax. He used metal directly, taking sheet metal and cutting it into shapes with shears, hammering the edges, and forging or welding the joints. Gonzalez possessed a special understanding of his material, for he had learned to work it early in life as the son of a master metalworker in Barcelona. And during a period at the Renault automobile factory in 1917 he learned to use an oxyacetylene torch on metal. It helped him prepare a method of direct assemblage that would have a decisive effect on the future of sculpture. This method allowed Gonzalez to make images in which space could be fully defined. Yet at the same time the use of industrial materials and techniques did not cause him to relinquish the body; he remained true to the tradition of human form in sculpture, and he continually insisted upon the relationship between his sculpture and the real elements—such as hair, teeth, and eyes.[27] But he delighted most in being a sculptor of space:

> In the tremulous night, the stars show us points of hope in the sky; this immobile spire [of a cathedral], too, reveals a countless number of them to us. It is these points in the infinite which are the precursors of the new art: To draw in space.[28]

Gonzalez wrote this poetic passage in the early 1930's as he was fitting his ideas about his work into a larger scheme. At this time, along with his compatriot Picasso, he was searching for the way in which the figure and space might become one. These two Spaniards, who began the decade in an intimate collaboration, picked their way through the complex artistic landscape of the 1930's, when a vital expressive content based on human imagery was being championed by the Surrealists, and when, in sharp contrast, serene non-objective forms and surfaces were being constructed by the abstract artists who had abandoned the human body. Gonzalez learned from each of these movements while remaining aloof from both. As the most gifted and refined metalsmith among sculptors he worked out one of the last significant figure types to evolve from Cubism. He did so by adopting a technique and a material that had no precedent in the history of art, as the American sculptor David Smith later pointed out. When he began his brief career as a sculptor Gonzalez had great hope about the aesthetic possibilities of metal. In 1932 he wrote:

> The Age of Iron began many centuries ago by producing very beautiful objects, unfortunately mostly weapons. Today it makes possible bridges and railroads as well. It is time that this metal cease to be a murderer and the simple instrument of an overly-mechanical science. The door is wide open, at last! for this material to be forged and hammered by the peaceful hands of artists.[29]

This hope was soon brutally demolished. The year Gonzalez made *Woman Combing Her Hair* was the year civil war broke out in Spain. For a while the sculptor continued to forge powerful figures, but as his anguish over the political situation grew they became fewer and were considerably altered by the nature of his response to the violence in his homeland. Ultimately global war impinged upon his work, and by the time of his death in 1942 his production had virtually ceased.[30]

Gonzalez did not reach the peak of his achievement in sculpture until he was over fifty. The person who contributed most to this fruitful commitment was Picasso. In the 1920's Picasso, who had not made sculptures since before World War I, found himself continually preoccupied with sculptural problems in painting. He recognized his older friend's extraordinary gifts as a metalworker ("You work with metal like a pat of butter!") and brought him into a collaborative venture that continued for four years. From it grew works that are a superb synthesis of contructive assemblage techniques and personal poetic imagery. Gonzalez and Picasso used to visit the junk yards outside of Paris, where they were likely to find scrap metal for their sculptures. They proceeded to fuse various objects into open forms, but each did so in different ways: Gonzalez obscured the metal's original nature, while Picasso rarely allowed its old identity to be lost in the process of creating a new one. Furthermore, Picasso's habit of using manufactured parts (such as two colanders stuck together to represent a head) accounts in large part for the fact that the sculpture he made during his period of collaboration with Gonzalez was less elegant but considerably more radical than his friend's.

The roots of Picasso's practice had their origin in his open-work construction-sculptures and his collages, both of which he began making in 1912.[31] In 1913 and 1914 he assembled three-dimensional still lifes of wood, cardboard, metal, and cloth. He was fascinated by these materials, by the shapes, by the process of putting them together, and he felt instinctively that three-dimensional work did not have to be tied to human and animal forms. In those years Picasso did something that had never been done before in sculpture. The Constructivists were to use the same approach a few years later when they developed three-dimensional forms in various materials based on mathematics and science rather than on biomorphic images. Picasso was also seeking to widen the potential of sculpture when he made his *Glass of Absinthe* (Fig. 7) in 1914. He cast it in bronze, painted it, and put a real silver sugar strainer on its rim. Picasso recognized the significance of the exclusion of the "furniture" of life—so long accessible to painters in their still-life and genre scenes and their *trompe l'oeil* productions—from the domain of sculpture. In a parallel contemporary work, *Development of a Bottle in Space* (1912), Umberto Boccioni (1882–1916), the Italian Futurist, modeled a plate, a cloth, and a bottle as multiple and shifting planes in an attempt to give the impression of encountering the object in time and space (Fig. 6). A new freedom came with these experiments; their implications would be fulfilled in the most important changes that twentieth-century artists have brought to the art of sculpture.

An even broader inclusion of bits and pieces of life in art came—though less directly and in a less expected fashion—through the poignant but powerful retreat from plastic form carried out by certain painters and poets immediately before and during World War I. These artists, clustered briefly under the nonsense word "Dada," felt imprisoned by traditional structures of syntax and media. Poets worked for the liberation of their words, and painters (no professional sculptors were involved in their activities), feeling burdened by oil's slickness, tried to side-step conventional working procedures through the paste of collage and the methods of assemblage.

Nothing was more conspicuous in this growing pursuit of artistic freedom around 1914 than a couple of three-dimensional objects brought into view by the painter Marcel Duchamp (1887–1969). One was a bicycle wheel screwed onto a kitchen stool and the other a rack for drying bottles (Fig. 144) purchased at a department store in Paris a few months before the outbreak of war. Duchamp never had any intention of using the rack to dry bottles; instead he took it home, signed and dated it, and hung it up. Through his action the object was divorced from its intended function and took on a new identity. In 1915 Duchamp moved to the United States and sometime after that the bottle rack was lost.[32] Yet its impact on modern artists has been remarkable: the American painter Robert Motherwell, who had never even seen it, said in 1949 that Duchamp's *Bottle Rack* had "a more beautiful form than almost anything made, in 1914, as sculpture."

Duchamp was spending most of his time with Cubists the year he purchased his bottle rack: one of his older brothers, Jacques Villon, was a leading Cubist painter; the other, Raymond Duchamp-Villon, had made outstanding sculptures in the Cubist style. Marcel could have been a good Cubist too, but early on his mental activities were more agile and intense than his manual ones—though he had no special quarrel with craft—and he took to indulging himself in wit and paradox. He distrusted normal means of communication, both verbal and visual, and he spent no small amount of time "unlearning" drawing and utilizing puns in the service of a new language. He paid enormous attention to the sounds of words, and to what happens to a familiar word once it is introduced into an alien context. It was "displacement" that fascinated him, just as it did when he took home the bottle rack and hung it up.

Duchamp did not deliberately set out to turn a piece of kitchen equipment into something special because it had a particular aesthetic appeal for him; he insisted (in a lecture at the Museum of Modern Art, 1961) that "the choice was based on a reaction of *visual indifference* with a total absence of good or bad taste . . . in fact, a complete anaesthesia." It was this attitude that made Duchamp's choice revolutionary in the history of art.

Shortly after he arrived in New York Duchamp coined a word for objects like the bottle rack: he called them "readymades." He had chosen three before he left Paris, and he continued during his early New York years to make new choices at fairly regular intervals—things like the snow shovel in 1915 (called *In Advance of the Broken Arm*) and the urinal in 1917 (called *Fountain* and sent to the exhibition organized by the Society of Independent Artists under the pseudonym "R. Mutt"). One of the great paradoxes about the readymades is that though Duchamp continually insisted on the accidental nature of his encounter with the objects and on the aloofness he maintained with regard to them, they have always elicited the most intense speculation about the role of Duchamp's subjective unconscious, which has been seen as "much more important in them than in all his other works." [33] Perhaps to ward off just such speculation Duchamp did not offer the public his readymades too often: "I have accepted only a small number of Ready-Mades. If I'd been producing ten a day, the whole idea would have been destroyed because large numbers alone would immediately produce a personal taste." [34]

Duchamp's opting for accidental encounter as a replacement for man's ability to cultivate his own taste was the most subversive choice in the art of the twentieth century. It mocked the whole Western tradition, not only in regard to the special place of taste, but also in regard to the position of the artist and his craft. The paradoxes surrounding readymades abound: when an ordinary object is made into a work of art by a process of "displacement" the traditional notion of art can no longer be maintained; we are in a realm where impersonal authorship is glorified,

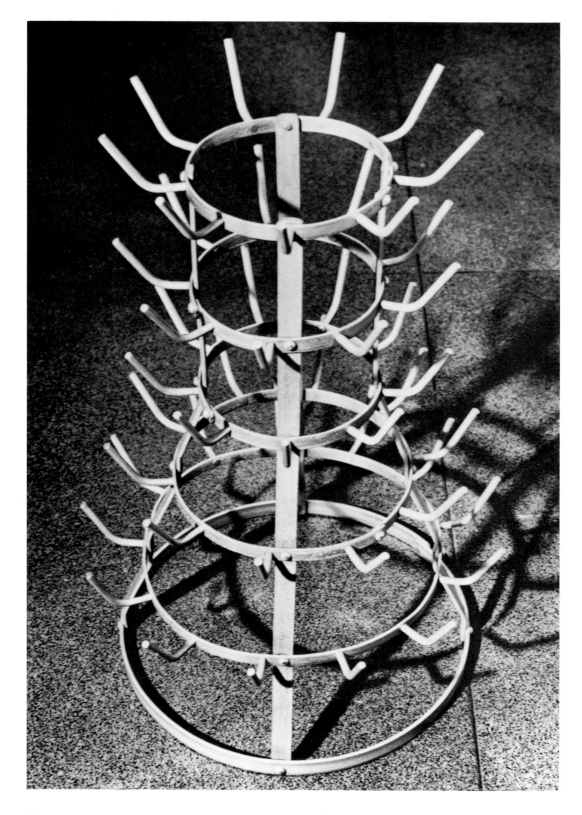

144. MARCEL DUCHAMP. *Bottle Rack*. 1914. Iron, 23¼″. Collection Man Ray, Paris.

where the distinction between the artist and the layman ceases to matter. And yet with a readymade the artist's name becomes more important than the piece itself; the object has prestige only because the artist has shared his thoughts with others about it. The artist is more important than ever; readymades are "fetishes," says Robert Lebel, and ever "since their consecration they have never ceased to inspire a devoted cult."

Duchamp was the most avant-garde artist of his generation, and decade after decade he maintained a position of unassailable consistency—eventually by ceasing to make art. In the year before Duchamp's death, the art critic Pierre Cabanne asked him, as had many others over the years, "You never touched a brush or a pencil?" Duchamp replied cooly: "No. It has no interest for me. It was a lack of attraction, a lack of interest. I think painting dies, you understand. After forty or fifty years a picture dies, because its freshness disappears. Sculpture also dies." [35] For an individual with the potential to create, denying that potential must have been hard. Duchamp took this path of pure negation: "I say man is not perfect, but at least I have tried to remain as aloof as possible, and don't think for one minute this hasn't been a difficult task." [36]

Why is this painter who stopped painting central to any account of twentieth-century sculpture? Because Duchamp—along with the Cubists, the Italian Futurists, and the Dadaists, with their collages, paste-ups and assemblages—brought so much new material into the history of art. And most of it, being taken straight from life, refused to stay on a two-dimensional surface. The Constructivists too had introduced new material to sculpture, but when we imagine their studios we think of neat piles of celluloid, sheets of steel and copper, and balls of Lucite thread. But the others scavenged for material out of the disorderly debris of everyday life and established a new sense of process—not one of simply making, but of seeing and collecting, which are a part of living. This process affected all art forms and removed the boundaries between them. For sculpture it had a special importance as it drew an ever greater number of artists away from their concern with surfaces into the palpable world of human activity, where sculpture had always been. In the course of the twentieth century, though sculpture and painting continue as such, the identity of the sculptor as contrasted to that of the painter became less distinct and less relevant in the visual arts.

By the late 1920's, Robert Lebel noted, Duchamp's creative activity was becoming "limited to more and more infrequent gestures. Sometimes a single word has been enough and with it he makes history—as in 1932, when he christened Calder's animated constructions 'mobiles'." Like many events in Duchamp's life, the meeting with Calder seems to have happened in a haphazard way: Mary Reynolds, with whom Duchamp had long had an "agreeable liaison," ran into a little-known American artist named Alexander Calder (b. 1898) in a Parisian photography shop in 1931. A friendship developed, and one evening Mary brought Marcel to the Calder apartment. Duchamp spied one of the American's recent works—a little motor-driven construction of wire. Calder recalls: "When he put his hands on it, the object seemed to please him, so he arranged for me to show in Marie Cuttoli's Galerie Vignon, close to the Madeleine. I asked him what sort of name I could give these things and he at once produced 'Mobile.' " [37] Duchamp was excited by Calder's motorized constructions for he himself had probably been the first artist to respond to the power of rotary motion: in 1920 in New York he had made an object out of five glass plates painted with black circle segments that produced the illusion of full circles when spinning with the aid of a fan belt; a few years later in Paris he made another motorized optical turning device—*Rotary Demisphere*. These gadgets, like readymades, became another avenue away from art. When he was invited to exhibit *Rotary Demisphere* in a

1925 group show, Duchamp's comment was, "All exhibitions of painting and sculpture make me sick.—And I would like to avoid associating myself with these manifestations. I would also regret it if anyone were to see in this globe anything more than 'optics.'" [38]

Duchamp made his last motorized experiments in the 1930's, then ceased his artistic activity altogether. The critic Jack Burnham believes that with them Duchamp found himself in the midst of the most crucial dilemma possible for an artist who has turned his attention to the machine:

> No longer dealing with the gentle illusion of painting, nor even the leverage of Dada's tools (irony, fallibility, and repetition), Duchamp realized that he had placed himself on the brink of raw technology. Such a situation demanded that one either draw back or plunge into a rational world of impersonally controlled effects. He chose to do the former.[39]

Inevitably in a period when the basis of man's understanding of the most fundamental truths about the universe has shifted from matter to energy, artists would come to understand motion as a crucial factor in their work. And when they turned their attention to the past they could find only the *illusion* of motion. Some thought this alone sufficient cause to reject all older art: "A racing car . . . is more beautiful than the *Victory of Samothrace*" was Marinetti's sacrilegious conclusion in his first "Futurist Manifesto" (1909). Other artists were more analytical; thus Gabo, considering the same sculpture (evidently, having the biggest wings in the history of sculpture, she came in for special attention), reflected:

> . . . who has not admired in the Victory of Samothrace, the so-called dynamic rhythms, the imaginary forward movement incorporated in this sculpture? The expression of motion is the main purpose of this composition of the lines and masses of this work. But in this sculpture the feeling of motion is an illusion and exists only in our minds. The real Time does not participate in this emotion; in fact, it is timeless. To bring Time as a reality into our consciousness, to make it active and perceivable, we need the real movement of substantial masses removable in space.[40]

They considered the solutions that could reside in a new kind of form; Boccioni spoke of

> . . . one that has nothing to do with all the forms conceived of until now. This double concept of form, *form in movement* (relative movement) and *movement of the form* (absolute movement) can alone render in the duration of time that instant of plastic life as it was materialized, without cutting it apart by drawing it from its vital atmosphere, without stopping it in the midst of its movement, in a word, without killing it.[41]

They pledged themselves to the future: "We affirm in these arts a new element, the kinetic rhythms as the basic forms of our perception of real time." ("Realist Manifesto," 1920). Curiously, however, they did not *make* much art actually incorporating movement. Gabo, who called the loudest for sculpture based upon kinetic rhythms, made only three such works and even these he thought of more as ideas for kinetic sculpture than as examples of it. In 1937 he wrote:

> Mechanics has not yet reached that stage of absolute perfection where it can produce real motion in a sculptural work without killing, through the mechanical parts, the pure sculptural content; because the motion is of importance and not the mechanism which produces it. Thus the solution of this problem becomes a task for future generations.[42]

254 WESTERN SCULPTURE

Authors devoting attention to kinetic sculpture have been quick to point out that in spite of enormous interest in motion among artists early in the century, after 1925 "a steady decline of activity was evident which . . . resulted in near stagnation during the 1930's and 1940's." [43] One of the reasons was that the great provider of motion, the machine itself, got in the way; it was too obtrusive, the motion it produced too repetitive, too lacking in a sense of life's spontaneity. The fallacy of mechanical movement confronting Gabo and other artists during the 1920's and 1930's was paralleled by reactions within the scientific community to the discoveries of modern physics. They were now in the process of giving up the old nineteenth-century mechanical explanations of the universe, for Einstein's research had shown that "even space and time are forms of intuition, which can no more be divorced from consciousness than can our concepts of color, shape, or size."

It was Calder who found a personal way of solving the problem of actual motion in a three-dimensional work of art. Better than that of any other artist his work bridges the gap between the years of initial curiosity and the 1960's, when finally a large number of European and American artists were involved in making kinetic sculpture. He arrived in Paris in 1926, aged twenty-eight, the son and grandson of sculptors, and trained in engineering as well as art. Calder went regularly to the Grande Chaumière to draw from the nude but what he learned there did not lead to conventional-looking art: his figures looked like toys, which is how they were initially shown and sold. Nevertheless, by 1929 Calder's work was being reviewed seriously; Emile Szittya wrote in *Kunstblatt:*

> I sought out Calder in Paris, found not a studio littered with clumps of clay, plaster figures, and Greek and Roman molds, but rather a workshop. Mr. Calder bustled about like a father who has just wrapped toys for the Christmas tree, seeking wood and wire to play with. Calder makes sculptures out of wire. These are actual plastic sculptures, although many regard them as frivolities. [44]

Calder's simplicity, his directness, and his wonderful sense of play became his entrée into the Parisian art world. Specifically, it was his Circus that attracted attention: he had made all the personalities and the animals of a circus in miniature—figurines a few inches high in wire, wood, and cloth. In 1927 he started giving shows in his apartment and by 1930 many of the greatest artists in Paris were spectators: Mondrian, Miró, Léger, Cocteau, Man Ray, Pevsner, Arp, Pascin, Van Doesburg, Le Corbusier. Calder gave freely of his sense of fun and wit, and he received inspiration in turn from some of his guests, particularly from Miró and Mondrian. The first time he set foot in Mondrian's studio he was overwhelmed:

> It was a very exciting room. Light came in from the left and from the right, and on the solid wall between the windows there were experimental stunts with colored rectangles of cardboard tacked on. Even the victrola, which had been some muddy color, was painted red.

> This one visit gave me a shock that started things.

> Though I had heard the word "modern" before, I did not consciously know or feel the term "abstract." So now, at thirty-two, I wanted to paint and work in the abstract. And for two weeks or so, I painted very modest abstractions. At the end of this, I reverted to plastic work which was still abstract. [45]

Calder was successful enough with his abstract work to join the artists of *Abstraction-Création* (which included Pevsner, Arp, and Mondrian) in their first exhibition. He showed recently

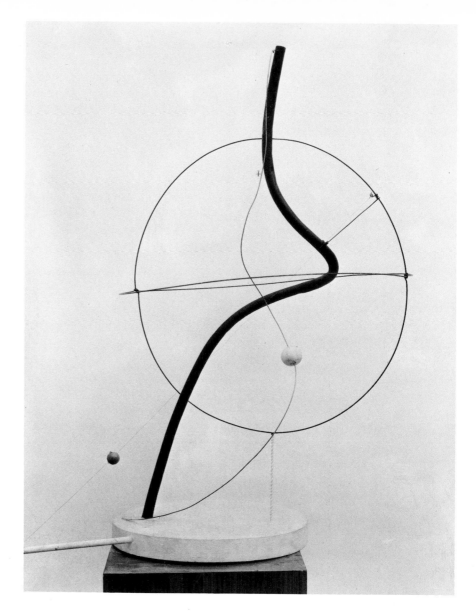

145. ALEXANDER CALDER. *A Universe.* 1934 (motorized version of stabile *Universe* of 1931). Wire, wicker, and wood, 40½". The Museum of Modern Art, New York (Gift of Mrs. John D. Rockefeller, Jr.).

finished pieces such as *Universe* (see Fig. 145), in simple, open, geometric compositions of wire. His statement in the group's publication opened with a question: "How does art come into being?" He answered himself: "Out of volumes, motion, space carved out within the surrounding space, the universe." He noted that every element in the universe "can move, shift, or sway back and forth in a changing relation to each of the other elements in this universe." The idea fascinated him and he began experiments with motion: first, single objects attached to bases; then, two or more objects whose spatial relationships could be altered with the aid of an electric motor or a hand crank. This was the kind of piece Duchamp saw the day he answered, "mobile." Calder found, however, that he was not really satisfied with the controlled patterns of motor-given motion, and so in 1932 he tried making some without motors—mobiles that relied solely on the movement of air. He found he could "compose" motions much as artists compose shapes or colors. He made small works that hung or stood with wooden balls and brightly

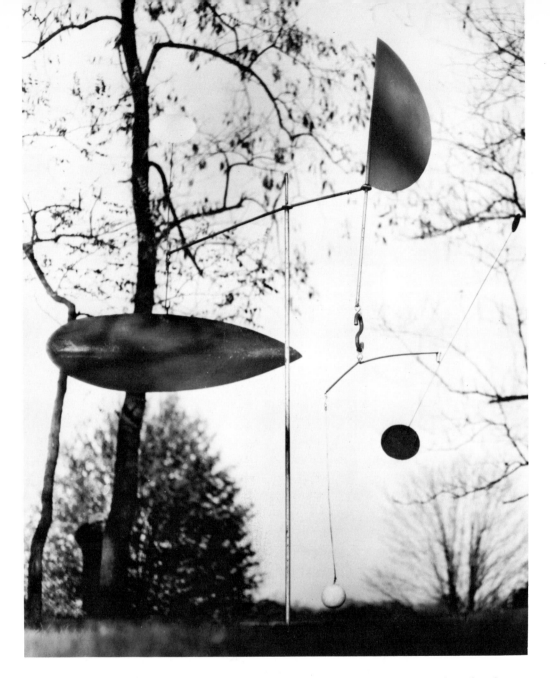

146. ALEXANDER CALDER. *Steel Fish*. 1934. Sheet steel, sheet aluminum, and steel rods, 10′. Collection of the artist, Roxbury, Connecticut.

painted metal cut-outs playing back and forth in delicate and fluctuating states of equilibrium. Calder stripped the plastic elements to the minimum, but the skeleton that remained was lively and lyrical. Movement depended solely on his own sense of balance and on an outside force—a current of air or a finger's touch. He replaced the regularity of motorized revolutions with randomness; the result was spontaneous and playful.

Calder's wire sculpture of the late 1920's and early 1930's had a highly personal character, both in the representational and the abstract pieces, but there is no doubt that this original spirit landed in Paris at just the right moment: 1926 was the year Lipchitz turned his attention to the transparents, and Picasso and Gonzalez were just about to launch their collaboration; the Constructivists were also consolidating their research in establishing measurable space in sculptural form.

Calder returned to the United States in 1933. The following year—in the open space of his New England farm—he made his first monumental piece, a ten-foot standing mobile, *Steel Fish*. (Fig. 146) A steel rod rises from the base on the ground; attached to it is a horizontal iron rod with arms of unequal length from which are balanced rods, circles, balls, and flat metal shapes. Even on this large scale the effect is light and playful as the big pointed oval piece swings through the air in its unpredictable way. Though using abstract shapes, Calder's work was becoming more and more suggestive of forms and movements in nature. For a few years he had chosen to work solely with the geometric forms of the Constructivists, sharing the pure abstractness of the *Abstraction-Création* movement, but it was not really the kind of art suited to his temperament. He preferred expressive forms and the sensuous little shapes he found in the paintings of his friend Miró. In *Steel Fish*, Calder combined geometric and natural forms; allusions to fishes, beasts, and flowers would grow more frequent as his art matured and he would eventually achieve a striking balance between the abstract and the organic.

Calder will retain an important place in the history of sculpture as the first artist to create a consistent body of kinetic works. Yet at times one has the feeling that, taken as a whole, his work is not quite serious enough, that it is somewhat lacking in a sense of growth and variety. George Rickey, one of the outstanding kinetic artists of the 1950's and 1960's, points out that Calder "discovered a new world but did not explore it." Such criticism overlooks, however, the sort of "healthy Dada," the sense of the intimate, casual occurrences of the life process, that keeps coming to the fore with any sustained look at Calder and his work. Books and films on Calder always intersperse views of his kitchen with those of his art, and in a strange way the former help us to understand the latter. In his autobiography there is more personal reminiscence than talk about art. Recalling 1934, the artist makes no mention of *Steel Fish* but talks of his wife's pregnancy, his friends, and the tomato crop. Like Duchamp, Calder has struggled with the problems posed by Art, but unlike Duchamp he has not had the wish to become a negative prophet by giving up creating. He has remained wary of the talk and the theories about art, feeling, as Duchamp did, that it is important to affirm art and life through humor rather than theory. And Calder's mobile, like the readymade, would seem to be an art for Everyman. And yet, simple as it looks, and as often as it has found its way into toy shops and decorators' departments, it has not been successfully imitated. It belongs to Calder alone.

In 1937 the Swiss art historian Carola Giedion-Welcker pubished *Modern Plastic Art*. It has proven to be the most significant book on modern sculpture to be published in the first half of the twentieth century. In a brief essay Giedion-Welcker focused on the sculptors of simple organic volumes and on those who were dissolving material solidity in light and movement. She described how static values were being transformed into dynamic ones, how sculptors used new techniques and materials, and how the "human scale, the human angle, has ceased to be the universal norm." Only one American work was illustrated: this was Calder's *A Universe*, a motorized mobile of 1934, which she found significant in the way it combined "the irrational world of dreams and the severely rational world of mathematics." She singled out Calder's mobiles as "the fruit of an almost astronomical imagination."

Before World War II, avant-garde sculpture in America was almost exclusively a matter of solid volumes, direct carving, and representational themes. Murdock Pemberton, looking back to the 1930's, recalled that "except for Calder, sculpture in those days was in the graveyard or war-monument school." This attitude, which held Calder as the only American sculptor of special note, continued right into the 1950's: Pemberton noted that the leading art dealer in

Paris said in 1954 that he considered Calder's "the 'only' American contribution to art."[46] Moreover, when Giedion-Welcker brought out an enlarged, updated edition of her book in 1955, this time including the work of ten Americans among the 243 illustrations, Calder was still seen as by far the most important. She illustrated seven of his works, more coverage than was allotted to either Pevsner or Gonzalez.

Most new sculptural images in America of the 1950's bore a relationship to Calder's sense of fine linear rhythms. Sculptors concentrated on creating open spatial work, abstract forms that were welded or soldered into elegant lyrical pieces. But in spite of the new breadth and diversity in American sculpture, it could not be compared to the kind of powerful explorations being conducted by the Abstract Expressionist painters. One critic, who had predicted in the 1940's that great things were about to emerge in American sculpture, felt he saw little other than "garden statuary, oversized *objets d'art*" in the 1950's.[47] The painter Ad Reinhardt saw the new sculpture as "something you backed into and ripped your pants on."

There was only one sculptor generally viewed as the equal of Abstract Expressionist painters. This was David Smith (1906–1965). Only eight years younger than Calder, he was drawn to the same kind of European art that had been most meaningful to the older artist: Cubism, Constructivism, and Surrealism. But it meant something completely different to him, for he learned about these movements in America. Smith studied painting in New York at the Art Students League. In the late 1920's and early 1930's his teachers and the recent art journals from Paris provided him with descriptions and photographs of Picasso's and Gonzalez's iron sculpture, the Constructivists' work, and the paintings of Kandinsky and the Dutch De Stijl artists. Smith did not go to Paris until 1935 and after only a month returned home. He later recalled what it was to be an artist in America in the 1930's:

> One did not feel disowned—only ignored and much alone, with a vague pressure from authority that art couldn't be made here—it was a time for temporary expatriates, not that they made art more in France, but that they talked it . . . and not that their concept was more *avant* than ours but they were under its shadow there and we were in the windy openness here.[48]

Smith's consciousness of this feeling of alienation took a firmly positive turn, and by the 1950's he was able to articulate what America meant to his artistic growth and freedom:

> Creative art has a better chance of developing from coarseness and courage than from culture. One of the good things about American art is that it doesn't have the spit and polish that some foreign art has. It is coarse. One of its virtues is coarseness.[49]

If Calder's studio looked like a workshop, Smith's looked like a factory. He shared with Calder and Gonzalez the ability to benefit from extra-artistic training: in 1925 he riveted and welded in the South Bend Studebaker factory and throughout World War II he welded armor plates at a Schenectady locomotive plant. His first series of welded sculpture was made not in an artist's studio but at the Terminal Iron Works in Brooklyn. When he built his own studio at Bolton Landing in the Adirondacks he kept right on referring to his place of work as the "Terminal Iron Works"—"partly because *the change* in my type of sculpture required a factory more than an 'Atelier.'" It was at Bolton Landing, once the war was over, that Smith worked out a unique and personal sculptural style using symbolic imagery in the creation of small but complicated steel pieces. He did this in relative isolation—building his work at the same time he sought a sense of personal identity. For Smith the two were one: "It is identity, and not that overrated quality called ability, which determines the artist's finished work."[50]

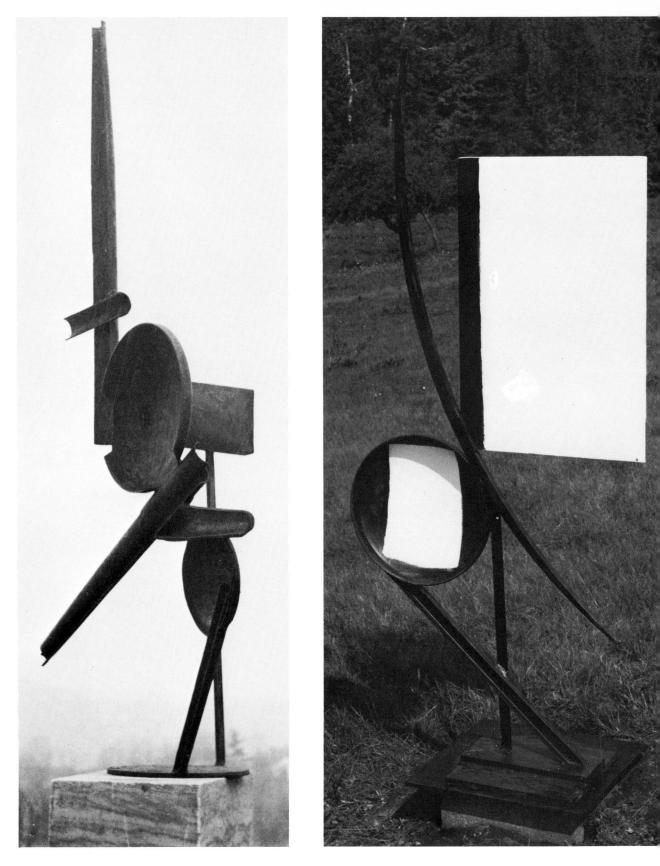

147. DAVID SMITH. *Tank Totem* V. 1955–56. Steel, 96¾″. Collection Mr. and Mrs. Howard Lipman, New York.

148. DAVID SMITH. *Tank Totem* VII. 1960. Polychromed Steel, 84″. Storm King Art Center, Mountainview, New York.

In the 1950's Smith began to develop a more monumental style, pursuing his ideas in different series of large sculptures. This was similar to Brancusi's procedure, and like the older sculptor, he probed various problems simultaneously. But his results were entirely different. Each Brancusi sculpture, once finished, takes on a finite and perfect existence. When we look at a Brancusi *Muse* or a *Bird* we are not aware of its being a point within a larger evolution; we become aware of this only through exhibitions or photographs in books on the artist's work. Such is not the case with Smith's serial sculptures, particularly those of the 1950's: they were more experimental, with successes and failures occurring in the same series. Smith's work is very different from Brancusi's kind of perfection.

The central image of Smith's sculpture is the upright figure. A sense of human presence is particularly powerful in the *Tank Totem* series of the 1950's (Figs. 147, 148). Here we can recognize the influence of Gonzalez (Fig. 143), for whom Smith expressed such great admiration in his very sensitive article, "Gonzalez: First Master of the Torch." [51]

Like Gonzalez—and ever since the 1930's—Smith assembled his figures. He put the *Totems* together, piece by piece, welding each part into place. But unlike the Spaniard's, his parts remain distinct, never merging with the whole. The *Tank Totems* are not built around the concept of a continuous spinal core, and they do not refer in specific ways to human anatomy. Yet we know by Smith's positioning of the supports and by his use of cylindrical parts that they have something to do with a human presence; we even feel by the shape and the concavity of the cylindrical tank drum sections that they are female. It is fascinating to see how combinations of boiler heads and concave shafts rearranged in new configurations can yield such images. As Smith developed his ideas he consolidated them, pulling forms together ever more tightly and putting greater emphasis on frontality and static gesture. He would experiment with different arrangements by painting guide lines on the floor of his studio and then laying down the parts to be assembled. This working process encouraged strong frontal images. At eight feet, the *Tank Totems* loom over the landscape like modern counterparts to some grand Archaic kore. Smith often placed them directly on the ground, omitting the traditional pedestal and thereby emphasizing them as presences. The viewer observes the *Totems* in a fixed position in front of him; they do not invite him to walk around them. Smith believed that sculpture was essentially a visual experience: "I think sculpture along with any art is strictly a visual response . . . the touch for me was a matter of physical labor on my part, and I don't touch, I touch with the eye." [52] All the parts of his figure-forms are accessible to sight; the surfaces *are* the work; there is no volume, no solid matrix, no hollow space within. By 1961 Smith had finished his last *Tank Totem*, but he was still concerned with the series: "I started the *Tank Totems* about ten years ago and I'm still working on them and don't rule them out until the day I die—that is, as long as concave and convex are still a mystery." [53] It was this balance between means (the material and the formal) and meaning (hidden symbolism and personal emotions) that was Smith's lifelong concern, a balance particularly well maintained in *Tank Totems*. The critic Rosalind Krauss has pointed out that Smith was fully aware of the psychoanalytic interpretations given to totemic practices. The *Totem* series became for him one of the steps in a progressive search for identity; they were "a manifestation of his own person."

Smith loved industrial materials—those metals that "possess little art history." They had the power to suggest improvisations that could initiate a series. The tank parts for the *Totem* series were already in his studio, along with I-beams and sheets of stainless steel, copper, and aluminum, when he decided to work with them. Often, as in the *Tank Totems*, the materials

themselves determined to a large degree the appearance of the sculptures—far more so than would be the case in a traditionally carved or cast piece.

Soon after Smith's death in an auto accident in 1965, Clement Greenberg went to Bolton Landing. He saw the platform outside Smith's studio where the sculptor had laid out pieces for an intended new work. Greenberg noticed that among the forms were lozenge-shaped pieces suggesting the human head, and he speculated that Smith had been getting ready to return to more anthropomorphic figures after his highly abstract open work of the early 1960's. Greenberg noted that "Smith returned periodically to the theme of the human figure as though to a base of operation." [54]

In 1967 the Los Angeles County Museum organized the largest exhibition ever held of contemporary American sculpture, showing works made in the 1960's by eighty artists. One of the fullest presentations was of Smith's work: a rich variety of both painted and burnished steel pieces—dowels, bars, beams, and cubes—all put together in a lucid spatial geometry. Beside most of the other work in the show his sculptures looked elegant and composed. They were based on complex visual relationships, and even though highly abstract were not totally devoid of anthropomorphic suggestions. In an introductory essay to the show's catalogue one critic stated:

> One way of seeing the best new sculpture is in its relationship to David Smith's work. Smith's late work seems to have opened avenues for exploration as rich as those originally unlocked by Gonzalez and Picasso, which Smith himself explored. In several important respects, the best new sculpture either continues Smith's researches or finds its identity in reaction to his work.[55]

The majority of the sculptures were in the latter group. Two tendencies were particularly evident among them. There were many non-anthropomorphic objects consisting of elementary shapes and unified surfaces. They had not been made in parts like Smith's sculptures, but as single large-scale units; works over fourteen feet were not uncommon and projected a dense, space-consuming capacity. The second group of objects at the Los Angeles exhibition was only slightly less dominant. These works did not thrust themselves upon the viewer by their large scale, but by their gaudiness. They were as colored as the other group was blandly monochromatic. Their garish hues were woven into familiar images of everyday life; they were "found objects" or fabricated Dada-like "parcels" of life, and many had been made in soft voluptuous materials quite foreign to traditional sculpture.

The one thing both groups shared with David Smith's work was their lack of bases and pedestals; sculptures hung from the ceiling or the wall, leaned against other surfaces, or stood directly on the floor. At first it seemed the two groups had no more in common than the absence of bases, but that was not quite true, for works in both groups also had a similar relation to the viewer, calling up an immediate response from him and forcing upon him (though in different ways) a strong sense of himself. They posed problems of both an aesthetic and a cultural nature for those who viewed them. And so it turned out that the sculpture of David Smith, that "coarse" American who loved the methods and materials of industry, looked newly beautiful and refined in Los Angeles in 1967.

The difference between David Smith's work and the new sculpture can be understood within the context of the 1960's—a decade of intense and varied ideologies, a time of special sensitivity to the imbalances in the social order, to racial and sexual affronts. A couple of months before the Los Angeles show New York artists had been involved in an even larger

organizational feat: six hundred artists participated in the *Angry Arts Against the War in Vietnam*. One hundred and fifty artists worked on a single collage in New York University's Loeb Student Center, covering sheets and sheets of paper with strong visual and verbal indictments of the war. During this period the American artist, like others in the society he lived in, was politically active to an unusual degree.

This heightened sensibility affected the lives and works of a good number of artists who were showing in Los Angeles in 1967. Ideology colored many an artistic vision and created an atmosphere in which the polemics of modern art could grow more profusely than usual. The critic Gregory Battcock saw in works by Robert Morris (b. 1931) shown at the Leo Castelli Gallery in New York objects that were "nonemotional, nonexpressive," yet "dictated by the deepest humanistic considerations," and he referred to the artist as "the leading sculptor of our day." [56] When Morris's work was later shown at New York's Museum of Modern Art along with the work of other artists who concentrated on single geometric forms in a show called *The Art of the Real*, Battcock disliked the exhibition, explaining that "we are pretty much fed up with the order, precision, and sterility so characteristic of modern institutions. What the Museum of Modern Art does is to take art away from us by putting it in historical perspective. The dream and mystery of art is erased." [57] What he could see and praise in a gallery exhibit of Morris's work he could not see in a museum. Such strong feelings, animosities, and contradictions were an essential part of the volatile notion of art in the 1960's.

Art historian Eugene Goossen, who organized *The Art of the Real* exhibition, believed the works he had selected showed the stance their creators had taken. He brought together sculptures and paintings by artists willing to confront "real" experiences and objects. He emphasized that "this new art has nothing to do with metaphor, or symbolism, or any kind of metaphysics," though he conceded it had something to do with "the urgencies of the last decade outside the arts." [58] If this was to be the new humanism, then it was a humanism devoid of idealism, one whose proponents simply sought the experience of self-knowledge and an understanding of human limitations.

The visitor who walked into the Castelli Gallery in the spring of 1968 when the Robert Morris show was being presented found himself in a room partially occupied by strips of felt hanging from the walls and falling to the floor in heaps (Fig. 149). If unprepared, he might have thought he had made the mistake of arriving at the gallery before the works were properly hung and would leave. If he stayed, what would he have had to deal with? First, there was the radical concept of space—there was nothing to walk around, to approach, or to peer into. Nor was there a predetermined path for him to follow, as there is when statues are placed on pedestals in a sequence; therefore, the viewer's movements were mostly of his own choosing: he could approach the pieces close up, and if he did so, it was immediately obvious that it did not matter if he handled the "sculpture" or altered the position of some of the felt strips, since their arrangement on the floor was random. The material—a thick, industrial felt—was dense and textured, a sensuous fabric with great tactile appeal. The voluptuous turnings of the strips created a strong presence; they were heavy and fell with gravity's pull, then tangled in masses, making it impossible to suspect that in fact their construction had been an ordered and measured cutting of felt rectangles.

When the visitor went into the second room of Morris's exhibition he was treated to another surprise (Fig. 150), yet one quite unrelated to the first work even though done in the same year. Here, filling the room, was a severe geometric metal object—almost the antithesis of

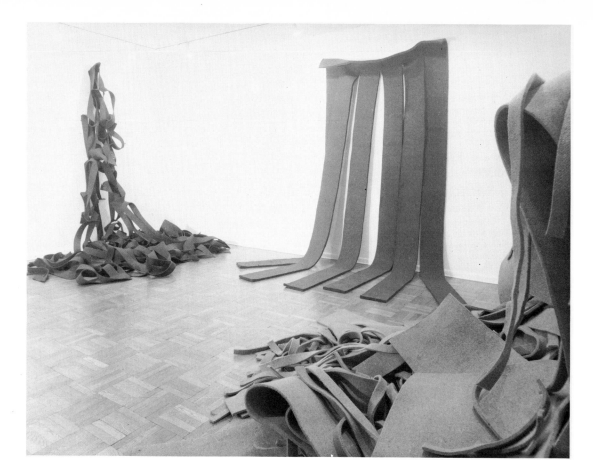

149. ROBERT MORRIS. *Untitled.* 1967–68. Felt, $\frac{3}{8}''$ thick. Installation view at Leo Castelli Gallery, New York.

the loose, soft flow of felt strips he had just seen. Instead of subtly invading the room from the edges, this large unit of bolted steel beams aggressively occupied the entire central space of the gallery. It took up so much space that it seemed clear Morris had little concern for the visitor's ease of circulation within the gallery. There was no hint whatsoever of hand-crafting in the work. It consisted of industrially made parts neither designed for artistic purposes nor assembled by the artist himself. The experience of looking was limited to the viewer's grasp of the dimensions, the right angles, the surfaces touched by light, and the sheer weight of the piece with its single beam resting heavily upon the floor. If the viewer had been tempted to rearrange the felt strips in the other room there was no such impulse in the presence of this massive deliberate piece.

Visual consistency has never been important to Morris. What is similar about the two works under discussion is that the viewer must decide for himself how he is to relate to them. Morris created two different aesthetic situations in which the nature, the size, and the arrangement of objects challenged the spectator rather than invited him to share space with them. A British critic, David Sylvester, being particularly aware of this when he saw Morris's work in 1967, asked how conscious the artist's intentions were in this regard. Morris answered:

> I think the sense of scale that a piece has is always a relation between your body and the object that's external to it. I mean, that is where the scale comes in, it seems to me: you relate it to yourself. And so I'm very aware that these pieces create this kind of situation in which one is aware of the piece, because I think that is the term that gives it its meaning or gives it its measure in some sense.[59]

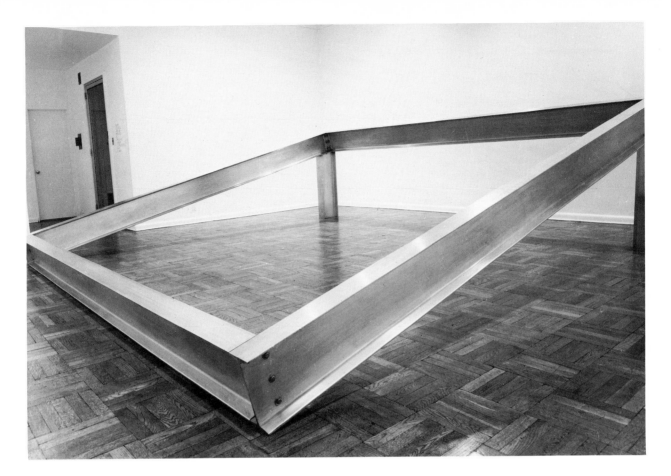

150. ROBERT MORRIS. *Untitled.* 1968. Aluminum I-beams, 54 x 180 x 180″. Installation view at Leo Castelli Gallery, New York.

Coming away from an exhibition of an artist like Robert Morris, the viewer is likely to feel that he has found little of substance: the objects are so intensely simple, so devoid of art's sensuousness, so seemingly empty of aesthetic considerations. Morris has been called a "super-Dada" artist because he is continually on the verge of not making art. The American critic Harold Rosenberg commented:

> The difference between historic Dada and the current fundamentalist version lies in their treatment of the spectator; instead of goading him into indignation at the desecration of art, the new Dada converts him into an aesthete. The monotonous shapes and bleak surfaces presented to him as objects wrapped in their own being compel him, if he is not to back out of the gallery, to simulate a professional sensitivity to abstruse contrasts of tone, light, and dimension.[60]

Rosenberg was disturbed by those who talked seriously about these "monotonous shapes and bleak surfaces." Yet whether we condemn it or not, it is clear that such work consistently has an intellectual quality at its core. An artist like Morris is like a scientist; he observes perpetual modes in the light of what he knows from existing objects. He poses "problems," answers them, and restates others. Morris believes that "once a perceptual change is made, one does not look at it, but uses it to see the world." [61]

Ever since the Renaissance one of the proofs of artistic talent has been the ability to draw. If a sculptor was a poor draftsman, his ultimate worth was often in question, even though his marbles might be excellent. This is no longer true. Instead, the artist must now be able to intellectualize and to articulate his thoughts. It is unlikely that Morris would occupy quite such

an important place in contemporary American art if he had never put his ideas down in written form. It is also quite possible that if the day comes when he cannot articulate problems verbally he will cease being involved in making art. He has already gone through such a closure in a limited way: he was a painter until 1959, at which time he gave up that genre for lack of problems to solve. The difficulty with sculpture had been that "it was terminally diseased with figurative allusion." But "the object mode in three dimensions was a new start." [62] Morris's statements have often been polemical and they are designed to perpetuate his own art. When he stated in 1966 "that the concerns of sculpture have been for some time not only distinct but hostile to those of painting," he was summarily dispensing with nearly half the sculpture that was on view at the Los Angeles show in 1967. But his lucid discussions about object sculpture have had considerable consequence for the development of what is termed "Minimal" sculpture: "Simplicity of shape does not necessarily equate with simplicity of experience. Unitary forms do not reduce relationships. They order them." [63] "The focus on matter and gravity as means results in forms which were not projected in advance." [64] Such statements are the verbal parallels to the disparate forms Morris was showing concurrently in the galleries.

How, finally, are we to view this kind of sculpture—these objects so peculiarly devoid of any anthropomorphic reference? Are they cynical or sterile, or of such a super-intellectual quality that only a few can fathom their value? Are they a grand attempt at a *tabula rasa*, their intention being to wipe out a decadent Western artistic past along with the objects collected so preciously by a moneyed elite? Or do they represent the new humanism that can lead us to perceive the "other"? The answer depends upon one's orientation. Nevertheless, there is some kind of truth in these objects—made by an artist not playing Pygmalion, not conjuring up any kind of mysterious transformations. Morris's art makes a statement about being: existence has its own meaning and a work of sculpture does not have to stand for something else. It need not preach, instruct, or commemorate. "The specific object of the '60's is not so much a metaphor for the figure as it is an existence parallel to it." [65]

In 1966 two New York critics sent out questionnaires to a number of American artists, asking "Is there a sensibility of the sixties? If so, how would you characterize it?" [66] That such an exchange could take place points to a major fact in recent Western art: a new consciousness about the history of art has entered the creative process. Artists are not only more aware of what fellow artists are creating, but are creating with a sense of the historical past and how they themselves might influence its evolution. Neither Duchamp's nor Morris's creative ventures could exist or be understood outside this context. Those who responded to the questionnaire used two words most consistently to characterize the art of the 1960's: detachment and irony. Or as Edwin Ruda put it: "Supercool meets Captain Cozmo."

If Morris stands for Supercool, Claes Oldenburg is Captain Cozmo. Oldenburg (b. 1929) was the only sculptor at the Los Angeles exhibition with more works on view than David Smith. He showed ten pieces in all, made over a four-year period: the garish *Giant Ice Cream Cone* (1962), over twelve feet high, and the pristine white vinyl *Soft Toilet* (1966) were perhaps the most whimsical of these works on banal themes. Oldenburg had begun to lose interest in the human figure as a model and in the canvas as a surface at about the same time as Morris did—in the late 1950's. Through profound self-analysis, through opening himself up to such new experiences as experimental theater and Happenings, and through a sincere desire to understand the role of the artist in society, Oldenburg found a new way to work. He started making objects based on simple everyday items and put many of these in his "Store" on East Second Street in

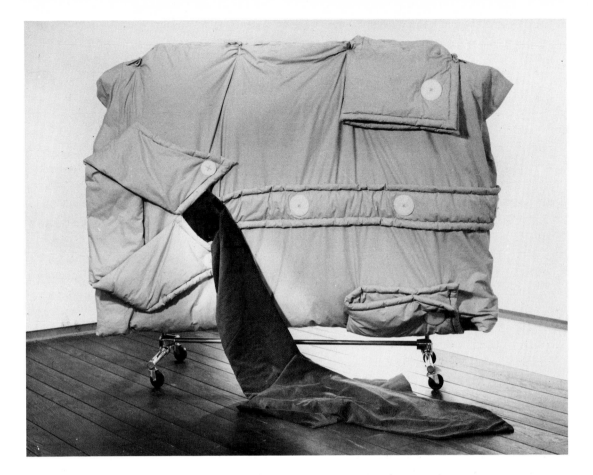

151. CLAES OLDENBURG. *Giant Blue Shirt with Brown Tie.* 1963 Canvas, cloth, kapok, dacron, metal, plexiglass. 54 x 82 x 12". Mr. and Mrs. Ian Beck, New York City.

New York City, which he had created in order to avoid the artificial environment of art galleries and museums. Oldenburg recalls how passersby would come in, take a look, and say: "This is not art, it's a hamburger," or "This is not a hamburger, it's art." He liked such reactions, for he felt that he was creating something halfway ("Nothing is interesting to me unless it is halfway") between art and life.

Although he no longer used models nor drew from the figure, Oldenburg never lost sight of the human body. But he was now using it in unconventional ways—as a fragment, by allusion, or in metaphor. We feel the body or parts of it always in Oldenburg's works—in shirts (Fig. 151), stockings, even in eclairs, blenders, and washstands. This is not accidental, since Oldenburg looked around him and projected himself into objects, seeing "not the thing itself, but—myself—in its form." [67]

Throughout the 1960's Oldenburg was formulating his personal version of Duchamp's "displacement," but rather than recognizing existing objects—Duchamp's readymades—he *made* his own and extended the variables through alterations in scale, density, and surface. In 1963 he began working with soft surfaces and made sculptures of cloth, kapok, and vinyl that yielded readily to the touch. Again, the human form is championed, for the effect of these "soft" works is to make one think of the human body. And part of Oldenburg's goal as a sculptor has always been to bring alive the sensations of the human body through his works. Yet as an artist he is also concerned with the formal results of soft sculpture: "I think . . . the reason I have done a soft object is primarily to introduce a new way of pushing space around in a

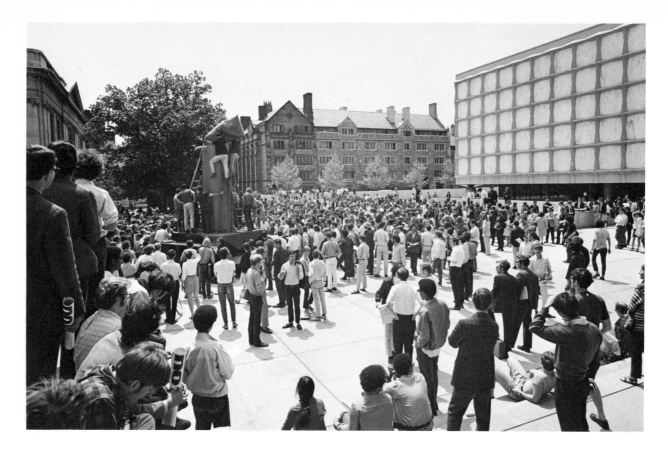

152. CLAES OLDENBURG. *Lipstick on Caterpillar Tracks* being erected at Yale, May
 1969.

sculpture. . . ." The more Oldenburg worked with his new surfaces the more he strove to create beautiful uniform planes of synthetic materials with slick industrial finishes and colors.

In 1965 Oldenburg moved into a new block-long studio in New York City; its gigantic dimensions were in keeping with the kind of spatial fantasies he was beginning to express in his work. He had always been concerned about environments—his own and that in which his work was to be shown. Now he began to think about this in a much more public way. It brought him to a consideration of something long out of fashion with the avant-garde—the monument. Putting his ideas down in crayon and wash drawings, Oldenburg thought about contemporary issues he believed to be urgent and public situations he found ludicrous and hypocritical. He developed a number of proposals in which displacement, colossal scale, and metaphor were used. One of the first was a projected war memorial for the intersection of Broadway and Canal Street; it was conceived as a giant pat of butter made of concrete, on which the names of war heroes would be inscribed. The "pat" would be so large that it would completely fill the intersection and thus physically impede all traffic at this crucial junction.

In April of 1967, *Art News* published an interview with Oldenburg in which he emphasized the shift that had taken place in his interest: "It's the problem of monumental sculptures . . . that really interests me now—colossal civic monuments that could be used to replace the ones that are already there." A couple of months later Oldenburg realized the first of these. It was the *Placid Civic Monument*, erected in Central Park behind the Metropolitan Museum of Art on October 1, 1967. Work on the monument began with the digging of a hole measuring six feet by three feet; gravediggers had been hired to make the hole and then fill it with its own dirt. To a largely perplexed public this was an incomprehensible act. Oldenburg's notebook jottings

153. CLAES OLDENBURG. *Lipstick on Caterpillar Tracks*. 1969. Steel and wood, 24'. Yale University, New Haven.

of 1967 are an aid to understanding his aims: "The artist is a communicator, and from experience he knows how difficult it is to communicate the pure sense of being alive. His life is a constant discussion with his audience over some small part of the earth which he has isolated, made or imagined. The grave form was chosen because of its high associational value. . . ." "There is no need to build sculptures. We do so, only showing our ambition and proving that we are not enjoying the things that are on this earth." "Relax, Monument. It is no longer necessary to do, do, do." "Grave is a perfect (anti) war monument, like saying no more." [68]

For an artist who loves to create more than to negate, the *Placid Civic Monument* represented both an outer limit and a beginning. It was not until 1969, however, that Oldenburg was able to build a monument on an imposing site and on a massive scale. At that time a group of Yale students asked him to create a monument to the "Second American Revolution." They were acting on a remark made by the philosopher Herbert Marcuse to the effect that if an Oldenburg object were to be erected on Park Avenue it would be truly subversive: "I would say—and I think safely—this society has come to an end. Because then people cannot take anything seriously: neither their president, nor the cabinet, nor the corporation executives. There is a way in which this kind of satire, or humor, can indeed kill. I think it would be one of the most bloodless means to achieve a radical change." [69] In view of the political unrest at universities in 1968 and 1969, Marcuse's statement became a challenge.

In February of 1969, Oldenburg went to Yale, his own alma mater, to select a specific site. He chose Beinecke Plaza, where his work would take its place in the shadow of the American flag near the monument to Yale alumni who perished in World War I—in proximity to the office of the president and the solemn marble façade of the rare book library. The monument

was thus to be seen in juxtaposition to the cultural and nationalistic might of an intellectual fortress. The students joined with Oldenburg to form a corporation, pooling their labor and their funds in a communal effort to build the monument. This collective act was deeply satisfying to Oldenburg, who saw the monument as "not just a piece of art set out to edify the masses but [as something] asked for and . . . taken care of and used." Oldenburg made two models; the one the students chose was *Lipstick on Caterpillar Tracks* (Figs. 152, 153). It was built in four months and erected in Beinecke Plaza on May 15, 1969.

The Yale monument allowed Oldenburg to combine several things that had meant much to him as an artist throughout the 1960's. He was able to indulge his passion for geometric forms using an oval, a lozenge, and numerous circles for the wooden caterpillar base and in the tubular metal shaft of the lipstick. It harmonized well with the classical architecture, particularly the columns of the Yale Commons with its entablature bearing the names of memorable World War I battles. But Oldenburg's simple forms lived wholly within the context of the realism of ordinary experience. And in these terms the monument was in strong opposition to its surroundings: everyday objects flaunting themselves before the pretentiousness of classical architecture, and brilliant colors (the base and the tip were red, the shaft was gold) mocking the university's solemn marble monochrome. Mounted on the caterpillar—familiar to Americans through television news from Vietnam—was the giant lipstick, an image that was distinctly erotic—a red phallic capsule extending and retracting and forever being spread across moist female lips. (Oldenburg was already fascinated with the eroticism of the lipstick motif in 1966 when he thought of using a whole group of lipsticks to replace the Fountain of Eros in London's Piccadilly Circus.) Originally, the Yale *Lipstick* was conceived of and made with a soft tip of inflatable plastic which would droop to one side when not completely filled with air; it could have been re-erected with an attached air pump. An inflated lipstick would have been the signal that someone had an announcement to make to the community. There was not time or money for this refinement and even the soft model that was installed had technical difficulties and within a week had to be replaced with a metal version.

The most important thing about *Lipstick*, however, is not how it worked mechanically but how it worked metaphorically. Here was a lethal "shooting stick" erected in the midst of an academic community painfully divided over the issues of the Vietnam war. It was a bright shaft, at once wonderful and terrible: "The American need constantly to ejaculate phallic warheads is revealed as a symbolic act of frontier *machismo*, while the collapsing, soft vinyl lipstick raises the implicit question: how long can America keep it up?" [70] This inappropriate object placed in peaceful Beinecke Plaza was a deadly thing—an unbearable presence were it not so very funny. Its humor was crucial to its existence: "The important thing about humor," Oldenburg has said, "is that it opens people. They relax their guard and you can get your serious intentions across. If I were as didactic in my work as I really am, I would bore people to death."

But its humor did not save it. The Yale Corporation did not consider *Lipstick* desirable for permanent installation on Yale's campus, and by March of 1970 it was gone. Oldenburg expected this; anyway, he did not want this work to go into a "museum phase . . . which is the fate of all works of art." He wanted to create something that would continue to function in life and to produce action (the concept of people pumping up the flaccid lipstick to signal an announcement exemplified this). He considered the possibility of sending *Lipstick* to universities all over the United States, anticipating that at each place it would be "forceably installed and rejected." Oldenburg understood what Duchamp meant when he said that art

works die, and he wanted to find "the way to keep a sculpture alive. There are so many monuments all over the country that people pay no attention to—they're just like trees." As has been true so often in Oldenburg's life, he was responding to Duchampian ideas, but rephrasing them in a thoroughly positive manner.

For many viewers the 1967 sculpture exhibition in Los Angeles offered such diversity of modes that it was difficult to find tangible links between them. Could the works of Oldenburg and Morris be discussed in the same breath? Today this seems considerably easier than it did then: when we look at the situation that encouraged both men to become sculptors and the direction their work has taken, we find that the differences between them are more apparent than real. Both Morris and Oldenburg first expressed their dissatisfaction with painting in the late 1950's, as well as their view that art of the human figure as it was known had little to offer. They then turned to sculpture. By 1960 a complete reversal of the nineteenth-century artistic situation had taken place: now it was painting that was limited—by its less tangible subject matter, its single two-dimensional surface, and its forced relationship with a support (usually a wall). By contrast, sculpture could be anything, be made of anything, and go anywhere; the borderline between art and life was far more fascinating, ambiguous, and tense than with painting. Once Morris and Oldenburg understood these things, they both became engaged in object-making. They went about their work in a similar fashion, like scientists setting up experiments: observing, thinking of every alternative solution to a problem, and classifying the results. Both men wanted to cut deep into the fundamental question of art versus reality. Environmental situations attracted both and at every point over the past few years they have wanted to know how people see, react to, and are engaged by the art they have made within a given setting. They have relied on industry to the fullest possible degree for materials, methods, and subjects. Until recently sculptors have always recognized some sort of division between organic materials and those fabricated by man; for Oldenburg and Morris the division has become irrelevant.

When Oldenburg was in Sweden in 1967 he found a particularly ornate electrical plug that "looked like both a castle and a church." From its design he developed a proposal for a chapel: "I sited it on top of a hill. The church connection lies close to the three-way plug because of the cross-vault structure of both objects and the folk identification of religious power and electricity." In 1900 Henry Adams's agony had been that of a classical humanist confronted by the results of the Industrial Revolution: he was unsure of how he would learn to compensate for the phenomena he experienced as true but could not perceive with his senses; he worried about the environment of the future—one of infinite speed and eternal light. Claes Oldenburg, as an artist of the second half of the twentieth century, though fully conversant with traditional Western values and art, does not share that conflict. Nor do many people who live in his society. Twentieth-century sculptors have played a part in offering signs and guideposts that this adaptation might take place. And artists such as Oldenburg and Morris are still engaged in trying to find further limits remaining to be explored.

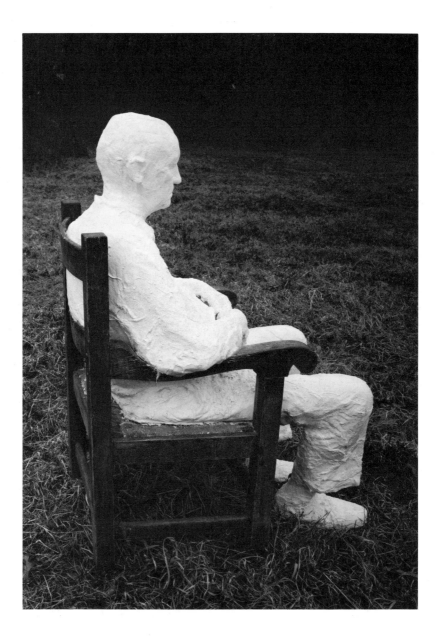

154. GEORGE SEGAL. *Man in Chair* (Helmut von Erffa). 1969. Plaster and
wood, 50 x 29 x 36″. Collection Giuseppe Panza di Biumo, Milan.

Epilogue
Sculptors and
the Human Body

The profound alteration in the traditional relationship between sculpture and the human body was revealed clearly at the Los Angeles exhibition, *American Sculpture of the Sixties*, in 1967. For many this sculpture was a shock; by the standards of an earlier generation these artists went too far—by representing the body too explicitly, by creating strange metaphors for its form, or by ignoring it altogether. Most of the artists exhibiting spoke to this crucial issue. George Segal said: "I have become interested in looking out at the world. . . . I think that's the real reason I am still casting models." [1] (Fig. 153) Similarly, Claes Oldenburg: "I have had repeatedly the vision of human form. . . . It is the forms that the living human being can take, in all its parts, mental and physical, and this is the subject, in the fullest sense possible, of my expression—the detached examination of human beings through forms." [2] But the object-makers denied the figure; Ronald Bladen spoke of involvement with sculpture "outside of man's scale," of "an attempt to reach that area of excitement belonging to natural phenomena such as a gigantic wave poised before it makes its fall . . ." [3] (Fig. 155); Anthony Caro wanted to eliminate "references" so that his works would "not remind you too much of the world of things, or of parts of noses or breasts or ears or anything . . ." [4]; Robert Morris, too, reminded us that his works were "not so much a metaphor for the figure as . . . existence parallel to it." [5]

Given the tradition of Western art—in which the sculptor has had what amounted to a mission to form our notion of a body-image in any given age—and the degree to which this tradition has been upset during the twentieth century, the dichotomy of the 1960's is not surprising. Thus, twentieth-century concern and questions about man's nature have affected the sculptor more tangibly than painter, poet, or musician. How could it fail to do so after such a persistent tradition of the human figure as the central image of sculpture? Cubist painters made available the premise that no particular subject—and especially not the figure—was sacred. But their contemporaries in sculpture did not take the lesson to heart. Rather, what fascinated sculptors was what *happened* to the human body in terms of the new vocabulary of faceted surfaces and spatial voids. It was not until the 1930's that sculptors were able to exercise their choice freely between abstract forms and anthropomorphic images. By then such a sculptor as Georges Vantongerloo (1886–1965), who played a leading role in abstract movements, was

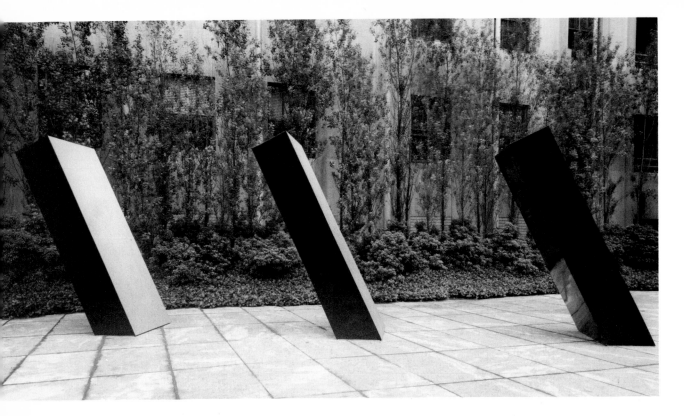

155. RONALD BLADEN. *Untitled.* 1966–67. Painted and burnished aluminum in three identical parts, 10′ x 48″ by 24″, spaced 9′4″ apart. The Museum of Modern Art, New York (James Thrall Soby Fund).

creating the purest kind of sculptural statements through mathematics, works that relied upon straight lines and a structural approach to architecturally balanced groups of forms (Fig. 156). His philosophy accorded perfectly with those forms:

> Sometimes man asks himself: what is the aim of creation (nature)? But at this precise point, he begins to attribute a false importance to man's existence. There is no favoritism. Our role is to propagate our species and create conventions that will help us to meet our needs. . . .

> Mathematics is one of our finest instruments. If it does not give us an absolutely exact and immutable picture of things, it is because this in itself would be contrary to continuity, for everything is in process of transformation and nothing can remain in an immutable state.[6]

Gonzalez's work, though primarily figurative (Fig. 143), was held in high regard by the same artists and connoisseurs who valued Vantongerloo's achievement. When we look at their works together they appear to be quite different; but if we consider their ideas about creation, we find that they are not so diverse. Vantongerloo believed that mathematical means were the best possible ones for portraying something about the real nature of our existence, while Gonzalez concluded that "the art of statuary consists in eliminating the living man and replacing his void by solid and durable elements having the same density as the vanished body. . . . there are some epochs which replace with nothing the void produced by the absence of man."[7]

The two artists were responding to the same new set of definitions in the Western world. Both, Vantongerloo perhaps more consciously than Gonzalez, spoke in a period when a revolution was taking place in science and when biologists were coming to explain the phenomena of life in terms of the laws of physics and chemistry, so that "the common division

of the world into subject and object, inner world and outer world, body and soul, is no longer adequate. . . ." [8]

Such abstract ideas—and they were most prominent in the cultural circles of Europe during the 1930's—came to seem ephemeral and inadequate to many after World War II. The sculptors were particularly conscious of this change, and the occurence can not be separated from the effects of the war and from sculpture's special place in making visible certain aspects of human self-awareness. Artists who had been working abstractedly turned more often to the figure and the subject. The sculpture of the 1940's of Lipchitz, Picasso, Giacometti, and Henry Moore provides good examples of the shift of interest. Others who had been working consistently with the figure came into prominence in this year—artists such as the Italians

156. GEORGES VANTONGERLOO. *Construction in an Inscribed and Circumscribed Square of a Circle.* 1924. Cement, 10 x 10 x 14". Collection Peggy Guggenheim, Venice.

157. GERMAINE RICHIER. *Don Quixote of the Forest.* 1950–51. Bronze, 93″. Walker Art
Center, Minneapolis, Minnesota.

Giacomo Manzù (b. 1908) and Marino Marini (b. 1901), and the French sculptor Germaine Richier (1904–1959), with her darkly imagined skeletal figures (Fig. 157).

In 1959 New York's Museum of Modern Art gathered together some post-war paintings and sculptures in an exhibition called *New Images of Man.*[9] What that show made particularly evident was that for many of the painters, Abstract Expressionist artists such as Willem de Kooning and Jackson Pollock, the human body was but an occasional image, but for the sculptors in that show, it was their whole art.

The renewed interest in the figure in sculpture following the war and the contrast in the way sculptors and painters approached it made evident at the *New Images of Man* show can serve to remind us that the most basic notions of birth and rebirth have always been transmitted in sculptural terms: Adam formed of earth by God, Pandora created of earth and water by Hephaestus, and stones turning into men and women to be the companions of Deucalion and Pyrrha, the only survivors of the Flood in Greek mythology (see the passage from Ovid, page 20).

Every people has formulated some kind of self-image in terms of a body-image; sculpture has been continually a key to what that self-image was in any given era. The maker of the *Venus of Willendorf* (Fig. 11) interpreted woman very differently from the maker of the *Cycladic Idol* from Amorgos (Fig. 12). He cared most about her function as mother and made that evident in giving expression to fullness, roundness; the Cycladic image-maker, however, formed his figure for a grave. She was either an offering or a protectress; representation of her powers in terms of fertility are reticent, but she is no less female.

We speak with greater fluency about the self-image of people in historical times, when we are aided by their writing. The unusual force of the Greeks' search to understand themselves through a study of nature stands out. By the sixth century B.C. they were engaged in that pursuit in a fully rational way, and they took their new knowledge and meshed it with their religious belief. Their aesthetic sense put life into images that could make visible their view of nature and their own spirituality at one time. The heroic bronze and marble images of the fifth century, particularly the nude male figures—structurally lucid, ordered, smooth of surface—were the perfect heroes and gods. They were images with which people could identify the highest moral value and in which they could recognize something of themselves. They sprang from new questions about nature, questions about what happens to a man's body when he walks, lifts, or bends. They were images through which Greeks were able to consider how they differed from other men—those who lived elsewhere and those who lived in earlier times—to them, men who were brutish and animal-like. The Greeks relied on observation, they sought to understand nature by looking at themselves, and the depth of their response can best be seen in sculpture. Eventually it even led them to speculate about man's evolving to a new kind of perfection: that he had power to create such an ordered beauty implied incalculable possibilities.

Consider the various ways man has seen his own image in the ancient world; it makes us realize that the ideal beauty of the Greek artist was anything but usual. But the link the Greeks established between visual reality and their own bodies had such force that it became an option to which people of the West have repeatedly returned since the fifth century B.C.

The opposite extreme was to empty the image of its potential to represent the human in naturalistic fashion; to take away its power to stand freely and live physically in-the-round. The spiritualization of man's image took place in the hands of the Christian community during the Middle Ages. Man feared God and his own flesh troubled him; it was soft, palpable, the

feminine part of his nature that he rejected. In the tenth century Rather of Liège wrote:

> Avoid then feminine softness and solidify your mind in virtue. . . . This you will be able to do
> if, exerting your energy, you will elevate the strength of your mind to the stars, will subject the
> flesh to the soul, and the soul to God, and will be hard and inflexible.[10]

Man's body was not to be the subject of isolated images; it would yield to a larger order—to the
structure of the church to which all men were rightfully destined, to the very walls of God's
temple. There in stony relief man's body joined other bodies—of beasts, plants, the whole
natural world—in a structure that was brilliantly colored, rhythmically shaped, and twisted into
a transcendental reality.

Even the lifesize figures lining the entrances of churches in the twelfth and thirteenth
centuries did so within that context. The historian William Brandt writes that people in that age

> did not separate the action of human beings and the action of objects of physical nature into
> different perceptual categories: both were essentially of the same nature. . . . The same
> categorical framework (which was a kind of unquestioned assumption about the nature of the
> ultimate) governed [their] perception of the human as well as of the nonhuman object.[11]

And those great carved figures (Figs. 58–60), for all their monumentality, reveal this; they do so
in their stoniness, in the meagerness of their spatial expansion, in their inability to move, and in
their lack of individuality.

A fundamental re-examination of the relationship between the Christian religion and man as
a creature was needed in order to create an ambiance in which artists would make another
choice. This occurred in the fifteenth century under the leadership of the Italian humanists;
their view of religion was human-centered, and their sense of individual achievement set the
stage for the great changes which would take place during the Renaissance. And yet it remained
a time of faith in which man still recognized himself as being "in the image and likeness of
God." The combination resulted in one of the most positive views of human nature ever
achieved, and no art form changed more drastically or more quickly because of it than sculpture.
Renaissance art began with sculpture; the revival of the freestanding, self-sufficient statue has
long been recognized as signaling "a radically unmedieval image of man." [12] Throughout the
Renaissance the parallel between God's creation of man and the sculptor's fashioning of life in
stone was ever present:

> Everything of nature, in heaven and earth, made by God is sculpture. And in order to
> demonstrate this more quickly, let us leave the discussion of heaven and speak only of those
> things of earth, made by the same God who made the heavens. The most marvelous thing that
> you see upon the earth is man, who was made, as we see him, in the round, what we call
> sculpture [*che si chiama Scultura*].[13]

This statement of Benvenuto Cellini's is absolutely man-centered, with his philosophy as a
Christian and his experience as a sculptor in full accord; he, as well as his society, was convinced
that the human figure in innumerable variation was of endless interest.

How subtle, but how real, was the shift during the seventeenth century as man altered his
attitude toward nature and discovered his passion for measurement and for explaining events in
terms of mechanical motion. He could even look upon himself as a machine—"nothing more
than a statue or a machine of clay," as Descartes said. By the eighteenth century everything
could be discussed in terms of atoms; mathematics could now be used to analyze Earth and all

her growth—man included. But these reminders of post-Renaissance science do nothing to summon up the visionary saints of Baroque churches, splendidly clad rulers of newly decorated palaces, or the nymphs of Versailles. What we must recognize is that by the seventeenth century the most vigorous thinkers were working with definitions too abstract and a sense of scientific order too vast to be shared by the larger community or interpreted by artists. But one thing visibly touched all—scientist, philosopher, and artist: an enhanced respect for personal experience as opposed to the Renaissance's overwhelming concern for ancient authority. We see it in the sculptor's search for new poses and physiognomic types, in his combining of materials, and in his interest in relationships (of figure to garment, to environment, to the spectator) rather than in the isolated figure.

The strangest historical junction ever between new philosophical ideas and new sculpture occurred in the late eighteenth century. There was that sudden appearance of the new "beautiful nakedness," seen best in single male figures that stood erect and smooth and were to be viewed in the clear light of day. It signaled a return to the absolute authority of the Greeks; this was coupled with a belief that the adherence to past vision would yield a Utopian situation through which nature would be ennobled and man perfected. The movement was scientific and up-to-date; classicism was approached through modern historical method and the developing study of archaeology. But the belief that this approach led to fundamental answers about the past previously beyond man's grasp and to new answers for the present seems from our vantage point more romantic than scientific. This movement—Neoclassicism—lifted sculpture once again into the position of primacy it had held early in the Renaissance. But in the end it put more strain on sculpture than on any other area of creativity, for sculpture stood for "high truth," for a universal standard of beauty to be captured in the human body alone. Not surprisingly, sculptors generally subscribed to this philosophy, and the rigid norms of Neoclassicism became institutionalized throughout the West. As a result, subsequent generations of sculptors faced a serious problem: to work with the nude was to identify with conservatism. Moreover, modern scientific investigation of man and his place in the universe did not yield an image of man that could give the sculptor a reasonable alternative. During the nineteenth century scientists came to recognize that human beings were subject to the same laws that govern all organic and inorganic matter. Their model was a mechanistic one, and they demonstrated that all things—including man's bodily frame—had gone through stages of alteration in a process of evolution. Such ideas, ideas with roots in the eighteenth century, were brought into focus in 1859 when Darwin published the *Origin of the Species*. Darwin's suppositions upset people deeply; they destroyed traditional values, offending the concept of human dignity and offering little in its place. For the notion of causation Darwin substituted the chance occurrence of evolutionary process. Thus the tension for the nineteenth-century sculptor, for he could neither comfortably find his imagery in the schools nor relate to recent theories about the nature of man. As for the usual baggage of past sculpture—figures of myth, allegory, and divine beings—this became increasingly unacceptable to people who came more and more to find truth through empirical means. Uneasy compromises occurred; innovators tried for new effects by concentrating on clothing rather than on bodies, by adopting new approaches to physiognomy, by relying on sculpture of the past that was *not* in the Greek mode, and even by escaping human subject altogether by going to the animal kingdom.

Only in the late nineteenth century, with Rodin's work (Figs. 4, 129–131, 133), do we find a statement in sculpture that was forceful and contemporary while still based on the nude. In the

sense that he worked with the nude Rodin's sculpture was traditional, but it was also anti-classical, for he did not believe in the body's perfection. He disfigured it, hacked it apart, even as he declared, "The sight of human form feeds and comforts me. I have infinite worship for the nude. . . ." (see page 194).

Rodin's total commitment to the human figure coupled with his desire to liberate it from past conventions provided a new situation at the beginning of the twentieth century, when a great number of sculptors felt free to return to the complete, unviolated human form. It was the first time in a century that the choice appeared to be a comfortable one. These sculptors created simple smooth bodies—for the most part female—large and whole, but cool, with little emphasis on sensuous or emotional overtones. It was a wonderful yet curious return to this major image in the history of sculpture—the full, radiant female figure. Gaston Lachaise (1882–1935), who turned to this subject most ardently, wrote:

> Woman, as a vision sculptured, began to move, vigorously, robustly, walking, alert, lightly, radiating sex and soul. Soon she came to forceful repose, serene, massive as earth, soul turned towards heaven. "La Montagne"! The feet almost disappeared. Mountains neither jump nor walk, but have fertile rolling pastures, broad and soft as fecund breasts.[14]

With woman's body these sculptors made a special statement, one that had nothing to do with narration, symbols, or public declarations. Woman became the way to concentrate on a single form again and to search for the essence of form-making. They stripped away the superfluous; in their hands woman became abstract; with artists like Brancusi and Arp references to her body became oblique and the figure evolved into the figure-object (Figs. 137, 138, 157).

Sculptors of the twentieth century have had two basic options for exploring the figure-object: to work with its "objectness," its physicality, its literal rather than illusionistic qualities, or to explore its spatial capacity, recognizing that like our bodies sculpture exists in space and suggests the possibility of movement. The acquisition of real movement in modern art has been the sculptor's business just as it has been the film-maker's. A great many sculptors have recognized that their art simply can not be defined as one in which movement is absent (or, as the revolutionaries of 1920 described it in the "Realist Manifesto," "that 1000-years-old delusion" that holds "the static rhythms as the only elements of the plastic and pictorial arts").

Modern sculpture—both as object and as kinetic configuration—has been involved in our own self-image; we find the partial figure, the spatial skeleton, and the dense vertical totem attached to some aspect of our body-image. And are not the experimentation and the diversity in recent sculptural images somehow related to a broader cultural "process of adaptation . . . going on continuously between man and the world he is creating?" The scientist René Dubos has spoken of how that process has been dealt with in his field, lamenting the fragmentary and piecemeal approach to the problem used by many natural scientists:

> While most human beings believe that the proper study of mankind is man, the scientific establishment has not tooled itself for this task. The great scientific institutions are geared for the analytical description of the body machine, which they approach in much the same spirit as they do simple inanimate objects. They pay little heed to the scientific study of man as a functioning entity, exhibiting all the complex responses that living entails. Nor do they pay much attention to the environmental factors which condition the manifestations of human life.[15]

158. JEAN ARP. *Human Concretion.* 1935. Cast stone (1949, after original plaster), 19½ x 18¾″. The Museum of Modern Art, New York.

Sculptors have been trying in recent years to deal with many aspects of this problem that Dubos finds so difficult for the scientist.

Westerners of the twentieth century do not experience the harmony that Renaissance people did in contemplation of their own bodies, nor do they recognize moral beauty in their own proportions as did the ancient Greeks. Rather we find ourselves interdependent with objects, unable to define ourselves apart from the things we make, and the gap between ourselves and the rest of nature grows rather than diminishes. A century ago Henry Thoreau feared that man would become a tool of his tools; he looked at the actions of his contemporaries and watched them apprehensively as they began to do things "railroad fashion":

> We have constructed a fate, an *Atropos,* that never turns aside. (Let that be the name of your engine.) Men are advertised that at a certain hour and minute these bolts will be shot toward particular points of the compass. . . . The air is full of invisible bolts. Every path but your own is the path of fate.[16]

That nineteenth-century prophet shrank from technology and its power to become *the* binding factor in our lives instead of nature. The technological society that filled Thoreau and Adams with apprehension has been broadly accepted by most Westerners for the better part of the twentieth century. The sculpture of the sixties stood closer to that established fact than any sculpture made before. In 1969 a critic observed with some satisfaction that the sculptural object was finally being freed from the figure—

> freed from the residual structure of the human figure, the inhibitions of expensive materials and complex craft processes. It would be an object among objects, privileged only by its unique configuration, its lack of recognized type of function. Its unity would be its own, not that given by an existing model in reality.[17]

Another wrote of the new "truthfulness" in sculpture since "the myth of Pygmalion" has finally been abandoned. "The artist accepts what exists, for its own sake, and presents it simply and directly. . . . Instead of art about the world (and especially *about* the human presence in the world) we are offered an art which is *of* the world." [18]

The 1960's was one of the most revolutionary periods in the history of sculpture. Two approaches—through the object and through environment—have offered new alternatives to the sculptor for dealing directly with some kind of union between technology, man, and man's environment. These approaches are of special value in a world that is painfully aware of the disjunction between man and nature and has a perpetual sense of being conditioned by things. But even with the opening up of a new range of possibilities of dealing with human reality, it seems unlikely, given the intensity with which sculptors have formed and re-formed the figure, that the object will ever totally replace the human body in sculpture; the need to make our own image has been too central in the development of human consciousness to be completely abandoned.

Notes

ONE

The Paragone

1 Max Kozloff, "Further Adventures of American Sculpture," *Arts*, 39 (February 1965), 24.

2 Clement Greenberg, "Sculpture in Our Times," *Arts*, 32 (June 1958), 22.

3 This letter is translated and published in Robert Klein and Henri Zerner, *Italian Art, 1500–1600* (Englewood Cliffs, N.J.: Prentice-Hall, 1966), 10–13. In 1546 Benedetto Varchi, an intellectual at the Medici court, decided to solicit the views of contemporary artists on the Paragone. Klein and Zerner reproduced Bronzino's answer "because it organizes all the required points with exemplary clarity. . . ."

4 *Ibid.*, 4.

5 Leonardo da Vinci, *Paragone*, introduction and translation by Irma A. Richter (London: Oxford University Press, 1949), 101.

6 Translation by Mrs. Henry Roscoe, in *Michelangelo, A Self-Portrait*, Robert Clements, ed. (Englewood Cliffs, N.J.: Prentice-Hall, 1963), 13.

7 Leonardo, *Paragone*, 104.

8 *Ibid.*

9 Bronzino's letter to Varchi in Klein and Zerner, 11.

10 Clements, *Michelangelo, A Self-Portrait*, 9.

11 Benvenuto Cellini, "Sopra la Differenza Nota tra gli Scultori et i Pittori Circa li Luogo Destro Stato Dato al Pittura nelle Essequie del Gran Michelangnolo Buonarotti," *I Trattati dell'Oregiceria e della Scultura* (Milan: Ulrico Hoepli, 1927), 268.

12 Baldassare Castiglione, *The Book of the Courtier* (Baltimore: Penguin Books, 1967), 98.

13 Filippo Baldinucci, *The Life of Bernini*, translated by C. Enggass (University Park, Pa.: Pennsylvania State University Press, 1966), 79.

14 Johann Gottfried von Herder, *Critical Forests;* cited in Malcolm Howard Dewey, *Herder's Relation to the Aesthetic Theory of His Time* (Chicago: University of Chicago Press, 1920), 87.

15 "Salon de 1846," *Curiosités Esthétiques* (Paris: Garnier Frères, 1962), 120.

16 "Salon de 1859," *ibid.*, 385. When Pradier showed *Phryne* at the Salon of 1845, Baudelaire had grudgingly expressed some admiration: "It is incomparably skillful—it is pretty in all its aspects—one could doubtless find some parts of it at the Museum of Antiquities; for it is a prodigious mixture of dissimulations." (*Oeuvres complètes* [Paris: Pléiade, 1961], 862.) But the following year he remarked, "That which proves the pitiful state of sculpture is that M. Pradier is king of it." (*Ibid.*, 945).

17 J. Grangedon, "Salon de 1868," *Gazette des Beaux-Arts*, XXV (1868), 30.

18 Edmund Claris, "Medardo Rosso," *De l'Impressionnisme en sculpture* (Paris, 1902); translation in Linda Nochlin, *Impressionism and Post-Impressionism* (Englewood Cliffs, N.J.: Prentice-Hall, 1966), 78.

19 *Ibid.*, 79.

20 Arthur Symons, "Rodin," *Fortnightly Review* (June 1, 1902), 967.

21 Roger Allard, "Sur quelques peintres," *Les Marches du Sud-Oest* (Paris, 1911); translation in Edward Fry, *Cubism* (London: Thames and Hudson, 1966), 63.

22 Duchamp-Villon, from a letter written *ca.* 1910 to Louis Vauxcelles, art critic for *Gil Blas*; cited in *Duchamp-Villon, Le Cheval Majeur* (Paris: Galerie Louis Carré, 1966), 30.

23 Umberto Boccioni, "Technical Manifesto of Futurist Sculpture," [April 11, 1912]; translation in Joshua Taylor, *Futurism* (New York: The Museum of Modern Art, 1961), 131.

24 *Cahiers d'Art*, No. 9 (1928), 383.

25 Henry Moore, "The Sculptor in Modern Society," *Liturgical Arts*, No. 1 (November 1954), 11.

26 Boccioni, cited in Taylor, 131–132.

27 Naum Gabo and Antoine Pevsner, "The Realistic Manifesto, 1920," in *Gabo* (London: Lund Humphries, 1957), 152.

28 László Moholy-Nagy, *The New Vision*, 4th rev. ed. (New York: Wittenborn, 1947), 47.

29 Wilhelm Valentiner, *Origins of Modern Sculpture* (New York: Wittenborn, 1946), v–vi.

30 Herbert Read, *The Art of Sculpture* (New York: Pantheon Books, 1956), 54.

31 Herbert Ferber, "On Sculpture," *Art in America* (December 1954), 263.

32 Warren Forma, *5 British Sculptors (Work and Talk)* (New York: Grossman, 1964), 109.

33 Naum Gabo, "Sculpture: Carving and Construction in Space," *Circle* (London: Faber and Faber, 1937), 105.

34 Gene Baro, "British Sculpture: The Developing Scene," *Studio* (October 1966), 175.

35 Pietro Consagra, *Necessità della Scultura* (Rome: Edizione Lentini, 1952).

TWO

The Mediterranean World

1 Gisela Richter, *Kouroi* (New York: Oxford University Press, 1942), 8.

2 The converse has been suggested as well—that a method of representing the human body influenced the character of the Greek narrative. Both views are summarized in Ernst Gombrich, *Art and Illusion* (New York: Bollingen Foundation, 1961), 128–130. Gombrich believes that "when classical sculptors and painters discovered the character of Greek narration, they set up a chain reaction which transformed the methods of representing the human body. . . ."

3 Dio Chrysostom in his Olympian Oration, XII, 50–52. Translation in J. J. Pollitt, *The Art of Greece* (Englewood Cliffs, N.J.: Prentice-Hall, 1965), 74.

4 Pliny the Elder, *Natural History*, XXXVI, 20. Translation in Pollitt, *ibid.*, 128.

5 From a speech ascribed to Cato by Livy, XXIV, 4, 1–4.

6 Tertullian, *On the Soul*, chapter 30. Translation in *Tertullian Apologetical Works and Minucius Felix Octavius* (New York: Fathers of the Church, Inc., 1950), 249–250. Tertullian was born in the middle of the second century at Carthage, and it is evident from his writing that he must have spent some time in Rome. It should be remembered that he was a Christian apologist and that in such a passage he was not just reporting but was giving a particular view in the context of a polemic. He saw the earth as becoming a better place because of Christianity and he argued this in a period when many slanders were being directed against Christians.

THREE

The Christian West

1 Henri Focillon, *L'Art des sculpteurs romans, recherches sur l'histoire des formes* (Paris: Librairie Ernst Leroux, 1931).

2 Meyer Schapiro, "From Mozarabic to Romanesque in Silos," *Art Bulletin*, XXI (1939), 313–374.

3 Gerhart B. Ladner, *Ad Imaginen Dei, The Image of Man in Medieval Art*, Wimmer Lecture, 1962 (Latrobe, Pennsylvania: The Archabbey Press), 59.

4 Erwin Panofsky, *Gothic Architecture and Scholasticism* (London: Thames and Hudson, 1957), 59.

5 John Ruskin, *Our Fathers Have Told Us* (Sunnyside, Kent: George Allen, 1881), 11–12.

6 See G.H. and E.R. Crichton, *Nicola Pisano* (Cambridge: University Press, 1938), 1.

7 John White discusses the color and other decorative effects on the appearance of the Pistoia pulpit in *Art and Architecture in Italy, 1250–1400* (Baltimore, Maryland: Penguin Books, 1966), 79.

8 Original and translation of the entire inscription is to be found in Michael Ayrton, *Giovanni Pisano* (London: Thames and Hudson, 1969), 123. This inscription is not accepted by all scholars as actually written by Giovanni, though there is no doubt that it is of the time. Gian Lorenzo Mellini (*Il Pulpito di Giovanni Pisano a Pistoia* (Venice: Electa, 1969), 7) believes that Giovanni would not have elevated himself at the expense of his father.

9 Ghiberti's autobiography is included in his second "Commentary," which was completed in 1447–48. This translation is from Richard Krautheimer, *Lorenzo Ghiberti* (Princeton, N.J.: Princeton University Press, 1956), 12.

FOUR

Renaissance Sculpture

1 Charles Trinkaus's book, *In Our Image and Likeness* (London: Constable, 1970), has been particularly helpful in considering the humanist concept of man.

2 This quotation is from Bruni's funeral oration for Nanni degli Strozzi in 1428. The excerpt quoted here can be found in Hans Baron, *The Crisis of the Early Italian Renaissance* (Princeton, N.J.: Princeton University Press, 1966), 417.

3 Charles Seymour, Jr., *Sculpture in Italy, 1400–1500* (Baltimore, Md.: Penguin Books, 1966), 4.

4 A photograph of the figure taken from the proper view is reproduced in Giorgio Castelfranco, *Donatello* (New York: Reynal and Company, 1965), Fig. 28.

5 It appears that Ghiberti was in Rome around 1416. See Richard Krautheimer's comparison of Donatello and Ghiberti with reference to their knowledge, appreciation, and use of classical antiquity in *Lorenzo Ghiberti* (Princeton, N.J.: Princeton University Press, 1956), 89–91; 272–293.

6 A review of scholars' varying chronologies and some of the reasons they have given for them can be found in H.W. Janson, *The Sculpture of Donatello* (Princeton, N.J.: Princeton Unversity Press, 1957), II, 81.

7 Kenneth Clark, *The Nude* (New York: Doubleday Anchor Books, 1959), 89.

8 Joan Gadol gives a summary of scholars' opinions about the dating of *Della statua* in *Leon Battista Alberti* (Chicago: University of Chicago Press, 1969), 76–77, fn. 29. The earliest date ever proposed is *ca.* 1435 and the latest *ca.* 1464.

9 The only busts generally accepted as works of Donatello are the early reliquary bust of *St. Rossore* in Pisa and the *Bust of a Youth* in the Museo Nazionale in Florence. The first surely is an idealized type rather than the likeness of an individual, and the second probably is also. See Janson, *op. cit.*, II.

10 John Pope-Hennessy claims the earliest surviving portrait bust of the Renaissance to be that of Piero de' Medici done by Mino da Fiesole in 1453. He gives a brief and excellent survey of the development of this type in *Italian Renaissance Sculpture* (London: Phaidon Press, 1958), 54–62.

11 Giorgio Vasari's history of Italian artists published in Florence in 1550 *(Vite de' piu eccellenti architetti, pittori et scultori italiani)*, and brought out in an enlarged edition in 1568, is the most extensive source we have on Italian Renaissance art. This quotation is from the Everyman Library translation: *The Lives of the Painters, Sculptors, and Architects* (New York: Dutton, 1963), II, 34.

12 Wilhelm Bode, in his catalogue for the Berlin-Dahlem Museum, 1888, attributed the bust to Desiderio and identified it with the work seen by Vasari. The majority of twentieth-century scholars have accepted the attribution, though it has not been unanimous: Pope-Hennessy attributes the bust to Antonio Rossellino (*op. cit.* 304). This has been endorsed by Anne Markham in her review of Ida Cardellini's *Desiderio da Settignano* (Milan: Edizioni di Comunità, 1962) in the *Art Bulletin*, XLVI (1964), 244. Cardellini upheld the traditional attribution after reviewing the literature on the work, and gave her reasons for rejecting Pope-Hennessy's attribution; see Cardellini, pp. 184–186. The identification of the work with Marietta Strozzi does appear unlikely. As Anne Markham says (p. 241), "Cardellini realizes that the portrait (which she dates *ca.* 1455) cannot possibly depict Marietta Strozzi, born only in 1448, but for sentimental reasons chooses to retain the name."

13 The question was posed by the humanist Marsilio Ficino (1433–1499) and is discussed in Trinkaus, *op. cit.*, II, 474.

14 *Ibid.*, 491 (from Ficino's *Theologia platonica*).

15 This translation is from Vasari's first edition of 1550. Both the original and the translation may be found in John Pope-Hennessy, *Italian High Renaissance and Baroque Sculpture* (London: Phaidon Press, 1963), catalogue volume, 10.

16 Robert J. Clements, *Michelangelo's Theory of Art* (Zurich: Buehler Buchdruck, 1961), 418. Charles Seymour, Jr., has also spoken of Michelangelo's identification with *David* in *Michelangelo's David, A Search for Identity* (Pittsburgh: University of Pittsburgh Press, 1967), 54–55.

17 G. P. Lomazzo, *Trattato*, 1584. Clements uses this quotation in his discussion of Michelangelo's serpentine composition (*ibid.*, 175).

18 Quoted by John Shearman, *Mannerism* (Baltimore, Md.: Penguin Books, 1967), 81.

19 Pope-Hennessy lists the various interpretations by scholars in *Italian High Renaissance and Baroque Sculpture*, catalogue volume, 24.

20 Translation by Creighton Gilbert, in *Complete Poems and Selected Letters of Michelangelo*, Robert N. Linscott, ed. (New York: Random House, 1963), 158.

21 The self-portrait figure is often considered to represent Joseph of Arimathea. There are good reasons for both identifications. The problem has been excellently reviewed by Wolfgang Stechow, "Joseph of Arimathea or Nicodemus?", *Studien zur Toskanischen Kunst: Festschrift für L.H. Heydenreich* (Munich: Prestel-Verlag, 1964), 289–302.

22 The original and the translation are reprinted in Pope-Hennessy, *Italian High Renaissance and Baroque Sculpture*, catalogue volume, 64.

23 Benvenuto Cellini, *The Life of Benvenuto Cellini*, translated by John Addington Symonds (New York: Random House, The Modern Library), 324–325.

24 Illustrations of the painting and the engraving and a discussion about the relationship between the panel and the works of the Italians can be found in Pierre Du Colombier, *Jean Goujon* (Paris: Editions Albin Michel, 1949).

25 Alexandre Lenoir, *Musée des Monuments Français* (Paris, 1802), 151.

26 Sir Anthony Blunt has further noted that the head of Nicodemus to the left looks like an idealized portrait of Michelangelo. Anthony Blunt, *Art and Architecture in France 1500–1700* (Baltimore, Md.: Penguin Books, 1954), 107, fn. 56.

27 Adolfo Venturi, *Storia dell'Arte Italiana*, X (Milan: Ulrico Hoepli, 1937), pt. III, 67.

FIVE

The Seventeenth and Eighteenth Centuries

1 From *La cena de le ceneri*, Dial. I. Quoted in Irving Louis Horowitz, *The Renaissance Philosophy of Giordano Bruno* (New York: Coleman-Ross Company, 1952), 64.

2 Discussed by James Ackerman in "Science and Visual Art," *Seventeenth-Century Science and the Arts*, edited by Hedley Howell Rhys (Princeton, N.J.: Princeton University Press, 1961), 63–90.

3 This frequently quoted remark is from the diary of Paul Fréart, Sieur de Chantelou, Bernini's companion during the sculptor's Paris visit. The quotation here (from the entry for June 6, 1665) has been published in Robert Enggass and Jonathan Brown, *Italy and Spain 1600–1750* (Englewood Cliffs, N.J.: Prentice-Hall, 1970), 123.

4 Filippo Baldinucci, *The Life of Bernini*. Originally published in Florence in 1682. Translation by Catherine Enggass (University Park, Pa.: The Pennsylvania State University Press, 1966), 42.

5 Irving Lavin, "Five New Youthful Sculptures by Gianlorenzo Bernini and a Revised Chronology of His Early Works," *Art Bulletin*, Vol. L (September 1968), 214.

6 Irving Lavin (*ibid.*, 241) has spoken of Bernini's interest in Cellini's portraits when he was working out his new portrait style during the 1620's.

7 Chantelou's diary, entry for June 6, 1665, published in Enggass and Brown, *op. cit.*, 123.

8 These words of praise come from Francisco Gerónimo Collado, *Descripción del túmulo y relación de las esequias que hizo la ciudad de Sevella en la muerte del rey don Felipe segundo* (Seville, 1869), and are quoted in Beatrice Gilman Proske, *Juan Martínez Montañés* (New York: The Hispanic Society of America, 1967), 24.

9 Pacheco was deeply interested in iconography and devoted much discussion to it in *El arte de la pintura*, published in 1649. This quotation comes from his section on the Immaculate Conception; it has been translated and published by Enggass and Brown, *op.cit.*, 165–67.

10 See José Lopez-Rey, *Velázquez' Work and World* (Greenwich, Conn.: New York Graphic Society, 1968), 31–32.

11 Enggass and Brown, *op. cit.*, 220.

12 *Ibid.*, 221.

13 Giovanni Pietro Bellori, *Le Vite de' Pittori, Scultori ed Architetti Moderni*, Part I (Rome: Mascardi, 1672), 269.

14 Giovanni Battista Passeri, *Vite de' Pittori, Scultori ed Architetti che hanno lavorato in Roma, morti dal 1641 fino al 1673* (Rome: G. Settari, 1772), 88.

15 Pierre Jaquillard, "Louis XIV, Guide de Versailles," *Revue Versailles*, Nos. 14–18 (1962–63).

16 Cesare Ripa's book of allegories and emblems was first published in Rome in 1593. It was translated into French by J. Baudouin and published in 1636 in Paris in an illustrated edition entitled *Iconologie, où nouvelle explication de plusieurs images, emblèmes, et autres figures hyérogliphiques des vertus, des vices, des arts, des sciences, des causes naturelles, des humeurs différentes, des passions humaines, etc.*

17 Part of the exchange between Lebrun and Puget can be found in Emile Baumann, *Pierre Puget* (Paris: Les Editions de l'Ecole, 1949), 96–98.

18 Letter of Oct. 20, 1863, in Klaus Herding, *Pierre Puget* (Berlin: Gebr. Mann Verlag, 1970), 224.

19 For protection, the *Milo* was moved to the Louvre in 1850.

20 Duc de Saint-Simon, *Historical Memoirs*, edited and translated by Lucy Norton (New York: McGraw-Hill, 1968), II, 223.

21 This remark was made by the Princess Palatine. It is quoted in Gillette Ziegler, *At the Court of Versailles* (New York: E.P. Dutton & Co., 1966), 328.

22 All the statues of Louis XV were destroyed at the time of the Revolution. This statue by Pigalle for Bellevue was probably destroyed in 1794. A reduced version in terra cotta is in the museum at Versailles.

23 George Levitine, *The Sculpture of Falconet* (Greenwich, Conn.: New York Graphic Society, 1972), 28.

24 Diderot wrote about the sculptor Mignot in his review of the Salon of 1763: "Speaking of Mignot, I have been told about a maneuver on the part of sculptors. Do you know what they do? From a living model they cast feet, hands, shoulders in plaster; this mold gives them the same parts in relief, and these parts they then use in their compositions just as they were from the model. In truth this is no longer the merit of a clever sculptor but of an ordinary founder. We suspect this trick in the fineness of details which would surpass the most extraordinary patience and in this minute study of nature." Quoted in Denis Diderot, *Salons*, text presented by Jean Seznec and Jean Adhémar (Oxford: Clarendon Press, 1957), I, 248.

25 This remark was made by the artist Cochin to Madame de Pompadour's brother Marigny in a letter of 1768. It has been quoted by Olga Raggio in "Two Great Portraits by Lemoyne and Pigalle," *The Metropolitan Museum of Art Bulletin* (February 1967), 221.

26 Louis Réau, *Les Lemoyne* (Paris: Les Beaux-Arts, 1927), 145.

27 Most authors give 1771 as the date of Houdon's first participation in a Salon, but Louis Réau points out that he exhibited in the 1769 Salon, although he entered too late to be mentioned in the catalogue. See Réau, *Houdon sa vie et son oeuvre* (Paris: F. de Nobele, 1964), I, 26.

28 *Ibid.*, 173.

29 Comparisons between the two sets of giant pier statues were inevitable, and for this earlier *St. Andrew* Rusconi took Duquesnoy's *St. Andrew* in St. Peter's as a model.

30 Since the Saxon court had been Protestant, there was no Catholic Hofkirche originally. The first Catholic Hofkirche, the one for which Permoser made his altar figures and other sculptural decorations, was in a converted theater. When it was replaced by the new Catholic Hofkirche, Permoser's works were moved to a church in Bautzen, where they remained until 1883. Between 1883 and 1914 the altar statues were in storage, during which time some damage (including the loss of the figure of the child at St. Augustin's feet) occurred. The statues were later moved to Bautzen's new State Museum, where they may be seen today.

31 Wolfgang Leppmann, *Winckelmann* (New York: Alfred A. Knopf, 1970), 128.

SIX

Neoclassicism and
the Nineteenth Century

1 The name of the poem, signed by *Anglicus*, is *Advice to an English Painter*. It has been reprinted in Jack Lindsay, *1764* (London: Frederick Muller, 1959), 142–143.

2 The article is signed "B." *The Universal Magazine* (May 1775), LVII, 242–243.

3 John Thomas Smith, *Nollekens and His Times* (London: Turnstile Press, 1949), 109.

4 *Ibid.*, 215.

5 *Gibbon's Autobiography*, edited by M. M. Reese (London: Routledge Kegan Paul, 1970), 83.

6 Smith, *op. cit.*, 159.

7 Oscar Antonsson, *Sergels Ungdom och Romtid* (Stockholm: P. S. Norstedt & Söner, 1942), 101.

8 From *The History of Ancient Art*, translated by G. Henry Lodge and published in 1880. Reprinted in Lorenz Eitner, *Neoclassicism and Romanticism, 1750–1850* (Englewood Cliffs, New Jersey: Prentice-Hall, 1970), 18.

9 Oscar Antonsson (*op. cit.*, 207–208) has suggested that Giovanni da Bologna was Sergel's major inspiration in this work.

10 Quoted in Fritz Novotny, *Painting and Sculpture in Europe 1780–1880* (Baltimore, Md.: Penguin Books), 216.

11 Le Chevalier Mariano Vasi, *Itinéraire Instructif de Rome* (Rome, 1817), I, 9.

12 Gérard Hubert, *La Sculture dans l'Italie napoléonienne* (Paris: Editions E. de Boccard, 1964), 149.

13 Count Cicognara published the first biography of Canova. It appeared in 1823, the year after Canova's death. The English translation used here is *The Works of Antonio Canova in Sculpture and Modelling* (London: Henry G. Bohn, 1849), I, n.p. Cicognara had earlier published the first history of Italian sculpture; the first volume was published in Venice in 1813.

14 J. S. Memes, *Memoirs of Antonio Canova with a Critical Analysis of His Works and an Historical View of Modern Sculpture* (Edinburgh: Archibald Constable, 1825), 437–438.

15 Antoine L. Quatremère de Quincy, *Canova et ses Ouvrages* (Paris: Adrien le Clere et Cie, 1834), 137.

16 Pierre Jean David d'Angers, *Les Carnets de David d'Angers* (Paris: Librairie Plon, 1958), II, 147–148. David d'Angers was one of the foremost sculptors in France during the first half of the century. What is interesting is that he so often praised the nude and damned statues in modern dress, while no one made more of the latter than he himself.

17 Emile Zola, *L'Evenement illustré* (June 16, 1868). This excerpt has been translated by Elizabeth Holt and is published in French in F.W.J. Hemmings and R. J. Niess, *Emile Zola Salons* (Geneva: Librarie E. Droz, 1959), 140.

18 J.-K. Huysmans, *Salon de 1879.* The whole selection is to be published in a forthcoming book by Elizabeth Holt.

19 Schoelcher, *L'Artiste* (1831), I, 314–315.

20 Charles De Kay, *The Life and Works of Barye* (New York: The Barye Monument Association, 1889), 107.

21 Glenn F. Benge has pointed this out to me. His work on Barye's antique sources will be included in a forthcoming publication on the artist.

22 *L'Artiste* (1833), V, 153.

23 Emile Cantret, *L'Artiste* (1863), 90.

24 Quoted by Louise Clément-Carpeaux, *La Vérité sur l'oeuvre et vie de Carpeaux* (Paris: 1934), I, 72.

25 Quoted by Léon Riotor, *Carpeaux* (Paris: Henri Laurens, 1906), 39.

26 Henri Charles Etienne Dujardin-Beaumetz, *Entretiens avec Rodin*, translated by Ann McGarrell and published in Albert E. Elsen, *Auguste Rodin: Readings on His Life and Work* (Englewood Cliffs, New Jersey: Prentice-Hall, 1965), 180.

27 W.G.C. Byvanck, *Un Hollandais à Paris* (Paris, 1891).

28 Taken from a letter written by Rodin and published in *Gil Blas* (Paris, July 7, 1904). An excerpt is published in Albert E. Elsen, *Rodin* (New York: The Museum of Modern Art, 1963), 53.

29 Léon Maillard, *Auguste Rodin Statuaire* (Paris: H. Floury, 1899), 82.

30 To a reporter writing for *Saturday Night* (Toronto, December 1, 1917). Excerpt published in Elsen, *Rodin, op. cit.*, 52.

31 T. H. Bartlett, "Auguste Rodin, Sculptor," *The American Architect and Building News* (1889), XXV. Published in Elsen, *Auguste Rodin: Readings . . .* , 91–92.

32 Octave Mirbeau, *L'Echo de Paris* (Paris, June 21, 1889).

SEVEN

Twentieth-Century Sculpture

1 Paul Morand, *1900 A.D.* (New York: William Farquhar Payson, 1931), 61.

2 Statement made by M. Coste, "Impressions de l'Esposition universelle de 1900," *Revue Internationale de Sociologie* (December 1900), 894. The article is quoted in Richard D. Mandel, *Paris 1900, The Great World's Fair* (Toronto: University of Toronto Press, 1967), 117.

3 Henry Adams, *The Education of Henry Adams* (Cambridge, Massachusetts: The Riverside Press, 1961), 380.

4 André Gide, "Promenade au Salon d'Automne," *Gazette des Beaux-Arts*, pér. 3, vol. 34 (December 1, 1905), 476–478.

5 This is the version given by Judith Caldel, *Maillol, sa vie, son oeuvre, ses idées* (Paris: Editions Bernard Grasset, 1937), 77.

6 Albert E. Elsen, *The Sculpture of Henri Matisse* (New York: Harry N. Abrams, Inc., 1972), 28–35. Professor Elsen gives a full discussion of Matisse's work with Bevilaqua and the relationship between *The Serf* and *The Walking Man*, accompanied by ample photographic material.

7 Andrew C. Ritchie, *Aristide Maillol* (Buffalo: Albright Art Gallery, 1945), 45.

8 Originally published in *La Grande Revue* (December 25, 1908). Translated by Margaret Scolari and published in Alfred H. Barr, *Matisse, His Art and His Public* (New York: The Museum of Modern Art, 1951), 122.

9 Raymond Escholier, *Matisse, A Portrait of the Artist and the Man*, translated by Geraldine and H. M. Colvile (New York: Frederick A. Praeger, Inc., 1960), 141.

10 Photograph reproduced in Elsen, *The Sculpture of Henri Matisse*, 93.

11 Told by Matisse to Pierre Courthion. Quoted in Jean Guichard-Meili, *Matisse* (London: Thames and Hudson, 1967), 168.

12 John Elderfield, "Matisse, Drawings and Sculpture," *Artforum*, vol. XI (September 1972), 168.

13 Lawrence Gowing, *Matisse* (London: The Arts Council of Great Britain, 1968), 18.

14 William Tucker, *Henri Matisse Sculpture* (London: Victor Waddington Gallery, 1969).

15 The basic research on the Brancusi chronology has been done by Sidney Geist, whose dates I have used exclusively. These four works, two of which are probably lost, are illustrated in his book: *Brancusi* (New York: Grossman Publishers, 1968), 24–29.

16 William Tucker, "Four Sculptors, Part I: Brancusi," *Studio International*, vol. 179 (April 1970), 159.

17 Henry Moore, *Henry Moore on Sculpture*, A collection of the sculptor's writings and spoken words, edited by Philip James (New York: The Viking Press, 1966), 6. Moore made this statement in 1930.

18 Clement Greenberg, "Modernist Sculpture, Its Pictorial Past," *Art and Culture* (Boston: Beacon Press, 1961), 162. Originally published in 1952.

19 Charles Baudelaire, *The Mirror of Art* (London: Phaidon Press, 1955), 120.

20 Jacques Lipchitz, *My Life in Sculpture* (New York: The Viking Press, 1972), 51.

21 *Ibid.*, 17.

22 *Ibid.*, 103.

23 Quoted by Waldemar George, "Jacques Lipchitz, père légitime des transparences," *Art et Industrie*, vol. 27 (1952), 28–29. I am grateful to Josephine Withers for bringing this quotation to my attention.

24 Ruth Olson and Abraham Chanin, "Gabo–Pevsner," *Five European Sculptors* (New York: The Museum of Modern Art, 1969), 52.

25 Naum Gabo, *Constructions, Sculpture, Paintings, Drawings, Engravings* (London: Lund Humphries, 1957), 156.

26 The Realist Manifesto has been translated into English and published in Naum Gabo, *op. cit.*, 151–152.

27 See David Smith. "Gonzalez: First Master of the Torch," *Art News*, vol. 54 (February 1956), 65.

28 Quotation from an unpublished manuscript in the possession of Roberta Gonzalez. It has been translated and entered in the appendices of a Ph.D. dissertation by Josephine Withers, *The Sculpture of Julio Gonzalez: 1926–1942* (New York: Columbia University, 1971).

29 *Ibid.*

30 Gonzalez was profoundly demoralized by World War II, and though he died of a heart attack, friends say it was the war that killed him. This information was made available to me by Josephine Withers.

31 *Guitar* in The Museum of Modern Art in New York is Picasso's first construction-sculpture. Picasso told William Rubin that he made it before he made his first collage, *Still Life with Chair Caning*, though it has generally been thought that the collage antedated all the construction-sculp-

tures. William Rubin, *Picasso in the Collection of The Museum of Modern Art* (New York: The Museum of Modern Art, 1972), 74, 207.

32 Man Ray bought a replica in Paris sometime after World War II. Robert Rauschenberg bought another replica (which Duchamp signed) in 1960 in New York. In 1963 Ulf Linde made a replica in Stockholm, and in 1964 the Galleria Schwarz in Milan issued eight replicas, all signed by the artist. See Arturo Schwarz, *The Complete Works of Marcel Duchamp* (London: Thames and Hudson, 1969), 449.

33 Robert Lebel, *Marcel Duchamp* (New York: Grove Press, 1959), 36. Arturo Schwarz has gone so far as to consider the bottle rack's "erect phallus-like spikes" in symbolic relationship to Duchamp's bachelor status, stating further that the item really "fulfills its function only when the bottles are inserted on the spikes"—something that never happened to this particular bottle rack.

34 Katharine Kuh, *The Artist's Voice* (New York: Harper and Row, 1962), 92.

35 Pierre Cabanne, *Dialogues with Marcel Duchamp* (New York: The Viking Press, 1971), 92.

36 Kuh, *op. cit.*, 92.

37 Alexander Calder, *An Autobiography with Pictures* (New York: Pantheon Books, 1966), 127.

38 Schwarz, *op. cit.*, 53.

39 Jack Burnham, *Beyond Modern Sculpture* (New York: George Braziller, 1968), 230.

40 Gabo, *op. cit.*, 169.

41 Umberto Boccioni. The quotation is taken from the preface of the catalogue for his exhibition in Paris, June 20–July 16, 1913. It has been translated and included in Robert Herbert, *Modern Artists on Art* (Englewood Cliffs, New Jersey: Prentice-Hall, 1964), 47–48.

42 Gabo, *op. cit.*, 169.

43 Burnham, *op. cit.*, 225. Burnham's chapter "Kineticism: The Unrequited Art" is the best survey I know on the subject of kinetic sculpture. See also George Rickey, *Constructivism, Origins and Evolution* (New York: George Braziller, 1967), Chapter X, and Frank Popper, *Origins and Development of Kinetic Art* (Greenwich, Connecticut: New York Graphic Society, 1968), Chapter 6.

44 Article of June 1929. Translated and published in H. H. Arnason, *Calder* (London: Thames and Hudson, 1971), 20.

45 Calder, *An Autobiography . . .* , 113.

46 Murdock Pemberton, "A Memoir of Three Decades," *Arts*, vol. 30 (October 1955), 30.

47 Greenberg, *Art and Culture*, 204.

48 Remark found in a 1952 sketchbook of Smith's. *David Smith by David Smith*, edited by Cleve Gray (New York: Holt, Rinehart and Winston, 1969), 35.

49 *Ibid.*, 77.

50 *Ibid.*, 166.

51 See note 27 above.

52 Interview held in 1964. Rosalind E. Krauss, *Terminal Iron Works, The Sculpture of David Smith* (Cambridge, Massachusetts: MIT Press, 1971), 63.

53 Kuh, *op. cit.*, 224.

54 Clement Greenberg, "Comments on His Latest Works," *Art in America*, vol. 54 (January–February 1966), 32.

55 Barbara Rose, "Post-Cubist Sculpture," *American Sculpture of the Sixties* (Los Angeles, California: Los Angeles County Museum, 1967), 37.

56 Gregory Battcock, "Robert Morris: New Sculpture at Castelli," *Arts*, vol. 42 (Summer 1968).

57 Gregory Battcock, "Art of the Real, The Development of a Style: 1948–68," *Arts*, vol. 42 (Summer 1968).

58 Eugene C. Goossen, *The Art of the Real* (New York: The Museum of Modern Art, 1968), 5.

59 Michael Compton and David Sylvester, *Robert Morris* (London: The Tate Gallery, 1971), 13.

60 Harold Rosenberg, "Defining Art," *The New Yorker* (February 25, 1967). Reprinted in Gregory Battcock, *Minimal Art, A Critical Anthology* (New York: E. P. Dutton and Co., 1968), 298–307.

61 Robert Morris, "Notes on Sculpture, Part IV: Beyond Objects," *Artforum*, vol. VII (April 1969), 53.

62 *Ibid.,* 51.

63 Morris, "Notes on Sculpture," *Artforum,* vol. IV (February 1966), 44.

64 Morris, "Anti-form," *Artforum,* vol. VI (April 1968), 35.

65 Morris, "Notes on Sculpture, Part IV: Beyond Objects," *Artforum,* vol. VII (April 1969), 51.

66 Barbara Rose and Irving Sandler, "Sensibility of the Sixties," *Art in America,* vol. 55 (January–February 1967), 48.

67 Barbara Haskell, *Claes Oldenburg, Object into Monument* (Pasadena, California: Pasadena Art Museum, 1971). The quotations in this section are mostly from Oldenburg's notebooks. They have never been published in total but excerpts are to be found in almost every article and book on Oldenburg. The best selections are in Haskell and in Barbara Rose, *Claes Oldenburg* (New York: The Museum of Modern Art, 1970).

68 Haskell, 60–62.

69 The statement was made in an interview with Stuart Wrede, Cambridge, Massachusetts, June 1968, and published in *Perspecta 12, The Yale Architectural Journal,* 1969, 75. See Rose, *Claes Oldenburg,* 110–111.

70 *Ibid.*

EIGHT

Epilogue

1 George Segal, "The Sense of 'Why Not'/George Segal on His Art," *Studio,* vol. 174 (October 1967), 148–149.

2 Oldenburg notebooks, statement of April 1, 1963. Quoted in Rose, *op. cit.,* 192.

3 Los Angeles County Museum of Art, *American Sculpture of the Sixties* (Los Angeles: Los Angeles County Museum, 1967), 44.

4 *Ibid.*

5 Morris, "Notes on Sculpture, Part IV: Beyond Objects," *Artforum,* vol. VII (April 1969), 53.

6 Georges Vantongerloo, *Paintings, Sculptures, Reflections* (New York: Wittenborn, 1948), 11.

7 Anatole Jakovski, "Julio Gonzalez" *Cahiers d'art,* vol. 9 (1934), 207.

8 Werner Heisenberg, *The Physicist's Conception of Nature* (New York: Harcourt, Brace, 1958), 24.

9 Peter Selz, *New Images of Man* (New York: The Museum of Modern Art, 1959).

10 Quoted by Gerhart B. Ladner, *Ad Imaginem Dei, The Image of Man in Medieval Art* (Latrobe, Pennsylvania: The Archabbey Press, 1962), 38–39.

11 William J. Brandt, *The Shape of Medieval History, Studies in Modes of Perception* (New Haven: Yale University Press, 1966), 157.

12 H. W. Janson, "The Image of Man in Renaissance Art: From Donatello to Michelangelo," *The Renaissance Images of Man and His World* (Columbus, Ohio: University of Ohio Press, 1965), 82.

13 Benvenuto Cellini, *I Trattati dell'Oreficeria e Della Scultura* (Florence: Felice Le Monnier, 1857).

14 Gaston Lachaise, "A Comment on My Sculpture," *Creative Art,* III (August 1928). Reprinted in Barbara Rose, *Readings in American Art* (New York: Praeger, 1968), 181.

15 René Dubos, "Science and Man's Nature," *Science and Culture. A Study of Cohesive and Disjunctive Forces* (Boston: Beacon Press, 1965), 268–269.

16 Henry David Thoreau, *Walden* (New York: The New American Library, Inc.) 83–84.

17 Charles Harrison, "Some Recent Sculpture in Britain," *Studio International,* vol. 177 (January 1969), 13.

18 Christopher Finch, *"Meaning and Specificity,"* 14 Sculptors, The Industrial Edge (Minneapolis, Minnesota: Walker Art Center, 1969).

Bibliographical Essay

The following books should be useful for further study of Western sculpture; most of them are readily available.

ILLUSTRATED SURVEYS

Jane Clapp, *Sculpture Index* (3 v.) (Metuchen, N.J., 1970) can be helpful in locating photographs of individual sculptures that have been published in books. For good color illustrations see the 10-volume series published by Fratelli Fabri, *Capolavori della Scultura* (Milan, 1960's). Germain Bazin, *The History of World Sculpture* (Greenwich, Conn., 1968) includes 1,024 color photographs. For outstanding quality in color reproduction of sculpture see the 5-volume *Scultura Italiana* published by Electa (Milan, 1966–1968). Numerous and good black and white illustrations appear in the new *Propyläen Kunstgeschichte* (Berlin; the first of the 18-volume series appeared in 1966). The largest number of photographs of Spanish sculpture are in *Ars Hispaniae*, volumes 5, 13, and 16 (Madrid, 1948, 1958, and 1963), though the quality is not particularly good. The same is true of Adolf Feulner and Theodor Müller, *Geschichte der Deutschen Plastik* (Munich, 1953), with 523 illustrations of German sculpture from the Middle Ages to the twentieth century. To accompany this, the student who wants an English text might read Charles Kuhn's survey, *German and Netherlandish Sculpture, 1280–1800* (Cambridge, Mass., 1965), which uses the sculpture in the Harvard University collections as examples. The only reasonably up-to-date survey of French sculpture is Luc-Benoist, *La Sculpture française* (Paris, 1963). For English sculpture the two Pelican volumes are best: Lawrence Stone, *Sculpture in Britain: The Middle Ages* (Baltimore, Md., 1955), and Margaret Whinney, *Sculpture in Britain: 1530–1830* (Baltimore, Md., 1964). Wayne Craven, *Sculpture in America* (New York, 1968) is the best survey of American sculpture.

GENERAL WORKS

Two books in English treating sculpture in a general, non-historical fashion can be recommended: Herbert Read, *The Art of Sculpture* (Princeton, N.J., 1954) and L.R. Rogers, *Sculpture* (London, 1969). With the aid of 224 excellent black and white plates Read focuses upon the essential elements of sculpture as an independent art form; Rogers's treatment is broader, looking at themes, the vocabulary of different sculptural types, materials, and techniques, as well as elements of style and form.

TECHNIQUES

Numerous books exist on sculptural techniques, but three are most useful in making techniques understood in historical perspective: Malvina Hoffman (she was a student of Rodin's), *Sculpture, Inside and Out* (New York, 1939); Jack Rich, *Materials and Methods of Sculpture* (N.Y., 1947); and John Mills, *The Technique of Casting for Sculpture* (New York, 1967). Anthony Radcliffe includes valuable information on the problems of bronze casting in his *European Bronze Statuettes* (London, 1966).

THE PARAGONE

In considering the Paragone, I found four sources particularly valuable: Leon Battista Alberti, *On Painting and On Sculpture* (edited with translations, introduction, and notes by Cecil Grayson, New York, 1972); *Paragone, A Comparison of the Arts by Leonardo da Vinci* (edited by Irma Richter, London, 1949); Charles Baudelaire, *The Mirror of Art* (New York, 1955); and Georges Vantongerloo, *Paintings, Sculptures, Reflections* (New York, 1949).

Erwin Panofsky's prologue to his investigation of Galileo's ideas about art, *Galileo as a Critic of the Arts* (The Hague, 1954), is the best brief review on the Paragone during the fifteenth and sixteenth centuries. Other studies of considerable importance for the subject are: Charles de Tolnay, *The Art and Thought of Michelangelo* (New York, 1964), particularly Chapter IV exploring Michelangelo's convictions about his material; Robert Clements, *Michelangelo's Theory of Art* (New York, 1961), especially Chapter V, "Comparison and Differentiation of the Arts"; Anne Betty Weinshanker, *Falconet: His Writings and his Friend Diderot* (Geneva, 1966), Chapter V, "The Arts Compared"; Jack Kaminsky, *Hegel on Art* (State University of New York, 1952), Chapter IV; and Henry Caraway Hatfield, *Winckelmann and His German Critics, 1755–1781* (New York, 1943).

GREEK AND ROMAN

George Hanfmann, *Classical Sculpture* (Greenwich, Conn., 1967) is a survey of Greek and Roman sculpture. The introductory essay is brief; emphasis is placed upon the 348 plates.

There are a number of good modern publications on Greek sculpture. Best for photographs is Reinhard Lullies and Max Hirmer, *Greek Sculpture* (New York, 1957). Rhys Carpenter, *Greek Sculpture* (Chicago, 1960) is rich in original insight. Though not a traditional survey, it does take the reader from Archaic through the second century. The parts on Classical sculpture are particularly interesting. See also three books on sculpture by Jean Charbonneaux: *La sculpture grècque archaïque (Paris, 1938), La sculpture grècque classique*, 2 v. (Paris, 1943), and *Greek Bronzes* (London, 1962). Gisela Richter's books are basic to any understanding of Greek sculpture, especially: *The Sculpture and Sculptors of the Greeks* (New Haven, 1950), *The Portraits of the Greeks*, 3 v. (New York, 1965), *Kouroi: Archaic Greek Youths* (New York, 1960, 2nd ed.), and *Korai: Archaic Greek Maidens* (New York, 1968). A fine comprehensive study of the second quarter of the fifth century is found in B.S. Ridgeway, *The Severe Style in Greek Sculpture* (Princeton, N.J., 1970). Bernard Ashmole, *Architect and Sculptor in Classical Greece* (New York, 1972) is an extraordinarily useful study of Classical sculpture, even though it deals with architectural sculpture on only three buildings (Temple of Zeus, Olympia; the Parthenon; and the Mausoleum of Halicarnassus). For the fourth century see the excellent book by Blanche Brown, *Anticlassicism in Greek Sculpture of the Fourth Century B.C.* (New York, 1973). The best place to start in order to understand Hellenistic sculpture is with Margarete Bieber's *Sculpture of the Hellenistic Age* (New York, 1961). For a description of Greek technique in sculpture consult Sheila Adam, *The Technique of Greek Sculpture in the Archaic and Classical Periods* (London, 1966).

There is no general recent survey of Roman sculpture, so the student might begin with George Hanfmann, *Roman Art* (Greenwich, Conn., 1964) in order to get a sense of the period as a whole from its brief introduction, and then proceed to Donald Strong, *Roman Imperial Sculpture* (London, 1961), which is a survey but is restricted to commemorative and decorative relief sculpture. See also P.G. Hamberg, *Studies in Roman Imperial Art* (Uppsala, 1945), which emphasizes State reliefs of the second century. There are a few recent books on individual Roman monuments, such as Inez Scott Ryberg, *Panel Reliefs of Marcus Aurelius* (New York, 1967) and Erika Simon, *Ara Pacis Augustae* (Greenwich, Conn., 1969). For late Roman sculpture *Art Forms and Civic Life in the Late Roman Empire* by H. P. L'Orange (Princeton, N.J., 1965) is particularly interesting. Richard Brilliant, *Gesture and Rank in Roman Art* (New Haven, Conn., 1963) approaches Roman statuary and reliefs through a particular iconography and deals with work from Republican times through the late Empire.

MEDIEVAL

Two highly stimulating essays dealing with particular aspects of medieval Christianity and philosophy that should be read by anyone interested in medieval sculpture are: Ernst Kitzinger, "The Cult of Images in the Age before Iconoclasm," *Dumbarton Oaks Papers*, no. 8 (Cambridge, Mass., 1954), and Gerhart Ladner, *Ad Imaginem Dei, The Image of Man in Medieval Art* (Latrobe, Penn., 1962).

The books edited by Harald Busch and Bernd Lohse are good as photographic surveys, particularly for German examples; they are: *Pre-Romanesque Art* (introduction by Louis Grodecki, 1966), *Romanesque Sculpture* (introduction by Hans Weigert, 1962), and *Gothic Sculpture* (introduction by Hans Weigert, 1963). A single volume covering the same material is

Roberto Salvini, *Medieval Sculpture* (Greenwich, Conn., 1969), which has a good introduction and informative comments on each of the 360 plates.

Two scholars who worked in the 1920's have been fundamental to our understanding of Romanesque sculpture: Arthur Kingsley Porter, who carried out a gigantic task in organizing the material for *Romanesque Sculpture of the Pilgrimage Roads*, 10 v. (Boston, 1923; reprinted New York, 1966), and Henri Focillon, who published his highly creative study of the interrelationship of form and iconography in Romanesque sculpture in *L'art des sculpteurs romans* (Paris, 1931; reprinted 1964). For Italian sculpture of this period the best survey in English is George Crichton, *Romanesque Sculpture in Italy* (London, 1954). Paul Deschamps, *French Sculpture of the Romanesque Period* (New York, 1930; reprinted 1972), which is mostly a picture survey, is still the only general book on French Romanesque sculpture in English; and the standard work on Spanish Romanesque is still Arthur Kingsley Porter's *Spanish Romanesque Sculpture* (New York, 1928; reprinted 1969). A fascinating study of a single Romanesque site and an individual artist is Denis Grivot and George Zarnecki, *Gislebertus, Sculptor of Autun* (New York, 1961).

In 1969 the Rhode Island School of Design museum held an exhibition, *The Renaissance of the Twelfth Century*, which was designed to reveal something of the relationship between Romanesque and Gothic sculpture. The catalogue, written by Stephen Scher and including essays by other scholars, is extensive and informative. This highly complex period of the mid-twelfth century in France has also been examined by Whitney Stoddard in two books: *The Façade of Saint-Gilles-du-Gard, Its Influence on French Sculpture* (Middletown, Conn., 1973), and *The West Portals of Saint-Denis and Chartres, Sculpture in the Ile-de-France from 1140 to 1190, Theory of Origins* (Cambridge, Mass., 1952).

For Gothic sculpture in France see the well-illustrated, authoritative book by Willibald Sauerläender, *Gothic Sculpture in France, 1140–1270* (New York, 1973). John Pope-Hennessy's concise and beautifully organized *Italian Gothic Sculpture* (London, 1955) is the basic book on that subject. It can be supplemented by the relevant parts of John White, *Art and Architecture in Italy, 1250–1400* (Baltimore, Md., 1966), in the Pelican series. There is no good text in English on early Gothic sculpture in Germany. Erwin Panofsky, *Die deutsche Plastik des elften bis dreizehnten Jahrhunderts* (Munich, 1924) remains the fundamental work on the subject, as is Wilhelm Pinder, *Die deutsche Plastik vom ausgehenden Mittelalter bis zum Ende der Renaissance*, on late Gothic German sculpture. This period is also covered, however, in the Pelican series, by Theodor Müller, *Sculpture in the Netherlands, Germany, and Spain, 1400–1500* (Baltimore, Md., 1966). For two excellent studies of Gothic iconography in the great cathedral portals see: Adolf Katzenellenbogen, *The Sculptural Programs of Chartres Cathedral* (Baltimore, Md., 1959), and William Hinkle, *The Portal of the Saints of Reims Cathedral: A Study in Medieval Iconography* (New York, 1965).

RENAISSANCE

For photographic surveys see: Herbert Keutner, *Sculpture, Renaissance to Rococo* (Greenwich, Conn., 1969), and Harald Busch and Bernd Lohse, *Renaissance Sculpture* (N.Y., 1964). There are two excellent general works in English on fifteenth-century Italian sculpture: John Pope-Hennessy, *Italian Renaissance Sculpture* (London, 1958), which is organized by types of

commissions, such as tombs and busts, and presented with first-rate photographs; and Charles Seymour, Jr., *Sculpture in Italy: 1400–1500* (Baltimore, Md., 1966), another Pelican, which is organized around certain ideas about Renaissance sculpture and the regional schools. A survey of Florentine sculpture by Charles Avery, *Florentine Renaissance Sculpture* (London, 1970), emphasizes the great masters who worked in that city during the fifteenth and sixteenth centuries; less scholarly than the surveys above, it is useful for the beginning student. The most informative general book on sixteenth-century sculpture is John Pope-Hennessy, *Italian High-Renaissance and Baroque Sculpture* (London, 1963). For a survey of French sculpture see Anthony Blunt, *Art and Architecture in France, 1500–1700* (Baltimore, Md., 1954), in the Pelican series.

The best monographs in English on Renaissance sculptures are: Richard Krautheimer, *Lorenzo Ghiberti* (Princeton, N.J., 1965); H.W. Janson, *The Sculpture of Donatello* (Princeton, N.J., 1957); Charles Seymour, Jr., *Jacopo della Quercia, Sculptor* (New Haven, 1973), and *The Sculpture of Verrocchio* (Greenwich, Conn., 1971); Günther Passavant, *Verrocchio* (London, 1969); Charles de Tolnay, *Michelangelo* (Princeton, N.J., 1947–1960); and Frederick Hartt, *Michelangelo, The Complete Sculpture* (New York, 1968), which is particularly useful for its fine illustrations. The most satisfying monograph in French is Pierre Du Colombier's *Jean Goujon* (Paris, 1949). Charles Seymour has written a fascinating monograph on a single work: *Michelangelo's David: A Search for Identity* (Pittsburgh, 1967).

SEVENTEENTH AND EIGHTEENTH CENTURIES

For photographic surveys see Busch and Lohse, *Baroque Sculpture* (New York, 1965) and the second part of the Keutner book mentioned in the Renaissance section. For these two centuries the Pelican histories offer the best general discussions; see: the second half of the Blunt mentioned above, *Art and Architecture in France, 1500–1700*; Wend Graf Kalnein and Michael Levey, *Art and Architecture of the 18th Century in France* (Baltimore, Md., 1972); Eberhard Hempel, *Baroque Art and Architecture in Central Europe* (Baltimore, Md., 1965); Rudolf Wittkower, *Art and Architecture in Italy, 1600–1750* (Baltimore, Md., 1958); and George Kubler and Martin Soria, *Art and Architecture in Spain and Their American Dominions, 1500–1800* (Baltimore, Md., 1959). For Italian Baroque sculpture see also the second part of the Pope-Hennessy volume mentioned in the Renaissance section above. Other books on sculpture in individual countries are: Sacheverell Sitwell, *German Baroque Sculpture*, with descriptive notes by Nikolaus Pevsner (London, 1938); Pierre Francastel, *La Sculpture de Versailles, Essai sur les origines et l'évolution du goût français classique* (Paris, 1930; reprinted in 1970); and Manuel Gómez-Moreno, *The Golden Age of Spanish Sculpture* (Greenwich, Conn, 1964).

The most useful monographs on seventeenth-century masters are: Rudolf Wittkower, *Gian Lorenzo Bernini, The Sculptor of the Baroque* (London, 1955), Howard Hibbard, *Bernini* (Baltimore, Md., 1965), Maria Elena Gómez-Moreno, *Fernández* (Madrid, 1953), Beatrice Proske, *Juan Martínez Montañés* (NY., 1967), and Luc-Benoist, *Coysevox* (Paris, 1930). Three major French eighteenth-century sculptors have recently been the subject of monographs; the books are: Louis Réau, *J-B Pigalle* (Paris, 1950), George Levitine, *The Sculpture of Falconet* (Greenwich, Conn., 1972), and Louis Réau, *Houdon, sa vie et son oeuvre* (Paris,

1964). On Houdon see also the excellent catalogue by H. H. Arnason written to accompany the exhibition at the Worcester Art Museum in 1964. Arnason's monograph on Houdon will be published shortly by the Phaidon Press.

NEOCLASSICISM AND THE NINETEENTH CENTURY

The discussion of sculpture in this period in English is almost nonexistent. For a general pictorial survey of the whole period see Fred Licht, *Sculpture: 19th and 20th Centuries* (Greenwich, Conn., 1967). The most expansive and richly illustrated book on nineteenth-century sculpture is Maurice Rheims, *La sculpture au XIXe siècle* (Paris, 1972). Probably the best book yet to appear on Neoclassical sculpture is Gérard Hubert, *La sculpture dans l'Italie Napoléonienne* (Paris, 1964). Guilio Carlo Argan, *Antonio Canova* (Rome, 1969), which deals with Canova's relationship to Neoclassicism and his place in the nineteenth century, is the most recent study of the sculptor, but it is a highly opinionated and interpretive work. For an adequately illustrated survey of Italian nineteenth-century work see Giuseppe Marchiori, *Scultura Italiana dell'Ottocento* (Verona, 1960). Luc-Benoist, *La sculpture romantique* (Paris, 1928) is a bit out-of-date, but it remains one of the best general treatments of nineteenth-century French sculpture. On this also see the exhibition catalogue of the J.B. Speed Museum, *Nineteenth-Century French Sculpture: Monuments for the Middle Class*, by Ruth Butler Mirolli (Louisville, Ky., 1971). A useful new book with broad coverage of bronzes is Jeremy Cooper, *Nineteenth-Century Romantic Bronzes: French, English and American Bronzes, 1830–1915* (Boston, 1975). An exhibition catalogue with good information on late nineteenth-century English sculpture is *British Sculpture, 1850–1914* (London, 1968) published by the Fine Arts Society. The catalogues by Jeanne Wasserman, Joan Lukach, and Arthur Beale, *Daumier Sculpture, a Critical and Comparative Study* (Cambridge, Mass., 1969), and Margaret Scolari Barr, *Medardo Rosso* (New York, 1963) are fine studies of individual sculptors. There are few monographs on nineteenth-century sculptors readily available. Notable exceptions are John Rewald, *Degas Sculpture* (New York, 1956), and a number of publications on Rodin. The best general discussion of Rodin in English is Albert Elsen, *Rodin* (New York, 1963); the most interesting for illustrations is Robert Descharnes and Jean-François Chabrun, *Auguste Rodin* (London, 1967).

THE TWENTIETH CENTURY

While the nineteenth-century literature of art lacks abundant good writing on sculpture, that of the twentieth century is rich in it. To consider the transition between the two periods read Albert Elsen, *Origins of Modern Sculpture: Pioneers and Premises* (New York, 1974). A brief but interesting book that relates twentieth-century sculpture to the past is Charles Seymour, Jr., *Tradition and Experiment in Modern Sculpture* (Washington, D.C., 1949). The earliest important book to be published on modern sculpture in general was Carola Giedion-Welcker, *Modern Plastic Art* (Zürich, 1937), which was brought out in an enlarged edition in 1955 under the title *Contemporary Sculpture* (New York). William Tucker has written some fine articles on early twentieth-century sculptors from the perspective of a sculptor working in the second half of the century; these have been published as a book, *Early Modern Sculpture* (New York, 1974). He is also the author of *The Language of Sculpture* (London, 1974). A book

organized around the important themes and styles of modern sculpture is Robert Goldwater, *What Is Modern Sculpture?* (New York, 1969). Other general surveys are: Andrew Ritchie, *Sculpture of the Twentieth Century* (N.Y., 1952); Jean Selz, *Modern Sculpture, Origins and Evolution* (N.Y., 1963); and Abraham Hammacher, *The Evolution of Modern Sculpture, Tradition and Innovation* (London, 1969). Two studies not exclusively on sculpture but dealing with important aspects of modern sculpture are: William Seitz, *The Art of Assemblage* (New York, 1961); and George Rickey, *Constructivism, Origins and Evolution* (New York, 1967). One of the most original books on twentieth-century sculpture is Jack Burnham, *Beyond Modern Sculpture* (New York, 1968); Burnham gives particular attention to the effects of science and technology on modern sculpture. Catalogues written for large group exhibitions such as Maurice Tuchman, *American Sculpture of the Sixties* (1967) and by the same author, *Art and Technology* (1971), both for the Los Angeles County Museum; and *Eight Sculptors: The Ambiguous Image* (1966) and *14 Sculptors: The Industrial Edge* (1969), both for exhibitions at the Walker Art Center, Minneapolis, are important for a view of recent American sculpture. Wayne Andersen, *American Sculpture in Process 1930–1970* (Boston, 1975), a survey with 300 illustrations, has just been published.

A number of twentieth-century sculptors have published their own ideas about sculpture; of particular interest are: Naum Gabo, *Constructions, Sculpture, Paintings, Drawings, Engravings*, which includes a translation of The Realist Manifesto (London, 1957); László Moholy-Nagy, *The New Vision* (New York, 1947); Jean Arp, *On My Way* (New York, 1948); Jacques Lipchitz, *My Life in Sculpture* (New York, 1972); *Henry Moore on Sculpture*, edited by Philip James (New York, 1967); *David Smith on David Smith*, edited by Cleve Gray (New York, 1968); and *David Smith*, edited by Garnett McCoy (New York, 1973).

Among the best monographs on twentieth-century sculptors are: Albert Elsen, *The Sculpture of Henri Matisse* (New York, 1972); Carola Giedion-Welcker, *Constantin Brancusi* (New York, 1959); Sidney Geist, *Brancusi* (New York, 1968); Roland Penrose, *The Sculpture of Picasso* (New York, 1967); Werner Spies, *The Sculpture by Picasso* (New York, 1971); Robert Melville, *Henry Moore: Sculpture and Drawings* (New York, 1971); H. H. Arnason, *Calder* (Princeton, N.J., 1966); Rosalind Krauss, *Terminal Iron Works, The Sculpture of David Smith* (Cambridge, Mass., 1971); and Barbara Rose, *Claes Oldenburg* (New York, 1971).

Index

DATE DUE

Demco, Inc. 38-293